Troubling Vision

Troubling Vision

Performance, Visuality, and Blackness

NICOLE R. FLEETWOOD

The University of Chicago Press
Chicago and London

Nicole R. Fleetwood is assistant professor of American Studies at Rutgers University and an art consultant who has worked with numerous museums and art institutions.

The University of Chicago Press, Chicago 60637
The University of Chicago Press, Ltd., London
© 2011 by The University of Chicago
All rights reserved. Published 2011
Printed in the United States of America

20 19 18 17 16 15 14 13 12 11 1 2 3 4 5

ISBN-13: 978-0-226-25302-2 (cloth)
ISBN-13: 978-0-226-25303-9 (paper)
ISBN-10: 0-226-25303-3 (cloth)
ISBN-10: 0-226-25303-1 (paper)

Library of Congress Cataloging-in-Publication Data

Fleetwood, Nicole R.
 Troubling vision : performance, visuality, and blackness / Nicole R. Fleetwood.
 p. cm.
 Includes bibliographical references and index.
 ISBN-13: 978-0-226-25302-2 (cloth : alk. paper)
 ISBN-13: 978-0-226-25303-9 (pbk. : alk. paper)
 ISBN-10: 0-226-25302-3 (cloth : alk. paper)
 ISBN-10: 0-226-25303-1 (pbk. : alk. paper)
 1. African Americans in popular culture. 2. African Americans—Race identity. 3. Blacks—Race identity. 4. Hip-hop. 5. Masculinity in popular culture. 6. Femininity in popular culture. I. Title.
 E185.625.F544 2010
 305.896'073—dc22

2010006147

♾ The paper used in this publication meets the minimum requirements of the American National Standard for Information Sciences—Permanence of Paper for Printed Library Materials, ANSI Z39.48-1992.

*This project is dedicated to Barbara Jean Fleetwood (1929–2008),
who remains my light.*

CONTENTS

List of Illustrations / ix
Preface / xi
Acknowledgments / xv

INTRODUCTION / 1

ONE / "One Shot": Charles "Teenie" Harris and the Photographic Practice of Non-Iconicity / 33

TWO / Her Own Spook: Colorism, Vision, and the Dark Female Body / 71

THREE / Excess Flesh: Black Women Performing Hypervisibility / 105

FOUR / "I am King": Hip-Hop Culture, Fashion Advertising, and the Black Male Body / 147

FIVE / Visible Seams: The Media Art of Fatimah Tuggar / 177

CODA / The Icon Is Dead: Mourning Michael Jackson / 207

Notes / 219
Bibliography / 247
Index / 267

ILLUSTRATIONS

I.1 Tracey Rose, *Span II*, performance installation (1997) 31
1.1 Rosa Parks on bus (1956) 35
1.2 Charles "Teenie" Harris, Children on Webster Avenue, Hill District 41
1.3 Charles "Teenie" Harris, self-portrait (1940) 48
1.4 Charles "Teenie" Harris, West Auto Body Shop (1947) 50
1.5 Unknown, Charles "Teenie" Harris with camera (1935–50) 52
1.6 Charles "Teenie" Harris, Birthday party (1963) 56
1.7 Charles "Teenie" Harris, Portrait of a man in a light-colored shirt (1950–65) 61
1.8 Charles "Teenie" Harris, Portrait of a man in a plaid shirt (1950–65) 62
1.9 Charles "Teenie" Harris, Portrait of two men in front of chain link fence (1950–65) 63
1.10 Charles "Teenie" Harris, Boxer Cassius Clay with family (1963) 66
1.11 Charles "Teenie" Harris, Rudy Clay, brother of Cassius Clay (1963) 67
1.12 Charles "Teenie" Harris, Photographer taking a picture of Cassius Clay (1963) 67
2.1 Dael Orlandersmith and Howard W. Overshown in *Yellowman* 83
2.2 Dael Orlandersmith in *Yellowman* 98
3.1 Renee Cox, *Yo Mama's Last Supper* (1996) 106–7
3.2 Renee Cox, *Cousins at Pussy Pond* (2001) 115
3.3 Renee Cox, *Baby Back* (2001) 116
3.4 Renee Cox, *Black Leather Lace-Up* (2001) 117
3.5 Tracey Rose, *Venus Baartman* (2001) 119

3.6 Janet Jackson, Super Bowl performance (2004) 129

3.7 Ayanah Moor, *Clap* (2006) 135

3.8 Ayanah Moor, *Lean* (2006) 136

3.9 Lil' Kim, "How Many Licks" (2000) 141

4.1 Jamel Shabazz, *Number 2 Train* (1980) 151

4.2 Advertisement in *Vibe* (October 2001) 164

4.3 Advertisement in *Vibe* (April 2002) 167

4.4 "I am King" advertisement featuring Sean Combs (September 2009) 169

4.5 Roca Wear advertisement featuring Jay-Z (September 2009) 170

5.1 Fatimah Tuggar, *Fusion Cuisine* (2000) 178

5.2 Fatimah Tuggar, *Meditation on Vacation* (2002) 185

5.3 Fatimah Tuggar, *Meditation on Vacation* (2002) 185

5.4a Fatimah Tuggar, *The Lady and the Maid* (2000) 188

5.4b Fatimah Tuggar, *Robo Makes Dinner* (2000) 188

5.5 Fatimah Tuggar, *Fusion Cuisine* (2000) 193

5.6 Fatimah Tuggar, *Transient Transfer* (2008) 200

5.7 Fatimah Tuggar, *Conveyance* (2001) 202

C.1 Autographed image of the Jacksons 216

PREFACE

My family and friends often joke that I can bring any subject matter, any conversation topic, back to my maternal grandmother, Barbara Jean Fleetwood. My grandmother is that person for me who is the steady, constant, always present reference point; she marks the beginning and the end of most things. I am no doubt a grandma's girl, which has given me the biggest soft spot for any woman who reminds me of her. Another friend likes to tease that I "love old folks." It's true. I do. My grandmother passed away in 2008 while I was on leave at the Schomburg Center for Research on Black Culture finishing this manuscript. She inspires the origins of this book.

She had a quiet, peaceful spirit that kept her calm through some very tumultuous and heartbreaking circumstances. She was not very talkative but when she did speak it was in language colored by subtleties and innuendos. She sang softly and hummed to herself and would often be heard saying aloud to no one in particular, "This too shall pass." Her inner calm was anchored to the spirit world and immaterial space not bound by the conditions of her lived experience. This produced in her the ability to distance herself from much of the pain and struggle in her life and the lives of those around her while remaining compassionate and committed to helping others. She kept her gaze far beyond the here and now, often staring off into empty spaces where she located possibility.

The only time that my grandmother seemed intimidated or fearful was in the presence of white people. These were usually spaces or circumstances where white people exerted their authority and their power to prescribe certain terms of her lived experience. For example, when she worked as a domestic for whites, she was once fired because she had been given a ride to work by her father, whose car was considered too nice for a black man to be

driving in that era. When a stray white person (an insurance salesperson, a mail carrier, a city worker) showed up on her porch, she would always send someone else to deal with the stranger.

When I was about thirteen and in junior high school, I lived with her for a while. During that time, I became good friends with a white girl named Shawna who was on the cheerleading squad with me. We lived in a very segregated town in southwest Ohio where poor and working-class black neighborhoods were separated from poor, working-class, and middle-class white areas by railroad tracks and a river. Shawna and I were drawn to each other because of our half-hearted feelings about cheerleading. We both relished the popularity but did not identify with the prissiness and strict codes of the squad. We were curious girls who wandered about the streets of her white neighborhood ignoring the stares of passersby and drivers who always slowed down as they passed us. In our town (at the time), public friendships among black and white kids were rare and provoked curious looks. The boundaries between black and white were strictly enforced with violence. Once when I was a child, I was playing with another young black girl on a fairly busy street that served as passageway between black and white communities. A group of drunken white men sped by yelling racial expletives. One threw out a half-empty beer bottle that ricocheted off the sidewalk and cut open my playmate's leg. This was one of many incidents of racial violence that I experienced or witnessed in the public spaces where blacks and whites intersected.

One afternoon I ran into Shawna outside of the local grocery store. I was with my grandmother, who had never met Shawna. I was so excited to have them meet. I said, "Grandma. This is Shawna. She's on the cheerleading team with me." My grandmother said softly hello and that it was nice to meet her. Shawna said a quick hello and then told me that she would see me in school the next day. She smiled, and my grandmother and I walked back to the car. I was oblivious to any exchange of looks between them.

As we walked away from Shawna, I could feel my grandmother's body tightening. She gripped her purse, a gesture that she did whenever she was uncomfortable or in an unfamiliar environment. A silence came over her. I ventured to ask, "Grandma, what's wrong?" This was not a question that children posed to adults in my family for several reasons. One, there was always something wrong and the asking about it would just make the presence of the wrongness that much stronger. Two, I was too young to be part of any solution to the things that were constantly wrong: those typically being a lack of money, lack of employment and educational opportunities, and the many wrongs of menfolk. Three, what in God's good name would

make me think that I had the right to pose a question, any kind of question, to a grownup, especially the matriarch of my family?

She said wide-eyed and exposed, with some anger toward me for putting her in the situation, "She looked at me like I was fat, black, and ugly." I wanted immediately to defend my friend with something like "but Grandma, she likes black people," but I said nothing. I felt guilty and angry. And I was shocked; I had never heard my grandmother use this kind of language. The words came out her mouth as if spoken by another. We didn't speak again until much later in the evening when we were home and had settled into our routine. Neither of us ever brought up the incident again nor did we mention Shawna's name to the other.

How could the look and reserved hello of a little white girl reduce my grandmother who was the strongest person I knew to understanding herself as being fat, black, and ugly?

I still feel guilty and angry.

ACKNOWLEDGMENTS

Writers often describe the process of constructing a book from its inception to research to writing and rewriting in terms of birthing. It is also a process of dying and mourning: the loss of time, the loss of relationships, the loss of sight, the loss of the body that began the project before knowing the toll it would take. In the process of writing this book, I have experienced many losses—the death of my grandmother, a divorce, the long-term incarceration of a very young relative. I have been paralyzed by grief at points in the process. I am fortunate to have had the love and support of many friends, family, and colleagues as I have mourned and written, the processes becoming one and the same toward the end. I could not have completed the manuscript without the unyielding support of Lissa Soep, Ebony Coletu, Cynthia Tolentino, Juana Maria Rodriguez, Julie Livingston, and Harry J. Elam Jr.

For reading the manuscript in its entirety, I thank Jennifer DeVere Brody, Juana Maria Rodriguez, John L. Jackson Jr., Nancy Hewitt, Louise Barnett, Ricardo A. Bracho, and Imani Perry; their comments and suggestions have expanded the possibilities that I see in the pages that follow. Harry J. Elam Jr., Deborah Willis, Allan Isaac, Leslie Fishbein, Julie Livingston, Lissa Soep, Kyla Tompkins Fisher, Cynthia Tolentino, Ebony Coletu, LeRonn Brooks, Yael Ben-zvi, David Eng, Ayanah Moor, and Paula Massood have read sections and have provided invaluable feedback. A special thanks to Ricardo A. Bracho who was my angel in the final stages of writing, agreeing to proofread and index the book. He offered brilliant feedback.

I offer my heartfelt thanks to the artists, scholars, and cultural practitioners who inspire this study. Fatimah Tuggar is a wonderful interlocutor and has taught me a great deal about the work of art and the integrity of the artist. I am grateful for the opportunity to engage with the works of Charles "Teenie" Harris, Zora Neale Hurston, Tracey Rose, Renee Cox, Dael

Orlandersmith, Ayanah Moor, Jamel Shabazz, Tracy Collins, Joan Marcus, Lil' Kim, Stephen Burrows, and the other cultural practitioners who populate these pages. I thank the artists mentioned above and the following entities and institutions for permission to reproduce works in this study: the Charles "Teenie" Harris Estate, Carnegie Museum of Art, BintaZarah Studios, The Project Gallery, Robert Miller Gallery, Studio Museum in Harlem, Manhattan Theatre Club, Bronx Museum of Art, and www.3c.com. I offer a very special thanks to Kerin Shellenbarger, Louise Lippincott, and Laurel Mitchell of Carnegie Museum of Art for their information, guidance, and enthusiasm.

This book began while I was a graduate student in the Program in Modern Thought and Literature at Stanford University. Although it is not my dissertation, the questions raised here grew out of the process of writing it. I could not have asked for a more supportive dissertation advisor than Harry J. Elam Jr., whose consistency, integrity, and support are unmatched. Robin D. G. Kelley generously agreed to be an outside reader although he was thousands of miles away from Stanford. His dedication and support were remarkable and he functioned more as second advisor. Both Harry and Robin have remained mentors and friends and my gratitude is immeasurable. Paulla Ebron exposed me to many of the issues that drive the inquiries in this study while I was enrolled in two of her graduate seminars in cultural anthropology ("Culture as Commodity" and "Reading Theory through Ethnography"). Shirley Brice Heath warmly embraced me and provided many opportunities to meet with cultural practitioners and arts administrators, and to gain experience in documentary production and visual ethnography. In the time since I left Stanford, Deborah Willis has been a remarkable mentor. She has served as a model for brilliant, ethical, and creative engagement inside and outside of the academy. I thank her for the love and support. I also have benefited tremendously from the mentorship of Nancy Hewitt, Craig Watkins, Mary Pat Brady, David Eng, Rosi Braidotti, Kate McCullough, and Colleen Cohen.

I was surrounded by a group of intellectually stimulating and kind scholars in graduate school. Many have become wonderful friends and their presence continues to enrich my life: Lissa Soep, Ebony Coletu, Richard Benjamin, Lisa Arellano, Raúl Coronado, Celine Parreñas Shimizu, and Kyla Wazana Tompkins. Thanks to the following students for collegiality and support while at Stanford: Evelyn Alsultany, Yael Ben-Zvi, Faedra Carpenter Chartard, Daniel Contreras, Maria Cotera, Manishita Dass, Mishuana Goeman, Marcial González, Shona Jackson, Bakirathi Mani, Yvonne Price,

Venus Opal Reese, Alicia Schmidt-Camacho, Darieck Scott, Shannon Steen, Lisa Thompson, Tim'm West, and Jacqueline Wigfall. I am thankful to faculty and administrators who provided resources and guidance while there: David Palumbo-Liu, Cherríe Moraga, Alice Rayner, Arnold Rampersad, Sharon Holland, Kennell Jackson, Akhil Gupta, Ramon Saldívar, Valentin Mudimbe, Monica Moore, and Jan Hafner.

I thank my colleagues, students, and the staff in the American Studies Department at Rutgers University–New Brunswick. I have grown in many ways from the intellectual exchange, warmth, and collegiality there. For providing wonderful advice and time to complete the manuscript, I am grateful to Ann Fabian and Ben Sifuentes-Jáuregui. Louise Barnett and Leslie Fishbein are amazing mentors in the department. Michael Rockland, Angus Gillespie, Allan Isaacs, Alice Echols, Ellen Wu, Louise Duus, and Al Nigrin have been exceptional colleagues. Helene Grynberg, departmental administrator, provided guidance on navigating institutional bureaucracy. Thanks to colleagues and administrators in other departments, including Barry Qualls, Deborah Gray White, Cheryl Wall, Aldo Lauria Santiago, and Tanya Sheehan. The Institute for Research on Women (IRW) at Rutgers has been an amazing space to learn from other scholars on campus and I thank all of the scholars who participated in the Diasporas and Migrations Seminar (2005–6). Nancy Hewitt provided professional and intellectual guidance and directed the institute during my fellowship. Scholars met through IRW made my experience at Rutgers rewarding and include Julie Livingston, Jasbir Puar, Carlos Decena, Kim Butler, María Josefina Saldaña Portillo, Robyn Rodriguez, Rama Chase, Renée Larrier, Catherine Raissiguier, Kayo Denda, Edlie Wong, Simone James Alexander, and Sonali Perera.

My time at the University of California–Davis was enriched by an active and intellectually engaged group of scholars. I thank the faculty and staff in the American Studies Department: Jay Mechling, Caroline De La Pena, Ruth Frankenberg, Eric Smoodin, Michael Smith, Julie Sze, Eric Schroeder, and Kay Clare Allen. I am grateful for the friendships built during that time especially through the Race/Sexuality/Gender Group where I grew close to Juana Maria Rodriguez, Rhacel Salazar Parreñas, and Gayatri Gopinath. I also appreciate exchanges with Caren Kaplan, Sergio de la Mora, Bettina Ng'weno, Beth Freeman, Glenda Drew, and Jesse Drew during my time at UC–Davis.

My research has benefited from two fellowships: the Scholars in Residence Program (2007–8) at the Schomburg Center for Research on Black Culture through the New York Public Library and the National Endowment for the Humanities and the Andrew W. Mellon Post-Doctoral Fellowship in

Visual Literacy at Vassar College. Colin Palmer, director of the Scholars in Residence Program at the Schomburg, created a wonderful collegial environment to generate and share work. Many thanks to Diana Lachatanere, Aisha H. L. al-Adawiya, and the library's staff. I thoroughly enjoyed being part of the lively and engaging community that the Schomburg fosters. I learned from the feedback and scholarship of other fellows: Evie Shockley, Anthony Foy, Carter Mathes, Laurie Woodward, Shannon King, Robert O'Meally, Chad Williams, Kali Nicole Gross, Venus Green, Carolyn Brown, Malinda Lindquist, Ivor Lynn Miller, and Johanna Fernandez. At Vassar College I was provided many resources and much space to develop my research; my time there was enriched by Colleen Cohen, Cynthia Tolentino, Lisa Gail Collins, Luke Harris, Deborah Paredez, Eva Woods, Uma Narayan, Sarah Kozloff, and many thoughtful and motivated students.

Thanks to the Women and Work Group sponsored by the Ford Foundation and the University of Maryland, College Park that brought together junior and senior women of color scholars to share research and for professional support. Participants included Taunya Lovell Banks, Vilna Bashi, Elsa Barkley Brown, Lynn Bolles, Carole Boyce Davies, Sharon Harley, Nancy A. Hewitt, Evelyn Hu-DeHart, Kellie Jones, L. S. Kim, Maria Ontiveros, Rhacel Salazar Parreñas, Clara Rodríguez, Vicki Ruiz, Denise Segura, Rebecca Tsosie, Deborah Willis, Francille Wilson, and others.

What a wonderful gift I received while at the Schomburg to have Seth Markle as my research assistant. I have also benefited from the wonderful research assistance of Tracy Smith, Ngozi Olemgbe, Mark Mazza, Andrew Ramos, and Rain Breaw. A warm thanks to Martine Bellen who provided wonderful writing guidance when grief and fear interfered with completing the manuscript.

I have benefited from many intellectual communities and from conversations with scholars across institutions and fields. I thank the following for intellectual support, encouragement, and kindness: Paula Massood, Judith Jackson Fossett, José Esteban Muñoz, Kellie Jones, Farah Jasmine Griffin, Mark Anthony Neal, Thadious Davis, Daphne Brooks, Brent Hayes Edwards, Hortense Spillers, Thomas Allen Harris, Jerry Miller, Miles Orvell, Tina Campt, Jennifer Morgan, Herman Bennett, Saidiya Hartman, Valerie Smith, Margo Crawford, Ruth Wilson Gilmore, Peggy Phelan, David Román, Andreana Clay, Nikhil Singh, Eithne Quinn, and Roderick Ferguson.

Sections of this study have been presented to various audiences, including those at New York University, Rutgers University–New Brunswick, University of Texas at Austin, University of California–Davis, Vassar College, Howard University, Harvard University, CUNY Graduate Center, Yale

Acknowledgments / xix

University, School of Critical Studies at Cal Arts, Temple University, Staten Island College, the American Studies Association annual convention, the Modern Language Association annual convention, American Sociological Association annual meeting, Society for Cinema and Media Studies conference, Association for Theatre in Higher Education annual conference, Screen Studies conference, and Race in Digital Space 2.0 conference. I have benefited from the comments, questions, and suggestions of audiences at these sites. Portions of chapters 4 and 5 were published in earlier forms in *Black Cultural Traffic: Crossroads in Performance and Popular Culture*, edited by Harry J. Elam Jr. and Kennell Jackson (Ann Arbor: University of Michigan Press, 2005) and *Signs: Journal of Women in Culture and Society.*

I was born into a huge family of hilarious, boisterous, and life-embracing women. I would not have it any other way. My strength is anchored to the strength of my grandmothers (Barbara Jean Fleetwood and Ernestine Moore), my mother, Eleanor Fleetwood Wilson, and her eight sisters (Melanie, Sharon, Frances, Margie, Sandy, Sheila, Yvette, and Yvonne). My mother's compassion and profound identification with others continue to teach me the power of caring. I grow each day from the sweet spirits of my brothers, Craig and Jarrid; I want more men like you two populating this planet. Thanks to my stepfather, Calvin Wilson, my maternal grandfather Sherman Fleetwood, and my step-grandfather Malcolm Moore, who have always been my biggest cheerleaders. I also appreciate my father, Billy Hickman, whose wild imagination pushes the limits of what is thinkable. I grew up creating a fascinating world of play and possibility with over forty cousins. I continue the play and conversations began those years ago with Cassandra, Rhonda, Eric, and Allen; those relationships have sustained me my entire life.

My thanks go out to the many families who have made me a part of their families. The Greene family has always embraced me and loved me as a daughter. I am glad to still be in your lives. Thanks to the Jones/Brown family (Lisa, Ken, Zoe, Hettie, and Kellie) and the McGeachy Kuls (Joycelyn, Norbert, and Jackson) for including Kai and me in your circle of love, creativity, and friendship. Thank you to the Kelley/Sattwa/Carter clan (Robin, Ananda, Meilan, Diedra, Kamau, Makani) for food, fellowship, community, and utopian ideals over the years. My heart melts from the love and generosity extended by Juana Maria Rodriguez and family who took Kai and me into their home at our most vulnerable moment.

I often marvel at the amazing friends whom I have acquired over the years. What would I do without Ebony Coletu, Lissa Soep, and Moriah Ulinskas, who are always with me and always available even when time differences and/or parenting responsibilities keep us from connecting. My

life is infinitely more interesting and stimulated by the friendship, humor, and warmth of Monifa Porter, Crystal Durant, Soula Notos, Ricardo A. Bracho, Cara Jackson, Marc Sharifi, Ivan Jaigirdar, Fredgy Noel, Tyrus Burgess, Stacey Hall, Uzi Frank, Selana Allen, Essie Blankson Turner, LeRonn Brooks, Gabrielle Thurmond, Nicole Franklin, Aki McKenzie, Limor Tomer, Terrance McKnight, and Emily Lundell. I could not have completed this project without the involvement of a few loving souls who have helped with child care so that I could have time and space to write; thank you to Jacky Johnson, Ashley Wade, Ngozi Olemgbe, Stephanie Lindquist, Denise and Julian Milstein, Sarah and Jesse Buff, Mona Skinner, Ms. Paulette, Lyn-Genet Recitas and family, and Rebekah Hammonds and family.

I am deeply appreciative of the relationship that I have built with Doug Mitchell at the University of Chicago Press. Every conversation with Doug is richly imaginative and acrobatic; the moments have propelled me forward. Thanks to Tim McGovern, Joel Score, my copyeditor Therese Boyd, and the staff at the Press for the care and detail that they have given my manuscript.

I have been enriched in countless ways by Benton Greene who has been in my life through every aspect of this project. And while our relationship has turned out very different than what we planned, I appreciate his continued presence, support, and wonderful co-parenting of our mutual love, Kai.

For as much as the project was written during a period of grief and loss, the book is ultimately about love, imagination, and a hopefulness that exceeds the here and now, and that is Kai Aubrey Fleetwood Greene, my boo-boo bear, who is such a source of love, light, imagination, and play.

Introduction

In the final weeks of summer 1989, as we waited for our senior year of high school to begin, three friends and I went to the movies late one evening. We were a racially mixed group of two blacks and two whites. The drive to the suburban community with the shiny multiplex—one of the only public spaces where teenagers intermingled across race and class—was thirty minutes from our postindustrial town. We arrived too late to enter the movie we had intended to see—what now appears to be a forgettable film, as I cannot remember the title. We decided to see something else and chose based on show times. The movie that we so happened upon was Spike Lee's *Do the Right Thing*.

As we sat watching the previews, I recalled that the film had been marketed (at least locally) through its comedic moments. In my mind, those ads had registered as a modern teenpic with black characters, similar to a cropping of low- to moderate-budget Hollywood films that marketed aspects of hip-hop culture to a mainstream audience in the 1980s.[1] Immediately, these assumptions were challenged by the striking visual depictions of the film: the color saturation of Ernest Dickerson's cinematography, the hyperreal urban street, and the frank and stylized address (and dress) of the characters. From the opening scene of Rosie Perez dancing to Public Enemy's rap song "Fight the Power" on a graffiti backdrop, the film was like none we had ever experienced. The visual and sonic charges ranged from its multiracial casting to the urban fashion of the youthful characters to the sex scene between the black male protagonist Mookie (Spike Lee) and Tina (Rosie Perez)—Mookie's loud, ethnicized, and eroticized Puerto Rican girlfriend, who is always portrayed in interior spaces. Then there is Mookie's sister Jade (Joie Lee)—the thoughtful and observant young black woman

whom Mookie cautions to stay out of public space, out of the lustful eyes of the white male characters. As the film's humor turned from play to battle and the sense of tragedy deepened, I remember feeling anxious about what was unfolding, but even more anxious about what my white friends were going to see unfold in the film. The climactic violent death of Radio Raheem at the hands of the police and Mookie's smashing the window of the white-owned pizzeria left me paralyzed. After the film ended and the credits rolled, my friends and I sat there in silence. Several minutes later, we walked to the car still not talking; then we returned home and waited for something to happen.

I would learn that we were not the only ones to feel so impacted by the film and to expect so much as a result of it.[2] Nationally, Lee's third feature film was the subject of much discussion that often turned into polarizing debates in various media outlets. The public conversations about *Do the Right Thing* in the weeks and months after its initial release were often expressed in extremes from declarations that it would forever change how blacks are represented in film to warnings that it would lead to race riots.[3] As one reviewer put it, "Depending on where you're coming from, *Do the Right Thing* is either an unflinching and cautionary look at race relations or an incitement to riot."[4]

Although I begin with a discussion of perhaps the most widely known black filmmaker in the history of film and one of the best-known and most-discussed films by a black filmmaker, *Troubling Vision* is a study of black visuality and performance, not a study of film or mass media. In fact, the book works against black iconicity of which Lee and his film are two of the largest in post–1960s American culture. By *iconicity*, I mean the ways in which singular images or signs come to represent a whole host of historical occurrences and processes. Nevertheless, I begin with these icons—the film and the filmmaker, because Lee's *Do the Right Thing* and its popular and critical reception demonstrate the affective power of certain instantiations in black cultural production to generate a response to what is racialized as black: subjects, matter, space, experience. The film also is an example of the larger cultural significance of the cinematic apparatus for the projection of racial difference and subjectivity, or even more broadly, how the language and mechanism of cinema permeate cultural experience in modern Western societies. Borrowing from Gilles Deleuze's concept of "the cinematic," film theorist Kara Keeling describes this as "a condition of existence, or a reality, produced and reproduced by and within the regimes of the image."[5] With *Do the Right Thing*, the impact of the film was to animate certain images in my mind about race, urbanity, gender relations, and interracial and

interethnic conflict. Seeing black in the film was a multisensory experience and a revelation of how synesthesia shapes the audience deciphering of blackness and black subjects. For example, the visualization of black bodies can be heard (i.e., Radio Raheem blasting "Fight the Power" on his large boombox) or can produce a range of sensory experiences beyond but rooted in the seeing of blackness.[6] But most important, I begin with *Do the Right Thing* because it continues to loom in my conscious as a clear and visceral moment of being *moved* by black visuality.

During the celebration of *Do the Right Thing*'s twentieth anniversary in 2009, critics and journalists noted the significance of the film's anniversary just months after electing the first black US president.[7] In an interview with Jason Matloff, Lee states: "There was a benefit for Barack Obama on Martha's Vineyard when he was running for the Senate. I didn't really know who he was. He came over and said, 'You're responsible for me and my wife getting together.' Then he told me how they saw *Do the Right Thing* on their first date, and then went to Baskin-Robbins for ice cream and talked about it." Lee follows up that story by joking that Obama was smart to take Michelle to see his film instead of *Driving Miss Daisy* (the film that has been the subject of much criticism for its portrayal of blacks as happily in service of whites and that won the Academy Award for Best Picture the same year that *Do the Right Thing* was released) because if he had "things would have turned out a whole lot different."[8] Lee's anecdote weaves his film into the national narrative that produces the first black president: quite a feat. While one might read both humor and hubris in Lee's recounting of the meeting with Obama, who was then unknown to Lee and who wanted to bond with Lee over *Do the Right Thing*, the anecdote and the larger national reception of the film elucidate the weight placed on black cultural production to produce results, to do something to alter a history and system of racial inequality that is in part constituted through visual discourse. That something, I contend, is the desire to have the cultural product solve the very problem that it represents: *that seeing black is always a problem in a visual field that structures the troubling presence of blackness.*

Lee's film was released at an exciting time in black cultural production and representational practice. The 1980s saw heightened levels of black crossover stardom and increased numbers of public and cultural figures. Black actors, athletes, and celebrities—Michael Jackson, Oprah Winfrey, Michael Jordan, Whitney Houston, Eddie Murphy, and Tina Turner, to name a few—gained popularity and wealth unseen in previous moments of American entertainment culture (a topic breached in *Do the Right Thing* through the controversy over Sal's Wall of Fame). In television *The Cosby Show*, as

analyzed by Herman Gray, expanded representations of blacks in dominant media while at the same time supporting hegemonic notions of American capitalism, conservative family values, and individualism.[9] As Craig Watkins examines, challenging the norms of black middle-class respectability that *The Cosby Show* represented was the emergence of hip-hop music and culture, of which *Do the Right Thing* is representative.[10] These advances in black mass media and cultural production occurred during the height of the Reagan era and the presidency of George H. W. Bush—a time known for the culture wars and the reign of neoconservatism. Broadly speaking, this era saw the consolidation and rise of a black culture industry that would continue to grow and become incorporated into dominant visual media and popular culture throughout the 1990s.

Do the Right Thing signals the emergence of new representational practices for black cultural producers, as well as an important moment in the institutionalization of US-based black cultural studies housed in English, African American/Africana studies, and other interdisciplinary studies departments in the academy. Reflecting on the public and political discourse of the time period when Henry Louis Gates Jr. edited the now-famous special issue of *Critical Inquiry*: "'Race,' Writing, and Difference," Valerie Smith writes that it was "an era when mainstream discourse in the United States about race had become deeply cynical; public officials proclaimed their support for racial entrenchment as a badge of honor."[11] Smith discusses the efforts of the Reagan administration and the Supreme Court to do away with many of the gains of the civil rights era at the same time that important intellectual contributions in black cultural and political thought were emerging. Considering the intellectual impact of the special issue edited by Gates, Farah Jasmine Griffin writes that the volume's contributors "were the creators of a paradigm shift that not only shaped our thinking about difference, history, politics, and literature but also produced faculty lines, graduate student cohorts, conferences, and publications." Griffin historicizes how the volume and other foundational scholarship of the era created spaces for race to be "an object of investigation considered worthy of attention even by those who were not racially marked."[12]

Within this emergent field of black cultural criticism, Lee's representation of black life, race relations, gender, and the culture of poverty became heated topics of debate. Of note is Wahneema Lubiano's "'But Compared to What?': Reading Realism, Representation, and Essentialism in *School Daze*, *Do the Right Thing* and the Spike Lee Discourse." Lubiano's essay highlights many of the stakes raised in black cultural criticism at that particular moment. Problematizing the label of Lee as a "politically radical or progressive

filmmaker," Lubiano argues that there is a deeply heteronormative ideology that underpins Lee's work and that continues the marginalization of black women in cultural discourse and the public sphere. A recurring critique that surfaced in the Spike Lee debate was the representational possibility afforded to other black cultural producers as Lee's power and stardom rose as the primary voice in black filmic and visual narratives. Lubiano supports this view when she writes, "Were a variety of African-American filmmakers framed with such a profile, such a salience, critics and commentators (both African Americans and others) might be less likely to insist that Lee's work is the 'real thing' and celebrate it so uncritically."[13]

Her analysis moved beyond a concern about who is afforded the right to represent black culture to query the reliance on visual narratives and realist aesthetics to get at *the* truth of black experience, or what I have called the expectation that the representation itself will resolve the problem of the black body in the field of vision. Lubiano theorizes:

> Telling the "truth" demands that we consider the truth of something compared to something else. Who is speaking? Who is asking? And to what end? I don't think that the problem of addressing the construction of reality can be answered by more claims to realism without considering how and why both hegemonic realism and resistance to or subversion of the realism are constructed. Reality, after all, is merely something that resounds in minds already trained to recognize it as such. Further, what happens in the shadow behind the "real" of Spike Lee—once it becomes hegemonic for African-Americans? In other words, what happens when this "representation" is accepted as "real?" What happens to the construction of "Blackness" in the public discourse?[14]

Lubiano's essay crystallizes many of the issues that have preoccupied studies of black representational practices and visuality. The struggle as she frames it is largely over the terms of the debate—what signifies black vernacular (i.e., authentic) experience and the problematic conflation of that with a progressive political critique. Lubiano points to how the field of black representational practices can shore up normative discourses, partly through a reliance on black iconicity and the authority given to black male cultural producers. Lubiano's question about what happens when privilege is given to certain iconic figurations of blackness as the truth of racialized experience: "What happens to the construction of 'Blackness' in the public discourse?" Most relevant to this study are two key issues that Lubiano raises about the production, reception, and circulation of black visuality: her critique of the troubling assumption that audiences see the same thing when viewing

that which has been coded as black and, related, the notion that audiences come to understand black lived experience and black subjects as knowable through visual and performative codes. Both serve as points of departure for the modes of analyses and types of reading engaged in this study.

Troubling Vision is a study of how blackness becomes visually knowable through performance, cultural practices, and psychic manifestations. The book considers the role of visuality and performance together as they produce black subjects in the public sphere. In arguing that the discourse of blackness is predicated on a knowable, visible, and performing subject, I examine how the process of deciphering itself is a performative act of registering blackness as visual manifestation. Blackness and black life become intelligible and valued, as well as consumable and disposable, through racial discourse. Blackness, in this sense, circulates. It is not rooted in a history, person, or thing, although it has many histories and many associations with people and things. Blackness fills in space between matter, between object and subject, between bodies, between looking and being looked upon. It fills in the void and is the void. Through its circulation, blackness attaches to bodies and narratives coded as such but it always exceeds these attachments.

Blackness troubles vision in Western discourse. And the troubling affect of blackness becomes heightened when located on certain bodies marked as such. By arguing that the visible black body is always already troubling to the dominant visual field, *Troubling Vision* investigates the productive possibilities of this figuration through specific cultural works and practices, including documentary photography, drama and theatre, performance-based photography, advertising and entertainment culture, and digital media art. *Troubling Vision* works across multiple fields, namely visual culture and media studies, performance theory, critical race theory, popular culture, and feminist theory. The lens of feminist film theory and psychoanalytic studies of race and difference influence my analysis of how racialized heteronormativity structures the gaze and the field of vision.[15]

In an effort to critically attend to the affective power of the circulation of blackness, the chapters move across various realms of the black visual and the black performative. The study shifts from the specificity of photographically indexing a local black neighborhood in the mid-twentieth century to the psychic domain of colorist logic to the hypervisible and excessive manifestations of blackness in contemporary art and entertainment culture. It then moves to the transgeographic and transhistoric mediascapes of digital art haunted by the presence of blackness. The study is concerned with practice, production, and critical reception. Each object of investigation pro-

vides a lens to look at the affective power of black cultural production, or the calling upon the spectator to do certain work, to perform a function as arbiter, or decoder, of visual signs that become aligned with blackness.

Given the vast amount of scholarship and criticism on black visibility and representation, the question is: how do we return to what we already know with curiosity and openness so that new forms of knowing and recognition emerge? The project looks curiously at what seems never to stop repeating itself, yet what startles, causes an uproar, produces visceral feelings (perhaps a sense of belonging or a profound alienation) from being hailed or self-identifying as a member of a racialized group whose visual rendering is always already troubling. And this to me is the power of certain black cultural production—artists' intentions aside—to strike at the very core of how blackness gets produced through visual discourse and how the manifestations of this discourse in certain instantiations—film, photographs, performances, social breaches, stylistic gestures—require audiences to consider the very definition of blackness as problem, as perplexing, as troubling to the dominant visual field. While I do not conceive of the works discussed in this study as necessarily or solely resistant of a dominant gaze, I do argue that these cultural practices and products reveal information about how we come to know what we know, particularly about the black body and the meanings that get attached to and circulate around it. They demonstrate that the visual sphere is a performative field where seeing race is not a transparent act; it is itself a "doing." For as Judith Butler writes, "The visual field is not neutral to the question of race; it is itself a racial formation, an episteme, hegemonic and forceful."[16] In other words, the field of vision is a formation that renders racial marking, producing the viewing subject who is, to paraphrase Norman Bryson, "inserted into systems of visual discourse that saw the world before" the particular subject came into being.[17] The notion of rendering/rendered is crucial to the formulation of blackness and blacks as objects and subjects of discourses of visuality and performance. A concept in art history, media, and artistic practice, the term *render* often refers to a technological process of production, as in a digital rendering of an image through computer software. In its explicit reference to subjectivity, "to render" means to make or become somebody. I keep in mind the polyvalent meanings of this term—to give help; to translate; to deliver a verdict; to submit for consideration; to purify through extraction; to surrender something; to exchange or give something back—as they each contribute to an understanding of the visual, visible, viewed and viewing black subject.

The book's title invokes three disparate scholarly contributions that pose problems about the key terms and questions at stake in my analysis: W. E. B.

DuBois' 1903 *The Souls of Black Folk*; Judith Butler's 1990 study *Gender Trouble* as well as her more recent scholarship on gender and performativity; and W. J. T. Mitchell's conceptualization of "showing seeing."[18] These scholars schematize in larger volumes individuated theories of the forces that operate in this study: race, performance, gender, and visuality. DuBois' proclamation, "the problem of the Twentieth Century is the problem of the color line," has inspired countless studies over the past century and continues to haunt African American studies and black diasporic scholarship. DuBois formulates the "Negro Problem" as the lived and psychic experience of those marked or who identify as black. It is a problematizing of the subjective individual and the group through affiliation or forced association that colors experience and perception (including, as I argue, the act of seeing): "They [Blacks] must perpetually discuss the 'Negro Problem,'—must live, move, and have their being in it, and interpret all else in its light or darkness."[19] Judith Butler's work provides a theoretical rope that loops many of the ideas, fields, and objects of study. Her call for troubling normative categories is part of the scaffolding of *Troubling Vision*. In the 1999 preface to the book, Butler explains how her aim in the study "was not to 'apply' poststructuralism to feminism, but to subject those theories to a specifically feminist reformulation." To paraphrase Butler the study set up the troubled relationship between terms as one not of application but as reformulation.[20]

W. J. T. Mitchell's work on the "pictorial turn" (also called "visual turn") has opened up a range of scholarship on visual perception and subjectivity.[21] Mitchell calls for an approach to the study of visual culture that

> does not content itself with victories over natural attitudes and naturalistic fallacies, but regards the seeming naturalness of vision and visual imagery as a problem to be explored, rather than a benighted prejudice to be overcome.... In short, a dialectical concept of visual culture cannot rest content with a definition of its object as the social construction of the visual field, but must insist on exploring the chiastic reversal of this proposition, *the visual construction of the social field*.[22]

These works allow for a reformulation of blackness as emergent through its troubling presence and association with bodies and subjects marked as black in the field of vision.

Throughout *Troubling Vision*, I develop concepts that are critically deployed to probe the space between subject and object, between instantiation and affect, to show how visualization works in the production of

blackness as that which is viewable and as discourse. Apart from troubling vision, these concepts are non-iconicity, excess flesh, and visible seams. *Non-iconicity* is an aesthetic and theoretical position that lessens the weight placed on the black visual to do so much. It is a movement away from the singularity and significance placed on instantiations of blackness to resolve that which cannot be resolved. Because the history of debates and scholarship on black representation and visibility have been so centered on masculinity, the study engages with a range of works of black female cultural producers whose practices highlight the troubling presence of the black female body both to dominant public culture and to black masculinist debates about race, subjectivity, and visuality. In this regard, the black visual has been framed as masculine, which has positioned the black female visual as its excess. The notion of *excess flesh* is a term that I develop to attend to ways in which black female corporeality is rendered as an excessive overdetermination and as overdetermined excess. It is a strategic enactment of certain black female artists and entertainers to deploy hypervisibility as constitutive of black femaleness in dominant visual culture. Whereas excess flesh enactments work through the spectacular, the *visible seam* works through the subtlety of a stitch that sutures but leaves visible the wound that it mends. It is technique and a discursive intervention to address narrative erasure and to insert a troubling presence in dominant racializing structures.

Affect and Historical Recurrence

It is the constant troubling presence of blackness and the recurrence of certain visual narratives of black subjectivity that thread together the chapters that follow. David Marriott links this recurrence to "a failed mourning" of slavery that results in

> both affect—remorse, guilt, blame, disavowal; the traces left by persons long dead—and spectacle; in particular, the occult presence of racial slavery, nowhere but nevertheless everywhere, a dead time which never arrives and does not stop arriving, as though by arriving it never happened until it happens again, then it never happened. . . . Here it is the power of exclusion that shapes black experience of political and ethical life and the awful feeling of one's visible invisibility.[23]

This affective response arises in American public discourse, but especially within the black public sphere. The arguments for or against, even the voice of authority offering context, ring with emotional excess. The investment

seems all or nothing, no matter how catastrophic—such as the abandonment of thousands of blacks during Hurricane Katrina—or seemingly fleeting.[24] The various responses convey not only the attachment to black representations in visual media but also a particular investment in black iconicity.

Black iconicity serves as a site for black audiences and the nation to gather around the seeing of blackness. However, in the focus on the singularity of the image, the complexity of black lived experience and discourses of race are effaced. The image functions as abstraction, as decontextualized evidence of a historical narrative that is constrained by normative public discourse. It is a critique that Lubiano launches against the use of images of Malcolm X and Martin Luther King Jr. throughout *Do the Right Thing*. Lubiano writes, "Iconography and fetishization is no consistent substitute for history and critical thinking. The film offers no consistent critique of 'pictures'—as icons, as fetishes."[25] Lubiano suggests that *Do the Right Thing* perpetuates the unquestionable evidentiary significance of the icon in black public culture. W. J. T. Mitchell looks at how iconic photographs circulate throughout the film as public art and represent a struggle over the public sphere. This struggle in the film takes place between Sal, the pizzeria owner whose Wall of Fame portrays a number of famous Italian Americans, and Buggin' Out, who challenges him to include images of African Americans on the wall given that the clientele is predominantly the black working-class residents of the neighborhood. This investment in black iconicity is reflective of black audiences and a national public. It is interwoven into the national narrative of democratic progress and American exceptionalism, in which the children of slaves become the exemplars of the nation-state, a topic pursued in detail in chapter 1 of this study.

The repetition of public outcries, cautious celebrations, struggles over "the image," or even tepid ambivalence reveal the affective power of black representational practices. The collective responses reinvigorate what cultural theorists call "the history of the present." In theorizing affect and the sociality of emotions, Lauren Berlant uses the phrase "collective attachment" and defines this concept as a form of optimism in how emotions can bring individuals together. It "is a way of describing a certain futurism that implies continuity with the present, but, it does not always *feel* good, attachment seems a better way to describe the pleasures of repetition without presuming their affective reverb." As Berlant writes, "the public spheres are affect worlds," evidenced in what Lubiano describes as the Spike Lee discourse.[26] Sara Ahmed's theory of affective economies is very useful to understand the recurrence of collective attachment to black visual representation. Moving

emotion beyond interiority (especially as conceptualized in psychoanalytic theory) to the externalizing effects in public discourse and collective belonging, Ahmed writes,

> In such affective economies, emotions *do things*, and they align individuals with communities—or bodily space with social space—through the very intensity of their attachments. Rather than seeing emotions as psychological dispositions, we need to consider how they work, in concrete and particular ways, to mediate the relationship between the psychic and the social, and between the individual and the collective.[27]

Ahmed states that emotions are not fixed or located in objects or bodies but move among objects, signs, and bodies; "they move sideways (through 'sticky' associations between signs, figures, and objects) as well as backward (repression always leave its trace in the present—hence 'what sticks' is also bound up with the 'absent presence' of historicity)."[28] In reading the work of Chicano playwright Ricardo A. Bracho, José Estaban Muñoz theorizes a method of understanding affect to attend to the ways in which racial and ethnic groups feel and perform difference. Muñoz writes, "In lieu of viewing racial or ethnic difference as solely cultural, I aim to describe how race and ethnicity can be understood as 'affective difference,' by which I mean the ways in which various historically coherent groups 'feel' differently and navigate the material world on a different emotional register."[29] The affective register that Muñoz references speaks to the way that black cultural practices continually produce the very notion of a black audience and the investment in this construct.

Inasmuch as the collective attachment to black visual production returns implicitly or unwillingly to "the real" and the compulsion to get it "right," John Jackson's theory of "racial sincerity" offers insight: "Racial sincerity is an attempt to apply this 'something-elseness' [referring to Ralph Ellison's phrase] to race, to explain the reasons it can feel so obvious, natural, real, and even liberating to walk around with purportedly racial selves crammed up inside of us and serving as invisible links to other people."[30] Jackson's theory allows for the possibility to read the collective attachment that circulates around black images and bodies in ways that are not pejorative to those who form a sense of belonging or kinship through visual rendering of blackness. Instead racial sincerity can be read as critical responses to the psychic wound that resurfaces as failed mourning, as "the history of the present." Through sticky association, racial sincerity gets attached to the troubling presence of the black body in the visual sphere. Berlant's,

Ahmed's, and Jackson's writings on affect help shape the emphasis placed on critical reception and public discourse about black visual and performative practices in this study.

From the Polemics of Black Visibility to the Visuality of Performative Blackness

In theorizing how the black body always troubles the visual field and how this troubling presence manifests itself in certain visual works and practices, I enter a debate over a century long about the representation of blackness in dominant visual culture and in black artistic production. Its historical relevance can be seen in the contemporary scholarship on W. E. B. DuBois' representational agendas such as in his much-cited "Criteria of Negro Art" and the aesthetic considerations made by Alain Locke in the edited collection *The New Negro*.[31] Or even more salient is the preacher's sermon, "The Blackness of Blackness," in Ralph Ellison's *Invisible Man* and the many interpretations of it in literary studies, drama and performance studies, and queer theory.[32]

Over the past two decades, several important studies have emerged that provide critical tools for engaging in historical debates and their resonance in more contemporary representations of blacks, particularly in television and film.[33] *Troubling Vision*, while indebted to these earlier works, moves away from an analysis of the politics of representation to a concern with how black subjectivity itself is constituted through visual discourse and performed through visual technologies. Two ways of marking this shift toward subjectivity and visuality are through contemporary scholarship on race and art history; and a broader intellectual shift toward visual culture and visuality. A growing body of work on black visual artists and on race and art history has influenced the field of black cultural studies and the types of images and visual material that scholars research. Of note is the groundbreaking work of Deborah Willis in the fields of photography, the history of black representation, and exhibition.[34]

Moreover, scholars writing about black visual artists and/or race and art history have pointed out that while black intellectual thought and public discourse have remained fixated on "the problem" of black images for much of the twentieth century, criticism has focused largely on television and film to the neglect of the practices of black visual artists. In her closing remarks to the "Black Popular Culture" conference—a field-defining event held in 1991—Michele Wallace criticized the audience of primarily black scholars and critics for marginalizing the visual arts in black culture.[35] She spoke of

the general disinterest, bordering on contempt, for the works of contemporary black artists whose works had been curated as a visual component to the conference.[36] Wallace's comments were well placed given that the conference highlighted scholars whose research grappled with contemporary imagery and historical legacies of black representation in dominant visual media. Building upon Wallace's assertion of the neglect of black visual arts, art historian Lisa Gail Collins frames the issue as "a visual paradox" in which there is a preoccupation with visual culture in its representations of blacks while simultaneously black visual art and artists are neglected. Collins argues that black American political leaders and intellectuals have placed emphasis on how blacks are represented visually, while ignoring or showing ambivalence toward the contributions of black visual artists throughout the last century.[37]

In essence, the visual sphere has been understood in black cultural studies as a punitive field—the scene of punishment—in which the subjugation of blacks continues through the reproduction of denigrating racial stereotypes that allow whites to define themselves through the process of "negative differentiation."[38] Based in a ruthless history of representing blacks as abject, the mobilization against dominant visual representations of blacks, particularly throughout the twentieth-century cultural history of the United States, has led to a fixation on getting images of blacks "right" as a way of countering racist stereotypes, or what Michele Wallace and others have described as the debate over "negative/positive images." This is a well-treaded area in writings on black visibility and one that I will not rehearse here but to mention its significance in shaping how blackness is conceptualized and made visible in scholarship. Visual representations of blacks are meant to substitute for the real experiences of black subjects. The visual manifestation of blackness through technological apparatus or through a material experience of locating blackness in public space equates with an ontological account of black subjects. Visuality, and vision to an extent, in relationship to race becomes a thing-in-itself.

Contemporary artists and thinkers have launched various attempts to conceptualize black visuality in ways that do not continue to marginalize black visual practices or that do not promote prescriptive notions of cultural engagement. Proponents of a post-black aesthetic and scholarship that argues for a new interpretive framework for analyzing art produced by black artists (one that is not bound by the history and connotations of African American art/artists) intervene in modes of engaging with visual arts and cultural production in black public culture and critical discourse. Thelma Golden and Glenn Ligon's notion of "post-black art" has been one attempt

of articulating a critical moment of exhaustion with historical frameworks of understanding the relationship between art production and race, especially blackness, when used to discuss the works of black artists.[39] Golden contextualizes the term in the catalogue of *Freestyle*, an exhibition curated by Golden and Christine Y. Kim, featuring work of a post-1960s generation of black artists:

> "Post-black" was shorthand for post-black art, which was shorthand for a discourse that could fill volumes. For me, to approach a conversation about "black art" ultimately meant embracing and rejecting the notion of such a thing at the very same time. . . . It was a clarifying term that had ideological and chronological dimensions and repercussions. It was characterized by artists who were adamant about not being labeled as "black" artists, though their work was steeped, in fact deeply interested, in redefining notions of blackness.[40]

While I do not make use of the term *post-black* as one of endorsement, I do think that the precepts of the term must be considered in a study of black visual discourse. Fundamental to the concept is dissatisfaction expressed by contemporary black artists with how their works are measured within arts traditions as demonstrative of black experience. I would venture to say that this exhaustion is with the privilege of iconicity in black representational practices and dominant visual culture. The concept of "post-black" registers a profound frustration with normative ways of understanding black representation, aesthetic practice, and reception. According to Golden, post-black art is not simply a doing away with old forms of representational and artistic engagement but an opening up of new possibilities that move beyond the strictures of old labels.

Darby English, in his study *How to See a Work of Art in Complete Darkness*, takes up a position akin to that of Golden and Glenn by posing the following question: what happens when we drop the label *black* entirely from works by artists racialized as black or African American? English urges criticism that moves beyond "black representational space," to consider the contemporary practices of black artists whose works he argues cannot be understood in their formal and aesthetic complexities by labeling the art black and the institutionalization with which the category black art becomes aligned.[41] English's interventionist reading centers the practices of viewer and critic to an understanding of artistic practice, visuality, and race. For him, much of the onus of a change in interpretation resides in the critical view of the spectator and the critic to resist subsuming the work of such

artists to overdetermined narratives of black arts traditions. While the different and related agendas of Ligon's and Golden's post-black art and English's query resonate with some of the concerns explored in this study, my interest is in the rich and productive possibilities of the simultaneously troubling and overdetermined discourse of blackness in the visual field. I am interested in how the labeling or marking of black troubles the production, reception, and interpretation of cultural production and practices.

Related to the movement away from the polemics of black visibility is the shift in understanding the racialized and visual(ized) subject of cultural discourse. Incorporating Ralph Ellison's articulation of (racialized, modernist) invisibility, Wallace argues:

> How one is seen (as black) and, therefore, what one sees (in a white world) is always already crucial to one's existence as an Afro-American. The very markers that reveal you to the rest of the world, your dark skin and your kinky/curly hair, are visual. However, *not* being seen by those who don't want to see you because they are racist, what Ralph Ellison called "invisibility," often leads racists to the interpretation that *you are unable* to see.[42]

Wallace points to the limitations of focusing on cultural representation and redirects scholars and critics to consider the field of vision itself as a crucial realm for structuring and enforcing race. We can think about these frameworks for understanding blackness and the visual field as (1) "positive/negative debates," (2) the valuation of black visual arts, (3) a call for aesthetics not bound by the strictures of racial history (i.e., post-black), and (4) a turn toward the relationship between subjectivity and visuality. My study takes up this latter concern through careful attention to visual practices of black artists and the psychic and affective domains of seeing and doing black.

According to Nicholas Mirzoeff, one of the interventions of visual culture scholarship is to address "the visual subject, a person who is both the agent of sight (regardless of biological ability to see) and the object of discourses of visuality."[43] This emergent field shifts inquiries away from the political or cultural efficacy of a particular representation and toward an investigation of the significance of visuality to produce and reinforce how subjects come to be racialized and come to understand the codes of racial differentiation. In analyzing the development of the studies of visual culture, Martin Jay grounds the formation in a 1994 conference at Dia Art Foundation that resulted in the edited collection by Hal Foster, *Vision and Visuality*. Jay argues that much of this work emerged out of a shift in understanding images as culturally specific and scholarship that historicized vision as a social

process. These studies have destabilized the "facticity" and objectivity of vision by emphasizing the historical and cultural context of the field of vision. Consequently, the visual and vision are considered context-specific factors embedded in specific cultural and historical processes.[44]

References to vision, visualizing, and visibility run throughout this study. *Visibility* implies the state of being able to be seen, while *visualization* refers to the mediation of the field of vision and the production of visual objects/beings. *Hypervisibility*, used often in black cultural studies, is an interventionist term to describe processes that produce the overrepresentation of certain images of blacks and the visual currency of these images in public culture. It simultaneously announces the continual invisibility of blacks as ethical and enfleshed subjects in various realms of polity, economies, and discourse, so that blackness remains aligned with negation and decay.[45] In *Vision and Visuality* Hal Foster distinguishes between vision and visuality as follows:

> Although vision suggests sight as a physical operation, and visuality sight as a social fact, the two are not opposed as nature to culture: vision is social and historical, too, and visuality involves the body and the psyche. Yet neither are they identical: here, the difference between the terms signals a difference within the visual—between the mechanism of sight and its discursive determinations—a difference, many differences, among how we see, how we are able, allowed, or made to see, and how we see this seeing or the unseen therein.[46]

Revising Foster's classic definition of visuality to attend to its conservative origins and its contemporary uses in interventionist and nonnormative projects, Nicholas Mirzoeff argues,

> Visuality, far from being a postmodern solution predicated by contemporary visual culture to the problems of medium-based visual disciplines, is then a problem of the conceptual scheme of modernity and representation that underlies it. Visuality is very much to do with picturing and nothing to do with vision, if by vision we understand how an individual person registers visual sensory impressions.[47]

Mirzoeff posits visuality as a system of visual meaning that is not only image-based but that also engages optics and visual metaphors. To visualize assumes a certain access to visible subjects/objects.

Film theorist Christian Metz's notion of "scopic regime" (Metz used the term originally to apply to cinema) has become an important framework

for discussing the power of looking and optical tools to assess, surveil, and represent the visual world. For Metz, the concept was used to explain the relationship between cinema and the imaginary in its production of desire as that which is "never possessible." According to Metz, "the absence of the object seen" is what defines the cinematic scopic regime and what distinguishes it from other media.[48] Scopic regime more broadly theorized gets deployed to describe the use of vision and visual technologies in a given historical and cultural context to maintain power relations. Scopic regimes in this sense are everywhere and nowhere.

Much of scholarship and art that address visual culture and race have demonstrated how optical technologies have been used to discipline racialized bodies. Vision and visual technologies, in this context, are seen as hostile and violent forces that render blackness as aberration, given the long and brutal history of black subjugation through various technologies, visual apparatus among them. Yet it is a rendering that often totalizes the gaze so that black subjects have no recourse in which to challenge scopic regimes. Vision becomes a metaphor for the far-reaching arms of repression and the inescapability of racial marking. In his insightful study *Blackness and Value: Seeing Double*, Lindon Barrett expresses this perspective on vision and visuality:

> [I]f considering the cultural logic of racial blackness in the New World entails articulating socially and historically powerful conceptions of literacy, it also entails articulating peculiar monopolizations, deployments, and countercultural dispellings of the sensory modality of vision. . . . It is the skin colors, the textures of hair, the shapes of skulls and noses, the placements of cheekbones, the thicknesses of lips, the contours of buttocks that visibly define those in the African diaspora and, accordingly, the enduring social, political, and economic oppressions of the African diasporia [*sic*]. Diasporic populations find themselves in circumstances in which the sense-making capacity of vision, the significance of vision, is monopolized from a hostile perspective. . . . Visual reflexes, in the same way literacy determines in large part the logic of racial blackness, aim to hypostasize racial blackness.[49]

Barrett, as in much of recent scholarship in black sonic cultures, proposes that sound provides expressive possibility for blacks to articulate subjectivity. Barrett writes,

> Given this situation—because African Americans are in this way disbarred from meaningful participation in the sense-making activity of vision, are

confronted with vision as a hostile realm of significance—one might argue that the priority of a musical legacy attests to African American populations' turning earnestly, ingeniously, and with marked success to the less privileged sense-making medium of sound. Sound, one might argue, gains especial importance for those who remain visibly outside the designation of most fully human.[50]

While I agree with Barrett's assertion about the significance of scopic regimes to subjugate blacks through visual coding (the subject of chapter 2 of this study), I also argue for the productive possibilities of black subjects to trouble the field of vision precisely by presenting the black body as a troubling figuration to visual discourse.

With this as the primary structuring principle of this study—that the black body is always problematic in the field of vision because of the discourses of captivity and capitalism that frame this body as such—then the crucial question is: how might we investigate the visible black body as a troubling presence to the very scopic regimes that define it as such? How does this troubling presence reveal the work of scopic regimes to efface through normalizing the gaze and racial markings? Who sees? How is seeing determined? When and where are the moments in which blackness visually comes into being?[51] These questions are deeply embedded in performance theory's inquiries into subjectivity, address, affect, and positionality. The words *performance* and *performing* in academic studies are popular metaphors and strategies especially in studies of gendered and racialized embodiment. Performance has been used as interventionist strategies to shake loose subject formation from fixed notions of identity categories. At the same time, some scholars have cautioned about performance losing its meaning and specificity because of its over-use and how it becomes a catch-all for that which is related to the constructedness of subjectivity.[52]

At times, *Troubling Vision* engages with performance as staged cultural productions and practices that are to be understood within traditions of theatre, performance art, and installation art. But the stage is not the center of this study. Unstaged enactments populate this study, and I critically approach the various responses and affect that they produce, by focusing on the production that arises through the exchange. Performativity, then, as reiteration articulated in feminist theory and linguistics serves to analyze these instantiations within larger discourses that shape what we understand as decipherable and relevant.

Performance as a framework for understanding social presentation, ritualized activities, and modes of exchange as developed in anthropology and

studies of everyday life figures into the conceptual use of the term in this study. Repetition (or Richard Schechner's "twice behaved behavior") and rehearsal are crucial to usage in theatrical realms and as social behavior.[53] Referencing Schechner's famous definition, Diana Taylor writes that performances provide "vital acts of transfer, transmitting social knowledge, memory, and a sense of identity through reiterated." Taylor looks at how performance operates as "ontological affirmation," as well as "the methodological lens that enables scholars to analyze events *as* performance." Taylor furthers its relevance and use by showing that "performance also functions as an epistemology. Embodied practice, along with and bound up with other cultural practices, offers a way of knowing." Expressing concern about how the performative becomes linked to discourse in its philosophical and rhetorical usage, Taylor argues for the need to distinguish performance from discourse: "performance also has a history of untranslatability."[54] Taylor writes:

> the problem of untranslatability, as I see it, is actually a positive one, a necessary stumbling block that reminds us that "we"—whether in our various disciplines, or languages, or geographic locations throughout the Americas—do not simply or unproblematically understand each other.[55]

The troubling of "we" as performers and audiences complicate our interpretations of art and cultural practices and the affective responses to culture making. What Taylor signals as the untranslatability of performance offers an angle for probing that which audiences and performers yearn to resolve but cannot resolve about the visible black body. That which exceeds our attempts at making meaning lingers long after the body has disappeared.

Disappearance, a preoccupation in performance theory, brings into question the boundaries of performance and also the primacy of the body as a viewable object in defining performance and more importantly in understanding subjectivity. Peggy Phelan encourages scholars of performance (and I would venture to say representation more broadly) to reconsider the primacy placed on the body as medium:

> I am investigating, in *Mourning Sex*, the possibility that something substantial can be made from the outline left after the body has disappeared. My hunch is that the affective outline of what we've lost might bring us closer to the bodies we want still to touch than the restored illustration can. Or at least the hollow of the outline might allow us to understand more deeply why we long to hold bodies that are gone.

Performance and theatre make manifest something both more than and less than "the body." And yet the acts made visible in theatre and performance are acts that we attribute over and over again to bodies, often immaterial and phantasmatic ones.[56]

Phelan's queries challenge some basic assumptions that operate in performance theory and performance studies. Especially in terms of race, gender and performance, the body is central to the power and impact that scholars afford to performance.[57] Given the historical associations between blackness and (in)visibility in racial discourse, the viewable black body holds a privileged place in black cultural criticism on performance and representation. At the same time, the black body, as black performance theorists have articulated, has been bound by notions of its performative abilities (i.e., the black entertaining body). E. Patrick Johnson critiques the associations between blackness and performance that binds definitions of blackness to tropes of performance:

> There are ways in which blackness exceeds the performative. . . . In other words, blackness does not only reside in the theatrical fantasy of the white imaginary that is then projected onto black bodies, nor is it always consciously acted out; rather, it is also the inexpressible yet undeniable racial experience of black people—the ways in which the "living of blackness" becomes a material way of knowing. In this respect, blackness supersedes or explodes performance in that the modes of representation endemic to performance—the visual and spectacular—are no longer viable registers of racial identification. No longer visible under the colonizer's scopophiliac gaze, blackness resides in the liminal space of the psyche where its manifestation is neither solely volitional nor without agency.[58]

Acknowledging the problems in seeing blackness as a performance in terms that reproduce normative notions of blacks as entertaining beings or as bodies in service of white society, *Troubling Vision* is more concerned with race as iteration through theories of performativity; the book considers how the markings and iterations of blackness are manifested through a deliberate performance of visibility that begs us to consider the constructed nature of visuality. The book then not only concerns itself with the black body in the visual field, but more broadly with how blackness gets attached to bodies, goods, ideas, and aesthetic practices in the visual sphere.[59] In focusing on black visuality and presence, the project queries the power of disappearance in terms of what Phelan describes as "the hollow of the outline."

The spaces where performance studies and visual studies meet are the sites that I find most productive for the possibilities that combined they afford to interpretation. Peggy Phelan's 1993 study *Unmarked: The Politics of Performance* remains insightful in terms of theorizing the workings of performance and vision in subjectivation. About the position of the viewing subject and the desire for recognition, Phelan writes, "All vision doubts and hopes for a response. . . . To see is nothing if it is not replied to, confirmed by recourse to another image, and/or another's eye. This confirmation is negotiated through representation—which is to say through distortion, and principally for this discussion, through the distortions produced by the desire for the real."[60]

Both visual studies and performance studies, while focusing on artistic and cultural production (as product, practices, and reception), emphasize the importance of the location of the interpreter or audience to make sense of meaning of a given cultural event, process, or object. With its roots in theatre, experimental arts, and anthropology, performance allows for the readings of embodied subjectivity and enactments in staged moments, in still images (like photography and print advertising), and everyday engagements. It is an approach to addressing the spectator in the construction of the object, event, or phenomena, and the production of cultural meaning. For example, in reading Edouard Manet's painting *Olympia* (1863) through performance theory, Jennifer DeVere Brody examines "the various performative engagements with Manet's active thought, which are performed through the meditative medium of paint put together on canvas. . . . [O]ur vision is dependent upon technologies of vision and recognition. These mechanisms work in conjunction with our remembering which always already implicates us as individual social actors and places us in positions determined by power, politics, and society."[61] Visual studies allows for the interpretive and contextual tools of art history to be applied to a variety of cultural products and phenomena, not traditionally (or by disciplinarily boundaries) deemed *objet d'art*. One of the primary spaces of intersection between the fields is "the relationships of corporeality to the visual," as Catherine Soussloff and Mark Franko write.[62]

The Fanonian Moment

Frantz Fanon is the starting point for many studies of black visuality and studies of race and subjectivity. Fanon's presence reaches across this study, though with some hesitation and self-consciousness, in large part due to his frequent citation in black visual scholarship and his reinscription of the

black female subject as unintelligible. Henry Louis Gates Jr., in analyzing Fanon's position as a "global theorist" who circulates widely across a range of fields, looks at the various stakes that other scholars have made in Fanon's writing. Gates writes that Fanon continues to resurface in scholarship on race, subjectivity, and colonialism because his writings are "highly porous, that is, wide open to interpretation, and the readings they elicit are, as a result, of unfailing *symptomatic* interest: Frantz Fanon, not to put too fine a point on it, is a Rorschach blot with legs."[63]

Homi Bhabha, one of the scholars whose investment in Fanon Gates closely considers, has articulated the significance of Fanon's work for prioritizing the psychic processes of racialization and for constructing a vocabulary and tools of engagement for generations of scholars succeeding Fanon. Bhabha writes, "From within the metaphor of vision complicit with a Western metaphysic of Man emerges the displacement of the colonial relation. . . . The white man's eyes break up the black man's body and in that act of epistemic violence its own frame of reference is transgressed, its field of vision disturbed." Later expounding upon a theory of identification with roots in Fanon's writing, Bhabha explicates: "the very question of identification only emerges *in-between* disavowal and designation. It is performed in the agonistic struggle between the epistemological, visual demand for a knowledge of the Other, and its representation in the act of articulation and enunciation."[64] Fanon signals, for many contemporary scholars, a mode of articulating the space where the black visual subject becomes intelligible through dominant discourse.

Given that this is a study about the affective domain of black performativity in the visual sphere, I return to what has become a foundational anecdote for many of the scholars working in these fields. Often described as his "Look, a Negro!" anecdote, it is what I call "the Fanonian moment." Meditating on how he was hailed by a white child who declared in public, "Look, a Negro!," Fanon provides brilliant insight into the terror and trauma of being marked visually as black in the public sphere. Fanon considers the power of that defining moment, the definition itself, and the public declaration to gaze upon blackness. He explains that his "corporeal schema crumbled, its place taken by a racial epidermal schema."[65] In considering the Fanonian concept of epidermalization, Stuart Hall explains that it literally means "the inscription of race on the skin" and that it is a cultural and discursive schema, not genetic or physiological.[66] The popularity of this anecdote in scholarship on race, masculinity, and/or visual culture has much to do with the affective power of the story itself and how it brings the reader into the narrative of being hailed in such a way that one cannot run for cover. The

anecdote is enticing and horrifying. It has become the inaugural moment for writings on black visual culture and studies of race and subjectivity.

"The Fanonian moment" marks a racial primal scene in which the black subject comes into self-knowing through the traumatic recognition of another's eyes.[67] By engaging and rehearsing what other scholars have done with "the Fanonian moment," I query the implications of using Fanon as the inaugural scene for scholarship on visuality and black subjectivity. Through the reverence and recitation of Fanon writings, a vocabulary and conceptualization of understanding black subject formation—its hailing and trauma—have taken on a facticity. At the same time, the gaps and elisions in Fanon's writings are made more meaningful by the richly varied body of scholarship that has emerged in response to his writings. In reading other scholars' readings of the racial primal scene of the black subject in the field of vision—"Look, a Negro!"—I attempt to highlight how frameworks of theorizing the (un)knowability of blackness are solidified, even as I find Fanon's writing invaluable to the work that I do in this study.

David Marriott's books *On Black Men* (2000) and *Haunted Life: Visual Culture and Black Modernity* (2007) emerge, in many respects, as responses to the Fanonian moment. Fanon, as thinker, psychotherapist, and subject of psychoanalysis, is a focus of much of Marriott's writings. Marriott returns to the Fanonian moment on multiple occasions, continuing to develop nuanced positions from which to witness Fanon's assault and the meanings produced through it. Focusing on the psychic and the visual, Marriott theorizes how conflict and ambivalence circulate through Fanon's writing. In his earlier study, Marriott emphasizes the importance of visual projection, in particular film, in petrifying the black man within dominant conceptions of understanding subjectivity.[68] In his more recent study, *Haunted Life*, Marriott returns to the scene; he writes:

> But this anecdote is, for me, not only about the sense of being breached by an intruding, ghostly imago ("Look, a nègre"); but about how the being of the black is rendered insubstantial by the white who sets his or her eyes upon it. I understand this as follows: in this form of looking, what haunts is not so much the imago spun through with myths, anecdotes, stories, but the shadow or strain that is sensed behind it and that disturbs well-being.
>
> ... Instead of an intact "corporeal schema," what we see here is a body disembodied by image, language, thought; the word "nègre" acting like some kind of chemical dye converting epidermal surface into imago. Here's a funny thing, though: the body is a medium for what has been transferred on to Fanon, like a genetic flaw, and simultaneously what is penetrated and

replaced by the ghostly incarnation that comes upon it, and whose effect gives Fanon vertigo.[69]

What strikes me in Marriott's analysis is his articulation of what the hailing of Fanon does to the black man's body. Marriott notes that this body is marked by its disembodiment and ghostly incarnation. This significance of his ghostly incarnation is in line with Phelan's theory of the power of disappearance and the haunting presence of the outline left after the body is no longer there. Marriott isolates the interstitial workings of vision, discourse (here, language of address and narrative scripts), and corporeality to the rendering of the black male subject; he recognizes the role of language—narration—in attaching the imago to black corporeality. Marriott emphasizes the body as being *disembodied* by image and the body's recasting through imago. This shadow or strain is what I understand as the residue that hovers, lingers, emanates, and circulates long after the moment of marking, here the Fanonian moment, has passed. Scholars have discussed this shadow or strain as producing an opacity that runs throughout discourses of visuality and race. In looking at black performance practices of the nineteenth century, Daphne Brooks argues that this opacity also provides possibility for black subjects: "A kind of shrouding, this trope of darkness paradoxically allows for corporeal unveiling to yoke with the (re)covering and re-historicizing of the flesh."[70] Opacity in the rendering of blackness and its attachment onto black bodies literally and figuratively clouds vision and produces ambivalence even in the most vociferous and decisive proclamations, as "Look, a Negro!"

According to Marriott's reading, it is not the imago and its narrative scripts but the shadow that is left behind wherein lies the affective power. To return to *Do the Right Thing* briefly, the killing of Radio Raheem by police officers is one of the most discussed scenes in the film. The brute violence of the death scene—the close-up of his feet off the ground as police strangle him with their billy club—is a traumatic moment. The shadow of his body, after the police have carted him off, after the riot has ended, as Sal cleans up the spot of his death the next morning, lingers. The emotions sweep across the audience. They seep into reviews and editorials. They remain long after the viewing has ended.

Sara Ahmed refers to the Fanonian moment to further her theory of affective economies. Her reading of Fanon focuses on how emotions circulate collectively across signs, bodies, and objects. Ahmed zooms in on the circulation of fear among Fanon, the white child who hails him, and the signs of race and negation. She argues:

It is the black subject, the one who fears the "impact" of the white child's fear, who is crushed by that fear, by being sealed into a body that takes up less space. In other words, fear works to restrict some bodies through the movement or expansion of others.

But this containment is an effect of a movement between signs, as well as bodies. Such movement depends on past histories of association: Negro, animal, bad, mean, ugly. In other words, it is the movement of fear between signs, which allows the object of fear to be generated in the present (the Negro is: an animal, bad, mean, ugly). The movement between signs is what allows others to be attributed with emotional value, in this case, as being fearsome, an attribution that depends on a history that "sticks," and which does not need to be declared.[71]

While Marriott looks at the rendering of the cultural body through the circulation and attachment of visual signs and narrative scripts (as he writes, "the body is a medium for what has been transferred on to Fanon"), Ahmed turns her attention to the circulation of emotions (here, fear) as they move among signs, objects, and bodies. Fear, according to her, has the power of restricting and sealing the body hailed as the Negro. The containment of Fanon's body (what petrifies him) in the process of being hailed is an effect of the movement of fear. Fear gains power through its circulation among signs and its historicity as part of its movement so that certain associations "stick" (Ahmed's term) to the Negro marked as a feared object. The affective value of the Fanonian moment—that is, its ability to produce an emotion in the present—is rooted here, again in its narrative scripts, which can also be understood as what Stuart Hall calls conceptual maps.[72]

In his study of black and Asian American masculinities, Daniel Kim returns to Fanon. Kim acknowledges how Fanon is often prioritized (or used as the point of entry) for analysis of racialized manhood. Interestingly, Kim's reiteration of the Fanonian moment actually decenters the hailing itself (i.e., "Look, a Negro!"). Instead, Kim quotes the first line of the chapter "The Fact of Blackness" in which the anecdote is included. And then without referencing the hailing by the white boy, he quotes Fanon's meditation on that moment of marking and his longing to be other than aberrant:

On that day, completely dislocated, unable to be abroad with the other, the white man, who unmercifully imprisoned me, I took myself far from my own presence, far indeed, and made myself an object. What else could it be for me an amputation, an excision, a hemorrhage that spattered my whole body with black blood? But I did not want this revision, this thematization. All I wanted

was to be a man among other men. I wanted to come lithe and young into a world that was ours and to help to build it together.[73]

Arguing that Fanon is asserting a masculinist and homosocial bonding not afforded him through normative structures of visualizing difference, Kim reads Fanon as suggesting that the power of racializing visual economies castrates the black man (thus, Fanon's reference to amputation). And moreover in Fanon's writing, scopic regimes create relationality between black men and women (i.e., the position of "to be looked at ness" in psychoanalytic theories of the gaze): *"that white men look at black men in much the same way that men look at women—as bodies whose alterity is signaled by the wounds of castration they bear.* The black *male* experience Fanon renders, then, is one of being looked at as a body that has been castrated by the white male Other who looks—of being, in a sense, castrated by the looking itself."[74] Yet, the woman in Kim's analysis is not any woman but the figuration of the idealized white woman who signifies both castration anxiety and desirability.

In Fanon's writing there is a compulsion of framing black male imago as produced in relationship to white phallocentric discourse. This is a discourse in which white men are aligned with discernment, assessment, and clarity of vision. Lola Young points out that it is a framework that leaves both black women and white women on the peripheries but "accorded differentiated textual status."[75] Marriott spends a great deal of time considering the significance of white women in Fanon's writings and as a mirror of Fanon's own deep ambivalence. Marriott begins "That Within," a chapter that focuses on Fanon's fixation on white women and the relationship between white women and black men, as follows:

> Frantz Fanon appears to have had a mania for white women. . . . She is not only the privileged representative of Fanon's psychoanalyses of Negrophobia but also the most tabloid, typed commonplace of the dreams and desires of his black male patients. In brief, her iconic stature has very much to do with being the most hateful and the most desired; her ambivalence is very much a mirror to the black man's own.[76]

Marriott elaborates the simultaneous articulation and denial of self that play out in fantasies and writings on the exchange between this most feared heterosexual coupling. As for the place of black women in Fanon's study, Lola Young argues that the absence or marginal presence of the black woman from within the Fanonian moment shows another form of ambivalence—at times, hostility—that Fanon's work conveys toward the black woman (e.g.,

Fanon's statement that "I know nothing about her"). Whereas Marriott demonstrates the levels of intimacy and identification, even as condemned subjects, expressed in Fanon's work about black men and white women, Fanon's detachment from the figuration of black womanhood is profound. This, for Young, is an ontological consideration about black women's "unknowability" in discourse, even in works by men of color that are posed as challenges to white privilege and power.[77] Fanon's theory and its heavy emphasis on the black male subject of colonial, racist, Western discourses is the symptom and the diagnosis of the heteronormative and masculinist underpinnings of dominant visuality, as signaled by the absence—and marginal presence—of the black woman as footnote to his analyses. She queries what a rewriting of the Fanonian moment would look like by incorporating another character:

> In this scene, which depicts the playing out of the struggle between black men and white men (the boy as "white man-to-be"), there is the coming together of the white boy, the white mother and the objectified black man. The missing person in this "race"/gender configuration is the black female. How might this sequence work with a different cast of characters? What if the scene were of a white father and daughter, with the child gazing at a black woman? Would the little girl speak out in public in the same startling manner as the little boy? In this new scenario, might not the father have initiated the sequence of looks, being male, being white? Would the black woman quiver with fear and self-loathing? Might she not, in any case, be invisible?[78]

I understand Young as asking if a black woman was standing in place of Fanon, would a verbal declaration have been made about her rendering within the field of vision? Or would her inferiority to white subjects be solidified through looks and gestures, or through not looking at all, looking beyond her? Young's questions return us to what is at stake in the Fanonian moment: the articulation of subject position through the forces of visuality, language—narrative scripts, and one's relationship to power vis-à-vis these forces.

My return to the Fanonian moment through its many interpretations is with a desire to shift the lens to frame another take: one in which *a* black woman looks at Fanon being looked at and hailed by the precocious white child with speaking privileges to demand his mother's attention, who directs her gaze, and who announces to her and the public at large to consider the curious and frightening specimen in their field of vision. The move is from mere observation of the peculiar Negro to the construction of an

audience and a performer of difference. Not only does the child demand the right to frame the black body through a cultural script of fear and danger, he also demands that something be done about that figuration. "'Mama, see the Negro! I'm frightened'" is a cry that requires action to assure the child that he is safe and that all is right in his relationship to difference. Fanon's performance during this moment is one that fails him. He states that his smile tightened. And as the repetition of the boy's declaration became more insistent, he attempted to laugh, "but laughter had become impossible." Fanon desires to resolve his troubling presence—the problem of black visibility—and the irresolvability of his attempts petrify him, as he writes, "I took myself far from my own presence, far indeed, and made myself an object."[79] The chapters that follow examine what happens when cultural practitioners question this irresolvability and use the troubling vision of the black body to produce visual work and cultural narratives precisely about this failure.

Chapter 1, "'One Shot': Charles 'Teenie' Harris and the Photographic Practice of Non-Iconicity," examines the work and practice of black Pittsburgh photographer Charles "Teenie" Harris who photographed the Hill District of Pittsburgh in the early and mid-twentieth century. Harris's photography ranges from everyday life images to local events and ceremonies to photojournalism for the black press. His work is notable for its volume (having amassed nearly 80,000 negatives throughout his life) and the characteristic movement in his shots that capture subjects in process. The chapter considers Harris's work as an indexical practice that offers a counterpoint to the dominant iconic images of blacks, especially mid-twentieth century documentation of the civil rights era and black freedom struggles. Engaging with his performance as neighborhood photographer (also known as "One Shot"), the chapter argues that Harris's photographic practice and imagery expand the dominant visual archive that cements black twentieth-century struggle through the stilled iconicity of singular acts and individuals.

Chapter 2, "Her Own Spook: Colorism, Vision, and the Dark Female Body," moves the investigation of how blackness circulates through visuality away from the social and the document to the psychic and the epidermal. The focus of this chapter is on colorism's deployment of vision to mark and decipher difference and value. Through close readings of two plays about colorism by black women playwrights, Dael Orlandersmith's *Yellowman* (2002) and Zora Neale Hurston's *Color Struck* (1926), chapter 2 deals with the gendered implications of a colorist system and the ways in which these practices attempt to fix a visible scale of blackness in the field of

vision. This comparative analysis examines the place of colorist ideology in conceptualizing the black subject as a visibly knowable subject. It theorizes how both plays trouble vision by depicting characters whose visions fail them due to their investments in colorist ideology. In both plays, the trope of a dark-skinned black woman is coded as both victim and arbitrator of a color/gender hierarchy that posits her as the bottom of the scale. In essence, she is her own spook through the psychic trauma of colorist logic.

"Excess Flesh: Black Women Performing Hypervisibility," chapter 3, promotes a theory of the black performative subject through expressive embodiment that hypervisualizes the overdetermined codes of the black female body. The chapter examines how hypervisibility is a performative strategy for black female cultural producers, one that emphasizes the faulty notions of a "visual truth" of blackness by representing excess and fantasy. The focus is on the works of black female performers and conceptual artists who employ visibility and excess to explicate the ways in which black women in the visual field are bound by a trope of blackness as aberration. The chapter discusses visual and performance works by Renee Cox, Tracey Rose, Ayanah Moor and popular cultural performances by music icon Janet Jackson and female rapper Lil' Kim. Using feminist theories of performativity and visuality, I develop the concept *excess flesh* to redress how black women are represented and constructed as having/being "too much" in relation to the ideals of white femininity. The chapter looks at the limitations of excess flesh enactments by considering how such performances operate differently in the realms of the contemporary art market, black popular culture, and mass culture.

In chapter 4, " 'I am King': Hip-Hop Culture, Fashion Advertising, and the Black Male Body," the study shifts from the explicit—often unclothed—body of the black female to the meticulously clothed, stylized body of the black male icon of contemporary popular culture. This chapter pushes forward my theory of the performativity of black visibility by examining how the black male body becomes the iconic figure for a consumer culture rooted in urban music, black masculine aesthetics, and nationalism. Through an analysis of the emergence and marketing of hip-hop fashion, I reorient fashion studies away from (white) women's wear and femininity to analyze black male fashion, the industry that supports it, and the interplay of masculinity, desire, and blackness. The chapter offers close readings of advertising campaigns on urban billboards and published in the hip-hop magazine *Vibe*, with special attention to the visual signs of race and gender and the role of clothing in fashioning black masculinity. Chapter 4 examines the strategies of hip-hop entrepreneurs to frame the black male

figure as possessor of a new American dream and inheritor of the legacy of Americana. The chapter makes the link between historical debates about struggles for black rights and freedoms and contemporary uses of black masculinity in consumer culture to privilege a masculine, but very different, figuration of blackness.

"Visible Seams: The Media Art of Fatimah Tuggar," chapter 5, moves a theory of black visuality from the material to the digital, from iconic black figuration to the production of difference by way of visual and technological narratives in transnational and transhistoric sites. The chapter considers black visuality with regards to technology studies, media theory, and contemporary digital art. Using the work of Nigerian media artist Fatimah Tuggar, "Visible Seams" demonstrates how technology narratives are based on notions of Western progress that produce black female bodies and non-Western subjects as folkloric and pretechnological. The chapter examines how Tuggar displaces dominant visual narratives and challenges the classical system of identification—whiteness and maleness—in visual media. I argue that the artist employs the visible seam and image fusion both technically and interpretively to reveal gaps, erasures, and ellipses in dominant visual narratives and their underlying ideology. Primarily through her examination of identification and fantasy, Tuggar debunks narratives that both deny the presence of the black female spectator and reduce the black, non-Western cultural producer to the folkloric in relation to technology. To construct a theory of the visible seam in digital media production, I reinterpret Kaja Silverman's theory of suture and her method of exposing the operations of the mastering gaze in dominant cinema to address digital media art. The visible seam and the redress of normative visual narratives through a fusion of transhistoric and transgeographic imagery account for the decentered viewing positions of postcolonial, transnational communities, viewing positions occluded by the "unified" singular identification structured through cinematic suture and iconicity.

In the book's conclusion, I return to the icon—destabilized, transmogrified, plasticized, artifactual, and unrecognizable as visible black subject—for the icon is dead. That is what we learned in the summer of 2009 when Michael Jackson was pronounced dead. I examine various attempts to remember Jackson that secure his blackness and masculinity as black icon, American icon, global icon. I also consider the imaginings and practices of fans—including myself—to render Jackson in the familiar and to provide an index of his iconicity.

The project moves through various realms of the local, the global, the diasporic, the transnational to consider how visuality and performance pro-

Figure I.1. Tracey Rose, *Span II*, performance installation, 1997. Courtesy of the artist and The Project Gallery, New York.

duce blackness, black bodies, and responses to them. As a meditation on the troubling vision of the black body and the productive possibilities and limitations of this figuration, I would like to consider South African multimedia artist Tracey Rose's Johannesburg Bienniale installation. Rose's performance installations *Span I* and *Span II* point to the scopic power—and the limitations—of visualizing the racialized and gendered body. This minimalist performance consists of two parts. In *Span I* a man dressed as a prisoner engraves text on one wall of the gallery. The prisoner inscribes memories from Rose's childhood, many having to do with black hair politics and racial marking. Rose employs the prisoner to perform her confession. In *Span II* Rose herself attempts literally to take apart her gender and race as visible objects of marking. She does this by stripping down of all covering and shaving all of her body hair. In this part of the installation, Rose is the object of study as she sits naked in a glass cabinet fully available to the spectator's gaze. Head shaven, the artist sits encaged in a museum setting reminiscent of Guillermo Gómez-Peña and Coco Fusco's *The Couple in the Cage* (1992). Tracey Rose, naked and on display, sits on a monitor that also displays the artist's naked body, a reimagining of the reclining nude model—invoking the tradition of art history and acknowledging the contemporary moment of media saturation. Rose sits and knots her cut hair, an act that she describes as "penance." Yet, in her doing she cannot escape the fact of blackness and femaleness. In her effort to par down, to possibly disappear, her blackness

and femaleness are further heightened. Her racial epidermal schemata are highlighted. She is spectacle in her naked blackness. She is colored materiality, struggling to conceptualize the definition itself. The narrative of hair, the spectacle of dark female sexuality on display. Rose, through this enactment, declares: *look a black woman, caged as captive flesh, attempting to refashion visibility through this act.*

ONE

"One Shot": Charles "Teenie" Harris and the Photographic Practice of Non-Iconicity

The camera loves the black subject whose struggles for equality represent the possibilities of American democracy. Twentieth-century American visual archives abound with iconic images of larger-than-life and fixed black subjects in duress and achieving remarkable feats. Documentary photography of black freedom movements, especially the period understood as the civil rights era, holds a special place in how blacks become visually recognized in the historical record. These images serve as one of the primary modes in which the fight for civil rights and equality gets understood and memorialized in dominant discourse and public culture.[1] While civil rights photography provides an invaluable resource of documenting the era, many of the images have become incorporated into the national imaginary to manage the history of racial subjugation. As photographic icons, these images circulate in dominant public culture as representative of a grand narrative of overcoming that solidifies American exceptionalism.

The term *icon* in public culture is rich with meaning as image, representation, symbol, someone or something famous—with larger-than-life status, a religious object. Philosopher Charles Sanders Peirce defines the icon within semiotics as a "diagrammatic sign" that "exhibits a similarity or analogy to the subject of discourse."[2] Contemporary cultural theorists, borrowing from Peirce, use the term more broadly as "an image (or person) that refers to something beyond its individual components, something (or someone) that acquires symbolic significance. Icons are often perceived to represent universal concepts, emotions, and meanings."[3] In their study of iconic photography and public culture, Robert Hariman and John Louis Lucaites conceptualize the photographic icon, produced by photojournalism, as a form of public art that generates a civic performance: "the iconic photograph is an aesthetically familiar form of civic performance coordinating an array of

semiotic transcriptions that project an emotional scenario to manage a basic contradiction or recurrent crisis."[4] Hariman and Lucaites explain that the crucial function of the photographic icon is to call forth a notion of the public and collective affect in the nation-state.[5] The icon, as I use it, borrows from each of these definitions. The icon, here, is an analogic or relational sign that produces affective responses in audiences by "sticking" the thing or person signified to normative codes, meaning, and values, what Hariman and Lucaites refer to as the "iconic affect" of certain notable images.[6] By focusing on one photographer's practice of rendering black subjects in non-iconic modes—favoring localized, everyday scenes and moments of the mundane and ephemera—I consider alternative modes of black visual engagement, not framed by iconicity and spectacular blackness that dominate visual culture.

The mighty weight and powerful narrative embedded in the photographic icon of the civil rights era is reflected in one of the most reproduced images of the twentieth century, that of Rosa Parks sitting on the front of a bus as a white male passenger glares behind her. The bespectacled Parks wears a modest dress, a winter coat, and a hat. Parks's body is contained next to the bus's frame; she sits with hands crossed and looks intently out the window. She is the embodiment of what Evelyn Higginbotham calls "the politics of respectability."[7] One row behind her sits a white man whose body is positioned to take up more space. The expression on his face might be read as a grimace, a slight grin, or perhaps even irony. Attention to the production and reception of this photograph reveals the "iconic affect" of the genre of civil rights photography. In this case, the singular image has two operations: it stands in for historical narrative, and through its circulation, the historical narrative of which it is the symbol becomes reduced to that of a decontextualized past.

The untitled photograph of Parks is meant to suggest the day that she was arrested for refusing to give up her seat to a white passenger. It is as if that precise moment had been captured by an astute observer who understood the historical significance of her action at the moment of its unfolding. An image that is known to have been staged, the photograph of Rosa Parks on the bus still produces visceral emotions and many iterations five decades later. The white man in the image who, in the context of the historical moment cited, might be read as a racist southerner, is Nicholas C. Chriss, a journalist who covered the civil rights movement for the United Press International (UPI). The photo shoot was organized by *Look* magazine, and the image was taken by an UPI photographer in December 1956,

Figure 1.1. *Rosa Parks, seated on bus, looking out window, her face in profile. Photographed at the end of the Montgomery bus boycott,* 21 December 1956. United Press photo.

shortly after the Supreme Court ruled Montgomery's Jim Crow bus policy unconstitutional and precisely a year after Parks's arrest for violating the city's back of the bus policy.[8] For decades Chriss remained unidentified in most reproductions of and references to the image. In a *New York Times* article written after Rosa Parks died in 2005, journalist Peter Applebome considers the significance of the staging of the image. Applebome notes that Chriss rarely commented on his role in the image; however, in a 1986 article Chriss wrote:

> Each anniversary of that day, this photograph is brought out of musty files and used in various publications around the world. But to this day no one has ever made clear that it was a reporter, I, covering this event and sitting behind Mrs. Parks, not some sullen white segregationist! It was a great scoop for me, but Mrs. Parks had little to say. She seemed to want to savor the event alone.[9]

Fred Gray, the civil rights lawyer who represented Parks in the Montgomery bus case, also commented on the image's historical significance: "What it says is true . . . that 381 days of walking had accomplished something historic so that instead of her getting up to give a white man her seat,

instead the white man was sitting behind her on the bus. It was staged, but I don't think it inaccurately represented anything."[10] For Gray, the staging of the event and the fact that the photographic subjects understood the weight of the image as it was taken do not lessen the importance of its representational impact. Gray argues that the image still stands for the "truth" of racial segregation and black disenfranchisement.

Parks's biographer, Douglas Brinkley, provides additional context for understanding the production and reception of the image. According to Brinkley, photo shoots had been organized for December 1, 1956, to mark the end of Montgomery's segregated bus system. Earlier that day several black male civil rights leaders had been photographed sitting in front of buses, including Martin Luther King Jr. and Ralph Abernathy. Parks had not been invited to be a part of these larger photo shoots. Parks recalled to Brinkley that later that morning a reporter and two photographers from *Look* knocked on her door and asked her "to come ride a bus so they could document the historic event." Brinkley states that Parks expressed apprehension about being photographed in such a manner but finally agreed to it. According to this recounting, the photographer encouraged her to gaze as she did on the day of her arrest a year earlier. Parks, considering the picture's impact, notes: "Children from around the world send me that picture to sign. . . . It's become my symbol shot, my historical honor badge."[11]

Parks emphasizes the power of that photographic shoot in framing her as a black American icon. Her statement and the popular response to the image spell out the significance of the photographic icon as historical evidence and the focus placed on individual acts and achievements within grand historical narratives. Attempts to demythologize these iconic photographs do not challenge the significance of the activism and protest represented (staged or not). Instead, context provides a more complex understanding of the strategies involved and deliberate actions taken to actualize black freedom struggles. They are part of what we might call the theater of social protest instead of "raw" and authentic documentation of social injustice.

The photograph of Rosa Parks on the bus is central in shaping a mainstream public's understanding of recent history and social change in the United States. It is literally and figuratively a symbol of an era, no more evidenced than its citation in contemporary public discourse and popular culture. The photograph is the basis of an Apple computer advertisement in which the image is appropriated and tagged with the slogan "Think Different," to suggest individualism, choice, and consumption. And the commercialization of Parks's image has only intensified in the years since her death, leading to multiple lawsuits and struggles to control and license her

image.[12] This form of appropriation is what Leigh Raiford calls "hypericonization in which viewers [are] presented with the restaging of representations."[13] Hypericonization suggests a level of familiarity with the icon that goes beyond its decontextualization. With the hypericon meaning has been solidified in such a way that the icon has limitless mobility. It can be transplanted to new arenas that both displace its historicity and abstract certain values, feelings, or ideas associated with its historical context to new audiences and settings. Its specificity is now an abstraction that can circulate throughout public culture, carrying both the weight of historical narrative and a decontextualized vague strain of its pastness.[14]

This chapter analyzes the photographic practice and work of Charles "Teenie" Harris. Harris's lens provides an alternative visual index of black lived experience of the twentieth century, one that does not rely on the familiar device of photographic iconicity. Harris focused on the specificity of black life in Pittsburgh and his work circulated primarily among a black audience who also served as the subject of his lens. This is an important departure from representative documentary photography of the era that centered white spectatorship and appealed to white sympathies for civil rights reform in the United States. Harris's photographic practice overlapped with the careers of many more well-known black photographers whose work became associated with documenting racial inequality and black freedom struggles, most notably the civil rights era—a period where many of the most iconic images of black American life and struggle circulated widely in print and television media.

What sets Harris's work apart from the more widely acclaimed photography of the era is the absence of the stilled icon in his pictures. Harris captured a myriad of small acts. His photography provides an opportunity to consider the impact that iconicity and blackness-as-spectacle have had on solidifying dominant visual signs and narratives of black twentieth-century experience. Spectacular blackness emerges as a concept to address the saturation of images of black bodies while also acknowledging the continual political, economic, and social disenfranchisement of millions of blacks both in the United States and internationally. Iconic blackness as larger-than-life image (Rosa Parks, Jesse Owens, Martin Luther King Jr., to name just a few) and spectacular blackness—from criminal deviance to excessive bodily enactments—are the dominant visual modes for representing black subjects and black lived experience, in particular throughout the twentieth century. In Harris's work, the icon is replaced by a repetitive representational strategy of documenting fleeting, seemingly ordinary moments and happenings in

the lives of black Pittsburghers. While his practice differs from the dominant canon of documentary photography, Harris was part of a photographic tradition in black communities of documenting local everyday happenings. These neighborhood photographers were known as "picture-taking men" and were often local celebrities in their communities.[15]

Through Harris's practice, what comes into question is the authority of the iconic image to enlarge—literally make larger than life—certain figures in dominant understanding of American and black American history, while obscuring other representations of black twentieth-century life. Harris's archive provides an important visual narrative of local community practices and experience in black American life. Harris's archive displaces spectacular and iconic blackness with images of localized, temporal everyday that are unfamiliar to canonical history of black American experience. Harris's practice and work map an alternative path of black visuality from that instantiated in photographs like the classic and intensely circulated image of Parks. In building this other path, I begin by considering iconicity through documentary photography in order to situate Harris and his work in a historical context of image, practice, and audience. It is only against this background that we can begin to appreciate the specificity of Harris's photographic practice and the recent work of Carnegie Museum of Art that have built up around it in Pittsburgh. Central to this argument is the circulation of his photographs during his time as a working photographer locally and also posthumously in the realm of the digital archive through the efforts of Carnegie Museum of Art. The museum's *Documenting Our Past: The Teenie Harris Archive Project* provides a rich context to analyze the after-life of the practice and the present and evolving life of his archive.

Harris, born in 1908, spent the 1930s through the late 1970s documenting Pittsburgh's black communities while working as a photojournalist for one of the largest black newspapers of the twentieth century, the *Pittsburgh Courier*, and running his own photo studio in the Hill District. For most of the century, the neighborhood was a vibrant, class-stratified community that was a hub of local black entrepreneurship and a cultural center. While the District was primarily black, in the early decades of the century it had a high population of immigrants and ethnic whites and was one of the gateway neighborhoods for newcomers to Pittsburgh. Working-class blacks lived in the lower Hill and middle-class blacks lived in the middle and upper Hill. Harris's family, well known in the neighborhood, at one time owned the Masio Hotel, where black celebrities and leaders stayed. His brother "Woogie" was a local legend, having operated one of the most successful numbers-running networks in the region, for which Harris himself was a

one-time runner. Harris's relationship to the neighborhood afforded him a level of familiarity and access to residents, ceremonies, regional politics, and local establishments, especially in his work as a photographer-for-hire for his neighbors, documenting birthday parties, weddings, and events in the city.

Over the course of his career, Harris amassed nearly 80,000 negatives of primarily local black Pittsburghers, in large part because he reportedly never destroyed a negative. According to historian Larry Glasco, Harris is believed to have built "the largest single body of photographic visual evidence and documentation of any black community in the United States, and probably the world."[16] Historians and scholars of photography have described Harris's significance to black American visual culture and American photographic history in terms of the quantity of photographs that he took over his long life span. Photographic historian Deborah Willis describes Harris's "major contribution to photography [as] his extensive documentation of black life in Pittsburgh from the post-Depression period through the post–civil rights era."[17] His photographs range from blacks' participation in World War II, to coverage of the local civil rights struggles, to political and civic happenings, to black entertainment culture, to many numerous and seemingly random images of unidentified individuals in various private and public settings. Among his collection are thousands of images of working black men and women posing for his camera while performing routine tasks. Harris offered detailed attention to a mid-size, mid-Atlantic city, unlike many photographic projects of the century that focused on New York, Chicago, and the rural South. Glasco argues that Harris's legacy offers a visual narrative of urban black life as compelling as the more well-known documentation of Harlem during the same era: "In the long run, his photographs may cause Pittsburgh's Hill District to join New York City's Harlem in forming our view of urban Black life from the 1930s to the 1960s."[18]

During Harris's life, the majority of his work circulated primarily among black residents in the Hill District, while certain images reached a national black public through his work with the black press. For most of his career he received very little scholarly or critical attention; his first public exhibition was not until 1986, almost a decade after he retired from the *Pittsburgh Courier*. In the final years of his life, Harris was not in possession of his massive archive because of a business arrangement with a local entrepreneur who offered to manage his photographic collection and distribute his work. In exchange, Harris was to receive royalties. However, he received very little compensation and lost possession of his collection. In the last years of his life, Harris began working with pro bono attorneys to reclaim his archive;

however, he died before the lawsuit was settled.[19] When the case was finally settled, Harris's family received over 90 percent of the photographer's collection, which they sold to Carnegie Museum of Art.[20]

In one of Harris's photographs taken in 1947 several wet children pose for his camera as a momentary pause in their play, while water spouts from outside the frame. The children are a range of sizes and shades. Some of them smile directly at the camera, while others are captured as they prepare to be photographed. Then there are those on the margins of the image who are running into the frame to take part. Water drenches their already soaked bodies. They stand close together. Some attempt to cover up while others hold onto nearby children. Some are in bathing suits; others play in their underwear and street clothes. While the majority of the children are visibly black, there also appears to be a couple of very light—possibly nonblack—children participating. In the background a few adults stand smiling at Harris's orchestration—to capture a still shot of an everyday momentary experience that is characterized by movement and frivolity in his local setting. The children are unidentified, but their smiles and expressions suggest a level of familiarity in the midst of their discomfort—failing to stand still under the motion of the flowing water.

The long and wordy title of the photograph, *Group portrait of children, some in bathing suits, standing on Webster Avenue under spray from fire hose, near Webster Avenue firehouse at Wandless Street, Hill District*, stands in contrast to the playfulness and temporality of the image itself. Harris rarely identified his subjects or titled his negatives.[21] Instead the descriptive title was generated by Carnegie Museum of Art when the museum purchased Harris's collection from his estate in 2001. Initially, the museum titled it *Children showered by fire hydrant*; later, the title was changed to *Group of children posed under shower from fire hydrant*. Then, more recently, the image acquired the title referenced above. As the museum's photo archivist Kerin Shellenbarger explains, the title of each item in Harris's collection continues to change as the museum learns more about the individual piece.[22] The Carnegie staff, along with a team of scholars, activists, art experts, and community members, work to label each image with titles that attempt to describe what they see in the image, while continuing to research the details of each entry for location, event, and individual subjects. Through its research, the museum was able to locate the above image published in an edition of the *Pittsburgh Courier* with the caption:

> "Cooling off in style"—These kiddies have Fireman Joe Watts to thank for one of the best of "cooling-off" periods last week when the weather was at

Figure 1.2. Charles "Teenie" Harris, *Group portrait of children, some in bathing suits, standing on Webster Avenue under spray from fire hose, near Webster Avenue firehouse at Wandless Street, Hill District*, August 1947. © Carnegie Museum of Art, Pittsburgh. Heinz Family Fund, 2001.35.3148.

its stickiest. After the genial fireman turned the large cool stream on them from the hose, squeals of pleasure could be heard the length of the block. The Webster Avenue was fun headquarters that day. Though not shown in the picture, Fireman Watts was really the "man behind the fun."—Harris photo, August 30, 1947

The museum's work results in constantly changing titles for Harris's works as they continue to acquire information about the collection.[23] The catalogue number attached to each image remains constant as details associated with the image continue to change. The museum's process of indexing Harris's work as it builds the archive complements what I theorize as Harris's indexical practice over the course of his career.

Index commonly refers to a list, a systematic catalogue, an indicator, or a way of expressing a relationship or value. In addition to its common usage, I employ *index* in relation to *icon* as analytical tools in semiotics, art

history, and visual studies. Within these fields and disciplines, often cited is Peirce's semiotic triad in which he explains:

> there is a triple connection of *sign, thing signified, cognition produced in the mind*. There may be a mere relation of reason between the sign and the thing signified; in that case the sign is an *icon*. Or there may be a direct physical connection; in that case, the sign is an *index*. Or there may be a relation which consists in the fact that the mind associates the sign with its object; in that case the sign is a *name*.[24]

Peirce's definition of the index grounds it in spatiotemporality and the material world. Film theorist Christian Metz writes: "Peirce called indexical the process of signification (*semiosis*) in which the signifier is bound to the referent not by a social convention (= 'symbol'), not necessarily by some similarity (= 'icon'), but by an actual contiguity or connection in the world: the lightning is the index of the storm."[25] Metz explains that Peirce considered photographs both indexical and iconic. In applying Peirce's definitions to Harris's work, both terms apply, but Harris's practices emphasize indexicality in terms of his repetitive emphasis on incomplete narratives of black subjects and communities as a counterpoint to overdetermined representations of black iconicity.

Documentary Photography and the Iconic Subject of History

While Harris's practice deviated from the tradition of social documentary photography in many respects, his work must be understood within that genre's history and its roots in "the social conscience of liberal sensibility," with its concern for "moralism" over "revolutionary politics," as articulated by Martha Rosler.[26] The Farm Security Administration (FSA) Photographic Project (1935–42), made popular by Depression-era works by Walker Evans, Dorothea Lange, Gordon Parks, and Russell Lee, produced many of the symbols of photographic iconicity for forthcoming photographic documentary studies in the United States.[27] While the photographers associated with FSA had their own distinct style and practice, the school in the broadest sense has been characterized as promoting a noble or transcendental notion of humanity embodied in the poorest and most disenfranchised members of society.[28] The FSA School, as well as the earlier documentary photographic projects of Jacob Riis and Lewis Hine, focused on the struggle of the working class and poor and the social forces that contributed to the plight of individuals. These photographic studies are foundational in creat-

ing a visual lexicon in the US public discourse, visual culture, and scholarship.[29] As photographic scholars have long established, these documentary works were intended to be part of social reform efforts and the photograph was seen as an index of social ills. In her study of social documentary photography, Maren Stange argues:

> In order to assert more or less explicitly that their images presented viewers with the truth, reformers relied on the photograph's status as *index*—that is, as a symbol fulfilling its representative function "by virtue of a character which it could not have if its object did not exist" [citing Charles Sanders Peirce] in a standard semiotic definition. But they also realized that codes of photographic realism could be used to associate reform with individuals' humanitarian impulses as well as with the social engineering institutionalized by reform movements.[30]

Stange uses Peirce's definition of index to emphasize how practitioners of canonical documentary photography relied on the power of the photographic image as evidentiary tool of reality. Stange points to the tension in many documentary projects between the claim of empirical truth as recorded through optical technologies and the agenda or strategic uses of the image by the photographer or others who control the distribution of the work.

Black photographers—Roy DeCarava, Gordon Parks, Richard Saunders, Roland Freeman, and Moneta Sleet Jr., to name a few—often have used the aesthetics of social documentary to produce visual records of the daily practices of blacks in the United States and more precisely to document the conditions of black life under racial segregation and systemic inequalities. David A. Bailey and Stuart Hall write that for black photographers, using documentary aesthetics is potentially an "attempt to reposition the guaranteed centres of knowledge of realism and the classic realist text, and the struggle to contest negative images with positive ones."[31] Of note, Roy DeCarava and Gordon Parks worked at the time when Harris was a photojournalist in the late 1940s and 1950s; also, like Harris, Parks's and De-Carava's careers spanned over five decades.[32] DeCarava's street scenes of Harlem, perhaps the most iconic and photographed black neighborhood of the century, provide important visual signs that shape our understanding of the social conditions of early and mid-twentieth-century urban black life. He is known also for his photographic series on jazz musicians.[33] Gordon Parks, whose long and varied career path is legendary, was the first black photographer hired by *Life* magazine. According to Deborah Willis, Parks

decided that he wanted to be a photographer after seeing the work of the FSA in 1937.[34] Early in his time with FSA, Parks photographed Ella Watson, janitorial staff for governmental buildings in Washington, DC. The photograph, entitled *American Gothic* (1942), is one of the most reproduced photographs of the twentieth century. In the image Watson stands in front of the American flag with broom and mop in hand.[35] The image is an obvious riff on Grant Wood's famous painting *American Gothic* (1930). Later in his life, Parks describes what led to the photograph:

> That was my first day in Washington, D.C., in 1942. I had experienced a kind of bigotry and discrimination here that I never expected to experience. And I photographed her after everyone had left the building. At first, I asked her about her life, what it was like, and so disastrous that I felt that I must photograph this woman in a way that would make me feel or make the public feel about what Washington, D.C. was in 1942. So I put her before the American flag with a broom in one hand and a mop in another. And I said, "American Gothic"—that's how I felt at the moment. I didn't care about what anybody else felt. That's what I felt about America and Ella Watson's position inside America.[36]

Parks enunciates the juxtaposition of signs that produce meaning in this iconic photograph: the broom and mop against the American flag; the black maid, the descendant of slaves, who cleans the federal buildings.

Parks, like DeCarava and others, offered a potent critique of US racial and class stratification often through the juxtaposition clearly articulated in *American Gothic*. DeCarava's *Man Coming Up Subway Stairs* (1952) is striking given that the image captures a seemingly ordinary moment of a middle-aged black man walking up subway stairs. However, the expression on the man's face and the contrast and tone of the image convey a stillness and solitude. The man is not just walking upstairs; he is struggling with systemic inequality as the visual signs suggest. His lips are pinched tightly; his clothes are soiled; the brim of his hat askew. Both Parks and DeCarava focused on documenting blacks in familiar urban communities in carefully studied and highly stylized portraits, and both went on to capture some of the most iconic images in US photographic history. I mention the works of these two great photographers in some detail in part because of the stillness and "timelessness" conveyed in some of their more notable works. Also I want to highlight how they are known for individual pieces that embody universalizing notions of humanity, freedom, and struggle.

The legacy of representing blacks in social documentary photography evidences the multitiered ways in which the photograph gets employed to make sense of history: (1) the photograph is the historical document; (2) it stands in for the historical moment; (3) it provides evidence of an historical event; and (4) it frames the possibility of understanding a specific historical time period. Roland Barthes theorizes that "the photograph possesses an evidential force, and that its testimony bears not on the object but on time. From a phenomenological viewpoint, in the Photograph, the power of authentication exceeds the power of representation."[37] Again as Peirce suggests, the photograph is the index and the icon. A series of iconic images from the mid-century has become one of the most foundational ways in which the public understands—and indexes—black twentieth-century struggles for equality and freedom.

Leigh Raiford and Martin Berger have written about the strategic uses of photography by civil rights activists to garner public support for organizations and the broader cause during the movement. Berger argues that images of the 1960s civil rights struggles were chosen and cropped in such a way as to "routinely cast African Americans as the passive and hapless victims of active and violent whites" to garner white sympathies and support.[38] He argues that images portraying blacks as active agents often appeared in the black press but were excluded from magazines like *Life*. Examining the Student Nonviolent Coordinating Committee's (SNCC) use of photography in the 1960s, Raiford argues:

> These images have shaped and informed the ways scholars, politicians, artists, and everyday people recount, remember, and memorialize the 1960s freedom struggle specifically and movement histories generally. The use and repetition of movement photographs in contexts as varied as electoral campaigns, art exhibits, commercials, and of course academic texts, have crystallized many of these photographs into icons, images that come to distill and symbolize a range of complex events, ideas, and ideologies.[39]

For the broader public, these images are not only evidence of the struggle but also provide its narrative. They are believed to tell the story of black freedom struggles. Raiford and Renee C. Romano discuss the ways in which a particular narrative of the civil rights era has been institutionalized and memorialized by mainstream discourse, which they label "a consensus memory, a dominant narrative of the movement's goals, practices, victories, and, of course, its most lasting legacies."[40] Raiford and Romano ask what is

left out of this consensus memory and whose purpose does this omission serve. Looking at how the state and public officials employ the legacy, they write:

> Especially in the case of the civil rights movement, which can be held up as a shining example of the success of American democracy, the state has a strong interest in using the memory of the movement as a tool of nation-building and of fostering and fomenting hegemony through consensus. The movement in this way can become proof of the vitality of America's legal and political institutions, and evidence of the nation's ongoing quest to live up to its founding ideals of egalitarianism and justice.[41]

The workings of this narrative became all the more prescient during the 2008 presidential campaign and election in which the news media, for months before the election, anticipated being able to mark the historical significance of Barack Obama as the first "African American" president.[42] In the national imaginary and public discourse, the civil rights legacy becomes incorporated into a grander narrative of the United States as the model of progressive democracy in which citizens can actualize change and pursue liberties.[43]

The icon is a fixed image so immersed in rehearsed narratives that it replaces the need for narrative unfolding. In its singularity—as exceptional moment, individual, event—it calls on universality, notably here the progress of democracy. While the icon evokes universality, it also plays with specificity as it encompasses a host of possibilities and contradictions for understanding what it means to be a black in the United States. Moreover, civil rights "consensus memory" relies on a nationalist framework of understanding black Americans as disenfranchised but *deserving* citizens of US democracy. The icon of this photographic genre is more often than not patriotic in its emotional appeal—to call out American hypocrisy while simultaneously upholding the belief in the superiority of the United States as a nation-state. The photographic icon of black freedom struggles is a noble image, a moral image, one that pleads for equality and upholds the ideology of democratic and capitalistic progress.[44]

Known for his many public and personal portraits of Martin Luther King Jr. and family, Moneta Sleet Jr. photographed some of the most recognized images of the civil rights era. Like many black photojournalists of the period, he began his career working for the black press. Sleet described his style as one of honing an "eye" to capture "special moments."[45] He focused his camera on black political leaders, celebrities, and cultural figures, stating,

"When you are dealing with people who really are renowned and are top stars or super stars, they have a certain quality about them that makes you feel at ease."[46] In 1956, early in his career, Sleet developed a close relationship with the King family while on assignment. He authored many of the most well-known photographs of King as civil rights leader, including the March to Selma and the March on Washington, and he accompanied King to Norway when he was honored with the Nobel Peace Prize in 1964. In addition to documenting King as the highly visible leader of the movement, Sleet also took many pictures of the King family in domestic settings. He is best known for his 1969 Pulitzer Prize–winning photograph *Mrs. Coretta Scott King and her daughter Bernice at the funeral of Dr. King*, making him the first black American to receive the prize for photojournalism. The image is a medium close-up shot of a veiled Coretta Scott King in black reclining in a church pew as she holds a mournful Bernice, the Kings' young daughter, in her arms. The photograph became a symbol of the waning civil rights era and marked the movement's successes and failures, as King's assassination stood for the relentless power of white racism while his death became a potent symbol of the struggle for American democracy.

My critique of black civil rights iconicity is not meant to do away with the image database or its circulation but to contextualize its significance within dominant notions of understanding blackness, inequality, and lived experience. The reliance on images of iconic blackness and spectacular blackness is wedded to binary modes of rendering black subjects through narratives of exceptionalism or deviance. This binary continues to pin visible blackness to the hybervisible and the invisible. In this context, Harris's photography troubles the dominant visual modes of representing black lived experience by offering a huge, yet incomplete, archive of seeing what Deborah Willis has described of his work as "the normalcy of black life."[47] According to Charles A. Harris, Teenie Harris's eldest son who collaborates with Carnegie Museum of Art to exhibit and archive his father's work, the photographer aimed for a representational practice that normalized black lived subjects, as a counterpoint to narratives of invisibility or deviant hypervisibility that circulated in mainstream media:

> One of the things that really bothered him was the uneven hand in the way that the mainstream newspapers handled the community, the Hill District community as a whole. They never had anything positive in the mainstream press, but if it was something negative, then you might see that in the newspapers. His problem was that people in the community had nothing to look at that was from a positive standpoint, to show them just how that

Figure 1.3. Charles "Teenie" Harris, *Self portrait of Charles "Teenie" Harris, in Harris studio*, 1940. © Carnegie Museum of Art, Pittsburgh. Heinz Family Fund, 2001.35.1706.

community was. And that community was just like any other community in a sense. I would say that it had everything in the community that was in downtown Pittsburgh and this is because of the race situation at the time. There was still quite a bit of segregation, so that the Hill District was forced to be self-sufficient. So when they got the newspaper on Saturday, as I said before, they saw pictures of kids' birthday parties, and they saw all kinds of activities, different social activities, as well as sports activities, which normalized them, just as the mainstream press would normalize the average everyday life.[48]

While the notion of "positive" and the aim to "normalize" lend Harris's work to critique of how such images reproduce dominant codes of gender, family, and progress, I read the idea of normalcy in his work in interventionist terms of producing visual subjects who have been excluded from dominant society and public memory, especially during segregation. Judith Butler's writing on norm, normalization, and normativity helps to explicate how some subjects are afforded a "livable existence" and how others are excluded through "socially instituted relations." Butler looks at the dual meaning of normativity as "the aims and aspirations that guide us, the precepts by which we are compelled to act or speak to one another, the commonly held presuppositions by which we are oriented, and which give

direction to our actions." The second meaning is more binding and exclusionary as "the process of normalization, the way that certain norms, ideas and ideals hold sway over embodied life, provide coercive criteria for normal 'men' and 'women.'" Butler does not call for a doing away with norms but that we "extend the norms that support viable life."[49] Such a revision would expand our understanding of intelligible life. In this sense, Harris's practice renders black living beings as intelligible and subjects of value.

The Making of One Shot: Photography as Performance

"'Here comes the camera man,' that's what they would say. 'Here comes the camera man.' And he'd say, 'Yep, and it's a one shot deal.'"[50] Nate Smith, a Pittsburgh labor activist, recalled how Harris would enter a space as he prepared to photograph it. For Harris the practice of documenting did not conform to what Bill Nichols describes as "discourses of sobriety" that tenor "nonfictional systems," namely the dominant practice of documentary production.[51] Harris is described in colorful language by many of his photographic subjects and those who knew him in Pittsburgh. Edna Chapell, his colleague at the *Pittsburgh Courier*, notes that Harris, in seductive terms, was able to generate a level of comfort and familiarity between photographer and subject: "People were attracted to him. He always had a smile and something pleasant to say. He sort of knocked people off guard. And this is why his pictures are so full of expression." Harris made his presence known to his audience, which was also often the subject of his work. He too was the subject of many of his images. In others it is clear that the photographic subjects are responding directly to him and are familiar with him.

Harris's photographic practice was not so much about the image photographed but the act of photographing subjects in his local environment. His photojournalistic practice, as well as his studio portraits, was based in the reciprocity among the photographer, the subject, and the audience, again which often doubled as his subject. What is highlighted is not an aesthetic impulse or a fixation with technique but the relationship developed through the act of documenting as a sustained engagement in one's community. Over the course of his photographing the Hill District, a system of referentiality develops among Harris, the neighborhood residents, and local sites. In many of his images one can see earlier photographs taken by Harris in the scene captured. For example, in *Man, possibly Al West, standing outside West Auto Body Shop with tire display, 2407 Centre Avenue, Hill District*, three of Harris's photographs of a local fire truck are on display inside the picture window of the auto shop.[52]

Figure 1.4. Charles "Teenie" Harris, *Man, possibly Al West, outside West Auto Body Shop with tire display, 2407 Centre Avenue, Hill District*, 1947. © Carnegie Museum of Art, Pittsburgh. Heinz Family Fund, 2001.35.3076.

Among Hill District residents Harris often went by the nickname "Teenie" but received a second nickname that came to represent his signature style of taking just one shot. Harris enjoyed telling how Mayor David Lawrence, with whom Harris had developed a friendly rapport while covering local politics, gave him the nickname "One Shot" because of his penchant for taking one picture and then moving on to the next event or photo shoot. The name became part of his performance as a familiar public character in Pittsburgh and a source of local legend with many stories circulating about how he acquired the nickname. According to journalist George Barbour, who wrote for the *Courier*, when Harris began to work for the paper flashbulbs were very expensive, and only one shot could be taken with each. Therefore, Harris had to limit himself to one shot of the events that he was sent out to document for the paper.[53] Harris's younger son, Lionel, explains that One Shot was part of his father's performance as the local camera man: "When he would take a picture, boy, he would look over at you and go 'Pop.' The bulb would fly out and he would catch it in his hand. He would throw it in his pocket. He was cool. He was cool. Dad was

cool . . . He loved that camera, that old big clunker. He loved that camera because he liked the way it takes pictures."[54] Lionel's recollection also explains how the apparatus becomes part of Harris's practice. It speaks to the father's love of performing the role of neighborhood documentarian and his public recognition of this position.

Charles A. Harris compares his father's one-shot technique with Harris's broader traits of brevity and frugality:

> Dad believed in brevity. He felt that more people should concentrate on giving shorter answers and writing shorter speeches. When Dad answered a question he was succinct. You knew exactly where he stood; there would be no sugar coating in his answers. This trait carried over into his work. He did not take unnecessary shots and he was frugal with his photographic materials. . . . While the other photographers were taking multiple shots, Dad had taken what he needed and was off to another assignment.[55]

Comparing his father's verbal style—"no sugar coating"—with his photographic language provides insight into his father's indexical practice. His one shot suggests that he resisted embellishment and did not deliberately study a shot in its singularity (with the exception of his studio practice, which demonstrates a careful attention to the conventions of studio portraiture). "No sugar coating" is an aesthetic choice of the photographer connected to a practice that allows him to enter and exit local scenes at will. The son's assertions of his father's brevity and frugality seem at odds with the photographer's penchant for volume, most notable in the extensive photographic archive left behind when he died. In the context of his son's description, we can begin to understand what sounds contradictory—that his father amassed 80,000 negatives over his life but considered his practice "succinct." The relationship between the practice of not taking "unnecessary shots" and of building the largest collection of negatives of blacks in any one community becomes comprehensible. We begin to understand as well the method behind his index through his repetition of capturing the daily occurrences in the few miles that make up the District.[56]

John Brewer, an oral historian who knew Harris and collects his work, challenges the one-shot myth:

> He was given that name because of how quick he was, but if you've seen the photographs I've seen—and I've seen thousands—you realize there were many shots. He should still be called "One Shot," because if he was in an environment with a lot of politicians, a tight spot, he didn't have much of an

Figure 1.5. Unknown, *Portrait of Charles "Teenie" Harris, holding camera and standing on sidewalk*, 1935–50. © Carnegie Museum of Art, Pittsburgh. Heinz Family Fund, 2001.35.2920.

opportunity for a picture. He wasn't the *Post-Gazette* photographer, for example. He couldn't ask them to wait a second.[57]

Brewer's comments suggest that his one-shot signature was very much part of Harris's persona but was a product of necessity given his limited resources working with the black press. They also support an understanding of Harris's oeuvre as both curious and process-oriented with no definitive end in sight. Harris's dynamic performance as One Shot, his relationship to his photographic subjects, and his distinct style—both focusing on Pittsburgh's local black communities and holding on to every negative taken—are at the root of his indexical practice of non-iconicity.

Brewer implies that had Harris worked for a larger, mainstream press that he would have been afforded more time and opportunity to photograph his subject matter. Yet, according to Louise Lippincott, curator of fine arts at the Carnegie Museum of Art, and Charles A. Harris, the *Pittsburgh Post-Gazette* had courted the photographer. The son states in the documentary about his father, *One Shot: The Life and Work of Teenie Harris*:

> Dad worked for the *Courier* for a long time. He had opportunities to go with other newspapers but he was more interested in the black community. Had he gone with one of the other newspapers, he of course would have made more money but he wouldn't have the opportunity to continue working in the community and doing the everyday life type of things that he was happiest doing.[58]

Lippincott explains that while much of Harris's work is known for its play, spontaneity, and light tonality, his decision to stay with the black press and

to focus on the Hill District was a very conscious effort to counter spectacular images of black criminality, poverty, and destitution in the dominant Pittsburgh press.[59] Though his work is not characterized by its subject matter or in political or ideological perspective, Harris was concerned about the limited range of possibilities in terms of visual representations of blacks in Pittsburgh's local media.

This concern translated into an aesthetic and technique of bringing into focus and centering black subjects in his image. Charles A. Harris for a time worked in his father's darkroom. In developing photographs with his father, the younger Harris learned that the developing stage was an important site to intervene in mainstream image making of blackness. The son said that his father was disturbed by how black subjects would often be blackened to the point of invisibility or features obscured in the mainstream press so that white subjects would be brought to the fore:

> One of the things that he taught me specifically is that when you look at a newspaper, a regular newspaper like the *Post-Gazette*, if there's an interracial picture, you will find that the darker person might come up as an ink spot. What he was teaching me was that when you are using the enlarger, you have to recognize that if people are lighter than others, it will take the lighter person longer to come up so that you can see their picture. So if you have a darker person, you have to have a little thing where you would put it over that person's face, so that as it came up, it wouldn't be on that person. And as the lighter person's picture came up, then you could remove it. Then they would both come up and you could see both of them. But if you did it as the mainstream paper did, they would just do it until the lighter skin person came up. Well if they did that, then the darker skin person came up as an ink spot.[60]

While Harris is not typically described as a civil rights photographer, his long tenure with the *Courier*, the largest of the nationally circulating black newspapers during the period of the civil rights movement and the Black Power era, meant that Harris inevitably photographed images that became part of the paper's ongoing coverage of black freedom struggles. According to Charles A. Harris, his father's presence as photographer was very important to organizers of local protests in Pittsburgh: "there are people who mention that the civil rights movement in terms of protests and so forth didn't start until Teenie got there."[61] Yet, there are times when images taken by Harris—which were not necessarily taken as part of the civil rights coverage—got incorporated into the newspaper's civil rights coverage or the paper's editorial position on segregation and civil rights activism. Harris was

known to be a big fan of Lena Horne, who lived in Pittsburgh off and on for a few years during her marriage to Louis Jones. Harris captured Horne, with her father and accompanist Horace Henderson, en route to Hollywood around 1943 when she began a career in movies. Upon her return to Pittsburgh, he took pictures as a guest and a working photographer of her homecoming reception. These pictures show her posing with musician Billy Eckstine. The pictures were captioned and incorporated into a series of stories in the *Pittsburgh Courier* published on October 21, 1944. Above four captioned images (one of the trio en route and three from the return party) is a story with the heading "Lena Defies Washington D.C. 'Jim Crow' Policy: To Play Howard Theatre Instead." Other headlines under the images read: "Hollywood Studies Negro's Wants in Movies," "Producers Aware of Ten Per Cent Boxoffice Total," and "Billy Eckstine Re-Shuffles Band for Second Big Tour." Advertisements for clubs like the Caribbean Club, Club Bengasi, and Tondaleyos are at the bottom of the page.

Perhaps another reason that Harris chose to stay with the *Courier* was because his position there allowed his images to circulate fluidly between various venues as photojournalism, studio portraiture, and images taken as photographer for hire of local events. In his archives are very personal images of blacks in leisure in public and private settings. Many of these, Shellenbarger has suggested, were taken by Harris as hired photographer for private events and personal celebrations of local residents.[62] bell hooks writes about the significance and "obsession" of blacks, especially prior to integration, to take and display pictures of their everyday and family life as "a critical intervention." The display of photographs on walls served as a form of documentation that she calls "pictorial genealogies" for blacks. hooks argues that these family pictures were important ways for blacks to engage in visual discourses of self-representation. hooks writes, "They provided a necessary narrative, a way for us to enter history without words."[63] This is very important given photography's association with the historical record and, moreover, with death. Susan Sontag writes about "the image-world that bids to outlast us all" and Roland Barthes and Peggy Phelan have written about photography, in particular portraiture, as a rehearsal of death and as a way, as Phelan says, "that one can address and be addressed by the dead."[64] It is the recording of the living that marks the inevitability of death. Harris's recording of living subjects in the Hill District defies the dominant historical record and visual archive of whose life—and death—is worthy of marking.

Harris's archive of family photos and events for the private collection of black Pittsburghers demonstrates that the photographer was actively engaged in creating personal histories for the city's black residents. In his

unpublished black-and-white photograph, *Woman holding cigarette, and Robin Bullard on her lap, seated behind sheet cake inscribed "Happy Birthday Peg" in kitchen, for birthday party for Margaret Bullard, 2801 Bedford Avenue* (June 1963), the subject of the image is a woman and a young girl at a birthday celebration. In sharp focus is a woman whose face is partially obscured by her hand with a cigarette held up to her right eye, but we can detect a partial smile as she stares directly into the camera. We might assume that the pair is mother and daughter. The woman's left hand is held to the back of her head in a relaxed and inviting pose. On her lap is a school-aged girl in a light frilly dress holding a bottle to her lips as she stares into the camera. The two sit at a kitchen table surrounded by desserts and drinks. Behind them are white kitchen cabinets with stainless-steel appliances, glasses, and bottles covering the countertop. Off to the right side is a woman in a formal dress with a pearl necklace caught in motion as she appears to be hosting the party. In the far-left corner is the partial view of another woman. We see her right arm, black lace dress, and her nose and lips turned toward the camera's lens. The image is, at once, intimate and startling, ordinary and anonymous. The play between familiarity and anonymity is intensified by the long, descriptive, and awkward title assigned by Carnegie Museum of Art. It appears that the photographer is among the invited guests at this celebration and that he has a connection, an exchange, a history with the subjects in the photograph.

The photograph marks a fleeting moment of pleasure for the woman and the girl as others on the periphery of the photograph perform various duties in support of the party. The photographer and the woman with cigarette are communicating through the framing and snapping of the shot. This photograph and others similar to it are marked by the intimacy and the attention to the routines and rituals of everyday subjects that marks vernacular photography.[65] However, locating this work within Harris's larger body, the concept of vernacular photography does not attend to the expansiveness and volume of the photographer's archive or his photojournalism. In this image Harris captures a "special moment" that is quite different than the iconic import of Moneta Sleet's special moment. Here is the celebration in a home of the extraordinary moment that we annually anticipate in recognition of the self. It is an image that does not fit easily into a singular narrative or into a dominant national archive of racial progress and democratic ideal, although I am not suggesting that the image is a *challenge* to such a historical framing.

In Harris's archive are other images that appear to be from the same party. In one image a group of women stands around the kitchen table hugging. Most look directly at the camera as the woman in the center holds

Figure 1.6. Charles "Teenie" Harris, *Woman holding cigarette, and Robin Bullard on her lap, seated behind sheet cake inscribed "Happy Birthday Peg" in kitchen, for birthday party for Margaret Bullard, 2801 Bedford Avenue*, June 1963. © Carnegie Museum of Art, Pittsburgh. Heinz Family Fund, 2001.35.17970.

up a bottle and smiles, presumably toasting the celebration. The young girl and woman from the previously discussed image remain seated. The little girl frowns as the woman previously holding the cigarette squeezes the girl's cheeks. The image appears to be toward the end of the party as the cake on the table has been eaten and exhaustion has replaced exuberance on the faces of the women photographed. The archival work of the museum has uncovered the location of the scene. The party was held at the little girl's grandmother's home. It appears that this celebration may have been in honor of the grandmother who was known for hosting many events. In several editions of the *Courier* over the course of many years, images from parties hosted at Mrs. Bullard's home end up in the paper. The little girl who appears in many of the images had several of her birthday parties published in the paper. One particular image is followed by the caption:

"HAPPY BIRTHDAY, ROBIN!"—Little Robin Bullard celebrated her sixth birthday on Feb. 1 at a party given at the home of her grandmother, Mrs. Bullard,

2801 Bedford Ave. Robin, standing in front of her birthday cake, with a party hat, is surrounded by some of her friends attending the interracial party.
—Harris Photo, February 22, 1964

Through the caption, we have an indirect form of marking the successes of the civil rights era. As noted in the paper, the little girl's birthday becomes a statement of integration. Through documenting the Bullard family's personal celebrations, the *Courier* audience is connected to a larger public and a national discourse. Such historical significance is framed through the personal celebration of a young girl in a domestic setting in contrast to the public settings and sobering tone of images traditionally associated with documenting the civil rights era.

Indexicality as Praxis

When scholars discuss photographic indexicality and race, they emphasize uses of photographic technologies to assign racial categories and validate racist discourse about difference and biology. The indexing of racial subjects through the photographic lens has been discussed as a method of enforcing violence and subjugation of certain groups. One of the most studied and well-known examples of this practice is Swiss scientist Louis Agassiz's collection of daguerreotypes of slaves in South Carolina taken in 1850. Agassiz employed daguerreotyper Joseph T. Zealy to take these images to support his theory of polygenesis, or the differentiation and hierarchy of races based upon a particular interpretation of biology.[66]

As photography developed in the later half of the nineteenth century, its use as an empirical tool for marking and categorizing difference became more widespread. Nicholas Mirzoeff argues that the photographic "indexicality of race" grew in importance after the abolition of slavery and that it was part of a much larger discourse to shore up a particular form of racialization in the United States "to which the archived, indexical photograph of the 1880s and 1890s was a powerful and dangerous supplement." Mirzoeff explains that this photographic practice was part of a modernizing and expanding visual culture in the late nineteenth century meant to classify and exhibit racial difference and hierarchy, such as World's Fairs, freak shows, museum exhibits, and early cinema. Developing practices of visualizing racial difference at the turn of the twentieth century were incorporated into law. For example, Anna Pegler-Gordon has written about the strategic uses of photography to index Chinese immigrants as part of exclusionary immigration policies. Anthony Lee and David Eng have examined how visualizing

practices shaped geographic and psychic boundaries around Chinatown and the policing of racial boundaries. In these terms, photographic indexicality works to turn difference into empirical evidence, thereby contributing to a discourse of scientific racism that long has been dismissed as a field of knowledge, but continues to be disseminated through visual culture and racist discourse.[67]

Regarding indexicality and documentary photography of black communities in the twentieth century, Joseph Entin examines the work of white photographer Aaron Siskind to document Harlem in the 1930s as part of the New York Photo League, a progressive collective of photographers whose works were socially and politically charged. Entin examines Siskind's work for the tension—and at times hostility—that is conveyed between photographic subject and photographer. Entin argues that unlike FSA work happening at the same time that was criticized for "obfuscating the potential intrusiveness of documentary photography," Siskind's work in Harlem makes it visible.[68] Entin analyzes the publication of *Harlem Document*, which combines Siskind's images with text by Michael Carter, a black sociologist, and the works of other Photo League photographers. He writes:

> the photographs (three by Siskind, five by other League members) bear a heavy burden of representation, each photo standing in for an aspect of Harlem life that is described by an accompanying explanatory snippet. Because the photographs serve as secondary evidence, reinforcing the arguments of Carter's text, the formal and compositional dynamics of the pictures are deemphasized in favor of the "indexical" qualities of the images—their ability to provide a factual "truth" that illustrates the quantitative, statistical documentation provided in the commentary.[69]

While the extensive history of photography's various uses to reproduce and validate racist discourse is critical, the concept of indexicality can also be seen as richly generative praxis in Harris's work. Instead of using photography as a scientific tool to mark and categorize racial difference, Harris produced a local archive that resisted empiricism by—in many instances—refusing labels and titles. Instead he relied on his own memory and that of the people he recorded. Harris's index documents the exchange between the photographer and the photographed. If anything, this index captures the impossibility of creating an "accurate" or complete document of black subjects and black everyday life.

Harris's archiving of all of his photographic negatives was a deliberate act of preservation. Even if a negative was miscalculated or did not result in

a legible print, he retained it, thus ensuring the Hill District's place in photographic history. At the same time, the fact that many of his negatives are not labeled presents an extraordinary challenge to archivists, scholars, and collectors of his work. While much of the photography in the *Courier* did not credit the individual photographer, his negatives for the newspaper tend to be labeled and captioned. Also, much of his studio photography has names of subjects and dates. The museum staff working on the Harris archive deduce that his studio assistants wrote these inscriptions.[70] Yet a great majority of his work in his local surrounding, many of which were for paid services to document social organizations, church events, birthdays, weddings, and other rituals, remains unidentified. One can read Harris's deliberate act of not labeling or titling his work as another method by which he chose to target his work toward his local black subjects/audience. The signification and legibility of much of his work reside in the space between Harris and his unidentified photographic subjects.

Charles A. Harris explains that much of the challenge of labeling and identifying his father's work is the result of the condition of the collection when it was returned after the legal settlement. Harris had kept his negatives stored by year and some cases by category but while they were out of his possession the catalogue became damaged and in disarray:

> When he [Harris] documented them, he put them in Kodak boxes by year and some of them were by also category. The negatives were out of his control for a few years and that is when some of the negatives were marred and in some cases destroyed . . .
> He [Harris's business partner] was looking for things he could sell. So he would almost ransack the negatives looking for something like Cab Calloway, Lena Horne, Joe Louis—pictures like that he was pulling out. And he wasn't putting them back into those boxes. So that in many cases where we wanted to say that this happened in such-a-such a year or date, we couldn't do that in many cases.[71]

According to the son, his father's collection was pilfered for iconic representations, as the business partner saw little use in the tens of thousands of images of Pittsburgh's residents. In the process of searching for the icon, what was tossed aside by the entrepreneur were thousands of images of black Pittsburghers in community gatherings, domestic settings, and ceremonial and ritualistic events.

The images that seemed of no value to the entrepreneur are the characteristics that make Harris's work so important as a counter visual archive.

Harris's collection of everyday Hill District residents amounts to a subtle but radically different way of perceiving and documenting blackness during the period. The image base does not create blackness as a singular totalizing narrative but entertains the notion of play, incompleteness, and resistance to the archive as primary source for tapping into historical evidence of black everyday experience. Harris's documentary project is one with no end in sight. It is necessarily incomplete, made more evident by the archive's massive size. Even more important, his indexical practice brings thousands of anonymous blacks into the historical record and the visual lexicon of black twentieth-century life.

Despite its stunning sweep and complexity, Harris's indexical practice was not a transparent project of documenting the "real" experiences of Hill District residents. Even as he resisted deliberate stylization, the tone of many of his images is light and playful, in particular his images of children playing in the streets and the District's nightlife. However, some images suggest a different tonality and mood about mid-century living in the neighborhood. They are somber and brooding in tone. Part of what is documented in these images is the changing face of the Hill District and Pittsburgh more broadly as a result of regional, national, and global shifts in the second half of the twentieth century.

Like many urban black communities nationally, the Hill District experienced massive disinvestment in the second half of the century. According to Glasco, Pittsburgh's black communities, especially working class-residents, were destabilized between World War I and the early 1980s in large part due to deindustrialization and "bulldozer renewal" practices that destroyed the lower Hill and displaced thousands of working-class blacks.[72] Pittsburgh, known as "Steel Town," was especially hit hard by the shift in the US economy and the movement of labor away from manufacturing toward service industries. As the steel industry began to decline in the United States, as well as other manufacturing sectors, unemployment rates among blacks in Pittsburgh increased exponentially.[73] The impact of deindustrialization, urban renewal, and post–civil rights integration led to a combined depopulation of the District and a high rise of poverty and poor social services for those residents who remained in the neighborhood.

In *Portrait of man wearing light colored shirt with pack of cigarettes in front pocket, standing in front of chain link fence* (c. 1950–65) and *Portrait of man wearing plaid double pocket shirt and moustache, standing in front of chain link fence* (c. 1950–65), Harris chose as his subject young African American men with moustaches, small body frames, and similar hair styles. In one of these images, the man gazes slightly off center, his eyes not making contact with

Figure 1.7. Charles "Teenie" Harris, *Portrait of man wearing light colored shirt with pack of cigarettes in front pocket, standing in front of chain link fence*, 1950–65. © Carnegie Museum of Art, Pittsburgh. Heinz Family Fund, 2001.35.18630.

the photographic lens (see fig. 1.7). Instead, his eyes are heavy and focused elsewhere. His forehead is furrowed with visible creases. His jaw is set tensely, and his lips appear swollen. He seems to be leaning on something or someone outside of the picture frame. In the background is a fence and behind the fence, out of focus, are weeds and dilapidated rowhouses.

In the second image, the subject appears to be around the same age as the man in the previous image (see fig. 1.8). He wears a plaid shirt. However, instead of looking away from the photographer, the man in the second image is locked in a mutual gaze with Harris. He looks directly into

the camera. His eyes are penetrating under heavy eyelids. His head is tilted slightly. His mouth is closed and his jaw tense. Instead of leaning, he stands straight with shoulders back. He appears to pose in front of the same fence as the man in the previous image. His look is heavy, and his tone is similar in contemplation.

In *Two men standing on brick road, holding torn plaid shirt, man on right holding cigarette, with chain link fence in background* (c. 1950–65), the two men stand together, holding what looks to be a ripped shirt (see fig. 1.9). In the picture of the two together it is clear that both have swollen lips and swelling on the sides of their face. Both hold the shirt as if displaying proof

Figure 1.8. Charles "Teenie" Harris, *Portrait of man wearing plaid double pocket shirt and moustache, standing in front of chain link fence*, 1950–65.
© Carnegie Museum of Art, Pittsburgh. Heinz Family Fund, 2001.35.18638.

Charles Harris and Photographic Non-Iconicity / 63

Figure 1.9. Charles "Teenie" Harris, *Two men standing on brick road, holding torn plaid shirt, man on right holding cigarette, with chain link fence in background*, 1950–65. © Carnegie Museum of Art, Pittsburgh. Heinz Family Fund, 2001.35.18609.

of some occurrence to the photographer and his audience. Their looks remain somber. One stands to the side of the lens and glares at the camera; the other looks down as if in thought.

The tone of these images contrasts the tenor of most of Harris's work. These portraits invoke interiority and stillness in the expressions of the men's faces. We, as readers who are aware of the history of racial violence, might without effort or much consciousness read this image through a history of antiblack racism. The tattered shirt held between the men's hands comes to represent evidence of injustice, of assault on the body of the

beholder of the shirt. The blurred background of chain-link fence and overgrowth suggest despair, urban blight, and class and racial malaise. The date range when the images were taken is also critical, 1950–1965—as the one marks the end of World War II and the seeds of the civil rights era and the other marks the beginning of urban renewal and deindustrialization that are primary factors in the decline of the District.

A Theory of Non-Iconicity

Harris cultivated an indexical practice of documenting the non-iconic. *Noniconic* is an aesthetic that resists singularity and completeness in narrative; one that exposes the limitations of its framing and the temporality and specificity of the moment documented. A non-iconic image cannot stand in for historical process in the way that the photograph of Rosa Parks on the bus has come to do. While non-iconicity is not necessarily indexical, Harris's non-iconic work contributed to his larger praxis. This does not mean that Harris did not photograph black icons. He produced hundreds of images of black celebrities—athletes, musicians, and politicians—who lived locally and others who visited Pittsburgh. In his later years he befriended baseball legend Roberto Clemente and shot the athlete as public figure as well as with his family over a significant period of time. Many of these images are multiple shots of specific scenes and settings. They do not suggest his penchant for brevity and frugality in the photographic image. The images of Clemente convey an unhurried meditation on the public and private lives of a sports celebrity. They also reveal a diasporic framing of blackness and color given that Roberto Clemente was from Puerto Rico but was widely admired and racialized as black by black Pittsburghers. As with images of Clemente, when Harris photographed icons he did so through a lens of the non-iconic. His editor, Frank Bolden, at the *Pittsburgh Courier* recalled:

> I'd send Teenie to get a picture of Count Basie or Cab Calloway. That's what we wanted. Teenie would always bring pictures of sidemen too. His sidemen pictures of Duke Ellington were far superior to Duke. I got tired of looking at Duke smiling all of the time. Nobody got those pictures but Teenie. And of course, he always took pictures of you and me and the audience looking at the band, and the faces of those people looking were worth a thousand dollars a picture.[74]

Bolden humorously critiques the popularity of the icon. He expresses exhaustion with the fixity of the image (e.g., the frozen smile of Duke Ellington)

and instead places value on Harris's ability to capture that which happens on the margins of the iconic frame.

By often relegating celebrities (in particular male celebrities) to the margin or leaving them outside of the photographic frame altogether, Harris quite literally decentered the icon in his photographic practice. Even as Harris's images of sidemen were always more interesting than those of the icon, more compelling are his photographs of Hill District residents, or the discursively anonymous subject, responding to the extraordinary moment of being in the presence of the icon. This is the case of his large collection of black entertainment culture in Pittsburgh, such as his many images of cheering fans of the Negro League. What Harris was able to capture was the social relations between audience and entertainer that contributed to the valuation of one as icon. Harris was able to document this by focusing on the power of the audience, spectator, discursively anonymous black subject in the act of looking. He was able to privilege the look or the gaze of these individuals over the fetish of the object/icon being looked upon.

In photographing such larger-than-life figures as Muhammad Ali, Harris often captured them in ways that were unexceptional and routine, in moments when they were not performing or being observed by a larger audience. Harris's archive contains images of Cassius Clay, circa 1963, taken before Clay took the name Muhammad Ali. Three of the five photographs are unremarkable images of one of the most celebrated twentieth-century icons. The images are set in what looks to be a small apartment identified as a domestic interior at the Carlton House Hotel. In one image, which appears to be staged, Clay leans back in a chair, holding a telephone to his ear. His profile is angled toward the camera; behind him and standing is his brother Rudy Clay, who leans on the chair with one hand on his hip and peers down at his brother with a slight grin on his face. Rudy seems to rather self-consciously pose as the big brother looking down on the activities of his younger brother. The brothers have similar haircuts and are dressed in casual button-down shirts and pants.

In *Boxer Cassius Clay (Muhammad Ali) kissing his mother Odessa Grady Clay, with his brother Rudy and father Davis, looking on, at Carlton House Hotel* (c. 1963), the family stands in front of a kitchenette. The father is dressed in an overcoat and hat, holding luggage, as he watches his son kiss his wife. Brother Rudy, with hand on hip, looks at his father and smiles. On the left side of the image, Cassius Clay is leaning over, kissing his mother, who faces the camera. As his face is turned in on her cheek, Cassius Clay is the least identifiable. Harris's ability to "normalize" Clay as equally accessible to his

camera as the cheering fans at the Negro League games that he documented communicates a great deal about the access that he had to various sectors of Pittsburgh. In another image, Cassius Clay's iconicity is revealed through his absence from the photograph. The image, *Rudy Clay, brother of boxer Cassius Clay (Muhammad Ali) reading newspaper in kitchen, possibly Carlton House Hotel* (c. 1963), shows Rudy sitting in a chair reading the paper. While this image and its title convey fairly routine activities, the tightness of Rudy's lips suggest an awareness of the camera and that perhaps the moment is staged. And while the icon is missing from the image, his absence is what gives the photograph meaning, especially for the indexing purposes of the museum whose title references Rudy in relationship to the icon.

Even in the one image that centers Cassius Clay, the overall composition challenges conventional iconicity. Clay sits on a sofa in the same interior in which the other images are set. He leans forward with his elbows resting on his knees and hands clasped. His gaze is fixed to the side as his body suggests self-conscious stillness. In the far corner of the image, another unidentified photographer kneels and adjusts his camera aimed at Clay's face.

Figure 1.10. Charles "Teenie" Harris, *Boxer Cassius Clay (Muhammad Ali) kissing his mother Odessa Grady Clay, with his brother Rudy and father Davis, looking on, in Carlton House Hotel*, 1963. © Carnegie Museum of Art, Pittsburgh. Heinz Family Fund, 2001.35.6706.

Figure 1.11. Charles "Teenie" Harris, *Rudy Clay, brother of boxer Cassius Clay (Muhammad Ali) reading newspaper in kitchen, possibly in Carlton House Hotel*, 1963. © Carnegie Museum of Art, Pittsburgh. Heinz Family Fund, 2001.35.1706.

Figure 1.12. Charles "Teenie" Harris, *Photographer taking a picture of boxer Muhammad Ali (Cassius Clay) possibly in Carlton House Hotel*, 1963. © Carnegie Museum of Art, Pittsburgh. Heinz Family Fund, 2001.35.3162.

Clay looks away from both cameras as Harris photographs the other photographer taking a close-up of Clay as icon. In this nuanced image, Harris conveys the movement of the photographer as he sets up the shot and the readying stillness of Clay as he prepares to be documented as black icon. Harris captures the process by which Clay the indexed subject of Harris's other images transforms into Clay the stilled icon of the (other) photographer's camera. In numerous shots of black celebrities like Clay, Jesse Owens, Lena Horne, and the like, Harris provides context for the making of the icon and he grounds their status and value in black cultural practices and foregrounds black spectatorship over the icon as exceptional individual.[75]

The Visual Record, the Digital Archive, and Collective Memory

In 2001 Carnegie Museum of Art, working with Harris's family, began a historic project called *Documenting Our Past: The Teenie Harris Archive Project*. The multitiered project is in part an attempt to label, date, and identify people in Harris's collection. It also attempts to place Harris's work within studies of the twentieth-century history of Pittsburgh, of documentary photography, and of black photography. The museum has enlisted historians, curators, community leaders, social and religious organizations, and residents who knew Harris or whose relatives were photographed by him. One of the most significant aspects of the project is the museum's efforts to make Harris's collection a living archive by having organizations and people outside of the museum help identify subjects and label the negatives. In 2003 the museum exhibited many prints in the show *Documenting Our Past: The Teenie Harris Archive Project*, partly in hopes that community residents would be able to assist the institution in cataloguing the collection.[76] Louise Lippincott stated that the exhibit's goal was "to show as many unpublished photographs as we can, and invite the public in to tell us what they are about, to help identify the people, places, and events they represent, and to tell us what memories the photographs trigger."[77] Oral historian John Brewer, who knew Harris and collects his work, has been important to the museum's efforts of creating narrative and contexts for the images, as well as associations like The Girlfriends, "a group of prominent African American women" who work to identify images at their meetings.[78]

Perhaps the most far-reaching component of the museum's work is the digital archive of tens of thousands of Harris's images available through the museum's website. The website encourages visitors to participate in collecting information for Harris's archive. Visitors can help to identify locations, subjects, and events. Continuing Harris's connection with the *Courier*,

the museum posts images from Harris's archive in the paper with a query asking readers for any information they might have about them. The museum has also held public viewings in which residents of the Hill District have been encouraged to attend and to participate in the labeling of images. According to the staff of the museum, in several instances people identified relatives in photographs that are decades old.

The archive project has tremendous significance for developing relationships between institutions and communities documented by and through these sites. The afterlife of Harris's practice evidences that there is nothing fixed about the archive. The project challenges us to rethink the visual record in the history of freedom struggles, documentary projects of black communities, and American public discourse. One of the most critical interventions provided through this project is that the photographic subject and/or the subject's descendants become the expert, interpreter, and, to an extent, co-curator of the archive. Consensus memory of black American history is displaced by the collective memory of those engaged with Harris's index. This collective memory takes up Harris's praxis to create a public record of black twentieth-century life that was not part of the coverage of dominant visual culture and public discourse. The work of Carnegie Museum of Art and the various organizations and individuals involved produces an affective community around Harris's images and legacy. The affect is that of belonging while mourning the loss of a period in the Hill District that was marked by kinship ties and black social and communal associations as a nostalgic togetherness. These efforts only highlight the temporality and relationality of the archive given that Harris's images record a past that is no longer the present of the District. Many of the buildings no longer stand or have been abandoned by waves of deindustrialization and the fragmenting of neighborhoods, populations, and public spaces.

On another level, the museum's archival project manifests Harris's voluminous documentary practice as an ongoing gesture of marking the historical and regional specificity of black lived experience. Moreover, Harris's practice offers a counterpoint to the romance of dominant mid-twentieth-century images of African American life. Yet, there is another form of romanticism that emerges in and around Harris's life and oeuvre. His work has been described as authentic because of his role as resident visual ethnographer and archivist. At the same time, Harris's obsessive practice of documenting the details of play, work, and ephemera of black life in the Hill District, of never letting go of a negative, of taking one fleeting shot, and building a massive archive highlight the impossibility of constructing a singular narrative of black American life. The photographic legacy of the

twentieth century has produced so many images of spectacular blackness. What makes the archive of Charles "Teenie" Harris remarkable is the absence of spectacle. Instead, he offers a methodical, repetitive representational strategy of visualizing black subjectivity in its fleeting, multitudinous incompleteness.

TWO

Her Own Spook: Colorism, Vision, and the Dark Female Body

How does one come to *know* subjects as black, or even more specifically as African American? What are the visual markings that make certain subjects legible as black? How does the seeing of skin color and phenotype contribute to one's recognition of what constitutes a black subject in visual sphere? How does value get accessed based on visible blackness?

In this chapter, I consider these questions by focusing on how black theatre and performance have staged racial and color marking through character type and narrative. The study is a move away from the social impact of documentation and its resonance in the public record, the archive, and the artifacts of history to the psychic and affective domains of racialized visual discourse. In further exploring how blackness and the black subject come into being through visuality, the study shifts to the embodied subject, the theatrical stage, and the dramatic text. Theater and staged performance have historically served as important mediums for black cultural producers to engage with the relationships among historical narratives, visual iconography, and racial performativity. Harry Elam Jr. writes:

> the discourse on race, the definitions and meanings of blackness, have been intricately linked to issues of theater and performance. Definitions of race, like the processes of theater, fundamentally depend on the relationship between the seen and unseen, between the visibly marked and unmarked, between the "real" and the illusionary.[1]

Black theatrical traditions' use of black performing subjects to articulate processes of racialization serves as an important domain for understanding how the codes of blackness and the seeing of certain bodies as marked racial subjects function in dominant public discourse.

Intraracial and interracial colorism have preoccupied black playwrights and performers historically, in particular the workings of color gradations as a measure of the subject's value. Black playwrights and performers have used the immediacy of theater to produce narratives of black psychic trauma resulting from colorist structuring and, to differing extents, framing the sociological and/or historical contexts out of which colorism becomes state-sanctioned and a social practice in the United States. Many of these dramatic works have interrogated how colorist ideologies not only produce racial categories but also gender and class affiliations. Two key plays by black female playwrights that address the psychic and social impact of colorism's reliance on visual perception and its structuring of black female subjectivity, Zora Neale Hurston's *Color Struck* (1926) and Dael Orlandersmith's *Yellowman* (2002), are the focus of this analysis.

The plays of Hurston and Orlandersmith are part of a tradition of work by black women that address color/gender/class distinctions among blacks, like Adrienne Kennedy's *Funnyhouse of a Negro* (1962) and Alice Childress's *Wedding Band* (1966). Similar to these plays, *Color Struck* and *Yellowman* use vision as a metaphor and a device to mark and distinguish colored and gendered subjectivities. Orlandersmith and Hurston make vision both a central concern of their characters and a metaphor for subject formation and knowledge. Not only does the vision of the characters concern both authors, but the visual deciphering that their audiences perform is central to the revelation of the colorist systems that operate in their respective plays. To make these works meaningful as staged events or dramatic texts, audiences/readers must become practitioners, or performing subjects, of colorist systems of differentiation.

The chapter begins with a consideration of dominant historical and discursive ways of understanding intraracial colorism, specifically discrimination among blacks based on color hierarchies. Hurston's *Color Struck* and Orlandersmith's *Yellowman* are then framed within a black theatrical tradition of using the stage and live performance to trouble the field of vision as it structures race based on normative discourse. In Hurston's and Orlandersmith's works, both playwrights employ character type and narrative structure to dramatize the psychic and affective domains of colorism. Their interventions are realized in their depictions of dark-skinned black female protagonists. Finally, using theories of abjection, the chapter considers how the figure of the dark-skinned black woman in both plays functions to show both the repressive power and the constant failure of vision in maintaining colorist practices. Colorism, vision, and performance are engaged on several fronts: the relationship between color and value, the visualization of intra-

racial distinction, and how intrarracial distinction is visualized, performed, and experienced as psychic trauma.

The focus on narrative in this chapter is a departure from the other chapters that give more consideration to medium in visualizing blackness. Yet, integral to my argument is that theatre is as much a visual medium as it is one of embodied performance and the live text, or dramatic script. It is in the staging and live moments that the optical regimes of race most clearly unfold.[2] Hurston's and Orlandersmith's plays demonstrate how visuality is intertwined with narrative in the medium of theatre. My argument is that narrative becomes a means to visualize blackness and to assign racial codes to certain bodies. Visuality cannot be separated from narrative especially in plays about race and colorism.

Colorism and the Regulation of Racial Difference

My concerns for analyzing these plays are twofold. The first is how the system of colorism produces a performing subject whose function is to enact difference through looking and deciphering, an act that is fundamentally about assigning value. In his study *Blackness and Value*, Lindon Barrett writes, "value is always a social formation that more or less openly comprises conflicting social practices in a carefully arranged hierarchy. Value must concern itself with the rejected and the anomalous and, compromising the very boundaries on which it relies to specify the rejected, and the anomalous."[3] To perceive color as epidermal difference hinges on a construct of a visual, visible, and viewing subject whose position to scopic regimes depends on her racial and gender markings and who can decipher value along the hierarchy that Barrett describes. Colorism attempts to fix a scale of blackness based on dominant structuring principles of the field of vision and through an understanding of the black body as a visibly identifiable body, even in traces. While privileging vision as the means of detecting difference, colorism also produces anxiety about the failure of vision to detect difference. Furthermore, colorism structures a relationship between the perception and marking of skin color and a performed embodiment. In part, the subject understands the colorist paradigm and assesses value in relation to the hierarchy; and a colorist gaze frames her understanding and perception of the actions of others marked through this system.

The second purpose of this chapter grows out of my reading and viewing of *Yellowman*. It concerns a contemporary understanding or reworking of the legacy of racial trauma and colorist ideology that obfuscates white racism and the history of state-sanctioned racial structuring by focusing on

its affect in the present moment as residual resentments, social pathology, or self-annihilating practices. For example, in a dramaturgical statement for a production of *Yellowman* at the Berkeley Repertory Theatre, colorism is described as a long-held and persistent social taboo in black communities.[4] The dramaturgical statement relies heavily on Midge Wilson, Ronald Hall, and Kathy Russell's *The Color Complex: The Politics of Skin Color Among African Americans*. The book, written by a black woman, a white woman, and a black man in a show of multiracial and cross-gender solidarity, introduces the topic as black pathology:

> Traditionally, the color complex involved light-skinned Blacks' rejection of Blacks who were darker. Increasingly, however, the color complex shows up in the form of dark-skinned African Americans spurning their lighter-skinned brothers and sisters for not being Black enough. The complex even includes attitudes about hair texture, nose shape, and eye color. In short, the "color complex" is a psychological fixation about color and features that leads Blacks to discriminate against each other. Because the color complex has long been considered unmentionable, it has been called the "last taboo" among African Americans.[5]

"Taboo" is a common term used to describe the social and psychic function of intraracial colorism among blacks and is not in any way new to this study. The quote, however, is reflective of a larger cultural tendency to decontextualize the history of blackness as a racial formation in the United States and to resolve the United States' history of racial inequality by focusing on individualized notions of self-actualization. In *The Color Complex*, this is achieved through pathologizing colorism as a psychological disorder that affects individuated black Americans—the "sisters" and "brothers" of the imagined racial family. But such framing produces a notion of black subjecthood without referent, a tautological subject who is her own spook. She is both master and slave in her psychic trip of racial suffering.

My analysis of colorist discourse is not meant to dismiss the weight or importance of colorism as a force that impacts black lived experience. Quite the contrary, literary and cultural theory on passing and the trope of the mulatta, recent critiques on multiraciality and the postracial state, and critical race theory and legal scholarship on miscegenation offer a range of disciplinary approaches and looks at the historicization and regulation of color/gender stratification in the United States.[6] While my analysis is not an account of the history of colorism, it is an account of the effect and affect of color/gender stratification as dramatized in Hurston's and Orlandersmith's

plays. In the context of the United States—I specify here the nation-state, given that colorist ideology has a long history of functioning in various regions, nations, and cultures with mutations on reading lightness and darkness—colorism cannot be divorced from the institution of slavery. As H. Lin Classon writes in an article on *Color Struck*, "The history of colorism is entrenched in the history of slavery. Rapes, sexual exploitation, and, though relatively rare in the earliest periods, legal and illegal interracial marriages, resulted in a wide spectrum of skin tones among African Americans."[7] The terror of colorism as a visual regime is rooted in the history of white rape and torture of black bodies and a larger racial structure of subjugating blacks as cheap and replaceable laboring bodies.

Over the course of the institutionalization of slavery, its eventual demise, and the continued exploitation of black labor and black bodies post–Civil War, nuanced gradations of racial categorization stratified sectors of blacks and other racialized subjects and governed levels of intimacy with whites. The result was the evolution of a visual system based on an index of skin-color differentiation and premised on the suspicion of racialized subjects slipping through this system undetected. By measuring the subject's value according to epidermal schema and other phenotypic features, colorist logic both reproduces and refutes notions of racial purity and immutability. It is a tenuous gradation that must be constantly monitored and measured by the viewing subject and the viewed subject. Colorist hierarchies depend on a mythic conception of whiteness as the standard of measurement and a totalizing blackness as its depraved opposite. One's degree of blackness becomes the basis of colorist hierarchies; whiteness, as the normative standard, gets measured by blackness, or its perceived absence.

P. Gabrielle Foreman considers the paranoia and anxiety that colorist regulation produced in the white public in the nineteenth century, specifically regarding the passing black body of the mulatta.[8] Challenging studies that read the passing of the (visually white) mulatta as a claiming of the white father and a rejection/denial of the dark mother, Foreman argues that in many historical accounts of passing the mulatta passes *through* whiteness to secure freedom and/or safety for other black (slave) relatives. Foreman's analysis of passing underscores the discursive nature of the visual field in marking bodies. Race and skin color are fluid concepts that often cause paranoia and fear in those determined to detect and define them, as Foreman demonstrates with the white outcry against "white blacks." The visual system of racial marking itself becomes visible through attempts to uncover "white blacks." Thus, one could argue that the white public's obsession with enforcing racial categories even when their vision betrayed them suggest an

insecurity about what exactly it means to be white.[9] If one who by all visual markers appears white is "in truth" black, then who can claim whiteness? In essence, if white cannot be distinguished from black, then how can a colorist structural system be regulated and maintained that is based on this distinction?

Because colorism as a system of creating and maintaining racial difference produces its own failure—that is, certain bodies escaping detection—the US legal system historically has been and continues to be a central institution for regulating and adjudicating colorist practices. Writing about the history of laws governing interracialism in Virginia, legal scholars A. Leon Higginbotham and Barbara Kopytoff argue that the management of these categories became even more important after emancipation to maintain white privilege:

> After emancipation, there was no special status of slave and oppression became entirely racial. . . . As race became the sole means of identifying those who belonged to the lower caste, the legal definition of race became more exclusive and maintenance of white racial purity became more important.[10]

As Higginbotham and Kopytoff's research makes clear, colorism emerges out of, yet denies, interracial sex. Moreover, as much as colorist stratification in the United States is a result of miscegenation, its most significant function and enduring impact are the governing of property relations and the reproduction of laboring bodies. Cheryl Harris shows how the color caste system in the United States has primarily functioned to secure a range of privileges for white subjects. Harris analyzes the importance of the state and the legal system for maintaining white privilege and property rights, and in turning whiteness itself into property. Harris writes, "Within the worlds of de jure and de facto segregation, whiteness has value, whiteness is valued, and whiteness is expected to be valued in law."[11] Harris examines how white privilege as legislated becomes naturalized and associated with property:

> Although the existing state of inequitable distribution is the product of institutionalized white supremacy and economic exploitation, it is seen by whites as part of the natural order of things that cannot legitimately be disturbed. Through legal doctrine, expectation of continued privilege based on white domination was reified; whiteness as property was reaffirmed.[12]

In contrast to the legalization of white privilege, Taunya Banks examines the lack of recourse that black subjects have to the legal system in claims of

injury based on intraracial and interracial skin-color discrimination. Looking specifically at employment discrimination cases of colorism among and against blacks, Banks points to the difficulties of addressing black skin-color discrimination because "the government's definition of the racial category black impedes recognition by courts that black people can be differentially racialized." Banks examines how courts, namely judges, function as arbitrators of epidermal variation in these legal disputes. Especially in cases of intraracial discrimination, judges were asked to distinguish the skin tones between defendant and plaintiff and if such variations given a larger sociohistorical context were grounds for a complaint of discrimination.[13] Critical race theory and legal scholarship, like the works of Higginbotham and Kopytoff, Harris, and Banks, offer insights into the historical and legislative workings that have shaped the ideology and practices of colorism in the United States. The works of Hurston and Orlandersmith offer insights into the visual and psychic effect and affect of the state-sanctioned system of colorism.

Hurston's *Color Struck* and Black Theatrical Tradition

Within black theatrical and performance traditions is a long history of playwrights and performers using the stage and the dramatic text to explore race, history, and visual regimes. Or even more broadly, American performance historically, whether explicitly or not, has been engaged with the optics of racialization, the spectacle of the racial body, and the fixity on vision as tool of deciphering difference. This is most evidenced in the popularity of minstrelsy in the nineteenth and early twentieth centuries.[14] In considering nineteenth-century performance culture, Daphne Brooks examines the work of black performers who "redirected the art of spectacle (representational) excess, and duality, and who signified on the politics of racial 'imitation' in order to reinvent the transatlantic cultural playing field from abolition forward." Brooks theorizes how performers like Henry Box Brown, Bert Williams, and George Walker were "[c]alling attention to the hypervisibility and cultural constructions of blackness." According to Brooks, their works critically engaged racial iconography and spectacular blackness and by "defamiliarizing their own bodies by way of performance," they were able "to yield alternative racial and gender epistemologies."[15]

This preoccupation with and critical redress of visual and performative codes of racial marking continued in the formation and institutionalization of black theatre and literature in the early twentieth century, most notably during the Harlem Renaissance. Many well-known literary works of

the early twentieth century, including Nella Larsen's *Quicksand* (1928) and *Passing* (1929), Jessie Redmon Fauset's *Plum Bun: A Novel without a Moral* (1929), Wallace Thurman's *The Blacker the Berry* . . . (1929), and George Schuyler's *Black No More* (1931), considered colorist ideology and systems of racial markings among blacks and between blacks and whites. For many artists, intellectuals, and cultural producers of the era, the psychic weight and visual anxiety of racial markings were worked out through the representation and rearticulation of the figure of the mulatta. Cherene Sherrard-Johnson emphasizes the importance of black painter Archibald Motley's *The Octoroon Girl* (1925) to black visual iconography of the era, in particular to marking the mulatta "as a predominant referent in the visual culture, art, and literature of the Harlem Renaissance era."[16] During the Harlem Renaissance the theatre—the stage and dramatic texts (including closet dramas)—was considered an important domain for black cultural practitioners to engage with the construction and reification of blackness through visual coding. The importance of theatre to engage performative and visual modes of racial meaning is evidenced in the creation of a theatre group by W. E. B. Dubois, in concert with the NAACP in 1925, with the "requirements for a real Negro theatre—that it be *About us, By us, For us and Near us.*"[17] Yet, as DuBois' declaration suggests and as contemporary critics have argued, these efforts were often attempts to displace the dominant visual iconography of blackness by positing what many black artists of the time considered a more authentic representation of black subjects and cultural practices (though the notion of authenticity was hotly debated among artists and intellectuals of the era). Hazel Carby writes,

> The desire of the Harlem intellectuals to establish and re-present African-American cultural authenticity to a predominantly white audience was a mark of a change from, and confrontation with, what were seen by them to be externally imposed cultural representations of black people produced within, and supported by, a racialized social order.[18]

Artists like Hurston and Hughes were involved in producing theatrical pieces that contended with the history of racial meaning and its visual iconography while experimenting with aesthetics and imagining possibilities for modern black spectatorship.

Hughes's *Mulatto* (written in 1930 and first produced in 1935) was an important play that considered the visual marking of blackness, psychic and material inheritance, and the regimes that maintain difference through optical structures and metaphors of vision. In their reading of *Mulatto*, Michele

Elam and Harry Elam Jr. argue that Hughes flips the racial conventions of the tragic mulatta by creating a protagonist in Robert who is a mulatto and who ultimately kills his white father in order to claim the property rights of the father. They argue that Hughes's protagonist does not embody the psychic profile associated with the tragic mixed-race character but instead demands to be included in "the national citizenry." In considering Hughes's concern for casting, Elam and Elam point to Hughes's attention to the significance of racially and color-coded bodies to produce certain meanings for his audience: "Hughes, well versed in other forms of representation, wanted to manage the image of his characters by including detailed stage directions about how the darker-skinned William and the near-white though clearly 'Negroid,' as he put it, mulatto actors who portrayed Robert and Sallie should look."[19] What Hughes's concern and more broadly the efforts of some nineteenth- and early twentieth-century theatre practitioners point to is theatre's reliance on the vision of the (imagined or representative) spectator to interpret staged performance, the dramatic texts, and, most crucially, the performer.

This reliance is both obvious and critical and takes the form of transparency. How does the assumed transparency of viewing performance and theatre rely on a spectator to engage normative codes of race, and specifically blackness, to decipher the performative body and narrative? More precisely, how do black playwrights and performers interrogate the psychic and social impact of racial marking and the visual economies that maintain them through the stage? The relationship between the audience's looking practices, the looks among the staged performers, and the visual markings of the performers' bodies becomes central to this restaging.

Color Struck was written and is set during a period where the color caste system was one of many institutional practices enforced to maintain Jim Crow segregation and a period marked by massive transition as millions of blacks left the South to move to northern and urban regions. Hurston, who is known for her work in ethnography, folklore, dance, and creative fiction, documents this period without following the "documentary impulse" of the era. Hurston's writings, notably *Jonah's Gourd Vine* and *Their Eyes Were Watching God*, are known for integrating anthropological observation in creative fiction. As has been well documented, her overlapping engagements with various fields of black cultural production, continued interest in representing rural black folk culture, and scholarly efforts were not without conflict.[20] David Kadlec, in looking at Hurston's work while on assignment with the Federal Writers' Project of the Works Progress Administration in Florida, explains that she expressed frustration with the frameworks of social

documentation while working with the WPA. Kadlec argues that Hurston's struggles were in part a result of problems with how governmental agencies represented blacks institutionally through an aesthetic directive of social realism.[21] Hurston, he argues, understood culture as practices in the making, and she therefore resisted the government's goals of producing static documentation of these communities as entries in the national archive of a historic moment.[22]

Scholars have widely debated Hurston's interest in and representation of black rural folk and have offered a range of interpretations of her creative and documentary work. Hazel Carby argues, "In Hurston's work, the rural black folk become an aesthetic principle, a means by which to embody a rich oral culture. Hurston's representation of the folk is not only a discursive displacement of the historical and cultural transformation of migration, but also is a creation of a folk who are outside of history."[23] Yet Classon argues that *Color Struck* is precisely an attempt to locate rural black folk in historical processes and to center the color caste system by representing the struggles of a dark-skinned, poor black woman within this system. Along these lines Jennifer Cayer examines Hurston's work to develop an aesthetic that Hurston describes as angularity—linking race and performance—to attend to rural folk culture practices and lived experiences in the midst of massive transition toward a rapidly urbanizing black culture.[24] Arguing that Hurston was interested in anthropological and theatrical conceptions of performance with regards to black folk culture, Cayer writes,

> Hurston makes it clear that race is constituted by particular performance styles and is, in itself, theatrical; in other words, race is performed every day, on the streets and in the fields. Hurston's hope was to make this performance explicit by bringing it onto the stage and by forcing the audience to reckon with race in the lived and present moment of the theatre.[25]

Hurston's *Color Struck*, as well as her other forms of engagement in black cultural production, can be understood as pulling at the frays of iconic documentary practice. In doing, she emphasizes both the threads that escape these institutionalized forms of representing blackness and imagines "Negro culture" in ways that do not privilege the empirical, even while using the tools of empiricism (camera, recording devices, pen and paper). Kadlec concludes that for Hurston documentation gained relevance when "the act of documentation itself became a kind of cultural activity."[26] Hurston's interest in documentary practice as part of cultural activity and her configuration of culture as process are possibly some of the reasons that she had a profound

interest in dramatic forms and the possibility of theatre for representing black cultural practices. *Color Struck*, Hurston's first play, is remarkable for both representing black rural communities as culture in the making and foreshadowing how these figures will be framed (or perhaps better phrased, amassed as one homogenous group) through the institutional history of early twentieth-century blacks in the United States. *Color Struck* was originally published in 1925 in *Opportunity Magazine*, during the same period that Hurston, Langston Hughes, and Wallace Thurman produced the literary magazine *Fire!!* and while she was also studying anthropology with Franz Boas. Scholars have argued that Hurston's *Color Struck* was not only written as a challenge to color hierarchies in black communities but also as a criticism of the focus on northern urban black culture and its male-centered black public culture.[27] Her critique was folded into her choice of subject matter and aesthetic, which did not privilege the sober discourse of documentary realism but instead privileged the frivolity, play, and repetition of black folk narratives.[28]

Color Struck reflects these concerns. The play illustrates the limitations of social realism and the power of theatre to examine the affect and psychic woes of colorism. Taking the familiar setting of the black rural South and the figure of the embittered dark-skinned black woman, the play combines this rehearsed—and typically melodramatic—narrative with Hurston's notion of documentation as itself a cultural activity, in particular her engagement with black folk and performance culture, to explore the psychic and material impact of colorism. Set in the Jim Crow South at the turn of the twentieth century, the play opens in the colored section of a segregated railroad car. (The stage directions read: "Time: Twenty years ago and present"/"Location: A Southern city" [35].)[29] The first three scenes revolve around a cakewalk competition in a southern community, opening with a performance within a performance as black southerners enter the train on their way to the competition. The characters strut their finest threads and practice the cakewalk moves that will bring them regional fame. In the stage directions of scene 1, Hurston writes: "There is a little friendly pushing and shoving. One pair just miss a seat three times, much to the enjoyment of the crowd. . . . The women are showily dressed in the manner of the time, and quite conscious of their finery" (35–36). Drama scholar Sandra Richards commends the play for grappling with "frivolity" and pleasure among working-class blacks in rural areas.[30] And while play is so central to *Color Struck*, H. Lin Classon notes that in *Color Struck* Hurston demonstrates that "Intraracial prejudice is caused by interracial discrimination; the reality of colorism always carries with it the invisible presence of racism."[31]

While the play encourages audience participation and laughter through comedic representations of black southern caricatures, Hurston also creates a sense of foreboding through the anxieties of her protagonist Emma. Even as the diegetic world that surrounds her is one of laughter, anticipation, and play, Emma is brooding, insecure, and resentful. In these early scenes, the audience gains insight into the tension that will drive the story's plot: Emma's obsession with colorism. In particular, she fixates on a light-skinned mulatta dance competitor, Effie, because of her color and the attention that John, who is romantically attached to Emma, shows Effie.

In its engagement with colorism and the importance placed on dark-skinned black women as an arbiter and register of value, *Color Struck* offers a rich framework for reading Dael Orlandersmith's *Yellowman*, written almost eighty years later. Hortense Spillers discusses some of the risks and possibilities involved in writing about texts of very different historical periods in her analysis of Harriet Beecher Stowe's *Uncle Tom's Cabin* and Ishmael Reed's *Flight to Canada*. Spillers writes: "I am not suggesting any explicit relationship of priority and indebtedness between textual performances in a selected spatiotemporal sequence by invoking these disjunctive literary instances. By bringing them into a posture of alignment, however, I do wish to concede textuality itself as a self-conscious systematicity that never closes."[32] Hurston's play and the scholarship on *Color Struck* are useful for engaging *Yellowman*'s depiction of the traumatic relationship between vision and black female corporeality due to colorism. Like *Color Struck*, Orlandersmith's work mirrors the issues of identification and negation within the black South as both geographic and discursive site. Both plays deal precisely with the power and the failure of vision in a racializing colorist system. Together, they provide the opportunity to reconsider colorist practices as moments where we can see racial marking and subjugation and where the thematic preoccupation with color coding brings to the fore the anxieties of the dominant visual sphere. Moreover, such an analysis reveals how the system of colorism produces a performing subject whose function is to enact difference through the act of looking and deciphering, even when such optical practices secure her subjugation.

Staging Blackness as Color Gradations

Yellowman is a poetic meditation on how color and vision are wedded to memory and trauma through a colorist paradigm of black self-loathing. The play considers the impact of intraracial discrimination among blacks in a rural southern community and the power of looking in maintaining this

Figure 2.1. Dael Orlandersmith and Howard W. Overshown in *Yellowman*, 2002. © Joan Marcus. Photo courtesy of Manhattan Theatre Club.

system of racial and sexual terror. Focusing on the gradations of color that place certain black bodies at the bottom of the colorist system and others in positions of relative power, the plot of *Yellowman* revolves around the friendship and love between a poor, brown-skinned black female, Alma, and a light-skinned, middle-class black male, Eugene. The drama moves between retelling Alma's and Eugene's stories of color/gender oppression and reliving them. Structured as a shared narrative between Alma and Eugene, the characters address the audience for much of the play, though at times it turns into interactive dialogue.[33] The dramatic tensions are heightened by the color and gender anxieties of Alma's dark-skinned, abandoned mother and Eugene's "jet black" father, who embody racial self-hatred. More important, the audience is asked to draw on the conceptual maps of the color caste system when other characters are invoked, as they are performed or remembered through the bodies and voices of Alma and Eugene.[34] So, for example, when the light-skinned Eugene vocalizes the words of his "jet black" father, we are looking at a man marked through normative visual discourses of race as a fair-skinned black but we are hearing the voice of a dark-skinned black man.

While *Color Struck* is characterized by a great deal of movement, characters (though there are only three main performers), and dialogue/exchange between performers, *Yellowman* is a remarkably still and quiet play as it is

staged for production. It is a meditation—an introspective retelling, as opposed to seeing the drama unfold in the "present" moment of Hurston's play. For much of the play, Orlandersmith's characters Eugene and Alma sit or stand, addressing the audience with minimal physical movement. The stage directions and set emphasize the importance of a minimalist aesthetic to convey the emotive power of the narrative: "The space is bare except for two chairs on a raked stage, which indicates the distance between the characters. . . . It is the bareness of the stage, save the chairs, that makes the musicality of the piece play" (5).[35] These production notes emphasize a move away from a presentational performance space to a psychic one where history and memory are always present.

Since its premiere at the McCarter Theatre in 2002 *Yellowman*, described as brave in tackling sensitive issues, has received a great deal of critical acclaim and awards.[36] In a *New York Times* review, Alvin Klein writes, "As a sculptor of words and structure, the playwright chips away at the layers of what she calls internal racism, which she sees as festering startlingly within families where shades of color determine degrees of status."[37] Orlandersmith was a finalist for the Pulitzer Prize in Drama in 2002, the same year that black female playwright Suzan-Lori Parks received the award for *Topdog/Underdog*.[38] Klein also argues in a later review of the show that Orlandersmith should have won the prize for *Yellowman*; he declares, "The committee was wrong."[39]

In the 1990s Orlandersmith, who was born in New York and grew up in East Harlem, traveled with Nuyorican Poets Café based in the Lower East Side of New York. She describes Puerto Rican culture, as well as New York's 1970s music scene, as two of her artistic influences. Orlandersmith's work speaks to the tradition of spoken word and performance poetry, as well as feminist performance art; prior to her work as a playwright, she performed as an accomplished poet and actress. *Yellowman* is Orlandersmith's first play written for more than one character; the majority of her theatrical pieces are structured as one-woman performances. Orlandersmith's plays tend to be set in New York and deal with the material hardships and psychic woes of underclassed black women. Other playwriting credits for Orlandersmith include *Monster*, *The Gimmick*, and *Beauty's Daughter*, for which she received an Obie Award after it premiered at the American Place Theatre in 1995.

My reading of *Yellowman* incorporates the dramatic text and my viewing of two different productions of the play at the Manhattan Theatre Club in October 2002 and at the Berkeley Repertory Theatre in February 2004. At the Manhattan Theatre Club in October 2002, the original cast of Dael Orlandersmith and Howard Overshown performed and the audience con-

sisted primarily of an older white subscriber base who responded with similar praise to that of the reviews and critics. Like many in attendance, I was moved by Orlandersmith's poignant language and the stark presence of Orlandersmith as Alma and Howard Overshown on stage in the earlier production. When I attended the performance in Berkeley, the audience was much more diverse and younger, and the cast had changed from the original performers to Deidre N. Henry as Alma and Clark Jackson as Eugene. Without dismissing Orlandersmith's skill and accomplishments as a playwright, I do question what might the praise for *Yellowman* say about white critics' desire to see the "dirty laundry" of black culture, given the language of secrecy and darkness that color the promotional material and reviews of the play. For example, the press release for the Manhattan Theatre Club production describes the play "as a look at how sins of the past become the legacy of the future and the harsh realities of internal racism."[40]

During intermission, an older white woman standing next to me whispered to her friend while waiting in line for restroom, "I can't believe she's showing that on stage." *Yellowman* comes to stand in for a visceral and repressed truth of black experience. The confessional style of the narration to the audience lends itself to this. Many of the positive reviews of the show are defenses of the play's representation and what has been described as Orlandersmith's courage and honesty. The assumption of a mixed or polarizing response seems to tenor the critical engagement with the play by critics and reviewers who speculated on how difficult the reception would be to the play prior to its opening in various locations.

In a review that I wrote of the play's production at Manhattan Theatre Club, I criticized the play for how it divorces intraracial colorism from the history of slavery, segregation, and other forms of institutional and psychic racism that reinforce white power and privilege.[41] Here I would like to re-situate my engagement with the play, for I find its affective power compelling even as I remain unsettled by its punitive casting of blackness. While as I stated earlier, I do take issue with how colorism gets divorced from whiteness in *Yellowman*; I do worry about this critique slipping into an unwitting notion that colorism has an originary moment and that whites must accept the blame for this system. While I find the relationship that she constructs between vision and subjectivity compelling, I am concerned that Orlandersmth's critique of intraracial colorism slips into a pathological assessment of blackness, especially dark-skinned blacks. Blackness as it circulates among the characters who populate her play is a sign of decay, to invoke Fred Moten's analysis in "The Case of Blackness."[42] It festers and sickens. It is a constant source of suffering and produces moments of

extreme violence. Blackness in the world of the play can only be experienced as possibility when it is decontextualized.

I do not want my ambivalence here to be read as an argument that black artists cannot or should not be critical of intraracial discrimination and gender relations. I take to heart Anne DuCille's criticism of black scholars (both men and women) who condemn black women writers for not telling "the truth" about black experience when their depictions challenge certain investments in blackness. My goal here is not to argue about the accuracy or truthfulness of Orlandersmith's representations. Instead, I would like to consider what it means to depict a world in which dark-skinned black women cannot experience any pleasure, are destined to reject their reflections, and must ultimately flee the black community that has raised them in order to recognize their own subjectivity and be recognized as subjects.

One of the striking differences between Hurston's play and *Yellowman* is the presence of white racism and state-sanctioned segregation that enforces colorist ideology. While both plays feature all black characters within black communities, *Color Struck* establishes that the setting is structured by Jim Crow—that is, the segregated train car in which the play begins. This institutional practice directly shapes the conditions of possibility for Hurston's characters. For *Yellowman*, the setting is a southern black town in which dark-skinned, working-class blacks occupy one section and middle-class, lighter blacks live in another. The town, we can assume, is a remnant of the Jim Crow practices that shape Hurston's play; yet, in Orlandersmith this world is solely occupied by blacks. *Yellowman*'s characters and communities inherit racializing norms and practices that, while established for white beneficiaries, are rigorously upheld by blacks of all skin colors. This distinction is due primarily to the very different time periods in which the writers produce and set their works. Orlandersmith acknowledges that her concern is how blacks participate in practices that maintain their own suffering. Orlandersmith purposefully distances herself from documentary legacies in black cultural production and positions her play as a post–civil rights' reflection on colorist practices of blacks based in a history of racialization and trauma.[43] In an essay that discusses the influences on her writing of *Yellowman*, Orlandersmith writes:

> My mother was from South Carolina, and this is very, very, loosely based on a family down there. When I was a kid my mother would send me down in the summer. And there was this family that used to interbreed to keep the light skin going. Yellow, "high yellow" was a nasty term for lighter-skinned black people.

When the '60s rolled around, the Black Power movement started in this particular region in the South and in other places as well. I remember people who were extremely dark and extremely light getting together simply because it was a taboo, and you could not do it before. *Yellowman* is loosely based on this community, on this family, when the '60s rolled around. There was a bust-out of stuff. It became a catalyst for me to look at internal racism—the rift between light-skinned people and dark-skinned people, which has its roots in slavery. So in this particular case I don't want to let anyone off the hook. The people that have enslaved, and the people who have taken on being enslaved and taken the very bias that's been done unto us. You know, because it still happens.[44]

Significantly, Orlandersmith locates her play as a response to post-1960s politics and more specifically the black power movement. While the play is set in the post–civil rights era (with cultural references to the periods between the 1960s and the 1990s), Orlandersmith builds a cross-generational narrative of suffering and trauma in which the woes of early twentieth-century sharecropping black women are reproduced in the identity formation of their late twentieth-/early twenty-first-century offspring. And "the roots of slavery" that Orlandersmith mentions in the above statement manifest in the treatment of blacks toward other blacks, in the absence of whites. Much of the narrative unfolds in and between the poor towns of Russelville, home of Alma and populated by working-class and sharecropping dark-skinned blacks, and St. Stephen where Eugene's family lives, a middle-class community of lighter-skinned blacks.

Studies of Hurston's play emphasize the significance that she placed on having the play produced so that the audience sees the color-gender positioning of the characters, similar to Hughes's concern with *Mulatto*. In other words, part of the power of the play is its visualization of racial-gender hierarchies through the phenotypic features of the performers and the audience's ability to assign value and meaning to these characteristics. As David Krasner writes, "The visual presence of Emma becomes a performative strategy, creating a potential for receptivity that must be considered together with the written text."[45] In *Yellowman*, the phenotype of the performers and the audiences' ability to access the conceptual map of colorism are both equally important. Alma, a poor black girl, is raised by a broken single mother who constantly relives her own trauma of being abandoned by Alma's father because she is big and black, adjectives repeated throughout the play. In the character notes, Alma is described as "[l]arge-size but in proportion, medium-brown complexion, strong-featured." Eugene is a

light-skinned, middle-class male who experiences the pain of rejection from his father and other dark-skinned men. He is feminized because of his pale skin and class status. His character description is "[t]all, lithe-bodied, almost feminine-featured. Extremely light-skinned man" (5). In the notes, we see a normative association of darkness with masculinity, brute strength, and rage and lightness with refinement, femininity, and attractiveness. At the same time, we see how these colorist features have different consequences based on the character's sex. But Orlandersmith reverses the gender roles by associating Alma and her mother with masculine characteristics and feminizing Eugene in relation to his "jet black" father.

Rooted Bodies: The Dark-Skinned Black Woman and the Rural South

In analyzing Toni Morrison's *Paradise*, Candice Jenkins looks at how colorist ideology and the myth of racial purity, while seemingly contradictory, work to produce a narrative of heredity, custom, and social containment. Ruby is a town formed by dark-skinned blacks who were rejected from living in a neighboring town—Fairly—populated by fair-skinned blacks. Those rejected, known as "8-rocks," built their town around a "blood rule" of racial purity which disallows any white or part-white genes from entering the community. Jenkins writes:

> "Taking in a bit of the other" is no small thing when that Other is whiteness, historically a source of aversion and dread for the black subject, as the 8-rocks' fear-driven avoidance of the world "Out There" makes clear. Even "being what [you, yourself] are" can present an ideological challenge, particularly in the case of the unacknowledged multiraciality of the "black" body. Such acknowledgement will always be difficult for those who have been obsessed with the idea of racial purity—and as *Paradise* reveals, white Americans hold no monopoly on such an obsession.[46]

Jenkins analyzes how the citizens of Ruby root the town's lineage in a reconstituted history that "begins and ends with American slavery" but one that avoids miscegenation. Theorizing what she calls the "vulnerability of blackness," Jenkins concludes, "the very terror of "blackness"—the fact that it always already contains, is inhabited by, the Other—is also the thing that forces us perpetually to seek and reseek it, to write and rewrite its limits."[47] Without distorting Jenkins's point, I want to substitute colorism for blackness to further my analysis of the operations of colorism in the writings of

Hurston and Orlandersmith. In other words, I wish to argue that colorism continues to perform and deny its very own definition, that of impurity.

As a literary and cinematic trope, the dark-skinned black woman is often burdened with the dual role of being the most despised subject of colorism and its most vociferous enforcer. The figuration symbolizes that which is *not* white femininity in the most absolute terms. In this framing her blackness and subjugation are solidified in the field of vision. Phenotypically, she is depicted at times not only as the counterpoint to white womanhood but also as masculinized.[48] Psychically, her subjectivity is aligned with negation. As a subject/object of study in contemporary scholarship, she does not offer the "transgressive" potential of the mulatta to cross racial hierarchies and destabilize ideologies and practices of race. Instead, as a trope, her inescapable blackness and rooted figure represent passé essentialist frameworks of understanding race and ethnicity. She is overdetermined as an overdetermined subject. In dominant culture, she is black matter—a subject bound by her corporeality like no other. The trope casts her as the done upon, and yet, she performs in ways that reproduce and intensify her subjugation. She, the bitter, self-hating dark-skinned black woman, is correlative to the literary trope of the mulatta in colorist narratives. Her envy of the desirable mulatta is equal to her hatred of self. As prescribed by this trope, the dark-skinned black woman is exploited, neglected, and despised. And yet, in this colorist racial system, she cannot be abused because she embodies self-hatred and degradation. Her wounds are necessarily self-inflicted.

In analyzing the detective fiction of Barbara Neely, Doris Witt raises critical questions about the base position of the dark black female body as representational trope in literature and culture. Writing against the trope, Witt reads productive possibilities in this corporeal and discursive subject and sees the figure as one who passes through certain settings because of her overdetermined subject position. Witt, in analyzing Barbara Neely's heroine Blanche White, a savvy domestic in North Carolina, argues that the excess of the dark black woman allows her to be both invisible and visible in both normative white culture and black communities. Blanche employs her visual markings as a large black woman to her advantage in her undercover work as a detective who goes unmarked as such because of her obvious phenotypic markings as a domestic servant. She recognizes that these overdetermined visual markings in fact lead to her ability to go undetected in certain realms, which contributes to her sleuthing capacities. Appropriating Peggy Phelan's work on the politics of visibility, Witt writes: "Human visual perception . . . is no more natural than the framing done by

a film director; in the process of constructing a visible world, we construct an invisible world as well."[49] Witt's analysis of the simultaneity of the dark black woman's excessive visibility and social invisibility is useful here. These psychic and discursive trappings frame the characters of Hurston's Emma and Orlandersmith's Alma and Alma's mother, as well as a long history of dark-skinned black women in literary and visual studies.

The dark black woman, because of the inescapability of her body as excess in the visual sphere, is ironically rendered invisible as a subject, and yet hypervisible as abject. Karen Shimakawa defines *abjection* as a process that attempts "to circumscribe and radically differentiate something that, although deemed repulsively *other* is, paradoxically, at some fundamental level, an undifferentiable part of the whole."[50] Shimakawa's theory relies heavily on Julia Kristeva's classic text *Powers of Horror: An Essay on Abjection* in which Kristeva conceives of the abject as:

> the jettisoned object [that] is radically excluded and draws me toward the place where meaning collapses. . . . [I]t is a brutish suffering that "I" puts up with, sublime and devastated. . . . Not me. Not that. But not nothing, either. A "something" that I do not recognize as thing. A weight of meaninglessness, about which there is nothing insignificant, and which crushes me. On the edge of non-existence and hallucination, of a reality that, if I acknowledge it, annihilates me. There, abject and abjection are my safeguards. The primers of my culture.[51]

Considering the abject in terms of the social body, Judith Butler writes that it demarcates "those 'unlivable' and 'uninhabitable' zones of social life which are nevertheless densely populated by those who do not enjoy the status of the subject, but whose living under the sign of the 'unlivable' is required to circumscribe the domain of the subject."[52] Shimakawa extends Kristeva's and Butler's writings on abjection by engaging with theories of race and ethnicity and performance studies. In her analysis of the Asian American body in performance, Shimakawa takes particular interest in Kristeva's understanding of the body as the site where abjection is experienced and the corpse as "the utmost of abjection." For Shimakawa the corpse is particularly evocative given the primacy placed on the body in performance. Furthermore, the abjection of the corpse as waste and decay is insightful in analyzing racialized subjects in relationship to the national body as Shimakawa does in her readings of Asian American theatre and performance.

Shimakawa's reading of the Asian American body—as a racialized body—as threat to the national body, what she terms "national abjection,"

can be applied to an analysis of the dark female body in Hurston's and Orlandersmith's plays.[53] As Shimakawa and Asian American theorists have noted, Asian Americans are constructed as foreign or alien to the national body.[54] Abjection is the context of Asian American studies scholarship provides a theoretical framework for understanding Asian-identified bodies as perpetually foreign. In relation to black cultural theory, abjection is through an understanding of the black subject of dominant discourse as familiar and domestic to the body politic, but also as aberrant.

Color Struck's Emma is a formative representation of the figure of the dark-skinned black woman who is psychically and socially bound by the South. Emma cannot escape the markings of her dark body and this inescapability is also connected to her location in the South. Hurston constructs Emma as one who suffers alone because of this system but who also is one of the system's necessary and most outspoken proponents. As victim and enforcer, she is a production of the repressive powers of the South—actualized through the color caste system, as well as more brutal forms including lynching, as Farah Jasmine Griffith examines in her study of "the African-American migration narrative." Griffin theorizes:

> Most migration narratives offer a catalyst for leaving the South. Although there are different reasons for migrating, in all cases the South is portrayed as an immediate, identifiable, and oppressive power. Southern power is exercised by people known to its victims—bosses, landlords, sheriffs, and, in the case of black women, even family members. . . . In fictional texts especially, Southern power is inflicted on black bodies in the form of lynching, beating, and rape.[55]

Emma is deeply invested in maintaining the racial and gender hierarchy that positions her as bitter and long-suffering, whose desires must remain frustrated and unrealized. Described as a "social problem" play, the light humor and banter turn tragic when Emma forces her lover, John, to abandon her because of the paralytic trauma of color/gender structuring (33). Emma and John, who are known as the best cakewalk dancers in the area, are positioned to defend their title. As they are called onto the dance floor, Emma freezes in part because of the couple's earlier arguments about her suspicion of John's interest in the light-skinned Effie. As John enters the dance hall without her, Emma laments:

> (Calmly bitter) He went and left me. . . . Ah, mah God! He's in there with her—Oh, them half whites, they gets everything, they gets everything

everybody wants! The men, the jobs—everything! The whole world is got a sign on it. Wanted: Light colored. Us blacks was made for cobble stones. (She muffles a cry and sinks limp upon the seat.) (43–44)

Emma articulates clearly the ways in which the color caste system marks light-skinned femininity as sexually desirable and the light-skinned woman as sexually loose. While dealing with color envy and racialized self-hatred, Emma imagines and thus renders herself as undeserving of anything other than the weighted and miserable toll that this position eventually takes on her.

By showing how black men had more access to mobility during the early twentieth century, Hurston renders visible the left behind and the forgotten: the dark, root(ed) black female subject. Emma is one who remains in the historical past as others become part of a new era of modernizing blackness that renders the South as the locus of racial subjugation and oppression. As audience, we are asked to mourn with Emma for being left behind, unable to experience possibility. Griffin explains how black cultural production of this era, such as blues music and folklore, documents the impact of the mass exodus of black southerners, especially men, as they moved northward for economic and social opportunities. Griffin writes,

> The vast majority of blues music lyrics tell of migrant men leaving their women, or women who are trying to escape the "blues." The overall pathos of the blues haunts the atmosphere and this is the reason for leaving. "The blues" encompasses the psychological state of someone who is exploited, abused, dominated, and dispossessed.[56]

Hurston locates in Emma a transitional moment in black culture from south to north; she pays homage to single, poor, dark-skinned women like Emma who were left behind as others, particularly men, migrated to northern urban centers.

At the end of *Color Struck*, Emma is left alone to suffer because of her inability to see—an inability to see the self as a subject of possibility. In the final scene, when John returns twenty years later for Emma, he finds her living with a sickly daughter who is described as "a very white girl" (35). It is not clear from the play if Emma is nurturing her daughter to wellness or maintaining her illness and dependency. John is alarmed by the child's condition and urges Emma to seek a doctor. After several cries from John to get medical assistance, Emma leaves to fetch the doctor. When she returns, she finds John standing over her daughter's sick bed. Emma erupts with rage. Based on her visual and psychic perception, Emma can see nothing

but his desire for light-skinned women. She accuses John again of being obsessed with "half white skin" (49) and threatens to kill him. John responds in anguish and disavowal: "So this is the woman I've been wearing over my heart like a rose for twenty years! She so despises her own skin that she can't believe any one could love it!" (50). Emma's vision of a dark-skinned man's longing for lightness drives this moment and leads to John fleeing in confusion and anger. Emma's last line is "Couldn't see."[57] What exactly Emma cannot see is left unanswered by Hurston. Her fate is sealed in her own colorist preoccupations and internalized hatred of her own corporeality. Emma's last line may refer to her fixation on lightness and a viewing position that only allows her to see John seeing light skin as desirable. Or perhaps Emma cannot see herself outside of a colorist and gendered system of the South where she is left with the offspring of a (presumably white) man who has abandoned her and her light-skinned, ill daughter.

Similarly, the failure of vision in a colorist southern community preoccupies *Yellowman*. While the title of Orlandersmith's play centers the black man's experience of colorism, the work delves deeply into the trauma and subjugation of black women in a colorist system.[58] Toward the beginning of *Yellowman*, Alma delivers a sorrowful monologue about how color and gender hierarchies impacted the lives of the women in her family across generations. Alma describes the brutal sharecropping system of early twentieth-century rural South Carolina where black men and women worked side by side under insufferable conditions. Under this system, Alma laments that dark-skinned black women were not allowed access to the codes of femininity, given that manual and reproductive labor were their most important functions. Mourning the *denigrated* position of her dark female ancestors, Alma refers to their bowed heads and large bodies as suffering objects of a hateful and spiteful gaze.[59] While she acknowledges the men who suffered under some of the same conditions and who were targets of white terror, she distinguishes black sharecropping men by their brute power over their female counterparts. Much of the suffering that the women endure in Alma's narration is at the hands of these suffering black men.

The women in Alma's family talk of the intense sun that created illusions; Alma recalls them saying, "da sun can make you see tings dat ain't dere" (7). Vision is a troubling sense for all within the play and its primary focal point is shades of blackness. In his review Ben Brantley writes, "Characters in this intricate narrative are sometimes described as looking through and past those in front of them, but it's not before they've registered, with categorical precision, the tones of the others' skin."[60] Orlandersmith depicts a southern black community whose primary focus is skin color and the

meanings associated with color as it correlates with the subject's gendered position. Most of the dialogue and almost every monologue is a reflection on color hierarchies among blacks. We are made aware of the fallacy of seeing and being seen through Alma's monologues. Most significantly, Alma struggles with vision, and this results in her inability to project the self as subject.

Because of the darkness and gender of their bodies, the women of Alma's memory were denied access to vision and light, meaning the ability to look out beyond their immediate circumstances, to meet the gaze of another, or to dream about possibility outside of this totalizing system. Their ocular impotence—that is, their inability to return the gaze—is a result of structuring principles that deny them vision while positioning their bodies as excessively visible objects and invisible (perhaps impossible) subjects. Alma is aware that vision is not only connected to systems of terror—such as the Jim Crow South—but also to one's ability to experience love, namely the recognition of another. Alma tells the audience: "There was no love for them on this plane / earthly plane so they praised and prayed in their Gullah Geechie / voices for a space—no matter how meager in heaven. In heaven they would be seen / loved / not big / ugly / and black in heaven / in heaven they'd be thin / light and beautiful" (8). This elegiac monologue tethers their restricted subject position to their abject corporeality. We learn of the economy of color that assigns low value to the bodies of Alma and her ancestors and that necessitates these women's rehearsal of their devalued position (here, through their prayers for a heavenly reconstitution with valued attributes of lightness, thinness, idealized beauty). Returning to Barrett's writing on value, the author argues:

> Value is a twofold action or structure, a presentation and representation, a performance riddled by the dialectic nature of its coming into being and, more than merely dialectic, categorically disjunctive in its binarism. In its latter and most visible form, value is a representation of an "object(ive)" design; however, as a result of its dialectic nature, value in this latter, objectified appearance is inexorably discovered as revising promiscuous interest in an under-privileged and displaced Other. Always inherent in value is the trace of an original, violent expenditure. Value is violence and, more to the point, value is violence disguised or dis-figured.[61]

Alma struggles throughout the play to be seen as other than this *disfiguration* and legacy. In her attempt to break out of the colorist prism, Alma seeks out other possibilities for the self. However, as the play unfolds, we

learn that her concept of vision, or her ability to come into a recognition of self, is defined by a troubling geographic and discursive spatiality that pathologizes the South as a site where blacks are the perpetrators and victims of a system of colorism divorced from whites.

Similar to Emma, Orlandersmith's Alma is weighted down by the colorist ideology and practices of her southern community. Yet, what is significant about Alma, and what makes Orlandersmith's rewriting of the dark black woman so important, is her ability to dream. Even though she is burdened by her corporeality, she imagines the possibility of seeing and being seen. This eventually leads to her migration to the North, a possibility not afforded Emma in the sociohistorical context of *Color Struck*. Orlandersmith's Alma yearns for another relationship to the visual field of her rural southern environs, one that moves her beyond the fixity of her large dark body. Yet, what remains unresolved in Alma's visions for her future is the significance of the South as the site of black woman's suffering. Thus, Hurston's and Orlandersmith's visions of the South coalesce as geographic and psychic space where black women cannot escape an optical paradigm in which they are despised and necessary and which makes vision inaccessible to them. The workings of vision and the different historical context lead Orlandersmith's Alma to a different conception of self than Hurston's Emma. Alma refashions subjectivity through transforming her spatial relations and cultivating a new look and a different mode of embodiment contingent on these spatial relations.

Traumatic Visions

In thinking about the dark-skinned black woman as a cultural trope, I want to gender a crucial question that Fanon posed in his work on race and psychoanalysis: How does the darkly coded black female subject come to see herself as abject being? And how is dominant vision structured in such a way that reinforces her abjection? Cultural theorists David Marriott and Maurice Wallace have queried this psychic problem in terms of the relationship of the black man to visuality. Their writings, along with the analytic tools offered in feminist visual theory, offer insight into conceptualizing blackness, female subjectivity, and vision in regards to the psychic awareness of Alma. Feminist cultural theorists have long articulated how normative vision is structured as male and white.[62] The social construction of vision, which is naturalized as a primordial tool of human perception and thus differentiation, is foundational in devising how blackness as epidermal schema, as phenomenological experience, and as a psychic wound on the black woman's

body comes into being. I will address these questions by focusing first on how vision functions as a device for Alma's self-recognition as abject, and later on her understanding of self as subject of possibility.

Fanon's theory of racial recognition as a process of projection and internalization works to explicate the codes and meaning of the black female subject in the visual field, a subject position bound by polarities of hypervisibility/invisibility. For Fanon the process of recognition of the black subject as black is multifarious, with hailing and visualization being two of the most powerful inscriptive mechanisms. In part the black subject comes to know herself by being identified and called out as such and by the repetition and circulation of cultural narratives, most important here visual narratives, that restate and reconstitute the subject's blackness and the cultural meaning associated with this denigrated position.[63] For example, Fanon analyzes the power of cinema to visualize social (and unconscious) fantasies of blackness—the imago of blackness. Marriott offers a sophisticated analysis of Fanon's understanding of the black imago in his study *On Black Men*: "the black spectator is reflected back to himself as, or by, the black imago passing between audience and screen—an imago which, by capturing his image *automatically*, virtually petrifies the black man forced to see himself in it."[64] Building from Marriott's analysis of how the imago of blackness shapes psychic experience, it is crucial to attend to the distinct processes by which the black female subject is demarcated by her racialized and gendered aberration in the context of normalized visual systems. Black feminist scholars have long established how black women's experience is a particular form of racialized sexuality in which her body functions as a site of sexual denigration, eroticized perversity, labor, and reproductive exploitation. The recovery projects of many black female scholars and artists convey the myriad ways normative visual systems frame, surveil, and dissect the black female body.[65] Black artists and cultural producers have mounted ways of redressing the terror of visuality in relationship to black women's positioning in the United States.

In the context of the stage, Timothy Murray writes that the scopic power of visual technologies to capture, contain, and project black female corporeality through a normative lens is a common theme in works by black women playwrights.[66] Through the mediums of theater and the performative body, these artists reveal the application of imaging technologies to render the black female subject in the dominant visual field as black woman. In many of their plays, the workings of visuality to code racialized and sexualized denigration are structured through the exchanges between black male and black female characters in which intimacy and terror are co-mingled. The

complex interplay between the looks of subjugated beings gets rehearsed and reworked in black theatrical productions, social discourse, intellectual debates, and other forms of black cultural production. In a dialectic of denigrated subject to denigrated subject, the black man is aligned with the dominant gaze as often the perpetrator of black woman's suffering. For example, early in *Yellowman*, Alma mourns the plight of her mother and women like her:

> Here on earth the men beat them/leave them/they ride them/they don't make love to them/they ride them/the men/always on top/like my father/they rode on top/they rode/they entered/they shot their seed/then left them. (8).

Looking at plays by Ntozake Shange and Adrienne Kennedy, Murray writes: "the fixating camera and the desirous male gaze come together in a performance of masculine entrapment as deeply oppressive as is the racism from which the characters all hope to escape." Yet, these cultural producers map out the potential of black women to sever the psychic and material relationship that tethers their suffering to black male suffering under whiteness. Murray writes that these plays evoke hope and possibility of "a liberating black image."[67] The question is whether a liberating image is possible and can be extricated from this visual regime. For Alma, the possibility of cultivating an image of self apart from structural violence is not without loss. She must enact a symbolic violence that severs a newly cultivated self from the burden of location, the weight of history, and the memories that traumatize her.

Yellowman, as a dramatic meditation on memory and trauma, locates Alma's trauma in her childhood memories of her mother's dark body. Alma identifies the source of much of her suffering in her mother Odelia's inability to accept her own dark skin and Odelia's struggles with gendered subjugation by the men in her life. Odelia is also unforgiving of Alma's large body and brown skin, which become a mirror that reflects the mother's own psychic monstrosity back onto the self, intensifying her resentment and subjugation. Alma and Odelia are locked in a mutual gaze of recognizing the self and other as undesired beings. Both mother and daughter experience self and other through abjection. Kristeva writes:

> The abjection of self would be the culminating form of that experience of the subject to which it is revealed that all its objects are based merely on the inaugural *loss* that laid the foundations of its own being. There is nothing like

Figure 2.2. Dael Orlandersmith in *Yellowman*, 2002. © Joan Marcus. Photo courtesy of Manhattan Theatre Club.

the abjection of self to show that all abjection is in fact recognition of the *want* on which any being, meaning, language, or desire is founded.[68]

Alma despises Odelia for her desperate desire to be loved and recognized by men. Even as Odelia's need repels her, Alma cannot separate her own desire and subject position from her mother's psychic loss, which is her own psychic loss. Alma recounts in vivid detail how her mother got down on all fours as she begged for Alma's light-skinned father to stay with them. In this scene of unrecoverable traumatic wound—both mother and daughter's psychic moment of recognition as abject—Alma performs the observing daughter, the suffering mother Odelia, and the abusive father John, who is described by Odelia as having "purty yella skin." Alma narrates:

> (ALMA) He looks at me again and walks off the porch into the yard onto the mini dirt road and then onto the tar road. Odelia runs after him (ODELIA) "Don lef' me—Alma, Alma, she yo baby—" (ALMA) She's running after him with her short nappy hair sticking up, her large, loose, defeated breasts swinging side to side. This tall, big, dark woman close to six feet tall. She grabs me under one arm, runs off the porch, into the yard and onto the dirt road and then hits the tar road. Her thick, bare feet hit the tar road. The soles of her bare feet are beating against the tar road—the hot tar road. (ODELIA) "DON'T GO!" (ALMA) She drops me—drops me like a sack of potatoes or corn. She reaches him and drops to her knees (ODELIA) "Please John"— (ALMA) Grabs him around the ankles (ODELIA) "Please John!" (ALMA) He grabs her by her nappy hair and yanks her head back (JOHN) "Bitch I ain't ga neva love you." (ALMA) He walks down the road. I go over to her and she pushes me away. I say "Come on—let's go back!" She pushes me away panting. She lay on the hot tar road panting—panting like a dog. (20)

In this scene of revelation, Odelia is rejected by the father of her child and by her child who both mark her as "bitch," "panting like a dog." Alma too is rejected by her father who denies her and Odelia who pushes her away. Alma experiences her body as well as her mother's matter (i.e., *mater*) as excessive, describing Odelia's "defeated breasts" and how she is a "tall, big, dark woman close to six feet tall."[69] Alma codes Odelia as abject—despised and weighty thing in a field of vision where she has too much body and absorbs too much light to be desirable. Unable to escape the terrorizing colorist gaze in which even her daughter, who is her likeness, experiences the repulsion of her corporeality ("short nappy hair" "thick, bare feet"),

Odelia can only submit to her subjugation as she "lay on the hot tar road panting—[once again] panting like a dog."

Alma cannot come to grips with the psychic toll of being born out of the wound of dark matter—what she describes in raw, animalistic terms and repeats: the panting bitch who is left dejected. The daughter internalizes the dominant gaze that sees her mother as such and struggles not to become the excessive being that is her mother: "I look at her—Odelia's body. I look at her body and see what my body will become. I look at her and see that it will become thick and wide" (34). Throughout the play, we are led to understand Alma's vision problem as a result of her mother's self-hatred and hatred of Alma for looking similar to her. In one scene, Alma recalls Odelia giving her roots to lighten her after their abandonment by John. Alma takes on the voice of her mother as she relives her desperation, "(ODELIA) 'I ga get a root to make ya lighter. I ga put it in yo food—an EAT IT—YA BETTA EAT IT!" (21). Alma imagines Odelia as psychotic because of her obsession with color and refusal to have a daughter who mirrors her trauma. Yet Alma cannot escape this psychosis: she develops a similar understanding of her body, gender, and color—one that is scaled on the black female imago.

The black female imago that haunts Alma's vision projects negation instead of the aestheticized ideals associated with projection and fantasy. Alma sees herself through others' eyes (as well as her own and her mother's eyes) as monstrous.[70] For the dark-skinned black female subject, negation and projection work together in the formation of self-recognition. With regard to this denigrated figure, projection takes places in the form of the monstrous, immovable thing whose sheer horror, as Kristeva writes, "draws me toward the place where meaning collapses"—the abject. Projection, for Alma, is complicated by how her view of Odelia informs her own view of the self and by how both are seen by others. Kristeva articulates this mutual recognition: "I experience abjection only if an Other has settled in place and stead of what will be 'me.' Not at all an other with whom I identify and incorporate, but an Other who precedes and possesses me, and through such possession causes me to be."[71] Alma comes into a sense of the self through this possession and struggles to displace abjection by locating it onto her mother's body.

Because of the black female imago that projects negation and gets rehearsed through others' vision of her, Alma engages in an intimate relationship of substitution and identification with the symbolic monstrous dark whole—the encompassing dark other. In considering abjection and the body of the racialized female, Francette Pacteau writes: "abjection is

in the impossibility of maintaining clear boundaries between inside and outside, clean and unclean, proper and improper—lines of demarcation that are constitutive of, and constituted by, the Symbolic order."[72] This is revealed in the sex scene between Alma and Eugene when he comes to visit her in New York. Eugene, who has always expressed desire for her, can articulate Alma's body in an idealized fashion not afforded them in the South. As he repeats how beautiful she is to him, Alma silently recites the insults that her mother has hurled at her over the years. The projection of self as denigrated other makes it impossible for her to be a desiring subject. After Eugene undresses her, Alma worries to herself, "How do I look against these sheets—how fat, black, and ugly do I look against these sheets? I tighten myself—I will make myself tight against these sheets" (55). Alma struggles with the immovability of her corporeality as lowly black matter. As Eugene moves slowly and carefully on top of her, Alma tells the audience, "I'm being ripped apart—I'm bleeding—I'm being ripped apart for being a 'fat black ugly' thing—I will not glide—I will not melt—I will not pant—(*Beat*) I want to glide into this/I want to melt into this—" (56). In this scene, Alma suffers from her own self-policing eye. She can only imagine Eugene's sexual advances through a framework of rape and denigration—the history and psychic terror at root of the color caste system in which a white or light-skinned man engages in sex with the dark woman through violence. Fighting against the symbolic always readiness of black female sexuality, Alma tightens herself. She visualizes her dark and large body against the sheets. Her efforts lead to a denial of desire and pleasure for self. As she puts it, she is undeserving and can only be "ripped apart." This exchange makes us aware that colorism is about social containment, but it is also a self-policing ideology that makes the subject paranoid and one who constantly monitors her relationship to its stigma.

Eugene is also self-policing and is paralyzed by the weight of black male brutality as structured through colorism. He is estranged from his maternal grandfather because of his mother's decision to marry a dark-skinned black man. When Eugene finally meets his light-skinned grandfather after whom he is named, his grandfather warns him, "The white man hates us/dark-skinned niggers hate us. . . . It's not the crackers you have to worry about—it's them darkassed Geechies. I hope you don't let them push you around" (35). His grandfather then tells Eugene how he earned respect in their community by fighting a dark-skinned man in the lumber yard where he worked. Eugene's grandfather can only achieve subjecthood in this system by understanding the dark-skinned black man as his inferior who must be beaten into submission.

This test is particularly important given the brute power and physicality associated with dark masculinity through colorist ideology. Again, vision resurfaces as an unattainable, yet dominant sense, in the character's world:

> We were fighting in the yard. The white foreman looked down at us laughing—laughing at the dark and light niggers going at it. (*Pause*) I guess we gave him one helluva show. (*Pause*) I threw some sawdust in his eyes and he fell to the ground moaning, screaming holding his eyes, "I can't see, I can't see." (*Pause*) I blinded him—Oh yeah, he went blind. (*Beat*) None of the darker men messed with me after that—none—but the hate was in their eyes. (37)

In this battle to secure masculine superiority relative to colorism, the white foreman does not engage even as his presence orchestrates the struggle. The grandfather's denunciation of the association between light skin and femininity can only be accomplished through the subjugation of his dark-skinned taunter. He wins the fight by literally denying his opponent vision, or the primary tool for marking social meaning and value within colorist discourse.

When his grandfather directs his hatred at Eugene's father, Eugene responds violently: "'Don't you call my father a black bastard!' (*Pause*) He looks at me giving me a look I recognize as my own. I walk out. I walk out recognizing the look as my own. I walk out shaking, afraid—realizing how I could hurt someone. I recognized the hate in his eyes and saw my own. I saw my own hate" (37). As we watch this fight unfold on stage, we are watching the light-skinned performer who plays Eugene also perform through memory and recollection his grandfather and his hated father. Eugene struggles with the black male imago and his positioning as someone with relative power because of his fair skin. While in a colorist system he can align himself with the idealized ego, because of his passion for Alma he must also recognize negation. Yet he understands his subject position as one who is destined to achieve selfhood through the negation of the dark-skinned black man—his father whose image he does not reflect.

When vision is clear in *Yellowman*, it is a profound look of hatred, as Eugene accepts after his meeting with his grandfather. It is a recognition of self as despised through another's eyes. It is the struggle to expel the abject from the self. The characters in *Yellowman* open their eyes fully through experiences of alienation and violence. During a pivotal scene near the play's end, the clarity of vision that Eugene experiences arises through a realization of his hatred for his father. Looking into his father's eyes brings Eugene face-to-face with his "pure unadulterated hatred" (11). Eugene comes into recogni-

tion of this intense emotion as a child. He foreshadows how this moment of clarity—seeing through his father—will lead eventually to violence:

> I looked up at Daddy's face/his dark, dark face/his mysterious, handsome face and he looked at my light face—my eyes were very open—very wide and within that moment the night before us became very thick between us. My light face looked up at his dark one and he winced—actually winced because as small as I was and as terrified as I was, I also hated him and we both knew within that moment, in a weird way, my hatred was stronger than his 6'4" frame and within that moment his physical stature meant nothing at all. (10–11)

This foreshadowing aligns Eugene with his grandfather in his hatred of dark-skinned black men. It makes futile Eugene's later rejection of his grandfather whose likeness he holds. This exchange of looks between Eugene and his father is symbolic. The next time, years later, when he and his father look at each other, Eugene kills his father during a fight over family inheritance—a struggle between men over property and entitlement. This struggle which leads to patricide recalls the patricide enacted by Hughes's Robert in *Mulatto* in which Robert kills his white father for denying his paternal responsibility.

In the final scene of the play, Eugene, imprisoned, is left alone with nothing but images. He recalls a moment from the past, his idealized image of Alma as the embodiment of sexualized desire. He remembers Alma one summer in a lilac dress: "I said, 'Alma you look soo good in that dress/you really do/you look good/why'd you have to look so good?'" (69). In this context, it is seeing that puts one in danger. His desire for the abject body of Alma has led to his crisis: at once a denial of his birthright as a light-skinned, middle-class black man and patricide. Orlandersmith has stated that while the play is about colorism, it is also about trauma and legacy. She writes, "There is a theme throughout the work that I write, about childhood and the sins of the father, the sins of the mother, and how people take on the very thing they don't like about their parents and they become them."[73]

While at the play's end, Alma acknowledges, "I am Odelia's daughter. Listen to my voice/watch me walk" (69); she is also stuck with the memory of a miscarriage that she self-induced because "I could not risk having a child—ugly like me—I could not risk being left to dog pant" (68). Alma's act of aborting the fetus is also a symbolic suicide and matricide. It is a refusal to bear offspring that might mirror the despised mother and the despised self. In considering the abjection of self, Kristeva writes:

> abjection is elaborated through a failure to recognize its kin; nothing is familiar, not even the shadow of a memory. I imagine a child who has swallowed up his parents too soon, who frightens himself on that account, "all by himself," and, to save himself, rejects and throws up everything that is given to him—all gifts, all objects. . . . What he has swallowed up instead of maternal love is an emptiness, or rather a maternal hatred without a word for the words of the father.[74]

Moreover, Alma must leave South Carolina and the legacy that is destined to her to understand the self as a subject of possibility. After she has left South Carolina and has relocated to New York, she describes this change in her body:

> I never knew how full life could be—it is so full. How expansive everything is outside of South Carolina. I cannot walk that walk anymore—that thick-heeled, crusty, hot, southern dirt road walk—How could I possibly go back to that? I never knew I could enjoy the full-ness of my walk—my hips. I can't wait to show this to Gene. How do you explain a new walk? (50)

Here Alma connects vision to performative possibilities. She no longer understands and performs the self through black female abjection rooted for her in the South. Alma has cultivated a possibility for subjective and sexualized expressiveness in a decontextualized sense, removed from her birth home and the community that raised her.

Unlike Emma of *Color Struck* who at the play's end is trapped in her own color/gender insularity, Alma emerges as a viewing and speaking subject. In New York Alma sees possibilities of rejecting a visual system that marks her skin as excessively colored and her body as excessive matter. Vision for Alma not only is a system of terror but also holds the possibility for expressive embodiment. She performs her corporeality (for example, "the full-ness of my walk—my hips") as "excess flesh," a concept developed in the next chapter to address black women's refutation of the discourse of abjection and negation. Yet for Alma this embodiment is precarious as it is based on her internalization of a colorist system that locates her suffering in a mythic South in which blacks exist to suppress the black other. It is, in the world of *Yellowman*, a totalizing system where one must kill her/his kinship to escape the legacy of black-on-black terror and the visual regime that regulates relations of alienation.

THREE

Excess Flesh: Black Women Performing Hypervisibility

The black female body as excessive body has been a widely explored topic in scholarship, artistic production, and larger cultural debates about representation, race, and gender. In the previous chapter, I examined what happens when the black female subject identifies with the aberrant image of black womanhood offered through dominant visual culture and the ways in which colorism produces a scopic practice of paranoiac self-surveillance in certain dramas by black female playwrights. The question that frames this chapter is what happens when black female artists and cultural producers take up the dominant representation of black women in visual culture and public discourse to construct new modes of operation. The understanding of the black female body as excessive is so much a given in cultural discourse that this conceptual framework has gained an aura of facticity. One might ask what is there to visualize or articulate about the black female body that has not already been represented? About this Francette Pacteau argues that it is "a relation of over-determination, which produces the black woman as 'excessive.'"[1] Further theorizing the abundance of representation of black women as aberrant, Daphne Brooks writes:

> black women's bodies continue to bear the gross insult and burden of spectacular (representational) exploitation in transatlantic culture. Systematically overdetermined and mythically configured, the iconography of the black female body remains the central ur-text of alienation in transatlantic culture.... Yet there are ways to read for the viability of black women making use of their own materiality within narratives in which they are the subjects.[2]

Considering the possibilities black women have to engage with visual practices as a reinscription of their corporeality, I analyze the works of black

Figure 3.1. Renee Cox, *Yo Mama's Last Supper*, 1996. Courtesy of the artist.

women artists, entertainers, and cultural producers whose cultural production is reliant on the very problem that their bodies pose as visible and corporeal bodies. The chapter moves among the realms of "high" art, mass culture, and black popular culture to look at how audience identification and expectations shape the critical reception and affective responses to these works.

Renee Cox's five-panel photograph *Yo Mama's Last Supper* (1996) unleashed an outcry from conservative politicians and policymakers, most notably New York City mayor Rudolph Giuliani, when it was exhibited in *Committed to the Image: Contemporary Black Photographers* at the Brooklyn Museum in 2001. The large photo-panel depicts a revision of the biblical Last Supper shared by Christ and his disciples through a reimagining of Leonardo Da Vinci's fifteenth-century mural painting *The Last Supper*. In Cox's piece, she, a black woman, stands center naked, taking up the position of Christ before he is betrayed and martyred. Her body is fully exposed, as she holds her arms open and apart in a gesture of sacrifice. A white cloth is draped across her arms and behind her back. Cox foregrounds her alienation and nudity with a gaze outward that refuses to meet the gaze of her audience. On both sides of Cox are black and brown male disciples. The disciples conspire against her; their eyes are averted suspiciously; as Cox holds the position of the one to be sacrificed. The men are clothed in robes and headdresses, further heightening her nakedness and sex.

After the show opened, Giuliani began an impassioned campaign against both Cox's work and the Brooklyn Museum. His response pitted artistic practice against notions of social decency and religious tolerance.[3] In this case, *Yo Mama's Last Supper* was condemned by Mayor Giuliani as "anti-Catholic" and "disgusting." His crusade against Cox's work and at-

tempts to create a board to supervise standards of decency in New York City–supported art followed a larger, nationally publicized attack on black British artist Chris Ofili for his work, *The Holy Virgin Mary* (1996), a mixed-media piece that incorporates elephant dung. Ofili's piece, also shown at the Brooklyn Museum, was curated in 1999 as part of an exhibition titled *Sensation*, featuring the art of emerging British artists. In response to Ofili's piece, Giuliani attempted to censor the Brooklyn Museum's selection of artists, but his efforts were ruled unconstitutional in court.[4] The controversies arising from Ofili's and Cox's art have become far too familiar to artists, art administrators, and curators, as right-wing forces directed several attack campaigns against the arts during the last decades of the twentieth century.[5] In both the Ofili and Cox cases, Giuliani's rage was targeted at black artists and their revision of Western religious narratives, precisely because these artists connected religion and its iconography to colonialism and the subjugation of nonwhites.

Unsurprisingly, the controversy and media attention surrounding Cox's *Yo Mama's Last Supper* offered a cultural cachet and visibility that increased the artist's marketability and desirability in the New York art scene. The, controversy produced celebrity-status for the artist. Throughout the ordeal, Cox was outspoken in defense of her work and took on many conservative ideologues in the local media. The growing debate that ensued around her art and Giuliani's actions turned Cox into a media spectacle as black woman and artist provocateur. For example, she participated in a debate about the First Amendment with the then-president of the Catholic League for Religious and Civil Rights.[6] Later that fall, a solo exhibition of Cox's work called *American Family*—a tongue-in-cheek revision of American family visual narratives that included images of the photographer with her

sons whose father is white and also the photographer surrounded by naked, doting men—opened at the Robert Miller Gallery in New York. The work in the show referenced her Jamaican American upbringing, her Catholic school education, and her sexual practices and fantasies. Acknowledging how the exhibit capitalized from the controversy around the artist, Jo Anna Isaak, in the introduction to the catalogue of the show, writes: "With *American Family*—a veritable minefield of taboo topics from the miscegnated family album to the erotic display of her own beautiful body—Cox, the latest artist to be subjected to New York Mayor Rudolph Giuliani's censure for her controversial *Yo Mama's Last* Supper, is likely to raise more than eyebrows."[7] A crowd of hundreds lined up outside of the gallery on the night of its opening, hoping to a get a glimpse of the artist-turned-celebrity and to be part of the scene.

Giuliani's outrage toward the Brooklyn Museum over the *Committed to the Image* show and his attempts to regulate city-sponsored art exhibitions were dismissed by art critics, scholars, and some city officials alike with admonitions that once again Giuliani was attempting to be a "culture cop."[8] Yet Cox's work was also treated with a suspicion by many of her defenders, even as they supported her right to artistic freedom and practices. Some journalists and cultural critics, while bashing Giuliani's response and attempts to regulate the arts, described her work as lacking nuance, "corny," "anti-WAW (White Art World)," and self-indulgent.[9] The issue for many became one of taste, that is, even art of poor taste should be defended based on one's right to free expression. It is quite apparent that Giuliani's and local Catholic leaders' disapproval of Cox's work had very much to do with the centrality of a naked black female figure in it and her attempts to disrupt dominant religious and historical narratives. As Michael Eric Dyson framed the issue in an op-ed piece: "Could it be that the outrage caused by Cox's art is linked to the fact that a black woman dared imagine God looking like her: ebony-skinned, dreadlocked and naked before the world?"[10] Giuliani's response was quite reactionary and in many ways uncomplicated, driven by his purported standards of morality, racial biases (such as the stop-and-frisk policy of the New York Police Department under his mayorship), and political showmanship. The response from many art critics and proponents of freedom of expression, who distanced themselves from both Giuliani and Cox, is more troubling in the ambivalence and disregard that they expressed toward the photographer's work. They too expressed hesitance, and occasional revulsion, at the sight of a naked black female body placed at the center of artistic debates and visual narratives. The intermingling of sensationalism,

reactionary moralism, and intellectual or journalistic ambivalence toward representations of the black female body extends beyond the realm of art to public culture in general and even to black cultural criticism.

One of the primary issues at stake in Renee Cox's art and embedded in the various reactions to *Yo Mama's Last Supper* is the problem of the visible black female body or, more precisely, that the black female body always presents a problem within a field of vision structured by racialized and gendered markings. The troubling presence of the black female body, especially the unclothed body, frames this study. As Cox's *Yo Mama's Last Supper* reveals by what spills over and out of its reception, the black female body functions as the site of excess in dominant visual culture and the public sphere at large. The explicit black female body is an excessive body (from the Hottentot Venus to Josephine Baker to Millie Jackson, Pam Grier, and Serena Williams in her cat suit). The public responses to Cox's work, as well as other late-twentieth/early-twenty-first century controversies over black women's bodies and body parts, demonstrate the continued currency and relevance of the black female figure as one that registers as excessive in public culture.

Given this discursive and symbolic structuring of black female corporeality, my project is to theorize the strategic uses of the body by black female artists and cultural figures. To this end, I aim to develop a theory of "excess flesh" to articulate the visual and discursive breaches that these enactments make in dominant visual culture, an important site of engagement with the public sphere. I analyze the art and cultural practices of certain black women, whose works investigate the relationship between visuality and notions of a performing black female subject. My purpose here is to move away from an analysis of how dominant visual culture represents black women to a focus on black female cultural producers' engagement with the imago of black female excessiveness and their critique of the racializing and gendering apparatuses of the visual field. I examine visual and performance works deemed high art, such as the photography of Renee Cox and Ayanah Moor and the conceptual art of Tracey Rose, as well as the cultural work of black women in mass art and black popular culture, namely Janet Jackson and Lil' Kim. I choose these different sectors of cultural production to examine how they inform the reception of black female embodiment as excess flesh. As demonstrated in the controversy over Renee Cox, the framing of a work as art—even when considered offensive—lends a certain privilege and autonomy not afforded cultural production in mass entertainment culture. At the same time, mass entertainment and popular culture produce meaning

about blackness and gender through large-scale dissemination and a constant streaming of visual information that deserve investigation.

The chapter proposes the following questions: Can the enactment of excess flesh by black female cultural producers trouble the particularities of being racialized and sexualized as black women in the visual field? Can hypervisibility be a performative strategy that points to the problem of the black female body in the visual field? Can visuality be deployed to redress the excessive black female body? If so, what are the limits of such redeployment?

The conceptual base of excess flesh as a performative strategy is in feminist performance theory, black women's artistic traditions of exploring identity and history, and the long and mired history of documenting difference through visual technologies. Excess flesh borrows from these histories and forms of cultural engagement in acknowledging the performative potential of visuality. Elinor Fuchs and Rebecca Schneider have analyzed the performance art of (primarily white) women performers who use their unclothed bodies as media to uncover gendered norms and dominant social relations. In her much-cited study of "explicit body" performances of women artists, Rebecca Schneider analyzes how feminist performance art that relies on the naked female body exposes the layers of meaning coded in female embodiment:

> Contemporary feminist performance artists present their own bodies beside or relative to the history of reading the body marked female, the body rendered consumptive in representation. In this sense, the contemporary explicit body performer consciously and explicitly stands beside herself in that she grapples overtly with the history of her body's explication, wrestling with the ghosts of that explication.[11]

Borrowing from Schneider and extending her study to consider black women's engagement with performance and visuality, I argue that black women's bodily enactments signify beyond "explicit." The explicit body performances of white female artists and cultural producers are, as Schneider points out, in relationship to norms of idealized white femininity. These norms mimetically posit white women in direct relation to the idealized figuration while black women historically represent negation within this structuring system. Within classic visual narratives and historical discourse, whether rendered asexual in the figure of the mammy, ambivalent or sexually submerged as in the trope of the passing woman, or bestial as in representations of the Jezebel, black women are produced through visual signs as

in excess of idealized white femininity. Through various renderings in visual culture the black female body and the sexual imaginary associated with that body not only set the boundaries around which idealized white femininity is understood and visualized, but as art critic Lorraine O'Grady argues, both the black female and the black male function in dominant representational codes "to cast the difference of white men and white women into sharper relief."[12] In other words, the black woman as excess establishes the boundaries for normative codes of the white female body and femininity.

Through an explication of excess flesh enactments, I zoom in on a productive look offered by black female cultural producers who construct an identification that acknowledges but does not adhere to racialized and sexualized aberrance. A form of what José Estaban Muñoz has theorized as disidentification, the productive look "works within and outside the dominant public sphere simultaneously."[13] It is an enactment of the gaze that does not necessarily attempt to heal or redress the naked, exploited, denigrated black female body tethered to the black imago but understands the function of this figuration in dominant visual culture. This productive look lays bare the symbols and meanings of this weighted figure.

My hope is to turn attention to the psychic realm of excessiveness and to conceptualize black women's engagement with hypervisibility as one that moves beyond frameworks that understand it as a totalizing negation. By *hypervisibility*, I mean to refer to both historic and contemporary conceptualizations of blackness as simultaneously invisible and always visible, as underexposed and always exposed, the nuances of which have been depicted in art, literature, and theory. The concept of hypervisibility has particular resonance in contemporary popular culture and mass entertainment where the black body as commodity fetish has a heightened salience. As commodity theorists have argued, the commodity fetish masks power relations and historical contexts that produce systems of inequality and the consumption of difference. Roderick Ferguson points out that the black body as commodity fetish is the surplus of late capitalism and its shrinking labor needs. Using Marx, Ferguson argues that surplus populations are always rendered available for capital exploitations. Ferguson writes: "Both superfluous and indispensable, surplus populations fulfill *and* exceed the demands of capital."[14] In the contemporary context, the plenitude of black bodies in advertising, entertainment, and dominant visual culture generally speaking occlude material conditions based on power imbalances. Specifically, the marketability and desirability of the black body, particularly the black male body, is premised on its very danger and aberration—its ability to move smoothly

along a scale of international recognition as iconic popular figure to one of millions of black bodies in the prison industrial complex. Ferguson argues that in the very production of surplus populations, transgressive formations emerge:

> As U.S. capital had to constantly look outside local and national boundaries for labor, it often violated ideals of racial homogeneity held by local communities and the United States at large. As it violated those ideals, capital also inspired worries that such violations would lead to the disruption of gender and sexual proprieties. . . . As formations that transgress capitalist political economies, surplus populations become the locations for possible critiques of state and capital.[15]

As black bodies have become a dominant fixture in marketing strategies throughout the 1990s and turn of the twenty-first century, we see emergent idealized bodies in the form of black celebrities, as I will discuss in more detail later in this chapter. The historical laboring black body has been transformed into the aestheticized body of leisure and wealth accumulation.

Excess flesh, then, is another conceptual framework for understanding the black body as a figuration of hypervisibility. Excess flesh is an enactment of visibility that seizes upon the scopic desires to discipline the black female body through a normative gaze that anticipates its rehearsed performance of abjection. The use of excess develops out of the distinction that Hortense Spillers makes between the body and flesh in her classic essay, "Mama's Baby, Papa's Maybe." This point has been elucidated further in Sharon Holland's study *Raising the Dead* in which Holland argues, "Spillers makes a dramatic distinction between *body* and *flesh*, using these terms as metaphors for captive and liberated subject positions, respectively."[16] Excess flesh is not *necessarily* a liberatory enactment. *It is a performative that doubles visibility: to see the codes of visuality operating on the (hyper)visible body that is its object.* Excess flesh does not destabilize the dominant gaze or its system of visibility. Instead, it refracts the gaze back upon itself. To enact excess flesh is to signal historical attempts to regulate black female bodies, to acknowledge black women's resistance of the persistence of visibility, and to challenge debates among black activists and critics about what constitutes positive or productive representation of blackness, by refusing the binary of negative and positive that Michele Wallace warns us against.[17] Such a challenge is not necessarily intertwined with a representational corrective that articulates a "true" or "accurate" framework for seeing the black female body. Yet it does demonstrate the impossibility of a totalizing gaze and highlights the limita-

tions of regulatory systems. Excess flesh enactments, like Renee Cox's *Yo Mama's Last Supper*, suggest that the black female body is always troubling to dominant visual culture and that its troubling presence can work productively to *trouble* the field of vision.

Renee Cox's Self-Portraiture and Play with Iconicity

Because idealized projection and fantasy are associated with whiteness in Western discourse, black portraiture and self-portraiture function quite differently in dominant visual representation and canonical art history. Portraits of black subjects by black artists often serve as counternarratives to cultural and discursive meaning associated with blackness and black bodies. They also become ways of creating critical genealogies and archives that speak to very different audiences, as in the photographic work—especially the studio practice—of Charles "Teenie" Harris, who spent his lifetime documenting black residents in Pittsburgh (see chapter 1). Art historian Richard Powell theorizes black portraiture through what he phrases "cutting a figure," an appropriation of black vernacular expression, that attends to the "aesthetic slippage between expressing a self-representational assuredness and an immodest flagrancy, or between enacting a stylistic transformation and an artistic breakout," characteristics that he notes in many portraits by black artists. Many of these works play with vanity and excess. Powell argues that these portraits often include aesthetic and discursive severing, cutting, and splaying that reconstitute "black bodies from crude commodities and ciphers into fashionable actors performing in displays and expositions of their own making."[18] These artistic processes contribute to a visual self-making and a transformation of the black figure into *flesh*. Powell's conceptualization of "cutting a figure" is akin to what I call the visible seam in much of black cultural practices (see chapter 5). The visible seam is an aesthetic device and a discursive intervention that reveal the gaps and sutures of dominant visual narratives and the underpinning ideologies that maintain them.

In positing herself as the female nude in her photography, Cox comments on the invisibility of the black woman as producer and the vexed imagery of the black female body as subject/object in art traditions. Cox's work also invokes the routine practices of visually documenting the black female body in medical, scientific, and sociological arenas as the embodiment of abnormality and femininity's opposite. Analyzing *Hot En Tott*, another portrait in Cox's *Yo Mama* series (one that references the Venus Hottentot), Hershini Young writes that Cox's photograph

reclaims the black woman's (sexual) subjectivity from the scientific gaze that dissected and reduced it to beast of burden and mechanism of labor. . . . Her gaze does not allow for modesty or shame at her nakedness but instead directly challenges the viewer—look at me, look at my body, and look at the imperial specters that have dictated how I have traditionally been viewed.[19]

Cox, like many black women artists and performers whose works demonstrate an intentionality in the presentation of the black female body, employs theatricality in her highly stylized, color-saturated photography to frame hypervisibility as a racialized construct with gendered implication and particularities. *Yo Mama's Last Supper* is representative of the aestheticized bodies and formal composition of much of Cox's work.

Cousins at Pussy Pond (2001) is another work that shows Cox's engagement with Western historical narratives, the exclusion of artists of color in art historical traditions, and the marginalization and objectification of racialized bodies in Western visual culture. Consisting of a large-scale photograph that was included in the *American Family* show, the piece is a revision of Edouard Manet's *Le Dejeuner sur L'Herbe* (1863). According to Jo Anna Isaak, there is much significance in Cox choosing to reimagine a piece by Manet, given that

> Manet's paintings are frequently subjected to this play of art upon art perhaps because Manet himself began the process of using art to call attention to art by lifting its veil of illusion and openly acknowledging its properties, its prior pilfering, and whether he intended this or not, its ideological underpinnings.[20]

In Cox's photographic remix of Manet's painting, she sits on a blanket with two muscular black men in front of a lake. She is nude while her companions wear loincloths. Cox looks out at the audience as the men holding spears stare at her in delight. Using Jennifer DeVere Brody's readings of artists who reinterpret or queer Manet's *Olympia*, Cox's reinterpretation of Manet can be read as an "act of translation" that unpacks the "visual rhetoric" embedded in his work as exemplar of Western art traditions and cultural discourse.[21] Cox's revelation of such visual rhetoric comes from substituting signs of European-ness with that of African-ness, such as the spears held by the male models and their loincloths.

Cox's photography works at the sites of convergence between performance and visuality as she restages and revisions many iconic pieces in the history of European art. Cox engages with this history through contemporaneity, as her images reveal the influence of mass culture and consumption,

Figure 3.2. Renee Cox, *Cousins at Pussy Pond*, 2001. Courtesy of the artist.

black popular and performance cultures, fashion, advertising, and the sports industry. Cox's earlier work as a fashion photographer influences her artistic practice, particularly in her use of the aestheticized, and typically muscular, body as primary subject for her photographic work, such as Cox's *Baby Back* (2001), in which the photographer stages her body in a fantasy scene of S-M play accentuated by her red pumps and satin whip. *Baby Back* is a revision of Jean-Auguste-Dominique Ingres' *Le Grande Odalisque* (1814) in which a white female nude reclines on a chaise longue. In Ingres' oil painting, the woman is surrounded with orientalist iconography. Her hair is wrapped in a patterned scarf with fringes; the chaise lounge is covered in tapestries, and she holds an ornament with peacock feathers. In Cox's revision, her title is a word play that invokes the consumption of meat, baby back ribs, a popular grilled dish in southern and African American traditions. "Baby back," even more relevantly for this study, invokes black vernacular and popular culture in which black women's buttocks are referred to as "back," such as the popular 1991 rap song "Baby Got Back" by Sir Mix-a-Lot.[22] Cox's invocation of the slang "back" shows the influence of black popular culture and vernacular culture on contemporary art. Mass entertainment and popular

Figure 3.3. Renee Cox, *Baby Back*, 2001. Courtesy of the artist.

cultural forms, especially the rise of hip hop in the last decades of the twentieth century, have resulted in shifting visual aesthetics for many black and non-black cultural producers. Thus, Cox's remixing of canonical art such as the work of Manet is also an announcement of an aesthetic shift for representing race and gender, an aesthetic that is steeped in the visual lexicon of consumer culture and everyday practices.

The iconic and much-discussed rear of the black female also centers Cox's *Black Leather Lace-Up* (2001). In the photograph Cox magnifies her buttocks by photographing her body angled in such a way that makes her behind dwarf the rest of her body. The artist engages with the aesthetics and practice of S-M, wearing a shiny black corset that laces up her back. Her body appears to strain the laces of the corset. Her back is to the camera and her buttocks are only partially exposed but are positioned in such a way that the width of her rear reaches the outer edges of the camera's frame. She leans away from the camera with her head down; we see her arms up to her face. Cox's laced and confined body glistens under the theatrical lighting and is covered in body oil, referencing both pleasure and pain.

Cox's work is a study in the relations between aberrance and idealization. The bodily forms at the center of her images are idealized black muscular bodies with assertive stances, poses, and gazes. Whether she is looking at the camera or away, the look is one of self-possession and the physical presence is an articulation of embodiment. The settings and costumes of Cox's fantasy-scapes are highly orchestrated and ornate. The black bodies in her rendering are akin to iconic bodies of contemporary celebrity and

Figure 3.4. Renee Cox, *Black Leather Lace-Up*, 2001. Courtesy of the artist.

marketing culture. They are hyperactualized in muscular form and posture, and their facial gestures are ironic and knowing, as they play with historical narrative and artistic form. Cox engages with the aesthetics of iconicity by working with the stylistic tools and visual signs of dominant form. Yet, the substitutions and remixings of Western art canon that operates in Cox's art destabilizes the singularity and privilege of the iconic in Western discourse.

Similar to Cox, works by other black female photographers such as Carrie Mae Weems and Carla Williams center the black female body as sites of inquiry into the structuring principles of racialized and gendered markings. These practices reveal the imposition of the Western gaze in framing the black female body as spectacle, aberrant and pathological. Artists like Cox, Weems, and Williams explicitly engage with the long and often brutal history of visually documenting and framing the black female body. Their works comment on the double bind placed on black female subjects in the visual field: that is, their blackness is tied up in the display of a denigrated sexual positioning that is both abject and desirable. She—the iconic and denigrated black female—is the object of pornographic, scientific, and ethnographic looks that continually render her aberrant.

Framing the Black Female Body: From the Image to the Performative

That black women's bodies are rendered excessive is now a truism of sorts in black cultural criticism, gender studies, and one might venture to say American public culture, more broadly. The last few decades have seen numerous scholarly and cultural projects redress dominant representations of black women's bodies. The specter of the "Hottentot Venus"—Saartje Baartman, the much-written-about Khoisan (South African) woman exhibited as a spectacle in nineteenth-century Europe—casts a broad shadow over both cultural production and scholarship on the black female body: representation as excessive and degenerate, as well as the body's commercialization. Many black female artists have used their media and bodies to reflect explicitly on the production and circulation of Baartman as "Hottentot" and the representational significance of her figuration historically.[23] South African conceptual artist Tracey Rose attempts to render a visual depiction of Western fantasies of black female savagery and exoticism that were projected onto the body of Baartman in her performance photograph *Venus Baartman* (2001). In the color photograph meant to resemble a diorama akin to those found in natural history museums, Rose performs the role of black female

Figure 3.5. Tracey Rose, *Venus Baartman*, 2001. Courtesy of the artist and The Project Gallery, New York.

savage—unclothed and untutored—as visualized through Western scopic regimes. *Venus Baartman* depicts the artist in "nature," walking through a field of high grass, crouched over, on the hunt and hunted. The title of the works conflates the historical woman with the commodity spectacle whose body performed as excess while Baartman was alive and in death. Baartman in performing the "Hottentot Venus" constituted the being of excess flesh for audiences of the period, that is, her flesh and body registered excess. Rose's piece performs an enactment of excess flesh as she points directly to historical context and racial and gender coding. *Venus Baartman* also centers the relationship among the visual, the performative, and the audience. In Rose's work, the audience is assumed to be familiar with the historical narrative of Baartman and can therefore interpret irony and reinscription in the contemporary image.

Baartman's international circulation and her historic and contemporary importance to both scholarship and artistic practice necessitate that investigations into the representations and meanings of the black female body function as a diasporic inquiry. In studying the various meanings and invocations of the black female as excess from a diasporic framework, it is also important to attend to the different ways in which blackness and black womanhood are coded historically and geographically. In other words, the black female body does not have the same social, economic, and cultural meaning in different locations and times. With that precaution toward generalizing this racialized and gendered position, it is still important to address the public imaginary, psychic meaning, and circulation of the black

female body to make sense of how this social body continues to resonate as a site of abnormality and dark fantasy through historical recurrence.

Black feminist scholars across disciplines have broadly examined the discourse of pathology that frames black women's bodies and sexualities in the visual field and the public sphere. Of note, legal scholar Dorothy Roberts's study *Killing the Black Body* examines social and legal policies in the United States aimed at regulating black women's bodies, especially their reproductive choices.[24] Hazel Carby in "Policing the Black Woman's Body in an Urban Context" looks at the "moral panic" over black women from rural and southern regions who moved to urban areas in the early twentieth century. Carby analyzes how early twentieth-century social reform pathologized black women as lacking moral virtue and prone to laziness and deviance. Carby analyzes how one of the solutions to resolving this moral panic (in addition to creating "lodging houses" to keep black women off of the streets at night) was "training schools to make black women 'more efficient.'" Here, a practice of efficiency serves as the counterpoint to black women's presumed excessiveness.[25] Efficiency in this context meant putting black women's bodies to use as laboring bodies that support systems of inequality, often as domestic labor to whites and upper-class blacks.

One important arena for investigating how the imago of black female excessiveness operates and gets reproduced is the history of photography and the creation of racial taxonomies that relied on photography to document racial and sexual differences. In *The Black Female Body: A Photographic History*, Deborah Willis and Carla Williams examine the history of the use of visual apparatuses to probe and document these darkly coded figures, particularly the unclothed black female body. Resisting a homogenizing discourse of black female victimhood, the authors attempt to read agency as "the act of confronting identity and taking control of the image," in many of the subjects of photographic study.[26]

In an earlier piece on representations of black women in photography, Carla Williams recalls her discovery of a now well-known daguerreotype of a nude black woman touching her genitals, circa 1850s. Most likely intended for private collection by a wealthy white of the era, Williams sees this explicit daguerreotype as "a crucial development in the visual depiction of African women." In studying the image, she argues for the possibility that this woman could be bringing pleasure to herself, as her hand on her genitals suggests, in similar terms of self-portraiture, that is, "self-sufficient, highly personal, and exploratory." Williams makes a distinction between the photographic nude and erotic imagery: "unlike a photograph of a 'nude' which is thought to be classic and formal and idealized, the specifically

erotic image is naked and dark, animalistic and fleshly."[27] Williams uses the coded language of black female sexuality to describe the operations of the erotic. In reading the possibility of pleasure experienced by the photographic subject, Williams suggests that the woman's pleasure is beyond the reach of the photographer and the various historic audiences of the image.

Williams emphasizes the importance of revisiting historical representations of the black female body and of resisting a reobjectification of these subjects by reducing them to silent victims who had no control over the visual reproduction of their bodies. For Williams, mapping this lineage is significant because of what she describes as the cultural imperative in black communities to cover—to hide one's flesh and de-emphasize black female corporeality, in other words the practice of respectability, as a response to dominant culture's probing, dissecting, and displaying of black female bodies. Williams, who is both a writer and a photographer, disidentifies with the cultural imperative to cover up the black female body in her photographic practice, while recognizing that because of historical and discursive forces, self-portraiture for the black female artist is necessarily problematic.

Considering the power of the counterdiscourse of respectability and silence that drives black female practices to resist the dominant gaze and systems of exploitation based on black female visibility, Evelyn Hammonds writes:

> Black women's sexuality is often described in metaphors of speechlessness, space, or vision, as a "void" or empty space that is simultaneously ever visible (exposed) and invisible and where black women's bodies are always already colonized. . . . Historically, black women have reacted to this repressive force of the hegemonic discourses on race and sex with silence, secrecy, and a partially self-chosen invisibility.[28]

Hammonds points out that these silences and ellipses have often been used to avoid the persistence of the dominant gaze to look upon and frame the black female body through discourses of deviance and excessiveness. Underlying Hammonds's statement is the irresolvability of the black female body as troubling presence in dominant visual culture. It is not a problem that can be "fixed" through proper dressing or rendering oneself invisible. Thus, excess flesh enactments not only reference dominant visual culture's ambivalence at times, hostility and desire at others, toward black female corporeality, but excess flesh enactments also acknowledge without conforming to the cultural imperative of blacks to promote a visuality of respectability and uplift.

Debates about the merits of various strategies of visibility and respectability have long preoccupied marginalized groups and have exhausted academic discourse specifically with regards to organized struggles in the civic and public domain. Peggy Phelan's 1993 study *Unmarked* registers an important moment in the study of visibility politics. The much-cited and rigorously debated study cautions politically oppressed and minoritized groups of the limitations of visibility as a strategy against dominant structures: "Visibility and invisibility are crucially bound; invisibility polices visibility and in this specific sense functions as the ascendant term in the binary. Gaining visibility for the politically under-represented without scrutinizing the power of who is required to display what to whom is an impoverished political agenda."[29] Many performance theorists and scholars writing on the practices of subjects and communities of color have pointed out the dangers of going "unmarked" by dominant political, judicial, economic, and social systems that have rendered marginalized populations already invisible, such as the masses of brown and black peoples who labor in the service industries of Western metropoles. Equally important is the critique that Evelyn Hammonds and other black feminist scholars have offered of how the strategy of invisibility and the "politics of silence" that black women have deployed to counter the penetrating gaze of dominant visual culture have helped maintain black female marginalization.[30]

Hammonds argues that black women's practices of going unmarked in the realm of sexuality and bodily politics reinforce the taboo of black female sexuality and hegemonic ideologies that encode their bodies with racialized and gendered meaning. Yet she cautions against an uncomplicated embrace of visibility to counter the damage of silence done to the black female body and black sexualities and argues, "visibility in and of itself does not erase a history of silence nor does it challenge the structure of power and domination, symbolic and material, that determines what can and cannot be seen. The goal should be to develop a 'politics of articulation.'"[31]

Embracing both Phelan's and Hammonds' skepticism of visibility as a political strategy while acknowledging the enforced invisibility placed on racialized subjects, I argue that understanding systems of visuality as necessarily troubling structures makes viable a different set of questions about black visibility. The question becomes how do the terms of engagement change in performative practices that are rooted in the trouble of visibility?

Excess flesh as an enactment, while not necessarily resistant, can be productive in conceiving of an identificatory possibility for black female subjects that refuses the aberrant representations of the black female subject in dominant visual culture. Excess flesh offers the possibility of particularizing

the spectragraphia that Maurice Wallace argues frames the black masculine figure in the public sphere, and I would add intensifies the gaze upon the black female subject. By spectragraphia, Wallace refers to a cultural vision that frames black men "through the spectral and the spectacular in racialist representations."[32] I would maintain that, with different gendered implications, "spectragraphia" also captures the black female body as ontologically aberrant. In Lacanian psychoanalytic terms, identification is the process by which the subject comes into being through a recognition and alienation of self, facilitated by the reflection of an idealized image.[33] Psychoanalytic theorists from Frantz Fanon to David Eng and Kaja Silverman have revealed in their writings that the process of identification for all subjects is not facilitated by an ideal ego. Equally important for my purpose here is how their writings—with respect to their distinctively different projects—demonstrate the significance of the imago in the process of subject formation as enunciated by Lacan.[34] About this, Silverman writes, "Lacan sharply differentiates the gaze from the subject's look, conferring visual authority not on the look but on the gaze. He thereby suggests that what is determinative for each of us is not how we see or would like to see ourselves, but how we are perceived by the cultural gaze."[35] It is to be understood without explication that "the cultural gaze" stands in for white male positionality in looking relations. This is abetted by a symbolic order that structures white men with perception and authority. Moreover, in much of the scholarship on visual culture and race, including my own work, the cultural gaze so defined is the psychic and symbolic impetus for divergent art practices that redress its subjugation of others as curious objects of scopophiliac play.

South African conceptual artist Tracey Rose, influenced by late twentieth-century women's performance photography and video art, takes on optics and the power of looking in her art. Much of her work engages directly—often confrontationally—with the dominant cultural gaze, as well as the multiple looks of the artist and her audiences. *TKO* is a black-and-white video installation projected on a translucent scrim. In the video Rose, naked, shadow-boxes with a punching bag that holds a camera. Three other cameras are positioned in the makeshift room where she boxes. The soundtrack is a mixture of pain and ecstasy as she becomes breathless from punching and dodging the bag. Her breathlessness leads to shrieks, then to sounds of exhaustion and moans, and back to slow, loud breathing. The reference to violence, self-mutilation, and aggression is heightened by the fact that we can never see the artist's entire figure. We catch glimpses of her face, her torso, her pubic hair as she struggles with the bag. Her performance of excess flesh is oddly through a lack of revelation. Spectators can never

see the artist's body in its entirety. Nor do we get a static shot of the artist. Instead, we witness fleeting glimpses of body parts accompanied by her sounds of effort and struggle. The video installation also references how pain and captivity get aligned with black female bodies historically and in contemporary culture. Rose complicates projects that simply frame black women as victims of a mastering gaze by occupying the hypermasculine and hyperviolent realm of boxing. In *TKO* Rose sets up the circumstances under which she struggles, whimpers, and cries. Performing as boxer, Rose inflicts pain and dodges it.

In a series of performative photographs and a video installation entitled *Ciao Bella*, Rose takes up various renderings of excessive dark female bodies and sexualities. The artist costumes herself, in the theatricalized manner of Cindy Sherman, to explore visually female archetypes. Through her performance of an eroticized abjectness, she emphasizes the exaggerated genitalia, à la Venus Hottentot, in tropes of the black female other. She meticulously references early feminist video and performance art in her work. In particular, Rose's work references the explicit body performances of feminist artists like Carolee Schneeman and Anne Sprinkle. An *Artforum* review describes Rose as "pushing herself beyond the point of physical exhaustion, parodying racial stereotypes, or overlaying sex with violence and pleasure with pain, Rose locates herself among women who have previously confronted themselves (and others) in their art."[36]

Rose's practice engages with the imago of black female excessiveness through the performative and expands our understanding of its impact. Rose's play with historical iconography and contemporary context complicates the conceptualization of the cultural gaze, one that acknowledges the heterogeneity of twenty-first-century visual culture and audiences. In Rose's work, as well as many of the other artists discussed here, the performative of black female excess combines the haunting presence of historical terror with a tongue-in-cheek satire and the aesthetics and tone of contemporary popular culture. To use Powell's term, it is a cutting and dissecting of the imago as structured through dominant visuality. Lorraine Morales Cox, in looking at the "performative turn" in the work of artist Kara Walker writes of the importance of "looking at performance within the field of the visual." The performative aspect of Rose's work allows for the audience to engage materially, spatially, and corporeally with the imago that bears such psychic weight. About Walker's performance of historical memory, Cox writes: "With the insertion of her own contemporary body, Walker more directly addresses the past through her present self, both as a two dimensional rep-

resentation as well as a more directly visceral presence through the theatricality of her actual body."[37] Such artistic practices privilege the performative component of visual narratives and in so doing turn excess flesh into a strategic enactment and not a being unto itself.

Mass Culture and the Spectacle of Black Female Excess

Rose's work reveals the influence of earlier women artists but also the ways in which art markets, popular culture, and mass consumption speak across various fields and industries in contemporary visual culture. So far, I have discussed the operations of excess flesh within the art industry. The contemporary art market is a sphere in which excess flesh might be folded into ongoing debates of artistic freedom, challenges to canonical art history, and the politics of institutional funding. Excess flesh enactments, framed through notions of artistic freedom, are folded into recurring issues that have emerged throughout the last decades of the twentieth century with regard to artistic standards, government funding, and notions of social decency. Even as artists like Cox and Rose maintain positions that challenge the racialized and gendered norms of art history and the art market and even as their works demonstrate their investment in mass and popular cultural forms of production and practice, they are read as artists within traditions and histories of art making and reception; and their works get read within that domain as *art*.

The fissures and limitations of excess flesh emerge when the concept is used to discuss the range of engagements and performative utterances of black female cultural practitioners in the larger domains of mass culture and black popular culture. By mass culture, I mean to invoke its usage within cultural studies to refer to the scale and reach of cultural production and dissemination targeted at the widest sectors of populations, regions, and societies both nationally and internationally. This is not to suggest a homogeneity or sameness in thinking among audiences and sectors of mass culture. In fact, the notion of the glocal—as in global localization—evidences both the scale of distribution of mass cultural ideas and goods and the ways in which specific communities and groups appropriate and create context-specific meaning out of these goods. My use of black popular culture grows from Stuart Hall's influential essay, "What Is This 'Black' in Black Popular Culture?," in which Hall defines black popular culture as a "contradictory space" that marks difference and commodification. Hall writes that like all histories of popular culture, black popular culture has roots in traditions,

memories, and everyday practices, and it calls forth the Bakhtinian notion of "'the vulgar'—the popular, the informal, the underside, the grotesque." Black popular culture is a hybrid, commercialized arena: one that while it is absorbed within dominant popular culture and often circulates as mainstream culture, it continues to assert practices and a rhetoric of "strategic contestation. But it can never be simplified or explained in terms of the simple binary oppositions that are still habitually used to map it out: high and low; resistance versus incorporation; authentic versus inauthentic; experiential versus formal; opposition versus homogenization."[38] It is not a site that is solely or exclusively black; and yet it recognizes the black public sphere, diverse audiences, and the slipperiness of the category "black" to define a cultural product. It is important to distinguish black popular culture from mass culture here because excess flesh enactments circulate and translate differently in the realm of black popular culture than in mass culture.

When considering excess flesh performance in these arenas compared to the art industry, overlapping and different issues come to the fore. Among the most profound differences are audience, authorship, and circulation. The presumed audiences of visual art, mass culture, and black popular culture are both distinct and overlapping. In hopes of avoiding the reification of class, educational, regional, and racial inflections of audiences, I would like to acknowledge that some spectators may circulate through all of these arenas. Moreover, the cultural practices in these arenas do not emerge in isolation; they speak to and come forth out of similar cultural discourses and conceptual maps. However, I would also venture to say that audiences read these media and contexts differently. Specifically, the reading of art as art, and the emphasis placed on the authorship of the artist as singular figure, in large part shape the audience consumption of the art objects as such.

Second, the context of mass culture and the ways in which visual spectacle is manufactured and widely distributed muddies issues of intentionality. The relationships between corporate sponsorship and the black body in contemporary mass culture are deliberately sensationalized, as black celebrities self-consciously produce hypervisible representations of themselves as commercial vehicles. The promotion of the relationship between the black icon and big business through advertising campaigns is a commentary on black cultural figures promoting and profiting from other forms of corporate commodities. Because of these relations and the capital interests of corporations and black cultural figures, the boundaries around excess flesh enactments are restrictive and must ultimately serve as a tool for capital accumulation. Within the marketplace of mass-produced and corporate-

sponsored production of difference, the productive possibilities of excess flesh in these two contexts bump up against the dominant workings of power with differing effects.

In the following pages, I look at two different popular cultural figures and the production and circulation of excess flesh enactments. The first reading is Janet Jackson's 2004 Super Bowl performance in which her breast was revealed and circulated instantaneously to television's largest audience. The second reading is of the rapper Lil' Kim, focusing on her late 1990s–early 2000s music videos, performances, and lyrics. In many respects, my analysis of Lil' Kim is an obvious move given that Lil' Kim is commonly cited in studies and criticism of black popular culture and black female sexuality. Because of her familiarity as topic in black cultural studies and the fact that her recording and performing career has waned throughout much of the last decade, my choice may be seen as dated, which in many ways reveals how we distinguish the value and relevance of that which is deemed as art (à la Cox and Rose) and that which is rendered as fleeting popular cultural products. However, Lil' Kim's excess flesh performances, which recite earlier excessive black female performers like Betty Davis and Millie Jackson, also push the boundaries of the more socially acceptable excessive performances of contemporary hip-hop and R&B performers such as Beyoncé, Rihanna, and Ciara. Also important is to consider Lil' Kim's popularity and circulation during the late 1990s and early 2000s primarily among blacks of different ages, youth, urban, and queer communities.

Excess flesh performances in mass culture produce a sharper lens to see the operations of the discourse of captivity and capital that frames the black body in the field of vision. The visible black body is interpreted through the discourse of commodification and the simultaneous punishment of circum-Atlantic trades in the flesh and the structures of racialization that emerges through these practices. Art historian Lisa Collins calls the workings of this discourse on the black figure "economies of the flesh" in her study of black female artists' engagement with historical narrative.[39] *The black body enters the field of vision through a visual economy of flesh and trade.* Hortense Spillers theorizes how the captive body of the Atlantic slave trade informs contemporary discourses about the flesh and the visibility of the black female body. Spillers writes:

> the captive female body locates precisely a moment of converging political and social vectors that mark the flesh as prime commodity of exchange. While this proposition is open to further exploration, suffice it to say now that this

open exchange of female bodies in the raw offers a kind of Ur-text to the dynamics of signification and representation that the gendered female would unravel.[40]

One of the most captivating aspects of late twentieth-/early twenty-first-century popular culture is how the once denigrated but utilitarian body of chattel slavery manifests itself as the idealized fetish object of contemporary transnational capital, often with black cultural brokers as its producer—a dynamic taken up at greater length in the next chapter with an analysis of black urban fashion and advertising. In many cases, black cultural brokers market and brand themselves as product, pitch person, and corporation. The most sensational crystallization of this growing position in dominant popular culture is the rise of the hip-hop mogul. In examining the emergence of the hip-hop mogul, Christopher Holmes Smith considers social, economic, cultural, and political forces that allowed for the emergence of the hip-hop mogul during the 1990s—the boom years of the Clinton presidency.[41] The successes of young black male filmmakers and music-video producers, the evolution of the iconic rapper into media entrepreneur (i.e., Jay-Z, Sean Combs, and others), and the various positions of power that blacks occupy throughout sports, media and music industries have changed the ways in which media critics and scholars must think and write about the relationship between production and reception in cultural theory. While several connections can be made between the black body as commodity in contemporary settings and historical uses of the black body as consumption good, it is important to acknowledge a significant structural change in the realm of entertainment arts in which many black entrepreneurs and artists are now producers of such goods.

The interplay between corporate interests, black cultural figures as brokers and performers of racialized spectacle, and historical legacies of capital and captivity surfaced in mass culture through the 2004 controversy over black popular musician Janet Jackson's Super Bowl halftime performance. In this case, national and international audiences witnessed one of the most sensational and publicized displays of the spectacular and deviant representations of black woman as excessive in contemporary memory. During the airing of the largest televisual event annually, Janet Jackson performed a medley of songs with young white pop musician Justin Timberlake in part to promote her new album. As they performed their final number—Timberlake's hit song, "Rock Your Body," Timberlake, who is a generation younger than Jackson and grew up studying the moves of the Jackson family and other black musicians, reached across the body of Jackson and ripped away

Figure 3.6. Janet Jackson, Super Bowl Performance, 2004. AP Photo/Elise Amendola.

the clothing covering her right breast, while singing the lines, "I'll have you naked by the end of this song."[42]

The immediate reaction by CBS, the network channel that broadcast the event, and media outlets nationally was one of shock, anger, and confusion. The sense of outrage was expressed, most virulently, by male politicians, media executives, and cultural figures. Ironically, Spike Lee (the subject of representational criticism as discussed in the introduction of this study)

called the performance—specifically the bare breasting—a "new low" in media spectacles by entertainers.[43] After the show Timberlake smiled and called it a "wardrobe malfunction." Yet a couple of days after the event and after the escalation in media response—including the announcement of an investigation by the FCC—Timberlake disavowed his role in the performance, stating that he had gotten word of the change in the performance when he arrived for the show. Even more ironically, Timberlake emphasized his alarm over the revealing of Jackson's breast in an interview, stating, "I was completely shocked and appalled, and all I could say was 'Oh my God, Oh my God.'"[44]

Timberlake's relationship to the performance is particularly striking. After the spectacle Timberlake and media coverage transformed him from a seducer who announces his intention to denude Jackson's body to an unsuspecting victim who was the injured party, assaulted by Jackson's breast. According to postevent publicity, Timberlake only agreed to perform after Jackson personally requested that he duet with her, suggesting his reluctance to participate. Second, MTV, CBS, Timberlake and later Jackson pointed to Jackson as being the mastermind behind the "stunt" (Jackson's choice of words during her videotaped apology), a ploy in which Timberlake agrees to perform a simultaneous seduction of and attack on Jackson's eroticized body clothed in tight leather, vinyl, and chains. In other words, deeming Jackson as the mastermind reinforces the innocence of Timberlake, who had no idea what was in store for him. Third, Timberlake denies any possible pleasure derived from the performance by emoting a response of shock and disgust. As the aftermath of the incident continued to grow with an increasing public outcry for someone to be punished, Timberlake's story solidified into one in which he reluctantly agreed to perform an attack on Jackson's ready and willing body. It is an attack that in the end victimizes him, as Jackson is represented as the dubious seductress and corrupter of the national audience's sense of moral and codes of conduct.

Donia Mounsef offers a close analysis of "Nipplegate" (the media catchphrase to describe the Super Bowl performance and fallout) by looking at obscenity debates and other public controversies over exposed breasts. Writing on shifting cultural notions of the obscene and the role of female nudity in defining the boundaries of decency, Mounsef states, "Jackson's slight is a performative *excess* that moves the activity of viewing from a transparent relationship of meaning and expression to a denial of significance and identification, creating the conditions for a profound loss of meaning, and absence of referentiality."[45] While Mounsef's piece acknowledges how race complicates Jackson's performance, her analysis does not fully engage with

how racialized sexuality constitutes the Super Bowl show as a different and heightened social breach. Racialized hypersexuality typically frames the dominant viewing public as the victim of the wanton ways of the woman of color whose performance, while titillating, threatens the social fabric of white heteronormativity and public decency. In her analysis of the spectatorial ambivalence toward the hypersexualized Asian woman's body, Celine Parreñas Shimizu writes, "hypersexuality leads to a traumatic viewing experience. In denying one's own pleasure from the sight of pathologic sexuality, the spectator is made perverse."[46]

Excess flesh performances in mass culture threaten white reproductivity through its invocation of miscegenation rooted in historical rape of black women, as well as contemporary fantasies and practices of interracial sex. In the particular case of "Nipplegate," Timberlake and others responded to Jackson's excess flesh performance by configuring the rapist/seducer (Timberlake), the promoter (MTV and CBS), and the general public (audiences of the Super Bowl) as the victims. Sara Ahmed's theory of affective economies explicates how shared emotions among normative subjects are produced often through the production of marginalized subjects/others as victimizers who disrupt the normative subjects' positive attachment to sameness: "The ordinary or normative subject is reproduced as the injured party: the one 'hurt' or even damaged by the 'invasion' of others. The bodies of others are hence transformed into 'the hated' through a discourse of pain."[47]

In a commentary Carla Williams places Jackson's breast exposure in the historical context of representations of black women's sexuality and the lack of ownership (for the most part) that black women have had over producing and controlling representations of their bodies. Williams writes:

> It was fine if her record company was selling her sexuality and no one was complaining, but when the public finally cried foul everyone backed away to leave her twisting alone in the media wind. So now Jackson solely is to blame. It's a familiar trope in American culture—the oversexed black woman, now even willing to whip her tit out on national television to sell some records. She has to be stopped.[48]

Williams's response suggests how social discourse narrates a relationship to the black female body that insists upon her punishment when she ventures (intentionality aside) to engage in excess flesh performances without the endorsement or sponsorship of dominant visual and commodity culture.

Similar to the response to Cox's *Yo Mama's Last Supper*, Jackson's bodily performance—for a different and much larger audience—provokes

controversy. Not unlike those who tepidly defended Cox, some of the critics and writers who spoke out in support of Jackson did so with skepticism, arguing that her publicity ploy was an attempt to reignite her diminishing career. For example, Frank Rich, in a tongue-in-cheek essay in the *New York Times* entitled "My Hero, Janet Jackson," writes:

> You can argue that Ms. Jackson is the only honest figure in this Super Bowl of hypocrisy. She was out to accomplish a naked agenda—the resuscitation of her fading career on the eve of her new album's release—and so she did. She's not faking much remorse, either. Last Sunday she refused to appear on the Grammys rather than accede to CBS's demand that she perform a disingenuous, misty-eyed ritual "apology" to the nation for her crime of a week earlier. By contrast, Justin Timberlake, the wimp who gave the English language the lasting gift of "wardrobe malfunction," did as he was told, a would-be pop rebel in a jacket and a tie, looking like a schoolboy reporting to the principal's office. Ms. Jackson, one suspects, is laughing all the way to the bank.[49]

Cox's transgression was one that disrupted dominant religious narratives. Too, Jackson's breach was sacrilegious as she was seen as disrespecting the rituals and etiquette of the sports industry's and advertising industry's most sacred moment—one that mixes religion, patriotism, and masculine competition for international audiences. More important, Jackson was discussed in similar terms as the attacks on Cox. Both were seen as black women who strategically and willingly used visibility as tools for the promotion of their careers.

The Hip-Hop Music Video and Technologies of Excess

While there are many similarities between the Cox and Jackson controversies, I am more interested in the differences between excess flesh enactments in various arenas of cultural production. In the example of Janet Jackson's performance for an audience of many millions, she must deny her performance and is punished for the enactment. The role of Timberlake and the display of interracial intimacy animated the fury over the performance. In black popular culture, excess flesh enactments are often read as culturally specific. They are contained as the excesses of black popular culture for black audiences. This is most clearly evidenced in the hip-hop music video genre of the 1990s and early 2000s where the shiny, bouncing, minimally clothed black female body is ubiquitous within the form. It is a black female

body in motion as hypersexed vixen that brands this otherwise male-dominated cultural production.

The hip-hop music video genre, popularized by notable black music video directors Hype Williams, Little X, and Paul Hunter, to name a few, has been applauded for technological and aesthetic innovation while at the same time thoroughly criticized for portraying black women in some of the most over-the-top and explicitly reductive representations in contemporary popular culture. The salience of these images has led to a system of classifying character tropes in this genre with women as extras referenced as "video vixens" and "video hoes." The music video has become the symbol of black female undervaluation as individual subjects, and overrepresentation as surplus populations within black cultural representation. These performers exist in a precarious relationship between being and enacting excess flesh. They exist in multitudes. The commonly used fish-eye lens of many of the videos that emerged in the mid 1990s–mid 2000s frames body parts: large butts accessorized in lingerie, shiny legs, navels, cleavage; faces are often excluded or blurred. The dance, too, is excessive. They bend over and fully expose their buttocks to the camera. Their fleshy thighs and jiggly buttocks captivate the camera. They are autoerotic, driving themselves to inappropriate levels of ecstasy. They appear in various manifestations of excess flesh surrounding the iconic male rapper. Often the lyrics dissect these figures. "Back that ass up," "I like it when you do that thang," "Shake that thang," and "Is there any room for me in those jeans" are just a few of the lines from popular rap songs.

The music video serves as a medium for the continual circulation and "global touring" of the black female performing body, in historical referentiality to Baartman.[50] Through analogic and digital video, the bodies multiply, reproduce, and perform continuously. These videos show the distinctions between excess flesh enactments in mass culture and black popular culture. While MTV commonly runs videos of male rappers, BET has created special programming that broadcast explicit or uncut versions of the more tamed versions that air on MTV. BET's late-night show *Uncut* airs the hybrid genre where music videos and pornographic videos merge.[51] Mireille Miller-Young looks at the burgeoning industry of hip-hop pornography, in which some well-known male rappers, like Snoop Doggy Dogg, capitalize on the popularity of black women as excess flesh in music videos and culture at large. Miller-Young looks at how softcore hip-hop music videos and hardcore hip-hop porn rely on the reproduction of black women's sexualized bodies to authenticate the masculinity of black male rappers and

porn actors. While these videos and performances reproduce in most cases heteronormative and misogynistic codes, Miller-Young argues that "black video models and sex workers mobilize their sexualities in the marketplace of desire for their own interests of access, opportunity, mobility, and fame."[52]

The hip-hop music video has been a familiar target of critique by black public figures, scholars, and cultural critics who have focused on the representations of black women in the genre. In particular, black feminist scholars and cultural critics have examined the precarious positions of black females as audience, artists, and objects of desire/disgust in hip-hop music and videos.[53] In *When Chickenheads Come Home to Roost*, cultural critic Joan Morgan considers the representation of black women in hip-hop in relation to heteronormative intimate relations between black women and men. Considering the power relations and the specter of violence and domination that color black heterosexuality, Morgan asks how a young black woman steeped in hip-hop can emerge with a feminist conscious and a body politic that sees the self as anything other than aberrant. Morgan works to articulate a position that she describes as hip-hop feminist, a position that claims "the powerful richness and delicious complexities inherent in being black girls now—sistas of the post–Civil Rights, post-feminist, post soul, hip-hop generation."[54] It is a position that she acknowledges is replete with contradictions and describes her own feelings of being seduced by the lyrics of many male rappers, lyrics that in the end often reduce black women to be splayed out, prepped, and ready for penetration.

Inspired by the excess flesh of the "video ho," artist Ayanah Moor created a photographic series entitled *Still*. Through the series, Moor dissects the music video by capturing still images of the "video ho" from popular music videos. In *Still*, the excessive performances of female video performers are framed as discreet photographic moments. The women performing as eye candy take center over the male rapper. The series consists of four digital still images titled: *Clap*, *Face*, *Lean*, and *Glow*. In *Lean*, a young female dancer is captured in the midst of a dance in which she leans backward with her legs spread apart. Her arms are outstretched and her midsection is bare. She stares at the camera with her lips pursed. She is caught in a moment of extraordinary feat where her midsection seems suspended in space. Behind her, we can see the headless bodies of others who cheer her on. *Glow*, another still, is a close-up of the face of a video performer as she looks out with her mouth half open. Her face, hair, and shoulders are made radiant by the light frozen at this moment. Behind but darkened by her light are others dancing and partying. Moor, in an accompanying statement, writes:

Figure 3.7. Ayanah Moor, *Clap*, photograph, 2006. Courtesy of the artist.

Captured frames imply moments unintended by the larger music-video narrative. Compositional choices reduce the depiction of once-dominant male performers to supportive background visuals, if they are represented at all. The images' focus exclusively on women offers a second look at the so-called music-video vixen. Formerly images based in time, the video characters, now frozen, permit unconventional portraits. . . . Within the feminist critique of hip-hop, is there room to consider women's embrace of sexually provocative performance forms?[55]

Moor's take on portraiture mirrors art historian Powell's assertion about the ways in which black artists create disruptive portraits of black subjects through severing, splicing, and cutting black figuration from dominant representation. Moor's process of generating the still image from the video performance is a component of her interventionist strategy in which she takes a photograph of video in real time as it plays on a television. For Moor, it is an attempt to frame a moment of dialogue between video performer and the artist as audience member and consumer.[56] In some sense, it is a contemporary form of Pittsburgh photographer Charles Harris's attempts to capture the sidemen and audience as opposed to photographing the black iconic entertainer (see chapter 1). Moor questions the possibilities of

Figure 3.8. Ayanah Moor, *Lean*, photograph, 2006. Courtesy of the artist.

the "video ho" to engage and perform sexual pleasure that does not simply and solely reinforce her overdetermination as always already hypersexed being. This reading is critical in moving cultural discourse away from the pejorative reading of the music video form and the reproduction of black female performing bodies as aberrant. Moor visualizes these bodies not as a state of being but as one of enacting, offering new possibilities of seeing pleasure and play in the hip-hop music video, even while attending to the ways in which excess performance plays into dominant conceptions of racialized sexuality.

Ayanah Moor's video's *Baby Got Back* (2004) takes us back to the earlier reference of Sir Mix-a-Lot's rap song, "Baby Got Back" and Cox's similarly titled *Baby Back*. Moor's video is quite striking in how it deviates from the music-video form while adhering to the song's lyrics. The video is minimalist in its composition of a close-up frame of a black woman in a black t-shirt and a white background. The woman recites Sir Mix-a-Lot's lyrics rapidly and with emphasis on references to body parts and features. As she demonstrates lyrical dexterity (rapping with more speed and precision than the original version of the song), she expresses pleasure and desire with smiles and hand gestures. In one part, the rapper slows down and enunciates each

word to emphasize her deviation from white beauty aesthetics: "When it comes to females, Cosmo ain't got nothing to do with my selection." Along these lines, Tricia Rose writes that Sir Mix-a-Lot's song expresses "both an explicit desire for black women's protruding behinds and at the same time mock[s] the fashion industry for celebrating anorexic-looking white women."[57] In remixing Sir Mix-a-Lot's song, Moor cites and queers the heteronormativity of its lyrics while still rendering the black female back a fetish object. Moor comments on her position in an artist statement:

> In contrast to MixAlot's rap and lively musical arrangement, I revisited the tune via an accapella rendition. The gender politics of this humorous ode to the derriere shifts when recited by a female narrator. Just as MixAlot enthusiastically blurs the line between objectification and celebration of black woman's bodies, the new gendered speaker playfully inserts queer identity into hip-hop's hyper masculine aesthetic. Often criticized for misogynistic lyrics, the change of commercial rap's male face expands such critiques to a larger American society whose women continue to confront sexism and fight for gender equality. In this work I invoke additional popular modes of performance and representation: the global popularity of karaoke and the tension it evokes when compared to drag performance. Equally I welcome associations with the genre of documentary, when the work is viewed as an impassioned confessional. Feminizing the orator in this video work both queers otherwise heterosexual lyrical content and offers praise of the representation of black women's bodies in mainstream media.[58]

Moor considers the spectatorial position of black female audiences of hip-hop music and videos. Do black women identify with the male rapper or the multitudinous women who adorn the rapper as body parts for his consumption? And how do black queer women negotiate and express desire in these heteronormative and masculine sites? In considering these questions, Andreana Clay writes that oftentimes when queer women participate in hip-hop it is through a performative restaging (a concept that she borrows from Jack Halberstam) where "black masculinity is changed in that these women are exploring their masculinity in relationship to the women that they love and have sex with."[59] For Clay, it is a claim for legitimacy and an expression of desire not afforded through dominant popular culture and public space. Excess flesh in this context serves as an intervention in heteronormative and hypermasculine black popular culture where desire is expressed among bodies marked as such through an appropriation of black masculinity.

What happens when the video vixen is the object, subject, and author of the video such as in the performances of sexually explicit rappers like Lil' Kim? In the late 1990s/early 2000s, Lil' Kim served as both an example of hip-hop's degradation of women and of hip-hop female empowerment. Not unlike Jackson, Lil' Kim participated in a televisual moment that centered her exposed breast. In 1999, during the MTV Music Video Awards broadcast on the cable channel, the rapper arrived with an outfit that exposed one of her breasts. A purple star covered the nipple of her exposed flesh. While presenting an award with legendary soul singer Diana Ross, Ross noted the rapper's outfit; Ross then reached out and bounced Lil' Kim's breast to see if the star was secure. I believe that this occurrence did not receive the outcry and level of anger expressed about the Jackson incident because instead the Kim incident circulated in entertainment news as evidence of her outrageousness and overdetermined excessiveness. Also, her breast while touched by another woman remained partially covered by the star. Furthermore, the social breach did not involve white entertainers. Instead it was the older black female star—once known as a crossover sexual icon—examining the hypersexed body of a younger generation of black female celebrity.

Lil' Kim's raps are known for appropriating the masculine language of sexual conquest, domination, violence, and the power of the penis. Playing on the terms set by well-known male rappers, especially her former lover and mentor Notorious B.I.G., Lil' Kim positions herself and gains street credibility by using a familiar braggadocio rap narrative structure, at times substituting references to her sexual organs for the lingo of penis common in rap. In her rap "Suck My Dick" (2000), Lil' Kim imagines herself with a penis and penetrating "niggas" in hip-hop who perform the bottom. Lil' Kim raps, "Niggas love a hard bitch / One that get up in a / nigga's ass quicker than an enema / Make a cat bleed then sprinkle it with vinegar."

She penetrates until he bleeds. Her acts of domination produce pain and pleasure in multiple audiences: "Kim got him in a zone beating they dicks / Even got some of these straight chicks rubbing their tits." Her role play in this song shifts between a woman queering heterosexual intercourse in which she as woman penetrates the man and occupying another queer position where her sexual identification is unclear but the object being penetrated is enunciated forcefully: that is, the black masculine figure who in heteronormative relationships sexually dominate and exploit black women.

> Imagine if I was dude and hittin' cats from the back
> With no strings attached

> Yeah nigga, picture that!
> I treat y'all niggas like y'all treat us
> No Doubt!
> "Ay yo, yo
> Come here so I can bust in ya' mouth"

At the end of her fantasy play, Lil' Kim dismisses: "Niggas ain't shit but they still can trick/All they can do for me is suck my clit/I'm jumpin' up and up after I come/Thinkin' they gon' get some pussy but they gets none."[60] Lil' Kim reverses the pimp-ho dyad that circulates in hip-hop culture and heteronormative black popular culture. The rapper turns her male partner into one who functions for her sexual pleasure and whose pleasure she denies.

Lil' Kim visually manifests her penchant for role playing and fantasy construction in her music videos that function as hyperreal, hypersexed exhibitions of excessive tropes. In the video to her rap, "How Many Licks" directed by Francis Lawrence (a well-known black male video director), Lil' Kim is the prototype of a doll whose function is to provide ecstatic pleasure to male consumers. Lil' Kim moves between various personaes as she packages herself as a series of sexual commodities. She fashions herself as a dominatrix in control of bringing her male audience to orgasm. Her male subjects in the video are framed as in the throes of a painful pleasure over which they have no control. Lil' Kim's proficiency at bringing them to orgasmic heights is a self-serving achievement, she declares. Their desire for her simply increases her power and her autoeroticism.

Figuring black female sexuality as technology, the first scenes of the music video show a state-of-the-art factory where a shiny object is being manufactured. In the corner of the video we see "MADE IN THE USA" with an American flag to the right. The following words flash in quick succession: "Back By Popular Demand," "the original," "realistic" "Anatomically Correct," "Fully Edible." Then we see the pieces of the commodity coming together, culminating with Lil' Kim's head being deposited on top of a petite manufactured body on an assembly line. Behind the assembled commodity are partially assembled Lil' Kim dolls on their way to being fully manufactured commodities as they move along the conveyor belt. These dolls do not bleed nor do their parts have bone, muscle tissue, or sinews. They twist, screw, and pop together with ease, perfectly assembled to serve a precise function. The flesh of the corporeal Kim has become infinitely reproduced in plastic pleasure. We then see the name of the commercial product: "Lil' Kim/Edible Dolls."

Lil' Kim comes to life and marches down a runway. The words "Candy Kim" are flashed as she begins to craft a millennial narrative in which she frames herself as the international, multicultural lover/commodity good. Lil' Kim begins the first verse in typical rap braggadocio fashion:

> I've been a lot of places, seen a lot of faces
> Ah hell I even fuck with different races
> A white dude—his name was John
> He had a Queen Bee Rules tattoo on his arm, uh
> He asked me if I'd be his date for the prom
> and he'd buy me a horse, a Porsche and a farm
> Dan my nigga from Down South
> Used to like me to spank him and come in his mouth
> And Tony he was Italian (Uh-huh)
> And he didn't give a fuck (Uh-huh)
> That's what I liked about him[61]

Lil' Kim invokes a top-bottom sexual dialectic and invokes dominant ethnic, racial, and gender tropes in describing her sexual exploits. The "Queen Bee Rules" tattoo that she references on one of her lovers is a homage to Lil' Kim, who also goes by the moniker Queen Bee. She brands John the "white dude" as her possession, referencing the complex history of slaves being named, branded, and raped by their masters. Later in verse one, she recalls another one of the men she conquered: "And this black dude I called King Kong/ He had a big ass dick and a hurricane tongue." Lil' Kim uses dominant racial tropes to her advantage as she performs in more excessive and dominant ways than the hypermasculine, hyper-hung figuration of the black male.

Of note is that the sexually ambiguous black male pop singer Sisqúo (best known for "The Thong Song") sings the refrain. Sisqúo urges on Lil' Kim's stories of sexual conquest with his query:

> So, how many licks does it take till you get to the center of the?
> (Cause I've got to know)
> How many licks does it take till you get to the center of the?
> (Tell me)
> How many licks does it take till you get to the center of the?
> (Oh, oh)
> How many licks does it take till you get to the center of the?
> (Oh, oh, oh, oh, oh)

Figure 3.9. Lil' Kim, "How Many Licks," video still, 2000.

Sisqúo's question is unanswerable as there is no end in sight of the autoerotic power of Lil' Kim and her endless reproducibility. As Sisqúo's cries for more titillation and for relief at the same time, we see Lil' Kim dancing with video vixens behind her. Lil' Kim and the dancers are minimally dressed in silver metallic bikinis and knee-high black boots. They kick their legs open to the side and Lil' Kim rubs her crotch. With each refrain, Sisqúo intensifies his plea to know the limits of that which has no boundaries: Lil' Kim's sexually and corporeally enacted excesses.

As the second verse begins, the words "Pin-Up Kim" flash across the screen with a glossy image of Lil' Kim's face underneath the words. She then begins to play out a fantasy of bringing sexual relief to

> my niggas in jail
> Beatin' they dicks to the *XXL Magazine* (uhh)
> You like how I look in the aqua green?
> Get your Vaseline

Under the images of inmates masturbating to "Pin-Up Kim," we see the words "Dramatization" and "Some Fantasies May Vary." As Lil' Kim brings alive a reimagining of the Jane Fonda *Barbarella* poster, the words "State and Federal Prison Approved" appear. We then see inmates gathering around the images of Lil' Kim as the artist raps, "Stop, look and listen; get back to your position/Kim got your dick hard, startin' fights in the yard."

Like many male rappers who give "shout-outs" to black men in prison as a way of acknowledging the systemic incarceration and subjugation of surplus populations of black men, Lil' Kim offers her own shout-out. Hers is one that acknowledges their desire for pleasure, sexual intimacy, and to be recognized through the look of another.

While the song is a playful take on the playa rap in which black male rappers detail their sexual exploits, Lil' Kim frames herself as both conqueror and sexual object explicitly marketed as such for her own pleasure. In the final verse, we are shown a third commodity object expropriated from the corporeal subject, "Nightrider Kim." We, as audience and consumers, are told that the commodity is much in demand with the words "Get yours while supplies last." She rhymes:

> After three bottles I'll be ready to fuck
> Some niggas even put me on their grocery lists
> Right next to the whip cream and box of chocolates
> Designer pussy, my shit come in flavors
> High-class taste niggas got to spend paper
> Lick it right the first time or you gotta do it over
> Like it's rehearsal for a Tootsie commercial

At the end of this verse as the song begins to wane, Lil' Kim pulls up in a car next to an unsuspecting young black man. The door of the car opens and the man is sucked in as if zapped by a space machine. Next to his abduction we see, "She doesn't satisfy you. . . . You satisfy her." One of our final images includes all three commodities with "Collect All Three/Taste the Difference."

While performing inside the world of her own making, one in which she is infinitely reproducible, and in which she marks the beginning and end of sexual desire and pleasure, there are no restrictions on her performative excesses and the power she derives from sexual enactment as commodity form. Yet, in the realms of black popular culture and mainstream American culture, limits are placed on Lil' Kim's excess flesh performances. For one, Imani Perry points to the visual signs that construct Lil' Kim's fantasy play in the "How Many Licks" video. Perry notes that each of the dolls manufactured in the video is designed to imitate white standards of beauty. Perry writes:

> The video stands as an apt metaphor for her self-commodification and use of white female beauty ideals. The video closes off its own possibilities. The

doll factory image might have operated as a tongue-in-cheek criticism of image making or white female beauty ideals, but, instead, the video functions as a serious vehicle for Kim to be constructed as beautiful and seductive with blond hair and blue eyes. To be a doll in American popular culture is to be perfect, and she will satisfy many male fantasies as many times as she is replicated.[62]

Perry's critique raises an important question about Lil' Kim's performative utterances: are the visual signs of white female beauty and pornographic figurations the outer limits of Lil' Kim's excessive enactments? Perry points to Lil' Kim's transformation through plastic surgery, color contacts, and blonde weaves as mimicking not just any notion of white female desirability but specifically the pornographic body of a Pamela Anderson type. The phenotypic changes in Lil' Kim occurred gradually as her celebrity status grew larger, and she moved, in some degrees, outside of hip-hop culture into wider spheres of American popular culture. Her facial features shifted as her nose became pinched and her cheeks sat higher; Lil' Kim's breasts became exponentially larger; and her hair extensions were longer and straighter, often blonde. Susan Bordo describes "cultural plastic," a concept that she applies to popular performer Madonna, as "a construction of life as plastic possibility and weightless choice, undermined by history, social location, or even individual biography."[63] Through MTV appearances and fashion endorsements that often aligned her with a self-referential and camp aesthetic in the entertainment industry, Lil' Kim appeared to be carving her figuration and in so doing carving out a place for herself in American popular culture as predictably shocking and even safe in the ways that she performed excessiveness. One example of this is Lil' Kim's endorsement of MAC Cosmetics' Viva Glam campaign, which is a fundraising tool for MAC AIDS Fund, a position that aligned her with other former spokespersons including black drag queen RuPaul, Boy George, and Pamela Anderson.[64] Might Lil' Kim's plastic surgery and performance be a version of what Powell describes as "cutting a figure" in black portraiture by using her body as the medium? Her practice, though not redemptive or resistant, nonetheless engages with play, ostentatious display, and historical narrativity, features discussed in Powell's theory of black portraiture aesthetics.

The slippage of excess flesh enactments arise in reading Lil' Kim through such a framework as she increasingly manufactured her body on notions of eroticized white female bodies throughout much of the 2000s. Yet and still, there, in my estimation, is a curious appropriation of plastic surgery and visual signs of white femininity in Lil' Kim's refashioning of her facial

features and body parts. Her hyperbolic invocation of white pornographic fetish parts—such as oversized breasts, blue contact lens, and exaggerated hair length—point to her economic success, that is, the ability to purchase implants so large that they distort the proportionality of her body. In part, Lil' Kim's transformation is a sign of the boom period of the late 1990s–early 2000s that Christopher Holmes Smith describes that produced the hip-hop mogul as a result of economic, cultural and technological shifts that led to massive wealth accumulation for a few in historically underrepresented groups. One could read Lil' Kim's refashioning of her body parts as signaling the unnaturalness of white beauty, that is, the construction of beauty standards and the technologies and industries that create and maintain these standards. In so doing, Lil' Kim's enactment of excess flesh has transformed into an entirely different performance of difference. It is a performance that destabilizes the being of excess flesh and corporeal attachment to one that turns race and gender into plasticity, highly manufactured and purchasable goods. Lil' Kim has relegated herself to a familiar spectacle who is no longer spectacular.

While Lil' Kim's career has faltered throughout much of the last decade, partly because of a criminal conviction in which she attempted to cover up the criminal acts of a black male rapper, Lil' Kim resurfaced in 2009 on one of the most-watched network television shows of the year, *Dancing with the Stars*. Lil' Kim's body and body parts often became the subject of discussion for the television show's judges over her performance as ballroom dancer. One judge coined her "the bionic booty." After one performance, the judge announced, "Your booty can do no wrong."[65] In this respect, Lil' Kim circulated in mainstream popular culture as the being of excess flesh, a representation that overshadowed her performance on a performance-driven television show.

As I have examined in this chapter, excess flesh enactments produce very different results depending on the cultural realm of circulation and the position of artist/cultural producer vis-à-vis structural hierarchies of art, commercial culture, or racialized popular culture. The different readings and responses largely have to do with the relationship between performer/artist and audience and the ways in which authorship is understood within those various domains. In each instance, the black female body has been overdetermined and these cultural practitioners have worked to differing impacts to destabilize this overly familiar figuration. The examples of excess flesh enactments here discussed have focused primarily on a fashioning of the black female corporeal figure through nudity or exposure of body parts. In the next chapter, I focus on the strategic deployment of the clothed black

male body in hip-hop fashion and advertising. Hip-hop fashion companies, many owned by black men in the hip-hop industry, have turned the excess associated with black masculinity into big business. They have done this through turning the idealized and despised hypermasculine trope of black heterosexual masculinity into a very popular marketable good, associated with a wide range of fashion apparel and accessories.

Contemporary black entertainers attempt to perform (and articulate) the ways in which black aesthetic practices have transformed dominant commercialized popular culture in the United States and internationally. Black male stars like Sean "P. Diddy" Combs, Jay-Z, Russell Simmons, Kanye West, and Pharrell Williams have ventured into new commercial cultural forms meant specifically to deracialize explicitly the vestiges of blackness from hip-hop. For example, hip-hop mogul Sean Combs's most recent MTV shows have focused on creating music bands with primarily white audiences. Black women performers, however, have been positioned and have positioned themselves quite differently in these cultural realignments. In the early twenty-first century, black women continue to be marked by blackness rooted in a legacy of a racial past and their bodies continues to bear these psychic and corporeal scars in dominant visual culture.

FOUR

"I am King": Hip-Hop Culture, Fashion Advertising, and the Black Male Body

From leather Louis Vuitton suits to fat-laced or no-laced Adidas athletic shoes to tight spandex shorts, African medallions, baggy Tommy Hilfiger jeans, and oversized hooded sweatshirts, hip-hop fashion has provided the visual markers for a larger cultural movement that has transformed popular music and international youth cultures in the last decades of the twentieth century. Since the 1970s, hip-hop music has been associated with a broader set of cultural practices, including a social presentation that is aggressive, defiant, and yet composed; a resignification of language, dance trends, graffiti art, and fashion. Aside from the music itself, fashion continues to be the most profitable and recognized of the practices affiliated with hip-hop culture.

Black fashion and style are interwoven into many studies of black cultural history and criticism. Yet they remain arenas that have been underresearched in terms of their significance to blacks' cultural and material histories and the social and psychic formation of black subjects. In her study of black dandyism, Monica Miller explores how style, namely fashion, has been integral to the formation of black diasporic identities since slavery. Miller analyzes the relationship among black stylization, the performativity of blackness, and black diasporic identities.[1] Miller looks at black self-fashioning through the history of racial subjugation that heightens the stakes and risk involved in such practices. According to Shane White and Graham White, the historical development of a style among black everyday subjects in the United States as a "public presentation of the black body" is rich with seemingly ordinary acts of defiance, pride, self-articulation, but always with the risk of white disapproval and violence. White and White recount an early twentieth-century anecdote from Benjamin Mays's autobiography in which Mays was hit in the face in a public space by a respected

white man because Mays was "'trying to look too good.'"[2] Mays's self-fashioning was read by his white perpetrator as stepping out of the subjugated place relegated to blacks during Jim Crow segregation.

Robin Kelley argues that twentieth-century history abounds with examples of everyday stylistic and fashioning practices among blacks that offered a challenge to systems of inequality. While it was often the case that black everyday subjects were not using style as an overtly political stance, Kelley in his influential study "The Riddle of the Zoot Suit" considers the cultural politics of 1940s young, working-class black males whose fashioning and public presentation affronted middle-class sensibilities. Kelley argues that these zoot suiters "sought alternatives to wage work and found pleasure in the new music, clothes, and dance styles of the period."[3]

The post–civil rights era marked an important shift in black fashion and style, largely because of aesthetic changes in black hair and fashion. The influence of black freedom struggles, especially the Black Panther Party's coifed Afros and black leather jacket, and the African-inspired fashion of the Black Arts movement, provided alternative imagery for black self-presentation. Political and aesthetic shifts as a result of these movements spurned many racially identified fashion trends throughout the latter decades of the twentieth century. Looking at changes in black fashion in the post–civil rights 1970s, Richard Powell reads the portraiture of Barkley L. Hendricks, whose works in the 1970s "introduced a new subject to painted portraiture: young, urbane blacks whose claims to pictorial posterity resided neither in deeds nor dictates but in their clothes, carriage, and color." The figures in Hendricks's painted portraits of the era are not iconic subjects of dominant history. Instead they are blacks whose sense of self-presentation relies on a self-conscious fashioning of the body that signals racial alterity, confidence, and self-possession. Many of the black men who are the subjects of his portraits are dressed in wear that can be read as racially inflected, platform shoes, hats with large brims, sunglasses, and long trench coats with upright collars. Powell notes that Hendricks's subjects appear to acknowledge being watched, "being the objects of countless spectators."[4] Hendricks's work of the era documents some of the key elements that presaged the development of hip-hop fashion, attitude, and social presentation.

Jamel Shabazz spent much of the late 1970s and the 1980s documenting young black and Latino subjects affiliated with the emerging cultural movement now ubiquitously and globally known as hip-hop. In over 10,000 images from that era Shabazz focused on the fashion, style, and posture of a wide range of children, teens, and young adults whose presentation of their stylized bodies in public spaces established many of the visual signs

associated with the early movement. The interplay between the photographer, the camera, and the photographic subject exudes in his work through the deliberate, determined, and yet often playful poses, facial expressions, and stares of those photographed. Yet, as Kalefa Sanneh explains, Shabazz's idealized portraits are not based in the canonical documentary tradition of photographing human dignity in struggle, but based in the tradition of street glamour, urban black culture, and attitude as a way of life. Sanneh quotes Shabazz:

> I took very few candid shots. . . . I would approach a person and say, "Can I take your picture?" They'd say, "How do you want me to stand?" So I would give them a stance, a pose, and the pose added flavor to it. I'd put them up against a wall that matched their shirt, or find a fence that matched their hat, or back them up in front of a fly car.

Sanneh emphasizes the ability of Shabazz to capture the emergent subjects. For him, part of what makes Shabazz's practice so fascinating is that he would document for the approving eye of his subjects. He worked with them to produce idealized images of urban black style and life. Sanneh writes:

> When Shabazz returned to the same spot, days or weeks later, to share the prints with his subjects, they were invariably pleased—not because he'd captured some essential truth, but because his camera was telling a lie they wanted to believe. They'd never looked so good.[5]

The looking good in early hip-hop documented by Shabazz was a strategic and playful performance of visuality that signals codes not aligned with dominant cultural norms of fashion, beauty, and social demeanor. The subjects of Shabazz's camera redefine the flâneur based on the aesthetics and social conditions of postindustrial urban black life.

In *Number 2 Train* (1980), Shabazz photographs two young black men posing for his camera on a New York subway train whose interior walls are covered in graffiti and tags. One subject stands with arms held out to the side in a familiar hip-hop gesture that asserts readiness. The subject directly faces Shabazz's camera. His expression is both playful and confrontational. The face along with the position of his arms can be read as posing "What?," a black vernacular question that can have many interpretations, including "Why are you looking at me?" Or even more precisely, "I know I look fly. What do you have on me?" Representin' in the black vernacular sense of the

b-boy of the day, he is dressed in a white-striped Izod, white jeans, and Adidas tortoise-shell sneakers with thick, red shoelaces. His outfit is made complete with Cazal glasses and a black Kangol. The second subject leans, one foot balanced on the train seat, in crisply ironed khaki pants, matching socks, and white leather shoes. He wears a camel-brown leather jacket, a white bowler hat tilted to the side, and a gold chain. His slight smile and dress are representative of a young, urban, sophisticated street mack with legacies in blaxploitation aesthetics and pimp mythology. Together, the young men in *Number 2 Train* reflect the various style and aesthetic influences on hip-hop fashion and the performative utterances of the hip-hop fashioned body. Connecting contemporary urban youth culture to the history of black style as self-presentation of racial differentiation, Regina Austin writes, "Today's B-boys with their baggy jeans, reversed baseball caps, fade haircuts, rap music and cool poses are the modern-day descendants of the zoot suiters of the 1940s."[6]

Like black fashion in general, scholars have paid very little detailed analytical attention to hip-hop's fashion system and the rapid growth throughout the 1990s and 2000s of hip-hop fashion companies often owned by young black entrepreneurs and entertainers. The trends and visual cues of hip-hop fashion have been taken at face value as a method of identifying individuals and groups associated with the movement. When early hip-hop fashion has been discussed, it is quite often through the lens of subculture theory and fashion is relegated to one of many practices that mark (and oftentimes romanticize) the cultural movement as distinct from normative American culture.[7] More recent discussions of hip-hop fashion, in journalism and cultural criticism, have framed consumption among hip-hop practitioners through pejorative terms of capitalistic excesses and material greed. Austin writes about how black consumption practices are labeled as socially deviant behavior; she argues,

> the efforts of young enterprising artists and media types of the Hip-Hop Generation to generate markets with their ingenuity have provoked an outcry against the commodification of black culture. In late capitalism all cultures are turned into commodities, not just black American culture. Black American culture is always already in the public domain where it is ripe to be ripped off by anyone paying attention.[8]

Neither the paradigm of black subcultural authenticity or black deviant consumption attends to the complex interplay of the social performance of looking good in black vernacular culture; the resignification of visual and

Hip-Hop, Fashion, and the Black Male Body / 151

Figure 4.1. Jamel Shabazz, *Number 2 Train*, 1980. Courtesy of the artist.

fashion signs; the symbolic, material, and sometimes obsessive quest for wealth accumulation; and the development of an industry to mass-produce fashion goods associated with hip-hop. Central to the evolution of hip-hop fashion and its transformation into an industry is the fixity of the black male icon of hip-hop. Examining the significance of urban male fashion and the

iconic, racialized, adorned male body of hip-hop's material and visual culture offers insight into the relationship among materiality, representation, and consumption in black popular culture. Embedded in representations of the fashioned black male body of hip-hop is the interplay between a highly stylized and reproducible racial alterity, nationalism, and hypermasculinity. By racialized alterity in the context of urban fashion and black masculinity, I mean how the black male body signifies within and outside of black communities a form of coolness through racialized and masculine difference and a diaphanous "outlawness" that maintains an affective quality even as it functions as a highly reproducible and mass-marketed commodity.

This chapter examines the emergence of a hip-hop fashion system and its strategic uses of urban, young black male iconography to frame the black male figure of hip-hop as possessor of a new American dream and inheritor of the legacy of Americana.[9] Using writings on fashion and the fashion system by Roland Barthes, Diane Crane, Fred Davis, and Dorinne Kondo, I reorient fashion studies away from (white) women's wear and femininity to analyze black male fashion, the industry that supports it, and the interplay of masculinity, desire, ambivalence, and national identity. Dorinne Kondo's influential study of Japanese businessmen fashion examines the relationship between masculinity, race, and nationalism in fashion codes. Kondo argues that "[c]lothing can have a political edge as signifiers of subcultural style and as components of ethnic/racial pride," while simultaneously reinscribing problematic codes of nationalism and essentialism.[10] In considering the racialization and masculine construction of hip-hop clothing, I also critique notions of subcultural authenticity by focusing on the strategic production and performance of racial authenticity through hip-hop fashion wear. Authenticity is a highly racialized and complex term in American culture. John Jackson, in his ethnographic study of racial authenticity and racial sincerity, argues:

> To talk exclusively in terms of racial authenticity is to risk ossifying race into a simple subject-object equation, reducing people to little more than objects of racial discourse, characters in racial scripts, dismissing race as only and exclusively the primary cause of social domination and death.[11]

In the context of blackness and masculinity, authenticity imbues the subject with a mythic sense of virility, danger, and physicality; in representations of hip-hop, authenticity most often manifests itself through the body of the young black male who stands in for "the urban real." Focusing on the

production of racialized and gendered wear in hip-hop fashion, I examine the visual advertisements of several hip-hop fashion companies with attention to how authenticity, masculinity, and nationalism are retooled and ad/dressed through black masculine street fashion.

Hip-hop fashion, like the music, flourishes on the "mixing" of elements as diverse as high-end couture with found artifacts, tagging (or brand-naming), and sports apparel. Tricia Rose explains that hip-hop—as a style based in referentiality and reflexivity—thrives on appropriation and redefinition, which is the essence of "mixing," the musical technique that is at the root of the cultural movement.[12] Hip-hop fashion also regenerates itself through the same process. The ever-changing trends, many of which appropriate upper-class status symbols that have been coded as whiteness and privilege, such as luxury car insignias and European fashion designers, are the equivalent of the musical practice of sampling. In *Hip Hop America*, cultural critic Nelson George cites Dapper Dan, a Harlem designer who in the 1980s custom-made clothing that appropriated branding and design elements of high-end labels like Gucci and Louis Vuitton. Dapper Dan's Boutique had a clientele of black Harlem gangstas, athletes, musicians, and local residents. As rap became more established and profitable, Dapper Dan designed much of the clothing worn in early music videos and concerts.[13] Kobena Mercer argues that this process of mixing is fundamental to the development of black diasporic practices in his analysis of black hair style:

> Diaspora practices of black stylization are intelligible at one "functional" level as dialogic responses to the racism of the dominant culture, but at another level involve acts of appropriation from that same "master" culture through which "syncretic" forms of cultural expression have evolved.[14]

Because of these diasporic practices and the interplay between various forms and discourses in black cultural practices, hip-hop fashion and music complicate simplistic cultural models that posit authenticity against appropriation, or originality against commercialism.

Hip-hop culture, particularly fashion and the referencing of fashion in lyrics, often defies ways of understanding subcultural practices as inevitably incorporated into mainstream society through forms of commercialism and commodification that destroy or disempower the authenticity of the cultural practice studied. Noel McLaughlin, in his study of rock music, masculinity, and fashion, argues that authenticity is also a much-bandied term in studies of popular music and intensifies in discussions of music and blackness:

Indeed, the performative possibilities of black performers have been overlooked by a more general rock discourse that has validated black music as the authentic expression of racial "essence," and a key aspect of this has been the longstanding "necessary connection" forged between black people, black culture (clothes and performance styles) and music-making: between blackness, the body, rhythm and sexuality.[15]

The significance of appropriation, the performance of success/excess, and the preoccupation with looking good that are performative enactments at the heart of the hip-hop fashion system challenge the aura of authenticity that cloaks much of hip-hop's earliest musical and clothing styles and grassroots cultural practices. The "syncretic" process by which an aesthetic of racialized alterity blends with the quest for material wealth and financial success is most clearly evidenced in the visual invocation of Americana (and its aesthetic of red, white, and blue) by hip-hop fashion designers. These symbols of patriotism incorporated into hip-hop fashion and consumer goods work together with notions of urban black masculine alterity to create a character who is at once an ultra-stylish thug and the ultimate American citizen. His embodiment is most realized in the manifestation of the hip-hop mogul, a turn-of-the-millennial phenom. Christopher Smith defines the hip-hop mogul as an elite social position that developed at the end of the twentieth century made up of primarily young black male entertainers who became successful entrepreneurs by selling a variety of products, ideals, and values associated with hip-hop. Smith writes,

> In a time of imminent technological dislocation in the recording industry, all these men became famous for turning the relatively segmented market for urban music into a sprawling mainstream empire of life-style based merchandise spanning fashion, restaurants, soft drinks, film and theatrical production, and personal services.[16]

The successes of hip-hop moguls in the fashion industry rely on their ability to signify racialized and gendered specificity through the marketing of the urban black male icon while appealing to a wide range of young consumers of various races.

The Development of an Industry

The relationship between hip-hop music, specifically its lyrics, and fashion is mimetic. Clothing acts as the visual identifier of the sound, and articles

of clothing, specifically brand names, are cited frequently in hip-hop lyrics. One of the most notable and documented examples of the exchange between the music and the clothing style—the visual, material and auditory signs—is Run-D.M.C.'s popular 1986 song "My Adidas," along with the wearing of the sports shoes in the rappers' music video, concerts, and public appearances. Nelson George relays how Russell Simmons, then manager of Run-D.M.C., negotiated a deal with the owners of the German-based company Adidas. "Within a year, Adidas and Rush Management had negotiated a $1.5 million deal with the rappers to market Run-D.M.C. sneakers and various accessories."[17] Run-D.M.C., it is important to note, is considered the first major crossover rap group to win large audiences of young white people, in addition to core urban black fans.[18]

This deal among Adidas, Run-D.M.C., and Rush Management serves as a defining moment when hip-hop fashion moved from the incorporation and redefinition of existing trends to actually designing and marketing products as *hip-hop fashion* on a mass scale, that is, beyond the custom boutiques like Dapper Dan's Boutique and other similar small enterprises located in centers of hip-hop culture, like Harlem and Brooklyn. The affiliation between the product and the rap group is significant because it set the stage for other rappers to endorse retail products. It marks an important transition of the localized cultural practices associated with hip-hop into a growing culture industry.

By the early 1990s the relationship among hip-hop musicians, their lyrics, and major apparel companies had grown more intermingled, as large retail companies realized the economic potential of tapping into hip-hop culture. According to journalist Marc Spiegler, Tommy Hilfiger was the first major fashion designer who actively courted rappers as a way of promoting his clothing label. Spiegler, writing in 1996, contends,

> Over the past few years, [Biggie] Smalls [aka the Notorious B.I.G., now deceased] and other hip-hop stars have become a crucial part of Hilfiger's open attempt to tap into the urban youth market. In exchange for giving artists free wardrobes, Hilfiger found its name mentioned in both the rhyming verses of rap songs and their "shout-out" lyrics, in which rap artists chant out thanks to friends and sponsors for their support.[19]

Hilfiger's success convinced other large mainstream American fashion design companies, like Ralph Lauren and Calvin Klein, to tailor lines to the lucrative market comprised of hip-hop artists and fans. This targeting of hip-hop markets by large mainstream fashion companies like Ralph Lauren

and Tommy Hilfiger is part of what Laura Kuo argues is the commoditization of hybridity in the fashion industry during the 1990s. Kuo describes how multiculturalism gets marketed in fashion of the decade through what she calls "commoditized hybridity"—the conflation of "race, class, gender, sexuality, ethnicity, nation, and culture within a totalizing logic of neoliberalism."[20] Kuo's analysis of the advertising campaigns that marketed difference to increase its consumer base is in line with another industry trend that Paul Smith analyzes occurring during the same period in fashion. Smith argues that designers like Lauren and Hilfiger (Hilfiger being the focus of much of his analysis) adopted an industry practice of "mass customization" of designer fashion as a response to economic globalization in the late twentieth century.[21] Through mass customization, the good life symbolically represented in clothes by Lauren and Hilfiger became attainable to a broader section of consumers.

The 1990s also saw another crucial shift in hip-hop fashion production, as the market continued to expand through the popularity of the music and the visibility of the artists in music videos, commercial endorsements, and other venues. Black designers, many having created locally for black urban communities throughout the 1980s, acquired success and recognition nationally for their urban gear targeted at hip-hop communities. As stated earlier, much of hip-hop's early fashion trends (like Run-D.M.C.'s Adidas and LL Cool J's Kangol hat) began as appropriations of existing cultural goods and products. With the growth of young urban black designers and entrepreneurs, then, fashion trends were created and targeted now specifically at hip-hop markets. One of the first black designers to gain national attention and success in this market was Karl Kani, who has received significant recognition and praise from the fashion industry and business magazines, like *Black Enterprise*.[22] In the mid- and late 1990s, Kani's success resulted from the appeal of his clothes beyond urban black hip-hop fans, a shift that brought profit to many hip-hop clothing companies. Journalist Tariq K. Muhammad writes, "His trademark style, which includes baggy jeans and oversized casual knits, found an unexpected white suburban audience eager to mimic black urban fashion." In examining the roots of Kani's popularity, Muhammad employs a typical schema used to analyze hip-hop that reinforces notions of authenticity about black cultural practices in which blacks create and whites consume. The success of Karl Kani opened the door for several other black designers and marked the expansion of a lucrative market. By 1998 the fashion company FUBU [For Us, By Us], founded by four young black male designers, made $350 million in sales.[23]

The success of designers like Kani, FUBU, and Moshood in the 1990s

has much to do with the in-roads that black fashion designers and models made in fashion centers like New York City during the last half of the twentieth century, especially during the disco era. Stephen Burrows, Willi Smith, and Scott Barrie were a few of the designers whose clothing was embraced in the 1970s. These designers were trained in fashion schools and apprenticed within the design world. Their work, like most fashion, was targeted at women's wear. Burrows, who graduated from the Fashion Institute of Technology and is a three-time Coty Award winner, was known for designing work that spoke directly to disco culture and music. In a review of his spring line in 1977—at the height of disco—fashion critic Nina Hyde described him as "a master of the sexy feminine look, whether in chiffon, crepe or jersey, and even in chamois. He uses elasticized or drawstring waistlines and drawstring necklines, partly for comfort but also 'so that the clothes work differently for each woman'" (quoting Burrows).[24] One recurring feature of his oeuvre is particularly relevant for how it speaks to black fashion and visual culture largely and directly to the development of hip-hop fashion a generation later: the visibility of seams and cuts in his design.

> Sociologically, Mr. Burrows captured a moment—presaged it, even—that being the moment of Gloria Gaynor and all of the 3 a.m. revelry attending it. Fashion history has ascribed to Halston the look of the disco years, but Mr. Burrows's clothes caught the messiness of that time more instinctively. Unlike Halston's, his lines were never quite as clean or refined. He worked in matte jersey and cut chiffons with uneven hemlines. His colors were bright to the point of assault. The necklines on his sequin halters billowed and sloped. His signature was lettucing, a technique that made a hem or the edges of a wrap dress, say, look like the crinkled tops of a carnation.
>
> The most distinctive element of Mr. Burrows's clothes is that they looked as if they left the house around midnight to wind up the next afternoon a crumpled heap on some bedroom floor at an address the wearer was probably not all that familiar with 24 hours earlier.[25]

I cite reviews of Burrows's designs in some detail here because of certain aesthetic elements in his work that recur in hip-hop fashion a generation later. The aesthetic of visible seams is a recurring "stitch" in black visual and cultural practices. The visible seam is a technique and a look that resurface in hip-hop clothing such as the designs of Karl Kani and FUBU in the 1990s. Much of their clothing incorporated bold or contrasting stitching that highlighted t-shirts, jeans, and sometimes shoes. Their lines were also known for asymmetrical contours and patterns often as stitch work on pants pockets,

sweaters, or the back of shirts and jackets. These hip-hop fashion designers would often work with Black Nationalist and pan-Africanist symbols and colors to signify racial differentiation through their fashion.

While hip-hop fashion lines began with fashion designers who specialized in clothes for hip-hop musicians and fans, the hip-hop fashion industry soon merged with the music industry as the hip-hop musician/producer turned fashion designer and business entrepreneur, that is, the hip-hop mogul, emerged. In Smith's analysis of the hip-hop mogul as cultural icon and business powerhouse, fashion is just one of the areas of capitalist and cultural expansion for this entrepreneur. He emerges as one of the successes of the continuous expansion of popular and entertainment cultures and the rise of the New Economy, marked by deindustrialization, technological advances, and the rise in the service industries. The most celebrated are Russell Simmons, Sean Combs, and Jay-Z, all having established very successful fashion lines that topped the market in profits during the past decade.

Among the first to establish his multiplatform reign in the areas of hip-hop cultural production and dissemination is Def Jam Records co-founder Russell Simmons, the same businessman who negotiated the deal between Adidas and Run-D.M.C. With his creation of the hip-hop clothing company Phat Farm in 1992, the production of the music and the creation of its fashion trends were inextricably linked. Simmons, one of the most successful entrepreneurs of hip-hop culture, opened up the possibility for the cultural producers of the music to become also producers of its fashion trends.[26] The number of rappers and hip-hop groups who have established clothing lines since Simmons's initial success is too long to list here; 50 Cents Eminem, Nelly, OutKast, and Pharrell are just a few. By the first decade of the twenty-first century, the companies were so numerous that in many respects a clothing line became just another venue of celebrity promotion and an extension of the rapper's lyrics and public image. Hip-hop cultural industries, like multinational retail companies in the mid-nineties (GAP and Abercrombie and Fitch, for example), successfully turned profits on branding a lifestyle.

Phat Farm apparel invokes the discourse of Americana while playing with and remaining bound by the trope of black male as public threat, or the menacing "hoodie"-wearing black thug of postindustrial American visual culture. Simmons's Phat Farm line makes for an interesting case study of how fashion becomes a venue for branding and marketing the hip-hop lifestyle and demonstrates the reproducibility and desirability of the hip-hop b-boy as a commercially viable marker of the cultural movement. Part of the company's success rests in Phat Farm's ability to market its line as

mainstream American culture, while simultaneously incorporating notions of subcultural authenticity. Simmons, who remained closely involved with the development of Phat Farm's fashion products in the 1990s, was quoted as proclaiming that t-shirts "'are gonna make me richer than records ever did.'"[27] Influenced by the successful marketing and design of fashion moguls Tommy Hilfiger and Ralph Lauren in hip-hop communities, Phat Farm employs the red, white, and blue of the American flag in clothing patterns and the company's logo. In the selective advertising campaigns—geared toward hip-hop and young adult magazines and billboards in urban settings—Phat Farm, as representative of many hip-hop fashion companies, seeks new sites of coolness through a reappropriation of the aesthetics of Americana. These campaigns exploit cultural nostalgia for a mythic national past while re-envisioning urban b-boys and those who want to be such hipsters as the native-born sons and inheritors of "the America" of myth.

While the urban black male who represents hip-hop fashion stands for alterity and difference from mainstream fashion and society, he is bound by the restrictive visual codes of this particular fashion system and the normative ideology of American capitalism and nostalgia. Fred Davis argues that fashion distinguishes itself from style and custom through its compulsion for change; he also argues that change in fashion is necessarily cyclical. According to Davis the cycle of fashion moves from cultural producer (such as fashion houses or independent designers) to elite consumers or small group-identified populations to mass markets to the death of the trend. While change is essential to fashion, originality and creativity are subjugated to familiarity with styles for retailers and consumers.[28] Diana Crane, in her study of the sociology of clothes and gender, expands this analysis to examine how social norms discipline fashion and the fashioned body.[29]

The trends of the larger hip-hop fashion companies exemplify the normative and commercial prerogative toward modesty as it also defines itself by its visibility and distinction from other fashion styles. For instance, a simple, quite mundane, item produces much of the wealth in hip-hop fashion: baggy, oversized jeans. Tommy Hilfiger built his fashion empire on this seemingly understated article of clothing. New lines by emerging designers often test the market by branding jeans (often competing lines are manufactured by the same sweatshops) and selling them selectively at street markets, in regional boutiques, or showrooms. Like most styles produced by the fashion industry, hip-hop clothing trends change each season; yet, oversized designer jeans, hooded sweatshirts known as "hoodies," athletic shoes and boots have remained staples throughout the past two decades. In this same period and through these conservative trends, the hip-hop fashion industry

has secured itself as a force to be reckoned with in apparel. As the industry grew throughout the 1990s and 2000s, the market moved toward a level of homogenization exemplified by the popularity of hip-hop styled jeans. Apart from denim and seasonal colors, the more popular hip-hop fashion styles are based on reproducing the three colors of the American flag in patterns and fabrics that both reference and redefine the nation and patriotism. What distinguishes the articles of clothing is the company's label placed strategically on the products. Wearing a hip-hop fashion line is a method of demonstrating one's affiliation with a particular rapper and whose line one supports as a customer, similar to supporting a favorite athlete by wearing the jersey of the sports star.

Like popular sports and the music itself, hip-hop clothing style is virulently and heterosexually masculine and designers cater to male teenagers and young adults. This is not to say that women do not exist in hip-hop fashion or music, but that the industry promulgates itself on the fetishized body of the young black male. Until the later establishment of fashion lines for women and girls in hip-hop—like Baby Phat (the feminized division of Phat Farm), Jennifer Lopez's fashion lines JLo and Sweetface, Eve's Fetish clothing line, and Beyoncé's Dereon, hip-hop designers almost solely made clothing for males or created unisex articles and accessories, in part because female fashion is a much more difficult and risky industry to enter. More significant, though, is the emphasis on the racialized and masculine body in hip-hop culture. When hip-hop fashion companies like Phat Farm create apparel for females, the line is branded as something distinct from its trademark male line. In Phat Farm's case, Baby Phat has as its logo a silhouette of a stationary domestic cat with a curvy tail. This clothing line is highly sexualized, consisting of club clothing, such as tight-fitting body suits, miniskirts, and revealing lingerie. The marketing of Baby Phat has centered around the image and style of Russell Simmons' now ex-wife, model Kimora Lee Simmons, who has modeled for the line since its inception and is an executive in the company. Kimora Lee is the face of the line and represents an unattainable fantasy for many of the line's female consumers to marry into hip-hop royalty. Phat Farm, with its relaxed style of baggy jeans, oversized sweaters and head gear, can be seen as an extension of Simmons's fashion style and personality (he is known for his casual dress, which always includes a Phat Farm baseball cap or hat), while Baby Phat embodies Simmons's (now ex-) wife, the iconic, mixed-race (Asian and black), runway model, whom Simmons at one time described as his trophy. The racial and gender signification in these articles of clothing is most clearly exemplified

in a Phat Farm t-shirt sold in the early 2000s; the t-shirt included a large imprint of Kimora's face and was targeted at young men, further highlighting that the figure of the female body exists to accessorize that of the male.

The more recent and ancillary female fashion lines in hip-hop have received much less attention and have been less profitable.[30] For example, the rapper Eve's Fetish line has been relaunched multiple times with different partnerships over several years but without being able to establish itself as a force in the fashion industry.[31] Of note is the controversial male rapper Nelly who has been the subject of much debate and protest among black women because of his representations of women in his music videos; Nelly has been moderately successful with his women's clothing line Apple Bottom, designed with the intention, according to marketing materials, of "liberating the natural curves of a woman's body."[32] These lines geared toward women and girls have had modest popularity among young urban consumers but have not had the national appeal or success of male hip-hop fashion lines. This, I believe, in many respects has to do with the cultural impact of the black masculine iconic figure that centers hip-hop style and culture. Many women who participate as consumers and rappers in hip-hop identify with the signs of heterosexual masculinity in hip-hop fashion. Imani Perry argues that some female hip-hop artists, practitioners, and consumers choose to wear what is perceived to be masculine fashion, like baggy jeans and athletic shoes, as a response against the codes of white and racialized femininity. Perry writes, "Even as black Americans maintain a separate sexual aesthetic, white female standards of beauty still haunt black women, so that some African American women have chosen more masculine outfitting as a counter-hegemonic move."[33] Thus, the racialized alterity of the black male icon in hip-hop fashion is also consumable and wearable by women and girls in hip-hop.

The consumption and performance of a racialized masculinity and success (material and sexual) are linked inextricably through hip-hop fashion. The declaration of success/excess is reiterated in the lyrical play of rappers. For example, Notorious B.I.G.'s "Big Poppa" analyzes and romanticizes the seduction and decadence of this condition: "Money, hoes and clothes all a nigga knows / A foolish pleasure, whatever / I had to find the buried treasure / So grams I had to measure / However living better now / Gucci sweaters now."[34] The growth in the hip-hop fashion market is one more example of the seemingly unlimited possibilities of capitalism to make a profit from cultural movements, no matter how dissident.[35] The diversification of hip-hop culture into various successful industries is also a result of the maturation

of the cultural movement after more than two decades of growing from the local to the national to the transnational.

Marketing Hip-Hop Americana

The growth of the hip-hop fashion industry and the spectacle induced by what has been framed as another hip-hop gold mine are seen in the coverage and advertising in hip-hop magazines, most notably *Vibe* magazine, founded by music producer Quincy Jones in 1993. From the late 1990s throughout the first decade of the twenty-first century, as the hip-hop fashion industry grew, *Vibe* magazine moved to incorporate more fashion into its content, not just through advertisements. The "V Style" and "V Fashion" sections of the magazine—consisting of theme-based fashion shoots that often include top models, musicians, and other celebrities—began to take up a significant portion of the magazine's pages. In the October 2001 edition of the magazine, the two sections occupied twelve pages and showcased designers as diverse as Gucci, Ralph Lauren, Helmut Lang, and Mecca USA. In *The Fashion System*, Roland Barthes outlines the relationship between "real" (my quotation marks)—or material—clothing, image clothing as in photographs and illustrations in magazines, and written clothing, or the language used to describe articles of fashion. "V Style" and "V Fashion" are particularly interesting because of their incorporation of narrative into fashion; the sections produce written clothing that, according to Barthes, "endows the garment with a system of functional oppositions (for example, fantasy/classic), which the real or photographed garment is not able to manifest in as clear a manner."[36] *Vibe*'s fashion spreads place the body of hip-hop in a state of constant leisure and play. The highly stylized fashion photography in the magazine often reinterprets music videos and rap lyrics. These "functional oppositions" arise in *Vibe*'s fashion sections, in part because of the inaccessibility of realizing these fantasies for most of its audience—teenagers who are in some way bound by parental, financial, and legal constraints. Dorinne Kondo analyzes the relationship among desire, identity, and fashion advertising:

> Within our regime of commodity capitalism, it is hardly surprising to find powerful articulations of identity in a domain whose business is the figuration of idealized objects of desire: advertising. Designed specifically to promote identification and provoke object lust, consciously deploying techniques to pull on issues resonant for their audience, ads—particularly fashion ads—become privileged sites for the examination of subject formation.[37]

The magazine served as a central site, along with music videos, for transmitting messages of the fashioned, and predominantly masculine, body of hip-hop (often through visual fantasies of material wealth and sexual excess) at the turn of the millennium.

A Phat Farm advertisement in the October 2001 issue of *Vibe* occupies two of the most expensive pages in the front of the magazine. The advertisement is seemingly simple. In close focus is a young dark-skinned black male in a gray sweat suit. In the center of his chest and on his left thigh is the "Phat Farm" logo in red and white block letters. His hands are in his pockets and the hood of the sweatshirt covers his head. The hoodie frames his features and the photographic lighting emphasizes his high cheekbones, bald scalp, polished skin, broad nose, forehead, and slightly puckered full lips. The model does not meet the spectator's gaze. Instead, he looks down and off to the side, outside of the spectator's line of vision. Behind him, a young Latino walks toward him with his hands in his pockets; he looks off to the side, in the same direction as the other model's gaze. His head is angled upward, while the black male's head is slightly tilted down. The approaching model wears ubiquitous baggy blue jeans and a plaid blue shirt with "Phat Farm" scripted above the breast pocket. He also wears a large blue casual jacket with the company's name again above its breast pocket. While he is clean-cut and carefully groomed, his clothes are referential of the uniform of the Crips gang, particularly the uniformity of the color blue by which the gang is identified. The two models are on a picturesque autumn lawn replete with auburn leaves. They both have anticipatory glances on their faces as they look outside of the spectator's line of vision. A large two-story brown shingled home serves as the backdrop with a peaceful sky above. Next to the Latino model is a graphic of the Phat Farm logo—a large letter *P* encapsulated by two slightly curved lines on each side. The ubiquitous motto of the company, "Classic American Flava," resides underneath the *P*. In the corner of the advertisement, as a small graphic, is the Phat Farm *P* again but this time in a layout reminiscent of the American flag with red and white stripes.

The Phat Farm advertisement invokes an aesthetic of suburban sublime oddly in harmony with the markers of an urban, youthful, racialized code. The suburban house with its colorful leaves on the lawn is not foreign territory for the urban young men in the photograph; instead, they exist in this space as its normative occupants. They *belong*. The black male model in the hoodie references the trope of the urban black menace so clearly visualized in the ghetto action films of the early 1990s and contemporary music videos.[38] Yet, here in this setting of suburban bliss, he is so clearly not

Figure 4.2. Advertisement as it appeared in *Vibe*, October 2001. Courtesy of Phat Farm, LLC.

a threat. He stands reflectively—at peace—with hands in pocket, looking with a reflective gaze. The Latino model, whose fashion symbols evoke gang identification, no longer signifies fear or intimidation; instead he walks with his body open toward the camera and a wistful gaze on his face. Although they employ the racialized and youth-based codes of visual threat in postindustrial US culture, here on the lawn in peaceful suburbia they occupy a place of tranquility and belonging. They are *together* here in this American dream. Their clothed bodies have become incorporated into the American sublime—the pastoral—the belief in mythic destiny and unlimited success. The Phat Farm tag line "Classic American Flava" is crucial to the *refashioning* of their bodies in the advertisement. Applying Barthes' concept of written clothing, language produces meaning that:

> conveys a choice and imposes it, it requires the perception of this dress to stop here (i.e., neither before nor beyond), it arrests the level of reading at its fabric, at its belt, at the accessory which adorns it. Thus, every written word has a function of authority insofar as *it* chooses—by proxy, so to speak—instead of the eye. The image freezes an endless number of possibilities; words determine a single certainty.[39]

"Classic American Flava" reinforces the image and the positioning of the two young males as inheritors of American wealth and destiny. At the same time, the use of "flava" in exchange for "flavor" implies a racial and stylistic rewriting of the American dream. The tag line invokes American privilege and dominance while subverting the normative whiteness and history of exclusion that these concepts connote.

Fred Davis's notion of ambivalence in contemporary fashion is useful here for analyzing the merger of normative icons of Americana with nonnormative or underrepresented (in the realm of fashion) bodies. For Davis, ambivalence—like change—is the basis of the regeneration of fashion styles. He writes: "As for fashion specifically, while it must of necessity work within the broad parameters of a relatively well established and familiar clothing code, it turns for fresh inspiration to tensions generated by identity ambivalences, particularly those that, by virtue of cultural scripting and historical experience, are collective in character."[40] The role of ambivalence is central to the success of hip-hop fashion marketing campaigns and is what makes the Phat Farm advertisement decipherable. Kuo considers such ambivalence a key to the marketing of commoditized hybridity. She argues that such advertising

> operate[s] on the ability to hold two contradictory beliefs. This disavowal of difference—*I know very well* that all people are not equal in the United States due to racism, labor exploitation, homophobia, classism, sexism, and so on, *but nevertheless*, I believe that everyone is equal and can be "one"—is structured on the dual recognition of: (1) racial inequality and (2) the multicultural promise that enables the political meanings of these photographs to circulate in the first place.[41]

Using Kuo and Davis, the visual salience and cultural value in the Phat Farm advertisement has precisely to do with the history of exclusion of these racialized bodies from the material and symbolic registers of American success and the good life, such as the suburban enclave.

This high level of self-consciousness about evoking the rhetoric of Americana while reinventing "the nation" emerges explicitly in Phat Farm's post–September 11, 2001, advertising campaign. In the April 2002 issue of *Vibe* magazine, Russell Simmons addressed his customers and his mythic hip-hop nation directly through a full two-page advertisement that consists of Simmons, dressed in Phat Farm clothing, standing in front of the Phat Farm rendition of the American flag. Text with his signature accompanies the image; the quote reads:

> Ten years ago we found Phat Farm,
> a brand born out of the
> Hip-hop lifestyle—
> a lifestyle others did not acknowledge.
> But one that became bigger than
> their ability to suppress.
> Today we stand in front. [in larger, bold and italicized font]
> We are humbled and give thanks to those
> who support us in the pursuit of
> a new American dream.

In the post–September 11 era, Simmons is even more explicit in invoking nationalism, possessing the symbols of Americana, and framing consumerism in patriotic terms. Simmons constructs race on nationalistic terms as a performative engagement with social and symbolic signs and through participation in certain practices as a consumer. He argues that hip-hop fashion becomes a shared language for the imagined nation as envisioned by hip-hop entrepreneurs.

The audiences targeted by hip-hop fashion advertisements show the contradiction in commoditized hybridity marketing as Kuo discusses. It has been widely acknowledged and discussed (possibly overemphasized) that by the early 1990s white young males made up the largest demographic of consumers of hip-hop cultural products. Thus, Phat Farm, in appealing to an audience beyond urban racialized fans, reframes the b-boy and gang-identified tropes of visual culture and domesticates them by setting the models in the milieu of hip-hop fashion's more lucrative consumer base—middle America, the suburbs.

The media coverage of one of the most public and successful hip-hop moguls, Sean Combs, demonstrates the ambivalence between the signs of hip-hop fashion and ambitions of hip-hop fashion designers and entrepreneurs. Combs and his highly publicized personal life, including trials for criminal wrongdoing, previous romantic involvement with Latina superstar Jennifer Lopez, and series of successful television shows and other offshoots of hip-hop culture, come to stand in for his clothing line. His representation as an above-the-law, resourceful, and refined thug overshadows the industry recognition that he has received for his clothing company. Most notably, Sean Combs was the first black designer to be nominated for the prestigious "Perry Ellis Award for Menswear at the American Fashion Awards."[42] Yet, in a February 2002 series covering New York's Fashion

Hip-Hop, Fashion, and the Black Male Body / 167

Figure 4.3. Advertisement as it appeared in *Vibe*, April 2002. Courtesy of Phat Farm, LLC.

Week, the *New York Times* featured Combs and his well-received clothing line, Sean John, with a headline reading "A Fashion Statement: Hip-Hop on the Runway." Journalist Guy Trebay writes:

> A clue to Mr. Combs' ambitions came Thursday, when he appeared, along with Terry Lundgren, the president of Federated Department Stores, to ring the opening bell at the New York Stock Exchange. Some on hand remembered that the last time Mr. Combs appeared publicly downtown was to hear his acquittal in criminal court on charges of carrying a concealed weapon in a nightclub. He was wearing a suit on that occasion last year, and he wore an even nattier one of chalk stripes from Versace this week, as he spoke about the importance of giving New York economic support.[43]

Trebay's comments invoke the language and imagery of black criminality and illegitimacy; in doing so, these racialized invocations overshadow the success of Combs's entrepreneurial venture and fashion contributions. For Trebay, Combs's fashion line is newsworthy in how it reflects upon

normative ideas about black masculinity, specifically the specter of the black deviant thug who is always a public threat and an illegitimate participant in the wealth and success of American capitalism.[44]

At the same time, hip-hop moguls capitalize on the media's twin representations of their entrepreneurial successes and their signification of black masculine alterity. In a 2009 billboard advertisement for Combs's cologne, King, an offshoot of his fashion and accessories line, Combs's body stands in for the former of these representations. The larger-than-life image runs eighteen stories alongside a high-rise building in New York City's Times Square. Sean Combs poses in evening wear with black slacks, a white dress coat, and a black bow-tie. Combs stands relaxed, confident, and intent, looking out over the cityscape. In his ear is a large diamond, reflective of the waning era of bling-bling. Under his image, scaled much smaller, is a bottle of the cologne being advertised. Next to the cologne reads, "I am King" with the signature logo of his fashion company, Sean John, in scripted letters—a signature of authentication. Above the poster is a larger inscription of the logo. Combs is dually dressed as the embodiment of American success and establishment and as racially inflected other.

A few blocks away from Combs's advertisement is another larger-than-life image of a hip-hop entrepreneur turned fashion designer. On the side of the building that houses MTV and VH1 channels, one of the most popular sites for tourists and youth in New York, is a billboard for Jay-Z's Roca Wear clothing line. The advertisement is a profile shot of Jay-Z performing with a microphone held to his mouth. Jay-Z, one of the most prolific and critically acclaimed rappers of the past two decades, is applauded by hip-hop fans for his ability to stay connected to the mythic and material "streets" of hip-hop as he has become one of the wealthiest individuals in popular music of the early twenty-first century. Jay-Z's image is moody and mysterious. His face is obscured in shadow and dark lighting. His head is tilted down and sunglasses cover his eyes. His dress is unimportant here; he is dressed in a gray button-down that is only partially seen. His hand reaches out as if penetrating the two-dimensional plane of the photograph and hovers above the crowds and passersby on the streets of Times Square. These twin billboards—Combs dressed in evening wear and the signs of the cultural elite, Jay-Z a "lyrical god" of the street—represent the interwoven messages marketed through hip-hop fashion and advertising.

Underlying this dual representation is a dialectic that places authenticity in hip-hop cultural in productive tension with the pursuit of capitalism—a dialectic that has existed as long as the art form itself. As the industry has grown, hip-hop entrepreneurs like Combs and Simmons have become conscious

Figure 4.4. "I am King" advertisement, Times Square, New York, September 2009. Courtesy of Tracy Collins.

Figure 4.5. Roca Wear advertisement featuring Jay-Z, Times Square, New York, September 2009. Courtesy of Tracy Collins.

about aligning their fashion companies with American cultural and national symbols while, at the same time, promoting their clothing as based in the realness or authenticity of the urban streets. Many hip-hop entrepreneurs perform the authenticity of their clothing as b-boy gear by wearing their labels routinely in public and simultaneously articulating their desire to have their line become incorporated into mainstream fashion. In a 1999 article journalist Nancy Jo Sales quotes Simmons's reaction to a buyer from a major department store who shows little interest in carrying Phat Farm apparel:

> "I'm talking to that [name deleted] who does the buying for [name of shopping mall chain deleted]," he sputters, "and she says, 'Oh'—he makes his voice high and phony—'we just don't want any *jeans stores* in our shopping center.' Now, what does *that* mean?" He's frowning, waiting.
> "Means she doesn't want a lot of little ghetto niggas runnin' up in there," he says.[45]

This exchange, as reported by Sales, brings to the fore what Simmons must do in order for T-shirts to make him richer than records, his stated ambition. Simmons' response to the buyer articulates the anxiety of hip-hop fashion producers who having capitalized on a niche market find themselves bound by the niche that they helped to create. The drive to turn a profit from hip-hop cultural production and the desire to create the visual markers of urban coolness in turn bring questions of credibility and an interrogation of the authenticity of the product and producer. By 2004, the success of Simmons' twin-fold goals—to signify hip-hop authenticity and to become extremely wealth through selling fashion goods—manifested in the purchase of his fashion empire, including the Baby Phat trademark, for $140 million by Kellwood, a camping and conservative apparel company known for moderate-price fashion items geared toward women.[46] In the same article, Sales quotes Andre Harrell, a black music producer and Simmons's good friend, expounding on the impact of the hip-hop industry on American culture and economy: "This is not about a moment. . . . This is way past a moment. This is Americana; this is a cultural change."[47] Harrell's grandiose statement announces to a larger public who fears a change in power from white male hands to black male hands that change has already occurred. Harrell explicitly claims American myth and legacy for the hip-hop community, specifically its black male entrepreneurial leaders, as he actively constructs a new narrative for "Americana." They are the new "forefathers" in Harrell's framework for understanding hip-hop's impact. We are to understand his proclamation as continuing, while reinventing, the legacy and

"greatness" of America. Harrell's statement can be read within what Hazel Carby calls the legacy of "race men" who consider the work of race and nation building in the United States as (black) men's business.[48]

"Black Style Now" as Hip-Hop Fashion's Past

As hip-hop fashion companies have grown larger and more diversified in goods produced and marketed, they have moved away from racial or culturally specific language in marketing their brands. In an article about hip-hop fashion, Leslie E. Royal writes, "To further widen their appeal many urban designers are moving away from using the label 'urbanwear' and moving toward 'contemporary' or 'metropolitan,' says Ellzy of the Fashion Association."[49] This is an obvious move to deracinate the lines and simultaneously have them reflect consumable difference. Herman Gray writes of this tension throughout black masculine visual and material cultures: "Self representations of black masculinity in the United States are historically structured by and against dominant (and dominating) discourses of masculinity and race, specifically whiteness."[50] Gray's analysis applies to the instability of authenticity or "realness" in hip-hop music and visual culture, given that these categories are shaped in terms of competition among hip-hop markets and entrepreneurs, corporate marketability, and white audience reception. The success of hip-hop designers and entrepreneurs to absorb hip-hop fashion into mainstream fashion apparel and, more significantly, dominant narratives of success and difference as depoliticized and individualized can be seen on multiple fronts.

Hip-hop fashion companies that developed after an established market had been secured have moved away from the conservative fashion apparel on which companies like Phat Farm and Roca Wear built their fortune: hypermasculine apparel, namely baggy jeans, oversized outerwear, caps, and t-shirts. Pharrell Williams, a well-known hip-hop producer and musician whose musical experimentation pushes hip-hop beyond the hard-edge representations of black masculinity that have proliferated since the late 1980s and the rise of gangsta rap, started two fashion lines in the mid-2000s. Williams's Billionaire Boys Club and Ice Cream combine hip-hop fashion with Japanese animation, skateboarding style, and science fiction and target consumers who are interested in the purchase of hip-hop as hybrid culture (as distinguished from hip-hop as representative of an "authentic" urban street or thug culture). Williams very self-consciously distinguishes his fashion sensibility from earlier hip-hop fashion lines. In an interview, he expresses

his distaste for "bling" and what he describes as bright and loud clothing (i.e., racially inflected colors and patterns). Marking his difference from the visual icon of black hypermasculine alterity, Williams states,

> I was a kid who wore Vans and Vision Streetwear, bad T-shirts, plaid pants and weird haircuts. But I admired Rakim. He was the best rapper, and stylistically he was about big gold chains, classic sneakers and customized Dapper Dan threads [the clothier to old-school rappers]. Billionaire Boys Club has some eighties influences—some of it reminds me of what LL [Cool J] used to wear when I was a kid. Ice Cream is more about skate couture.[51]

For Williams, old school hip-hop fashion becomes one of many influences of an aesthetic that signals "commoditized hybridity," not simply as marketing strategy but as the fashion wear itself. Williams's references to hip-hop are not in terms of its authenticity but one of many elements for a new urbane self-fashioning. It is an example of a twenty-first century relationship to hip-hop in which hip-hop's past is rendered palatable and even somewhat kitsch. No longer does the black male icon of hip-hop signal threat. Instead audiences interpret the posturing as a performance of racial alterity, of self-conscious differentiation based on familiar tropes of race.

Another sign of hip-hop fashion's incorporation into mainstream fashion industry is the self-conscious historicizing and institutionalizing of hip-hop's fashion history and its impact by key figures in hip-hop. In fall 2006 the Museum of the City of New York hosted a wildly popular exhibition titled *Black Style Now*. The show's brochure describes it as

> dynamic and diverse, bold and colorful. It's street style and it's high fashion. It's sexy, soulful, athletic, and it's all about attitude. BLACK STYLE NOW explores how black style has evolved in New York City and how the hip-hop revolution has turned fashion on its head. Hip-hop—today America's most important cultural export—has made black style big business, bringing attention to black designers and claiming a huge market of consumers—black and not—who have been eager to buy the latest in BLACK STYLE NOW.

The promotional material contains hyperbolic statements about hip-hop including "today America's most important cultural export." The show becomes a reflection on hip-hop fashion by hip-hop fashion companies with the sponsors of the exhibition including three of the largest hip-hop fashion companies, Academiks, Roca Wear, and Sean John. The exhibition was

wholly celebratory of black style innovation and, more important, commercial success, with almost no critique of the culture of excess and material consumption.

In reviewing the show, Eric Wilson notes that black fashion designers of an earlier era, like Stephen Burrows, have received more attention due to the prominence of hip-hop fashion companies and the black hip-hop moguls who own these companies. However, Wilson questions the credibility of hip-hop moguls as designers, writing:

> If that has changed [recognition of black designers], it is mostly a result of the runway arrivals of hip-hop artists and record producers like Sean Combs and Russell Simmons, who are not really designers but entrepreneurs building clothing brands from their outsize personas, capitalizing on a style born of black street culture, and not so different from, say Donald Trump's constructing a brand on the culture of the boardroom.[52]

Interviewing the two curators—Michael Henry Adams and Michael McCollom—Wilson writes that the curators worked to expand the vision of the exhibit beyond its conception by the staff of the museum:

> The two men said senior museum administrators envisioned a crowd—pleasing display of youth styles that started in the streets and became an exuberant worldwide uniform. They did not want the show to fully explore thornier issues behind the mass market embrace of hip-hop looks—specifically, whether styles based in criminal subcultures perpetuate antisocial attitudes.[53]

The success of hip-hop fashion has hinged on the tension it produces as performance and promotion in authenticating "the urban real" while mass marketing commodifies a new reading of "Americana" and "American"-ness. While the popularity and success of hip-hop fashion companies are in every way a manifestation of advanced capitalistic processes in which the development of niche markets and the marketing of lifestyle brands continually fuel capital's expansion, the phenomenon is also an example of the rich and complex history and practices of hip-hop culture. Throughout much of the movement's history, its cultural producers have courted capitalism and promoted consumption through the marketing of difference. The late twentieth century trend to refashion "Americana" as cool and racialized through hip-hop clothing provides another lens to view black masculine investment in the legacy, wealth, and myth of nation. As significantly, these recent strategies to reclaim "America" have increasing significance given hip-

hop's growing transnational marketability. Wilson quotes Sarah Henry, the deputy director and chief curator of the Museum of the City of New York, "Black style has become American style and arguably world style. . . . The hip-hop revolution has transformed the way the world dresses."[54] The refashioning and promotion of the new and cool America performed through the black male b-boy and produced by the hip-hop mogul are manifestations of globalization and the marketing of youthful and racialized alterity as a stylized and reproducible commodity.

FIVE

Visible Seams: The Media Art of Fatimah Tuggar

Media artist Fatimah Tuggar's video *Fusion Cuisine* (2000) unveils connections among historical and present notions of technological progress, racialized and gendered subjectivity, and globalization. Specifically the artist's work illustrates how these issues coalesce through visual representational practices, such as the images and language of advertising, Hollywood cinematic narratives, and consumption. *Fusion Cuisine*, coproduced with The Kitchen (an experimental nonprofit arts center in New York), playfully reveals Cold War American fantasies of consumer technology as gendered emancipation and national progress, while exposing the racial and geographic erasures that form the basis of these visions of the future.[1] The video consists of two sets of footage: post–World War II American commercials advertising domestic technologies and targeted toward white American middle-class women and contemporary footage of black African women videotaped by the artist in Nigeria. *Fusion Cuisine* shifts continuously between the archival filmstrips of postwar fantasies of modern life and suburbia and more recent images of labor and domestic life in Nigeria. This visual and sonic collage moves through several scenes, locations, and temporal moments and, as the artist states, "toggles back and forth between these worlds, creating a constantly shifting space, asking: What happened to the dreams of the future and 'the kitchen of tomorrow'? Are we there yet?"[2]

Fusion Cuisine is an example of Tuggar's digital video and photomontage art that employs contemporary technology to comment upon the history of technological development and the fantasies and nationalist imperatives invested in these movements. Tuggar produced *Fusion Cuisine*—a medley of clever, kitsch images from the United States' advertising and technological past and contemporary ethnographic-style footage of Nigeria—on site

Figure 5.1. Fatimah Tuggar, *Fusion Cuisine*, video collage, 2000. Courtesy of BintaZarah Studios.

at The Kitchen, referencing the history of that organization. The Kitchen, founded by video and performing artists, began literally in a kitchen in 1971; its mission continues to support multidisciplinary artists and experimentation. The arts center served as Tuggar's lab for domestic experimentation just as the modern kitchen was promoted for the suburban housewife in Cold War advertising. In one early scene of *Fusion Cuisine* taken from a 1950s commercial, a male voice narrates over camera pans and wide shots of a large, open kitchen: "By the way things look as well as how they perform, our homes acquire new grace, new glamour, new accommodations, expressing not only the American love of beauty but also the basic freedom of the American people, which is the freedom of individual choice." A quick montage follows, juxtaposing colorful kitchen gadgets twirling, spinning, and juicing with images of Africans cooking over open fires and gas cookers and manually preparing foods.

At times in *Fusion Cuisine*, the artist emphasizes juxtaposition by displaying the visible seams of her digital composites and making her cuts abrupt. In other scenes she transparently fuses these two narratives together through splicing, layering, and compositing, creating a new narrative that connects postwar fantasies to contemporary technological pursuits. Through digital manipulation, Tuggar challenges the divide between the United States and Europe as technologically developed and Africa as rustic and folkloric. Her work displaces culturally embedded objects, like sophisticated domestic appliances, robotics and mud huts, by splicing them into often-humorous digital spheres marked by uneven distribution, unexpected appropriations, and asymmetrical consequences.

Born in Nigeria and now based in the United States, Tuggar is prominent among a generation of transnational media artists who function in global

art markets as cosmopolitan subjects versed in various sign systems, namely in the metropoles of the United States and Western Europe and regions understood as in a perpetual state of underdevelopment. Tuggar has exhibited in solo shows throughout the United States and Europe and has shown her work in major group exhibitions at the Museum of Modern Art, the New Museum of Contemporary Art, and international biennial exhibitions. Her art turns our attention to the process and labor involved in constructing visual knowledge about vectors of subjectivity, and technological consumption as progress. As *Fusion Cuisine* indicates, Tuggar's media art relies heavily on computer-based technologies and image-manipulation software. Her process uses the medium to comment upon the medium itself; thus, she employs technology as form and content to express and analyze its significance in the creation of current economic, cultural, and geographic systems.

This chapter intervenes in both feminist media studies and technology studies by focusing on visual media production by Tuggar whose digital art challenges the primacy of the West in technology discourses and gender studies.[3] Tuggar's digital assemblage, meaning her appropriation and displacement of dominant visual narratives combined with her footage of contemporary Africa, challenges the classical system of spectatorial identification and offers a critique of dominant Western narratives of bourgeois domesticity and technological progress.[4] I argue that the artist employs the visible seam and image fusion both technically and interpretively to reveal the gaps, erasures, and ellipses of dominant visual narratives and their underlying ideology of spectatorship. To use Donna Haraway's terminology, Tuggar acts as a "modest witness" of how existing and emerging technoscapes reconstitute the meaning of gender, race, and subjectivity in representational practices of contemporary cultures and economies of globalization.[5] Given her status as a "modest witness," I also want to contextualize Tuggar's work within contemporary African art and black diasporic visual culture and the precarious role of the transnational black artist within Western art markets. Primarily through her examination of identification and fantasy, Tuggar debunks narratives that both deny the presence of the black female spectator and that reduce the black, non-Western cultural producer to the folkloric or primitive with regards to technology. Moreover, Tuggar assembles narratives of seemingly disparate components (rural Nigerian village women and suburban white American women) that show the ideological and political underpinnings that figure scales of development and that promulgate a set of visual and symbolic signs about the perpetual underdevelopment of racialized and geographic others.

To construct a theory of the visible seam in digital media production, I want to reconsider Kaja Silverman's psychoanalytic film theory of suture and her method of exposing the operations of the mastering gaze in dominant cinema. With this in mind, I consider how the employment of visible seams and Tuggar's method of fusion reveal the gaps in visual identification with the image and narrative that the system of suture attempts to seal. The visible seam offers a more appropriate framework for understanding the structural relationships that digital media require through its viewership and interactivity. More important, the visible seam and the redress of normative visual narratives through a fusion of transhistoric and transgeographic imagery account for the decentered viewing positions of postcolonial, transnational communities, viewing positions occluded by the "unified," singular identification and seamless narrative structured through the editorial strategy of cinematic suture. Outlined in her classic study *The Subject of Semiotics*, Silverman's analysis of suture informs my reading. Tuggar's work provides entry points for considering the application of the theory of cinematic suture to fragmentary and interactive digital media arts. Tuggar's work exposes both the seams and fusions of narrative and confuses spectator identification, inserting black female narrative subjects into discordant spaces and addressing and decentering habituated viewing positions.

Suture is a stitch. It is a technique and a discursive tool. As a theory of cinematic identification, it explains how classic narratives forge a relationship with the viewing subject through masking the process of production, most notably through a shot/reverse shot editorial relation. Silverman writes that suture is "largely synonymous with the operations of classic narrative, operations which include a wide variety of editing, lighting, compositional and other formal elements, but within which the values of absence and lack always play a central role."[6] Silverman connects the technical and aesthetic with the discursive in extricating the workings of suture. In its putting together and creating a thread between two or more parts, suturing also structures viewing relationships. Silverman makes clear how the system of the suture allows for identification on behalf of the white male spectator:

> One of the chief mechanisms by which the system of suture conceals the apparatuses of enunciation is by setting up a relay of glances between the male characters within the fiction and the male viewers in the theater audience, a relay which has the female body as its object. Similarly, one of the most effective strategies at its disposal for deflecting attention away from the passivity and lack of the viewing subject's own position is by displacing those values onto a female character within the fiction.[7]

The process of suture grows more complex when we consider racial, linguistic, sexual, and national differences. Whereas many white and European-based feminist theorists have articulated the gendered impositions of cinema and of film theory, scholars who do not identify with racial, sexual, regional, and heteronormative assumptions of classic feminist film theory have theorized other complexities and relationalities that structure looking, being looked at, and pleasure. Theories of an oppositional or interventionist gaze and subject position have broken open the dyad that centers the white man and white woman in theories and practices of looking, desiring, and decipherability.[8] Kara Keeling's theory of "the black femme" is an important model of theorizing a disruptive position to this dyad.[9]

"Suture" in its theoretical context, and in its more rudimentary definition as the binding of wounds, provides tools for understanding digital assemblage in contemporary media art. Much of contemporary digital art not only challenges the normative process of identification but also the process of assemblage in visual media narratives and technology. Digital assemblage, employed by many contemporary media artists, borrows upon but is not the same as cinematic assemblage. Cinematic assemblage as an editing technique and aesthetic device abets in the production of dominant narratives. In contradistinction, digital assemblage may simulate "cutting shots together" but its practitioners also composite "shots" and their disparate elements to make meaning. Because of the ease of compositing, digital media artists can more readily insert and juxtapose discarded refuse, remains, "found" materials, and disparate images that, despite their compositing, disrupt the cohesion of a normative cinematic "shot" or "scene." Digital assemblage becomes an aesthetic and discursive tool for many to disrupt unified and complete messages of other forms of visual media. Digital assemblage can be used to challenge the seamless "stitching up" of the "cuts" or "wound" that characterizes classic cinematic narrative and normative visual culture. Indeed, Tuggar's work foregrounds and meditates on the normatively "invisible" wounds caused by narrative erasure and uneven development patterns. This critique takes place by focusing on the transnational flows of goods and peoples and the mechanisms of visuality that represent some as having and others as not. Through a consideration of the digital suture that I define as the visible seam and "impossible" fusion made possible by the artists' employment of technical and aesthetic practices of disruption and assemblage, we see the possibilities of Tuggar's intervention in visual narratives of Western progress and technological development.

Art critic Sylvie Fortin describes how Tuggar's artistic practice analyzes the reproduction of laboring bodies: "By foregrounding the process of

production, Tuggar positions representation as a different type of production: the reproduction of market imperatives through the dissemination of sanctioned images of rural African women and their labor."[10] Tuggar's unstitching of dominant visual and technological narratives afford critical space to reconsider the racial, gendered, geographic, and linguistic differences that inform other viewing and speaking positions. In effect, the concepts of suture and gendered identification in feminist film scholarship of the 1970s and 1980s lay the groundwork for examining digital nonnarrative media productions in the twenty-first century, marked as an era of unprecedented technological advancement and economic globalization.[11]

Contemporary Art Markets, Digital Aesthetics and the Colonial Conquest

Sidney Littlefield Kasfir positions Tuggar as a part of a generation of transnational African artists, such as Yinka Shonibare, Tracey Rose, and Wangechi Mutu, who use commodity culture, mixed-media practices, and advertising aesthetics to comment upon the effects of modernity in contemporary African societies.[12] These artists' works are often described as a bricolage of pre- and postcolonial African art practices, contemporary Western art training, and the influences of nomadic subject positions.[13] Though many were born in African nations, by and large they reside in European and American metropoles. Tuggar is exemplary of this type of cosmopolitan nomadism, the result of political, economic, and cultural developments that allow select intellectuals and cultural workers from postcolonial nations access to certain urban centers in the United States and Western Europe. This geopolitical and economic movement must be distinguished, however, from the nomadism of political and economic refugees.[14] Trained partly in England and with a MFA in sculpture from Yale University, Tuggar resides in the United States and has had institutional affiliations with Indiana University and Duke University. Her background in sculpture is reflected in the compositional structure of her work, her attunement to the social implications of space, and the ways in which she builds her multitiered video and photo collages that combine elements from various regions and historical moments.

Tuggar's media art turns a critical eye to those discussions of racialized and gendered subjectivities and digital technology that too often reduce complex issues to utopian notions of a futuristic technotopia or to dystopic notions of the "digital divide."[15] Alondra Nelson writes that the digital divide "is frequently reduced to race alone and thus falls all too easily in

stride with preconceived ideas of black technical handicaps and 'Western' technological superiority."[16] Those without access to the computer and other technological commodities, or who choose not to engage, are framed as inhabitants of a past era; they have no place in technological narratives of the future. Such framing of technological disparities or differences in consumption practices is steeped in a long tradition of understanding race and technology as incommensurate terms, while employing technologies to surveil and subjugate racialized groups.[17] Tuggar's media art challenges the representational codes and practices of the race/technology divide. Her artistic practice and art itself resist this paradigm by showing how such framing fails to address the relationship between technology and subjectivity in contemporary culture, a relationship explored by key feminist theorists in technology studies.[18] Feminist philosopher Rosi Braidotti argues that we have yet to consider seriously the implications of our overwhelming embrace of technology for our understanding of subjectivity, nation, and difference.

Crucially, Tuggar's work draws a correlation between the pursuit of technotopia and the motives that led to the colonial conquest of centuries past. Curator and scholar Erika Muhammad, writing about black diasporic new media artists. explains that they "not only use digital media to comment on digital culture, but they also employ digital tools to comment on the chronicling of history and to anticipate future realities."[19] In Tuggar's work, this commentary occurs on multiple levels. First, her art links geopolitical and technological pursuits to the desire to dominate and conquer. Second, her art highlights not only how technologies have been used by Western powers to subjugate and exploit peoples in other regions, but also how the drive for more advanced technologies is based in unequal power and labor relations. Furthering this correlation, Anna Everett argues, "the current scramble for domination and domestication of the Internet and the World Wide Web is not unlike that unleashed on the African continent by the West in the nineteenth century."[20] Third, she shows how technologies become racialized, even as they are touted as unifying and democratizing forces, à la the global village.

Meditating on the notion of progress that sparked both colonial and technological expansionism in the West, Tuggar's media art explores how Atlantic "trade routes" between Africa, Europe, and the United States impact the distribution of technology in such disparate localities as African street markets and American domestic settings.[21] The artist makes visible in her work the seams and rupture caused by globalization, transnational

consumption patterns, and the creation of technological fortresses. Her artwork, like that of many other African artists in similar positions, circulates intentionally as transnational products in an increasingly globalized culture industry in which current imbalances are made more extreme. Because of the transnational stature of these contemporary African artists and the highly capitalistic nature of art markets, their work circulates throughout international metropolitan cities, such as New York, London, Hong Kong, and Berlin. Their audiences tend to be a mixture of cosmopolitan intellectuals and collectors from the United States, Europe, and former colonies.

In *Meditation on Vacation* commissioned by the Museum of Modern Art, Tuggar explicitly addresses her primarily white, educated audience as Western tourists who pursue the good life through travel as leisure. Curated as part of the multimedia exhibition *Tempo* at MOMA in 2002, the sculpture and video installation considers the overdetermined narrative, and its visual tropes, of tourists traveling from Western countries to former colonies and resort nations seeking idyllic settings and peaceful natives. The sculptural and video piece recreates the experience of travel, including a section of an airplane replete with passenger seats for the installation's audience. The passengers/audience face a monitor, similar to those used to display safety procedures and in-flight entertainment.[22] On the monitor, a four-and-a-half minute video of quick visual montages and multiple voiceover narration loops as audience members enter and exit. The video, like much of Tuggar's art, consists of appropriated images from other media, in this case visuals of the Caribbean as travel destination, as well as footage of workers shot by the artist in Nigeria. The artist, at points, narrates: "This is a meditation on vacation."

Borrowing and slightly altering a passage from Jamaica Kincaid's nonfictional text *A Small Place*, Tuggar records a woman's voice narrating over stock footage of vacationing whites, clips from Stephanie Black's documentary *Life and Debt* (2001), and ethnographic-style footage of African subjects and locales:

> Every native is a potential tourist, and every tourist is a native of somewhere. Every native would like to find a way out. Every native would like a rest. Every native would like a tour but some natives, most natives in the world, cannot go anywhere. They're too poor to escape the realities of their lives and they're too poor to live properly in the place that they live, which is the very place that you, the tourist, want to go. So when the native sees the tourist, they envy you. They envy your own ability to leave your own banality and boredom. They envy your ability to turn their own banality and boredom into a source of pleasure for yourself.[23]

Figure 5.2. Fatimah Tuggar, *Meditation on Vacation*, installation, 2002.
Courtesy of BintaZarah Studios.

Figure 5.3. Fatimah Tuggar, *Meditation on Vacation*, video collage, 2002.
Courtesy of BintaZarah Studios.

Addressing the tourist, presumed to be wealthy, Western, and white based on the visuals in the piece, the video draws correlations between leisure activities (tourism), globalization, colonial history, and transnationally circulating commodity objects. Her nonwhite spectators are framed as postcolonial subjects whose occupancy of Western metropoles recognizes the colonial past and ongoing economic and political imbalances. At the same time, Tuggar resists didacticism and the tendency to create a rigid divide between "victim" and "perpetrator" when discussing issues of global unevenness. Her audiences are structured through the artist's address with a tone of irony, as both knowing and unknowing subjects of their consumption of difference. As a transnational artist who has the privilege to occupy the West, she makes herself complicit in these cultural and economic imbalances. Through her use of humor and the ways in which her artistic practice always reveals the hand of the producer, Tuggar posits herself as a participant in the West's fetishism of technology, conquest and difference, and yet she also recognizes the specificity of her position as a racialized and gendered subject from a region rendered as both authentic (i.e., folkloric) and barren (i.e., underdeveloped) in dominant Western narratives.

Tuggar's inquiry moves beyond a critique of privilege and access and evolves into an ethical meditation on difference and technology. In considering how race gets explored as a performative commodity in black female artist damali ayo's interactive digital art project, www.rent-a-negro.com, Brandi Catanese considers the performativity of racial difference even when the corporeal figure is absent, or through the enactment of a disembodied racial presence. ayo's online installation, similar to Tuggar, uses humor and audience accountability to probe the consumption of difference and the currency of blackness, especially in an era of public consciousness about "sensitivity" to racial difference and inequality. About ayo's website, Brandi Catanese writes:

> Suddenly, the FAQ "How do I rent a Negro?" becomes not a procedural but an ethical question that raises the stakes of the entire project by demanding a very personal decision by each visitor. How do I, for example, as a black woman, rent a Negro and thereby lay claim to the white privilege that the work indicts? More importantly, why would I want to engage in this dark play? In the raced and raceless interface that is the request form, how do I register my blackness, and therefore my disidentification with the easy white privilege that this site attempts to critique? Without the silent salience of my black body, how do I ironize my rental request?[24]

Meditation on Vacation produces similar ethical considerations for its viewing subjects. Through the repetitive address of the audience as "you," viewers are challenged to consider their spectatorial position in relation to the project, the artist, and the consumption of difference. Also relevant to Tuggar's work is Catanese's analysis of race as category operating performatively in technology even when the subject is disembodied. In such works, race is rendered through technological mediation through codes and narrative scripts that are associated with black bodies even when bodies are absent from view.

While an understanding of the status of African art and the positioning of contemporary African artists in a transnational art market and within the framework of cultural tourism offers insight into the reception and circulation of Tuggar's work, her art should also be contextualized within the contemporary movement of digital art and aesthetics. As mentioned earlier, the recycled or archival footage that contributes to Tuggar's assemblage tends to come from Cold War American culture. Her transhistorical imagery outstrips notions of postmodern play and pastiche, and instead forges critical approaches to addressing the historical and contemporary conditions that produce technological and transnational inequalities and fusions. Art critic Sylvie Fortin explains how the political and interventionist history of photomontage surfaces in Tuggar's work:

> From its emergence in the 1920s, much photomontage has critically engaged the most technologically advanced modes of image production and dissemination to analyze and expose the ways in which some images refashion the world. These images are the ones sanctioned by the dominant ideology; other images are simply censored. Photomontage seeks to expose this process. It enlists and juxtaposes mass media fragments to create awakenings and realizations through tensions and collisions. Photomontage provides Tuggar with a politically-inflected visual syntax, a pedigree of political activism and, at the same time, an intersection with the visual language of advertising.[25]

Two of her digital photomontages, *Robo Makes Dinner* (2000) and *The Lady and the Maid* (2000), are multitiered panels of several images that have been layered and composited to create alternative narratives, or "awakenings and realizations," as Fortin describes Tuggar's use of photomontage.

In *The Lady and the Maid*, a 1950s, aproned white woman performs domestic chores in a living room that combines elements of contemporary décor with mid-century kitsch collectibles and display shelves filled with

Figure 5.4a. Fatimah Tuggar, *The Lady and the Maid*, computer montage, 2000. Courtesy of BintaZarah Studios.

Figure 5.4b. Fatimah Tuggar, *Robo Makes Dinner*, computer montage, 2000. Courtesy of BintaZarah Studios.

antiques. A black African woman in a patterned West African dress relaxes in an overstuffed chair eating from a dish in her lap. The subjects look in different directions: the white woman down at her chore, the African woman outside the frame of the camera. Here, the artist leaves ambivalent who is the lady and who is the maid. In *Robo Makes Dinner*, Tuggar sets Robo—a nonhuman subject created to fulfill all of life's necessities so that humans can enjoy a life of total leisure—in an African family compound with all of the accoutrements of American domestic culinary settings. Robo, an anthropomorphized character who appears in several of Tuggar's video and photo collages, has replaced the black female domestic. Robo's presence in this African village and the proximity of incommensurable objects

make lucid how technological narratives construct subject positions based on racialized, gendered, and US-centric norms. In both digital collages, we see how the resulting effects of colonialism and the growth in consumer technologies impact domestic space in the West and Nigeria, Tuggar's native country.

Both photomontages create new frameworks for thinking about racialized and gendered development and human relationships to technology by creating proximities and intimacies between bodies and subjects that have been discursively and spatially marked as separate and unrelated. One of the unfortunate results of a serious critique of normative whiteness, gender relations, and racist discourse has been a retreat from thoughtful engagement across differences in public discourse, scholarship, and cultural practices.[26] This is strongly the case in technology and science studies. Ann Weinstone argues that posthumanism, out of which certain strains of technology studies and digital media art production emerge, have constructed human relations as *"both unbridgeable difference and dangerous similarity* [italics in original]."[27] And to avoid the muddiness of the slippage between difference and sameness, posthumanist thought has turned attention to relations between humans and nonhumans or other entities. Weinstone analyzes how posthumanism emerges as a post–World War II ethical inquiry:

> In keeping with much post-war thinking about ethics, posthumanism wants to prevent violence by undermining notions of a superior, self-willing, self-possessed person and its march toward ontological and epistemological transcendence. Posthumanism's specific style of rethinking concepts of the person and the human proceeds by considering how subjectivity, bodies, agency, and cognition are altered by engagements with communications technologies and networks; by the changing technological conditions for the production of language; by new media generally; by the artificial life science and computer science; and by related concepts of extant in science studies and philosophy such as sociotechnical systems, rhizome, and machinic assemblage. Each of these domains provides opportunities for decentering, destabilizing, and complicating categories of the human and the person.[28]

According to Weinstone, such detailed attention to human-nonhuman interactions, on some level, avoids the difficulty of thinking through the ethics of human-human relations. Tuggar's work does not provide answers to this complexity nor a map for engagement. What it does is create digital photomontages of relations amongst difference that are too often obfuscated or separated into discrete categories.

Tuggar's art, in all of its seriousness and complexity, is recognized for its playfulness and humor, crucial elements in both *Robo Makes Dinner* and *The Lady and the Maid*. Tuggar uses humor as a strategy through which to point out complex relationships among technology, subjectivity, and development. The value given to forms of technology and their incorporation into everyday practices becomes a point of laughter through, for example, the placement of Robo in an African village. Humor in part gets built through her reuse of archival material such as Cold War television commercials once meant to instruct American women how to use domestic technologies but that now read as kitsch, as endemic of "Americana." The tone and level of analysis often comes from the sound bites that the artist excerpts from motion-picture archives. In *Fusion Cuisine*, the artist includes a melodramatic conversation between a white mother and daughter as they stand next to a washing machine discussing how difficult the mother's life must have been before the advent of certain domestic gadgets. Tuggar intentionally manipulates existing footage to allow space for herself as uninvited spectator and as complicit cultural producer who participates in the obsession with and consumption of the latest technologies. Her playfulness and humor distinguish her intended audience from the audiences addressed by the archival imagery. While we laugh at the Cold War footage, while we assume that we know more than the intended audience of the commercials knew about modernization and global economics, the artist encourages us to face our own complicity in the latter's systemic practices. Through her humorous manipulations and dislocations, we, as her contemporary audience, may laugh at the technological dreams of the postwar generation but in so doing, Tuggar's work suggests, the joke is also on ourselves.

Materiality, the Digital Cut and Feminist Media Practices

Fatimah Tuggar's work can be read within a tradition of feminist media art that questions the gendering of domestic space and that deconstructs the public sphere and private sphere as distinctly separate, bounded sites. Tuggar's videos often posit the domestic interior of American households next to the open fair, street markets, and outdoor cooking areas of contemporary Nigeria where African women labor. Earlier feminist video works like Martha Rosler's *Semiotics of the Kitchen* (1975) and Sharon Millner's *Scenes from the Micro-war* (1985) interrogate the gendered expectations placed on suburban white women as housewives and debunk the myth of the ideal nuclear American family as representative of national progress.[29] Furthermore,

in the 1970s and 1980s, many feminist video artworks combined a critique of domestic subjugation with personal narratives. Centers like The Kitchen were not only crucial to the development of media art but were also vital to women artists who were often excluded from male avant-garde art scenes. Video art, in general, led to a movement of self-conscious artistic practice in which the artist used the medium of video for an often intimate exploration of the self, most intimately one's own corporeality. In addition to the focus on the female body, many of these artists challenged the belittling of the personal in "high art," a critique strategically launched by male critics in response to female artists who focused on autobiographical subject matter.

Whereas Tuggar's media art shares the focus on technologies of gender and the family as a consumption unit, her work also differs in many arenas from this tradition. While furthering feminist media art's deconstruction of the private/public sphere divide, Tuggar resists autobiographical narratives in her artistic practice. Additionally, Tuggar's art elaborates on the distinctions between gendered space in Western Africa (primarily Nigeria) and the United States. Many of her images place white American women in the public spaces of African villages while locating black African women in American suburban homes. Tuggar's spatial dislocations demarcate differences in the public sphere regionally and the various ways in which gender norms are enforced. Specifically, black women have had to operate as menial laborers in the public sphere and in the domestic settings of white families, while simultaneously remaining invisible as subjects in these spaces. At the same time, white middle- and upper-class women have been bound to the home as domestic duty and safe haven from the dangers of public space. Tuggar's investigation into gender, domesticity, and nation draws a correlation between American domestic space and the management of difference embodied in the foreigner. As Amy Kaplan suggests of nineteenth-century domestic literature, the domestic sphere necessitates not only gender division but also racial and national distinctions. She argues that the domestic presupposes its opposite—the foreign—and that domesticity relies on images of the foreign to sustain its discourse. More significant, Kaplan theorizes that domesticity mirrors American imperialism: "Both follow a double compulsion to conquer and domesticate the foreign, thus incorporating and controlling a threatening foreignness within the borders of the home and the nation."[30] Tuggar's intervention into domestic narratives and her dislocations of white American and black African women demonstrate not only the expansionist ideologies underpinning American domesticity but also the way in which the "domestic" and the "foreign" function as cultural tropes.

Fusion Cuisine most successfully reveals the disruptive potential of Tuggar's practice in light of the public/private sphere divide, racialized and gendered domesticity, and nationalism. The domestication and gendering of certain technologies preoccupy this piece. To create the video, heavily based on Cold War commercials and advertisements that took the form of short films, Tuggar researched advertisements that touted a "new era" in domestic chores for white middle-class women. Technology was promoted as the private domain of the housewife and as having the potential to liberate her from the domestic sphere by transforming her life into one of limitless leisure. This growth in domestic technologies accompanied the expansion of the US economy after World War II, the demographic shift toward suburbanization, and the architectural trend of making the kitchen the center of the house. Karal Ann Marling analyzes the gender implications of 1950s domestic technology and argues that these gadgets became symbols of American advancement and superiority over the USSR in the Cold War competition between the two countries. The postwar kitchen became a critical emblem of American democracy during this period. In recounting a famous disagreement over consumerism between Soviet Premier Khrushchev and then–US vice president Richard Nixon, known as the "Kitchen Debate," Marling summarizes that, for Nixon, "the latest in kitchen consumerism stood for the basic tenets of the American way of life."[31]

Another important feature of this era was the targeting of women as consumers and viewing subjects. Whereas classic narrative cinema appeals to male identification, much of Cold War television was geared specifically to cultivating a female viewing audience.[32] Advertisers targeted women by promoting "choice" and "empowerment" through consumerism. Marling discusses how kitchen gadgets were equated with masculinity and power. Yet, the promotion of these technologies fed into gendered notions of women's instability and reinscribed women in traditional roles. Focusing on the rise in the late 1950s and 1960s of cultural critics and psychologists warning about the decadence of consumer culture and the homogeneity of suburban life, Marling writes, "'The Pushbutton Way to Leisure' promulgated by *Better Homes and Gardens* in the mid-1950s, sometimes led straight to the psychiatrist's couch."[33] Though commercials of domestic gadgetry presented themselves as offering women a new sense of power in the form of leisure and choice, women's consumption of these goods reinforced their subjugation and inferiority, through discourses like "pushbutton" malaise.

Tuggar picks apart the intertwined narratives of technology as national progress and consumption as emancipation in her video *Fusion Cuisine* by using the raw materials of the postwar fantasy in unintended ways. In one

Figure 5.5. Fatimah Tuggar, *Fusion Cuisine*, video collage, 2000. Courtesy of BintaZarah Studios.

scene of the video, a husband who appears dressed as both a groom and a magician carries his young new bride into a futuristic kitchen. In this clip from a 1950s commercial, the white newlyweds enter the space in a dance routine reminiscent of Ginger Rogers and Fred Astaire. Tuggar removes the commercial from its original context—postwar efforts to promote domestic technologies to suburban housewives—and creates a transhistoric, transnational dialogue on racialized and gendered domesticity and technological consumption. Just as the husband releases his dance partner, he disappears. Accompanying the visual narrative is a jingly soundtrack with a female singing, "Just like a man, you give him a break and you wind up in the kitchen, baking a cake." The abandoned bride, in a long white gown and an apron, is briefly at a loss and then realizes that she is in a utopian kitchen of the future—a large, shiny space with metal, glass, and plastic surfaces—where all domestic chores can be completed with the press of a button. Upon this realization, she dances around the kitchen in jubilation and sings, "Tick, tock, tick, tock. I'm free to have fun around the clock." The bride then performs a series of costume changes reflecting her life of leisure made possible by the Frigidaire kitchen.

Haunting this humorous narrative are contemporary visuals of black African women completing "domestic chores" and, at points, they appear to dance along with the bride. After her day of work-as-leisure, the bride removes a cake replete with icing and candles from a futuristically styled oven. She then blows out the lit candles and thus ends the fantasy of a domestic technotopia. The digital insertions of African female bodies reveal the seams of this fantasy. They make visible the labor practices that become mystified through narratives of technology as gendered emancipation. The haunting figures foreground the fantasy as a product of specific political, racial, and geographic systems. Fortin writes, "Digital imaging enables Tuggar

to redistribute labor, reallocate spaces, and reassemble African and Western relations with pointed precision, thereby presenting a feminist critique of development and biotechnology."[34]

By visually inserting African women into archival footage, Tuggar exploits the narrative and temporal implications of the cut to allude to an alternative discourse than the one presented in the original commercial. The cut in film studies has long been understood as a mechanism for manipulating temporal and spatial constraints. For example, through the cut, a subject can instantaneously be moved from one geographic-temporal location to another. Silverman analyzes the significance of the cut:

> Cinematic coherence and plenitude emerge through multiple cuts and negations. Each image is defined through its differences from those that surround it syntagmatically and those it paradigmatically implies ("this but not that"), as well as through its denial of any discourse but its own. Each positive cinematic assertion represents an imaginary conversion of a whole series of negative ones. This castrating coherence, this definition of a discursive position for the viewing subject which necessitates not only its loss of being but the repudiation of alternative discourses, is one of the chief aims of the system of suture.[35]

The overlays of dancing black women that are cut and composited into individual frames of this classically coherent scene of plenitude operate differently than cuts between frames. They disrupt and complicate the fantasy of technology as national progress and gender emancipation. Their ghostly presence brings to mind Toni Morrison's analysis of the absent presence of the black or "Africanist" subject in the canon of American literary tradition.[36] Analyzing the specter of black subjects in American literature, Morrison writes that this dark presence shaped the narrative trajectory of the American national canon. She argues that the formation of the nation and the narrative of "the American Dream" were connected to the fears and longing projected on the specter of blackness. This dark, but ghostly, figuration has persisted in and through other cultural formations, especially the moving image—and thus the absent presence/potential of the dark other is very much a part of the discourse of technological progress and the history of visualizing racial normativity and difference.

Fusion Cuisine continues to rupture existing narratives and to fuse them into new ones about nationalism, difference, consumption, and technological development. In the final scene, Tuggar uses a 1950s industrial film about the advertising device of the billboard as the canvas for her visual

manipulation and narrative building. An authoritative male voiceover discusses the science of advertising and the necessity of consumption to American culture:

> Potential consumers are also reached by this all-inclusive medium. . . . Each location is selected on the basis of known rules of traffic. The number of persons who move past each panel over a given time is an accurate scientifically established figure. So accurate is this figure it forms an immutable law: where you find the poster panel, there you'll find the traffic moving to market. Strategic locations ensure repetition and repetition creates consumer remembrance driving home a message not once, not twice but many times, thus bridging the gap between the manufacturer and the consumer.

Images illustrate and at times subvert the narrator's point about the science of generating consumer desire. Tuggar uses the images from the original film that pictorially represent the narration: scenes of busy thoroughfares with billboards alongside, large poster panels outside of shopping markets, and posted advertisements near public transportation. We see consumers scurrying into stores and traffic driving along business districts. The posters advertise an array of domestic consumer goods, like packaged food products. Yet, in some of the billboards, Tuggar has removed the original commodities and replaced them with a variety of images of African subjects and settings. In one panel, she inserts her photomontage *Suburbia* (1998), a reflection on development and consumption with identical large modern homes in the background and African bodies surrounded by an assortment of technological and consumer goods on the driveway to the homes. Another billboard has been spliced so that we see Tuggar's photocollage *Working Woman* (1997), an image of a smiling African woman surrounded by a computer and other technological goods. Most significant, in multiple frames that uses both *Working Woman* and the archival footage, Tuggar digitally puts the audience of the original commercial in conversation with her targeted audience. The archival footage shows workers pasting a new advertisement onto a billboard; the complete image is untold. The narrative remains incomplete. The section of the panel yet to be covered contains an African woman who looks trapped in a visual and historical script, but who peers outside of the frame.

Continually, the incompleteness of visual and technological narratives erupts in the artist's play with American archives and contemporary imagery of West Africa. By focusing on the visible seams and gaps, Tuggar's digital art departs from notions of materiality and experience that have traditionally

framed discussions of women's arts, as well as non-Western arts. The growth in digital technology and digital image production generates questions about the materiality of objects and experience and the ways in which visuality and narratives are manufactured in a highly mediatized culture. Recognizing how digital technology allows for artists to more readily alter material, Tuggar is aware of the complex relationship between materiality and digitality, particularly given that her work is often based on historical materials that exist independently of her appropriation and manipulation of them. She considers her process in an early artist statement:

> I have chosen computer graphics as a tool for these images because the language of advertisement as a medium affords a sense of "casualness." My hope is that by adopting this language, art too can share the mass popularity of the media. Furthermore, my choice of the computer as a means of production allows me to extend the metaphors of "possession," "material," and "property" which are all inherent within the work. The use of the computer raises the question of the physical existence of the work itself. Where is the "real" work located? There is the image you see on the screen. The jet ink print mounted on a museum gallery wall. There is the binary information stored on a disc. In its basic physicality it is impossible to locate where the work is, though it is certainly available to human experience, in a virtual space.[37]

In this statement, Tuggar acknowledges the living bodies of her audience, even as they experience her work in the virtual realm. She locates them as corporeal subjects in specific space and time, while articulating the various perceptual fields in which her work can be experienced (i.e., as physical object on wall, as data stored on disc, and as pixels on a computer screen). The spectatorship of her work is premised on the multiple presences of her art: digitally (as bytes stored on computer and DVD), analogically (as televisual images through VHS playback tape), and physically (as object on gallery wall). Examining the relationships among perception, the lived body, and visual technology, Vivian Sobchack expands upon the "decentering" features of digital media that Tuggar's statement describes. Sobchack writes: "Digital electronic technology atomizes and abstractly schematizes the analogic quality of the photographic and cinematic into discrete pixels and bits of information that are then transmitted *serially*, each bit discontinuous, discontiguous, and absolute—each bit being-in-itself even as it is part of a system."[38] Digitization has not only radically altered the ways in which images are captured, processed and manipulated, these innovations have, as Sobchack suggests, changed how information comes into being

and the relationship between parts of data to the whole.[39] Essentially, digital technology allows Tuggar to take specific material—bits of discontinuous data—from archival film stock, for example, and visibly stitch them into alternative narrative systems.

Moreover, as demonstrated in *Fusion Cuisine*, digitization presents a challenge to the classical concept of the suture as a relationship between individual cinematic shots. Digital media has the possibility to present a structural relationship *in* an individual shot or image. In the shot/reverse shot of cinematic narrative, the narrative and spectator's viewing positions are stitched together—while the authoring subject and cinematic apparatus remains hidden. Tendencies in media art, since its inception in the late 1960s, have included the explicit alienation of audience through various mechanisms, the creation of installations of which the visual media are just one component, the combining of visual media with live performance, and the merging of the fictional subject and authoring subject as in the works of Cindy Sherman, Vito Acconci, and Adrian Piper. In media art based in digital bricolage, the two shots that structure the suturing process may occur in a single individual image. For example, in *The Lady and the Maid* and the fantasy dance scene in *Fusion Cuisine*, the system of suture is replaced by a compositing and fusion of discontiguous data. In these works, the spectator's gaze meets the gazes of the authoring subject through the discontiguous gazes of the subjects *in* the archival footage as well as the implied gaze of the viewing subject *of* this original footage. Tuggar's technical and interpretive process rips open the "seamless" seams of the original material so that her audience can see the multiple positions invested in bricolage material. The odd and complex relay of glances constructed in one shot through digital bricolage acknowledges multiple viewing positions denied by the normative identification promoted in dominant visual narratives.

"Forsaken Geographies": New Mediascapes and the Haunting Presence of the African Female Body

Reviews of Tuggar's art often focus on the prominence of juxtaposition in her work, as opposed to the compositing and fusion present in the pieces discussed thus far. When critics invoke the language of opposition to discuss her art, this juxtaposition most often gets framed in terms that posit Western technological objects *against* African or "occidental" subjects and traditional instruments.[40] While Tuggar's work can be certainly read this way, such descriptions overlook the nuances and visible seams that challenge notions

of opposition between these two regions and instead emphasize the mutually dependent relationship between these regions and respective tropes. The concept of fusion offers insight into the type of cultural, geographic, and representational intersections that Tuggar aims to construct. This goal is reflected in her practice and the deliberateness of the visible seam in her video and photographic work. Art critic Elizabeth Janus, aware of what is symbolically and discursively at stake in Tuggar's representations, describes the intentionality of the cut and composite in *Fusion Cuisine*:

> Tuggar seems to use computer imaging not so much to mask the flaws in the pictures she chooses or hide her process (the cuts and pastes remain intentionally visible) but rather to underscore the fact that one's understanding of another culture usually relies on a tightly constructed (and often ideologically tinged) version of the truth. She makes the case that technology, both high and low, in industrial and developing countries, is a tool used for basic survival and development but also to control, influence, distort, and reinforce the status quo.[41]

Tuggar's use of digital imaging software and her investment in conventional forms of visual narrative building highlight the uses of technology to produce subjectivities. In so doing, Tuggar avoids a positivistic construction of technology that frames black Africans and other others as always behind human progress.

In *Changing Space* (2002), an interactive Internet project produced by the Art Production Fund, Tuggar allows the audience to participate in the creation of transnational technospheres.[42] We can choose from various backgrounds, including a tropical beach with palm trees, an ornate colonial foyer with marble statues, an African dirt road with mud huts, and a modern Western living room. As audience/producers, we are then able to place various subjects and objects onto this background. Movement and sound accompany many of these content choices; for example, one could choose a speeding New York City Police Department squad car with sirens wailing or a small black child who bounces a ball that resembles the Earth. This online art project, while making explicit the process of constructing representation, also demonstrates the asymmetry of global flows and technological consumption. Though we as audience cannot add elements to the choices offered in this interactive project, we are allowed partially to author the outcome.

In *Transient Transfer* (2008), the interactivity of Tuggar's work mixes with the tradition of public art. Curated in the exhibition *Street Art, Street Life*

and commissioned by the Bronx Museum in collaboration with the Public Art Fund, *Transient Transfer* provides the material and tools for audience members to produce their own visual narratives. For the show's opening, the organizers held a street fair outside the museum where Tuggar set up an interactive computer terminal for the public. Holland Cotter explains in his review, "With it [Tuggar's computer terminal] people—anyone—can collage images of the Bronx in whatever patterns they want, print the result and take it home: street art, 21st-century style."[43] Tuggar engages with various aspects and residents of the Bronx through a digital platform for audience participants to create their own visual/audio tableaus of contemporary life in the Bronx. Tuggar's platform emphasizes movement and transport of people locally and transnationally. As backdrops, Tuggar offers an array of familiar visual symbols of New York's urban and racialized landscape. They include the exterior of the Bronx County Housing Court, a housing project, a subway platform, and local storefronts. Onto these backdrops, audiences/producers can choose from several animated video/audio excerpts. They include a moving sanitation vehicle that zips across the screen; a vendor with an ice cream with a ringing bell; a running fire hydrant; a breakdancer; a teenage boy singing, "I can't do this no more. I don't want to be with you no more," with headphones on; a young girl rollerblading; a jumping and yelping dog; graffiti-covered subway train rolling across the backdrop; a Latino hair stylists with clients; a "conscious" black vendor at a food stand lecturing on "rapping on black on black crime" and "mental genocide."

The setting of the Bronx as the site where the installation appears and as visual landscape and subject of Tuggar's work is significant given the relationship between public art and urban development historically in the United States. Tom Finkelpearl has examined how public art practices are often connected to urban renewal/displacement/gentrification issues.[44] As a counter to what Finkelpearl describes as "Art-as-Urban-Development," Tuggar's *Transient Transfer* incorporates disparate visual material and narratives into an art-making process of which audiences create the final products. Tuggar's installation culminated with some of the selections of visual collages made by audiences being selected to appear as posters on bus stops in the Bronx or as street projections on the museum's façade.

Through the interactivity of *Changing Space* and *Transient Transfer* (and the disruptive narrative offered by the visible seams in her video and photographic collages), Tuggar's work assumes decentered viewing positions and active audiences who do not necessarily share geographic, racial, gender, or temporal sameness. While Tuggar's art circulates among Western art critics and cosmopolitan, transnational communities in urban centers,

Figure 5.6. Fatimah Tuggar, *Transient Transfer*, users' collages/ poster layout, 2008. Courtesy of BintaZarah Studios.

it also addresses spectators who are familiar with the cultural and economic politics of "othering" and those who reside in Western cultural centers but who come from "forsaken geographies," to use artist and critic Olu Oguibe's phrase, referring to regions of the world that stay on the margins of technological-capitalistic systems. This recognition is apparent in *Transient Transfer* where the title refers to the temporality of subject position and locality. Oguibe concerns himself with how these geographies, "the localities of the 'Other,'" remain outside of the discourse on the digital revolution and how dire needs of nutrition, safety, education, and health care render technophilic discourse irrelevant in these locales.[45]

Expanding upon his analysis, I would argue that these "forsaken geographies" also suffer from normative representational codes that frame them as timeless, faraway, and *forsaken* places where technology is useless, inaccessible, or at odds with the way of life. These localities are both regional and discursive sites of othering where certain subjects are marked as outside of futuristic narratives of progress and development. Disparity in resources and access that subjugate certain regions and subjects to a state of "permanent" impoverishment are critical and are connected to the violence of

Western discourse and technological apparatuses in rendering these regions and subjects as invisible and/or technologically *forsaken*.

Tuggar's use of the visible seam acknowledges the imbalances of power between different viewing positions. The others from "forsaken geographies" are stitched into narratives not to cover the fissure or gap between these positions but instead to highlight it. The visible seam and the fusion of multiple narratives in Tuggar's work do not promote a multiculturalist discourse that ignores historical and present injustices. Instead, it asks the spectator to consider the unintended and intended consequences of narratives of development and visual rendering of technological and national progress. In her three-minute video *Conveyance* (2001) curated as part of *Africaine*, an exhibition of contemporary African women artists at the Studio Museum in Harlem, the artist contemplates industrialization and the disparity between its utopian ideal and its material consequences in both overdeveloped regions and "forsaken geographies." The video examines how the factory line and the automobile have changed infrastructural systems around the globe. Thus, the title of the work takes on multilayered significance as the artist considers the cultural, geographic, and symbolic impact of the Industrial Revolution and its shaping of transportation and human movement across the planet. Her signature style of pairing contemporary African imagery with Western popular cultural icons and archival footage from American commercials and industrial films frame the piece.

At one point, a long black-and-white clip of a factory line in which the audience sees an automobile being built is followed by the artist's recent footage of a busy intersection in an African city where motor vehicles spew out visible exhaustion fumes. In one humorous scene, the artist borrows footage from the blockbuster Hollywood science-fiction film *The Fifth Element* (1997) to construct a postnational, transhistorical narrative about the precarious roles of subjects of forsaken geographies—specifically African women—in political and economic systems. A futuristic police vehicle, excerpted from *The Fifth Element*, floats through air and encounters a startled, elderly African woman videotaped by Tuggar. The artist creates a complex relay between the two sets of images. The officers in the vehicle attempt to identify her through sophisticated security technology. They zoom in on her features and scan her but cannot locate her in their system. One officer declares, "She has no file." The unsuspecting and startled gaze of the African woman meets the officers, who are portrayed in the narrative of *The Fifth Element* as robotic, dehumanized enforcers of an ever-present state surveillance system. In shot one, we briefly see the woman as she appears trapped in the frame of the camera; we then see the officers in their vehicle. In the

Figure 5.7. Fatimah Tuggar, *Conveyance*, video collage, 2001. Courtesy of BintaZarah Studios.

next shot we see the woman, whom they cannot recognize, staring out of the frame beyond the viewing subject's reach. The exchange between the state and the woman continues; the state looks at her, as she looks beyond them and adjusts her headdress. The officers then use technology to grid and scan her body into a computer located in their vehicle. This is to no avail. They cannot recognize her, for recognition would be an acknowledgment of her as a subject: her discursive and corporeal presence. She is alien and cannot be detected by this technologically sophisticated future state for she does not belong in this future narrative.

This scene relies on the significance of the shot/reverse shot in suturing narrative gazes and spectatorial identification. In revealing the artifice of visual technology and the specificity of viewing and speaking positions, *Conveyance* ultimately alters this shot construction by offering a series of shots that represents a breakdown in the seamless relations constituted between the fictional subjects and the spectator. The shot/reverse shot is a common device to suture cinematic narratives; it allows the camera to deny its existence by inviting the audience to believe that the look is always that of a fictional character, as opposed to that of the cinematic apparatus and/or director. Silverman writes that the shot/reverse shot "derives from the imperative that the camera deny its own existence as much as possible, fostering the illusion that what is shown has an autonomous existence, independent of any technological interference, or any coercive gaze."[46] Tuggar interrupts this strategy by offering a series of shots that highlights not only her technological manipulation of the visual material but also reveals two

different narrative worlds that contain different authoring subjects, fictional subjects, and viewing subjects, while simultaneously putting these worlds in conversation through her process of compositing and visible fusion. Most significant, the African woman's refusal to return the gaze frustrates the shot/reverse shot formation, as well as the coercive power of the mastering gaze, here represented as the state. Instead, she looks beyond the fictional subject and the spectator's reach and identifies a world outside of the visual field. Her gaze alludes to another narrative beyond the narrative worlds conveyed in both sets of imagery. Not only does her presence as a black female subject in this technological world make her unreadable, but also her extrafilmic look cannot be understood within the system of the suture and normative identification.

Conveyance ends with an American woman singing a commercial jingle from a postwar commercial to an audience of whites who clap along to her voice: "Everyone says the future is strange but I have a feeling some things won't change." This strangely chirpy and foreboding song seems to reinforce the normative codes that govern fantasies and visions of the future. Much of Tuggar's work presents her audience with fantastical imagery of the possibilities of technology to underscore the singer's words that "some things"—power relations, gendered domesticity, racialized and geographic disparities—won't change. Tuggar's choice to end on this note, taken from postwar commercial footage that is eerily resonant today, disavows utopian visions of a more egalitarian future as a result of technological innovation.

Tuggar's positioning as a subject of a "forsaken geography" who is trained at elite institutions and who practices internationally contributes to her critical acclaim and reception in European and American art circles. Her compositionally rich photocollages and digital video pieces are well received in part because of her constant toying with not only the tools of technology but also the fantasy and discourse of technological progress. In no way here do I want to diminish the aesthetic and political significance of her work; however, I do want to suggest that, for some critics and curators, Tuggar appears anomalous in her mastery of technology, her detailed interest in medium and composition, and her position and artistic practice inside the United States. Artist Guillermo Gómez-Peña comments on the construction and reception of artists from "forsaken geographies" in international art circles and the mythology of the folk artist versus the high artist that frames their entry into these markets. Specifically describing the experience of Latino cultural producers working in the United States, he writes:

> Caught between a preindustrial past and an imposed postmodernity, we continue to be manual beings—*homo fabers* par excellence, imaginative artisans (not technicians)—and our understanding of the world is strictly political, poetical, or metaphysical at best, but certainly not scientific. . . . [W]hen we decide to step out of our realm and utilize high technology in our art (most of the time we are not even interested), we are meant to naively repeat what others have already done. We often feed this mythology by overstating our romantic nature and humanistic stances and/or by assuming the role of the colonial victims of technology.[47]

I read Tuggar's practice as resisting such mythmaking, particularly in how the artist addresses her audience and deals with the cultural complexities of technological consumption and transnational cultural and economic flows. Oguibe explains how contemporary African artists in such precarious transnational positioning must play it safe, always aware of the ease of erasure in the global marketplace of contemporary art and visual culture.[48] Oguibe criticizes the Western critic and scholar's desire to reduce the cultural production of contemporary transnational African artists to overdetermined narratives of African folk culture, crafts, traditions, and mythologies.[49] These reductive paradigms become incorporated visually and narratologically into Tuggar's art. Tuggar does not necessarily resist the reductive paradigms or mythmaking of Western discourse, but instead explores the elements that comprise them through aesthetic practices of cutting, stitching, and fusion.

Tuggar's rupturing of technological, nationalistic, and historic narratives is at once symbolic, while also being literal in her manipulation of preexisting visual archives to reconstitute alternative meanings about race, gender, and technology. As I have suggested throughout this chapter, returning to the theory of suture and expanding its reach to account for digital media practices through the concept of the visible seam offer insight into the media production currently changing the playing field of who functions as producing subjects of visual media and technological narratives. Employing the visible seam, the artist digitally stitches black African female bodies into visual and technological narratives of US progress and gendered emancipation. Through her disruption of familiar narratives, her work considers the history of dominant representational codes that frame the racialized, gendered, and geographic other through folkloric paradigms. Tuggar's digital video pieces and photomontages allude to the crisis of representing transnational subjectivities in an increasingly globalized and technologized world where new tools are used to maintain old imbalances and certain geographies remain marginal to these emerging developments and

narratives. Yet her work successfully reveals that the global and the local are in no way opposing forces and are in fact mutually constitutive. As her work and her subject position demonstrate, intervention through production and uninvited spectatorship—that is taking up digital, visual, material and discursive space as a "modest witness"—can disrupt the binary discourse that necessitates a subject who is timeless, ahistorical, and *forsaken* to maintain the technological fantasies on which the United States' concepts of citizenship, progress, and democracy are built.

CODA

The Icon Is Dead: Mourning Michael Jackson

In summer 2009, I was one of many millions stunned by the death of Michael Jackson. That day I was at home in Harlem with three teenage cousins who were visiting from Ohio. In the early afternoon—about three hours before the national media confirmed his death, one cousin received a text message that simply said, "Michael Jackson is dead." I became enraged and lectured her about how text messaging and the Internet were used to circulate all kinds of unfounded rumors. But then I quietly went to my computer and searched for information that would confirm or deny Jackson's death. The clamoring to verify his death and to share the news online was frenzied and led to the website crash of Twitter, a social networking site where users share status updates with virtual friends and communities.[1] I felt an odd sense of satisfaction to be the first of my friends on a social networking site to write that a "legitimate" news source had declared his death with the headline, "Pop Icon Michael Jackson Is Dead."[2] After I posted the headline, I walked out on to my front stoop and looked around for confirmation that the world had shifted. I said to my neighbor—a young black man who spends every waking hour on his stoop—"Did you hear?" He said, "Yeah, yeah. That's crazy but that's how it happens in the game."

After the death had been made official, my cousins and I turned to MTV, which was running a Michael Jackson music-video marathon. I sat there watching his videos with my cousins who were surprised by my emotional response. They had not seen many of the videos that aired that afternoon. Of course, they knew of Michael Jackson but his glory days were abstract to them. They knew of the monstrous spectacle that he had become and considered him both tortured and creepy. One of them said to me, "Dang, Niki, I didn't know you liked him like that!" I responded hysterically, "Like? Like? I grew up with him. Your mother and I loved him!" I became more emotional

throughout the day and repeated statements like "I can't believe this is happening" and "This is crazy." My cousins remained sober and quiet, as if they were receiving a lesson on black history that they knew should be taken seriously even if it did not make sense to them.

Later that night, I walked to the Apollo, knowing that crowds would be there, celebrating his legacy and mourning together. Cars, homes, and bars were blaring his music. Street vendors were selling t-shirts, posters, and pins that had been rush-ordered. Many on the streets seemed stunned, blank expressions on their faces. We, and yes I speak generically and romantically about the grieving masses of which I was one, were in shock and yet it all seemed so familiar and orchestrated. Prior to his death, Jackson had achieved a place in popular culture as dehumanized icon. He was no longer alive but also not dead. He had ceased being flesh; for years, he had performed a transmogrification that had shifted his role in popular culture and fandom from beloved to shocking to lamentable to repulsive, for many. Music and cultural critic Greg Tate writes, "Michael's death was probably the most shocking celebrity curtain call of our time because he had stopped being vaguely mortal or human for us quite a while ago, had become such an implacably bizarre and abstracted tabloid creation, worlds removed from the various Michaels we had once loved so much."[3] Jackson's demise had been rehearsed for years through visual rendering that documented a disappearing presence that never seemed fully realizable. Jackson had entered a realm of iconicity that detaches the image from corporeality and lived experience. And yet, his death rendered iconicity unfixed and unstable. His flesh and body had become substantive and organic through death.

For days, the public grieving was pronounced and became the subject of debate itself. How much importance and public space should be afforded to memorializing and emoting over a singular icon, in particular such a vexed individual whose public and private worlds were so unsettling? The public space of grief was indulgent; cable news channels ran coverage nonstop. General interest and music magazines printed special-issue editions. Clips of Michael Jackson's performances traveled virally through the Internet. Some expressed frustration with the constant rotation on news circuits and Internet sites of Michael Jackson's legacy, controversies, and the circumstances around his death. A few cyber friends began to post their annoyance and questioned why coverage focused on this singular tragedy and not the ongoing tragedies in Iraq, Iran, and Afghanistan (to name a few). I found myself unable to think about anything or anyone else. I was absorbed by it and in a defensive posture to criticism of the spectacle of public grieving, I posted on the same social networking site where I announced Jackson's

death a threat to those who questioned the time, resources and space given to mourning Jackson. I wrote that I was going "to unfriend some folks who are putting sarcastic, mean-spirited stuff on FB [Facebook] about the coverage and mourning of MJ's death. Keep that nastiness to yourself, ya'll. The response around the world to MJ shows that the politics of culture is as important as politics of state." I felt both justified and ridiculous after posting the message. It was a sentiment that many of my friends supported and bonded us closer.

The official record of Michael Jackson's life and impact, as produced through the genre of obituary, is that of a once-larger-than-life icon who had become irrelevant or marginal in his later years. Jackson's obituary in many of the largest and most lauded newspapers referred to him as a fallen star, as someone who had whittled away his talents and money with bizarre antics. Many of them referred to him as a Peter Pan–like figure or as one who lived in myth. That which had produced his stardom—his talent, his spectacular performances, the rise of a late twentieth-century black culture industry—were no longer the substance, but the context that produced a subject who would be memorialized in terms of failure and perversity. The *New York Times* described his life as a "quintessentially American tale of celebrity and excess [that] took him from musical boy wonder to global pop superstar to sad figure haunted by lawsuits, paparazzi and failed plastic surgery."[4] The declaration of his death served as an affirmation of his life as a haunt, a spook, as black opacity troubling the public's visual and psychic imaginings. David Gates's analysis of Jackson's significance summed up the overwhelming responses of critics and journalists:

> Jackson was the Prince of Artifice. As the prepubescent frontboy of the Jackson 5, he sang in a cherubic mezzo-soprano of sexual longing he could not yet have fully felt. As a young man, however accomplished and even impassioned his singing was, he never had the sexual credibility of a James Brown or a Wilson Pickett, in part because of his still-high-pitched voice, in part because he seemed never to fully inhabit himself—whoever that self was. In middle age, he consciously took on the role of Peter Pan, with his Neverland Ranch and its amusement-park rides, with his lost-boy "friends" and with what he seemed to believe was an ageless, androgynous physical appearance—let's hope he believed it—thanks to straightened hair and plastic surgery.[5]

The representation of Jackson in obituaries, journalistic reflections, and criticism was strikingly at odds with the public response. Whereas Jackson was described in alien and nonhuman terms by obituary writers (e.g., the

Los Angeles Times reads, "As a child star, he was so talented he seemed lit from within; as a middle-aged man, he was viewed as something akin to a visiting alien who, like Tinkerbell, would cease to exist if the applause ever stopped"), the expressions of individual fans render Jackson in terms of the familiar and the intimate.[6] A fan's response cited in an obituary reads: "I am in shock and awe. . . . He was like a family member to me." Another fan is quoted as lamenting: "He has always been a source of pride for Gary, even though he wasn't around much. . . . The older person, that's not the Michael we knew. We knew the little bitty boy with the big Afro and the brown skin. That's how I'll always remember Michael."[7] The latter quote from a fan highlights what gained the most significance after the initial shock of his death: how does the public remember him and how do individual fans remember him? The fan speaks of Jackson's knowability through certain visual registers: his brown skin, his Afro, his small frame as a prepubescent boy, his regional locality in a midwestern industrial town.

How to encode his life visually and to memorialize his body's troubling presence become so crucial to the many invested in Jackson and what Jackson represents because there are so many ways to remember him and the accumulation of those images produce much discomfort for the general public. The visual record of Jackson is one of the largest of any celebrity of any era; there are thousands of images of him over a thirty-year period. For much of Jackson's career, he strategically used visual media to manufacture and circulate his own image as one of the most inaccessible and desired commodity fetishes. Jackson created symbols of self as icon. About this, Geoff Boucher and Elaine Woo write, "he created his own iconography: the single shiny glove, the Moonwalk, the signature red jacket and the Neverland Ranch."[8] Jackson's mastery of visuality coalesced with the rise of MTV and the widespread dissemination of entertainment culture. He in many respects established the genre that has become understood as the music video, in which the visual became a central component of the popular music industry. For Greg Tate, Jackson's use of visuality is significant for what it suggests about race and performance in contemporary culture. Referring to his groundbreaking music videos of the 1980s, Tate writes,

> Looking at those clips again, as millions of us have done over this past weekend, is to realize how prophetic Michael was in dropping mad cash to leave behind a visual record of his work that was as state-of-the-art as his musical legacy. As if he knew that one day our musical history would be more valued for what can be seen as for what can be heard.[9]

Tate's comment signals the synesthesia of black cultural practices and reception, but it also speaks to how value gets attached to black cultural production and black cultural bodies. The consideration of how to remember Jackson demonstrates the shifting value placed on Jackson as he phenotypically moved away from blackness; and as the "purity" and "genius" associated with his spectacular talents were replaced with his spectacular and ghostly aberrance.[10]

Michael Jackson's visual legacy documents not only the significance of black performance and expressive cultures but also the continually vexed workings of blackness as visually knowable objects and subjects. As audiences and critics, do we locate Jackson's blackness in his black working-class, midwestern roots, in his music and performance, or on his mutating body that confuses us? Michael Awkward, examining Jackson's transmutation and relationship to blackness, writes:

> The ghosts evident in Jackson's surgically transformed face are not simply ancestral traces but also the much-photographed, negroid-featured lead singer of the fabled Jackson Five to which the adult singer is always visually, if not stylistically, compared. However Jackson looks now, however far his appearance changes from what might have been, in the absence of skin disease and cosmetic intervention, his natural visage and "flesh," he remains, because of the widely distributed pictorial history of his dark past, indelibly black. So when he proclaimed to Winfrey . . . "I'm a black American . . . I'm proud to be a black American. I'm proud of my race," he acknowledged both the transmutability of the flesh and the inescapability of categorical blackness.[11]

Jackson is black and is not black. He frustrates the public and visual archive because of the knowledge and the history of his phenotypic blackness as solidified by the image. And yet, he has escaped the phenotypic "trappings" of race but cannot escape the discourse of blackness. Thus his inevitable affirmation, "I'm a black American." His affirmation of blackness is spoken through negation and limitation because of the skeptics who have criticized his flight from race. In front of Winfrey and the national public, Jackson must declare that he is not above blackness. He must return to the inaugural moment of racial marking.

For some, Jackson's physical transformation is evidence of an obsessive desire and hopeless failure to embody whiteness. David Gates reads Michael Jackson as having racially and sexually neutered himself to appeal to broader audiences. Gates continues in *Newsweek*,

Why did he feel so deeply uncomfortable with himself? The hopeless task of sculpting and bleaching yourself into a simulacrum of a white man suggests a profound loathing of blackness. If Michael Jackson couldn't be denounced as a race traitor, who could? Somehow, though, black America overlooked it, and continued to buy his records, perhaps because some African-Americans, with their hair relaxers and skin-lightening creams, understood why Jackson was remaking himself, even if they couldn't condone it.[12]

Gates's reading of Jackson is as a larger pathology from which black subjects suffer of wanting obsessively and hopelessly for what they cannot achieve. For Gates, black attachment or support of Jackson is either ignoring or endorsing his dis-ease. Gates fails to see the possibility that Jackson's attempts at self-making could be a gesture at another subject position that is not white.

For others, Jackson represents transraciality. In memorializing Jackson, many stated that the pop icon was one of the most important figures in moving the nation post–civil rights toward integration. His description as a transracial figure is sometimes meant to describe his crossover status and his one-time global embrace. Al Sharpton and other black public figures enunciated Jackson as part of a legacy of racial progress and integration. Speaking at the Apollo shortly after his death, Sharpton asserted, "Michael Jackson made culture accept a person of color, way before Tiger Woods, way before Oprah Winfrey, way before Barack Obama."[13] Transraciality has also been used to describe Jackson's transformative figuration in terms of his racialized and gendered permutations. In a study of Jackson written many years before his death, Awkward argues that Jackson represents a practice of transraciality that reveals "the constructedness of the rules of racial being. . . . [T]ransraciality represents an individually determined, surgically- and/or cosmetically-assisted traversal of boundaries that putatively separate radically distinct social groups."[14] Awkward's interpretation of Jackson's transraciality as a practice that dissects the un-naturalness of race. Awkward likens it to a form of racial transgression, similar to passing that recognizes the limitations of fixing definitions of race onto marked bodies.

Jackson's visual transmutation have also been discussed in terms of a broader boundary crossing that moves beyond race and gender and moves the icon into the realm of the nonhuman, either as one so innocent and vulnerable that he was not accustomed to social norms or as one whose sense of risk-taking imagined life and possibilities outside of the strictures and norms of human life. This was part of Jackson's appeal and later his revulsion. Michael Jackson, for me and I venture to say for many blacks and

nonblacks, expanded imaginative possibilities. He had entered my adolescent dreams in such a profound way that he stretched notions of self-making and imagination. He seemed fundamentally not to understand boundaries, and that became a sad public narrative of his last decade of life. In *On Michael Jackson*, a meditation on Jackson prior to his death, cultural critic Margo Jefferson ponders,

> He [Michael Jackson] imitates no kind of life known to us. He passes in plain sight. Each appearance through the years has been a rehearsal, a restaging. Our doubts are never soothed, our questions never answered. Passers are supposed to hide their past, shed their racial or sexual history. Michael's past is everywhere. It exists in thousands of photographs and film images. He makes no attempt to hide it.[15]

Jefferson suggests that Jackson's unsettling presence and visage had much to do with his familiarity historically as black icon and musical legend and the terrifying unfamiliarity of what he would become. What, many of us asked, are the limits of his self-making?

His rendering as nonhuman also played out in his relationship to other species. There was something perverse about his relationship with other animal forms and his expression of a way of loving that did not center heterosexual adult romance. Quincy Jones in reflecting on the making of the icon explains the struggle to cultivate Jackson's artistry and persona into one that spoke to norms:

> Michael was so shy, he'd sit down and sing behind the couch with his back to me while I sat with my hands over my eyes—and the lights off. We tried all kinds of tricks to help with his artistic growth, like dropping keys just a minor third to give him flexibility and a more mature range, and adding more than a few tempo changes. I also tried to steer him to songs with more depth, some of them about real relationships—we weren't going to make it with ballads to rodents.[16]

Jones's reflection calls into question black heteromasculinity. Jackson becomes queered as a black man who cannot claim the phallus or does not strive for it; he hides behind furniture. He can only perform in the dark when no one is looking. He prefers to love a rodent over a woman.

The general consensus in public culture was to remember the prepubescent Jackson who performed with his brothers and whose black masculinity seemed secured and multiplied by the presence of his older male siblings.

This is the Jackson whose visage stated his black Americanness and did not need the speech utterance, "I'm a black American," to secure the identity. Also acceptable as a memorial image was the Michael Jackson of the early 1980s at the peak of his career: the one whose arrival marked unprecedented levels of fame and iconicity: heights never achieved before by a black cultural figure or, one would venture to say, a cultural figure of any race. This was the period when Jackson moonwalked across the stage and produced one of the most sensational televisual spectacles of the last few decades, a performance of transcendence where he defied strictures of race and the weight of historicity. He performed the impossible, a being not bound by gravity or circumstance; as his obituary in the *Los Angeles Times* describes, that performance "created the illusion of levitation" and coronated him into iconic status.[17]

In the struggle to fix his iconicity, some argued that we should set aside his pictures altogether and instead we should remember his music. The desire to separate his music from his image brings us back to the concerns raised by Lindon Barrett as quoted in the introduction of the unrelenting and hostile working of visual regimes to define blackness and the conceptualization of sound as somehow divorced from these regimes. Forget his "odd" behaviors, his obsession with plastic surgery, the accusations of child molestation, the peculiar circumstances under which he became a father. The call was to remember Jackson the innocent, the wunderkind, the gifted genius before he entered the public imaginary as the monstrous and grotesque.

The debates and struggle to actively memorialize him in a way that resolves his troubling (but what I would not call contradictory) presence played out on the front pages of major magazines in the weeks after his death. The cover of *Newsweek*'s special issue "The Meaning of Michael" is a 1971 close-up photograph of Jackson as a boy.[18] The image is cropped in such a way that attention is drawn to Jackson's facial features, pre-surgical and -cosmetic interventions. Jackson is unsmiling and his eyes are focused and relaxed. There is the sense of assurance and self-awareness in the face of the adolescent boy. It is his face alone, minus other symbols or imagery of musical or iconic status. *Newsweek* offers an image of Jackson as "pure" and decontextualized; and it is a Jackson divorced of the later complications that make it difficult to look at the icon straight on, and that makes it difficult for the icon to look at his audience. Later in his career, Jackson was almost always seen and photographed with another piece of iconography: aviator sunglasses. We were no longer afforded glimpses into his eyes, and perhaps we were afraid to look in them.

In contrast, *Ebony* magazine chose for its special-issue cover a recent image of Jackson as the transmogrified adult who bares no resemblance to that of the child on the *Newsweek* cover. In this medium shot of Jackson from waist up, he stands in a shiny suit jacket with hands crossed, very light skin, and long straight hair. And what is remarkable about *Ebony*'s image is not only its choice of a de-racinated Jackson but also the atypically large smile on his face and the absence of sunglasses. Jackson appears to be the emblem of black success and achievement. He is the result of the entire black race's struggle for recognition and self-determination. There is no attempt to conceal Jackson's manipulation of his visage. His smile is one of self-satisfaction and self-awareness of his accomplishments.

One customer noted on *Ebony*'s website, "I just had to have a copy. I love Michael Jackson so much. . . . Ebony put a beautiful Photo of MJ on the cover which says a lot. Many magazines put photos of Michael on their cover that were of him looking sad or at a trying time in his life, not very thoughtful. The contents are beautiful."[19] Another customer commented, "these are pictures that highlight MJ's life and career and they are placed appropriately in the magazine; meaning his face is not chopped off or in the gutter (spine) of the magazine . . . There is no gossip or salacious tabloid garbage which is refreshing. Instead it shows MJ as a happy, singing, dancing electric entertainer/performer which is how he should be remembered."[20] The responses of fans to Jackson's memorialized image show the personal and the public investment in the iconicity of blackness, but they also reveal what individuals do with iconic images. The photographs of Jackson become woven into the personal narratives of the individual subjects who comprise the collective "we," mourning his loss and ultimately his lack of fixity.

The degree to which individuals attempted to personalize their mourning of Jackson was striking. A former student of mine traveled to Gary, Indiana—Jackson's birthplace—that summer after his death. He photographed the modest home where Jackson began his career and the memorials of stuffed animals, cards, and flowers that were piled on the lawn. Through his photographs, he tried to index Jackson before he became the icon as a way of connecting with the material and social circumstances that produced the icon.

On the same social networking site where I emoted about his loss and posted videos and reminiscences of my childhood and adolescent fascination with the star, an online friend posted a story about how she had met Jackson when she was a child while on vacation in Florida. The story captivated me in the ways that it became a part of her family's "critical

Figure C.1. Autographed image of the Jacksons as Platt family's vacation photo, early 1980s. Courtesy of Platt family.

genealogy."[21] Kym grew up in the same town that I did, but we did not know each other. However, years later we became linked to each other through collective mourning for the icon.

As Kym tells the story, in 1982, when she was ten years old her parents vacationed in Florida. Months in advance, her working-class mother and stepfather decided to reserve the Michael Jackson suite at Disney World. Kym recalls:

> You basically make a reservation and you can stay in the actual suite that Michael Jackson stays in when he's there. At the time, he had it decorated with all of his Grammy's and photos of the tours. So it was almost like a Michael Jackson play land. So when my step-father made the reservation, which was ridiculously expensive. It was like $450 a night in 1982. We were totally working class but my mom was addicted to Michael Jackson. So we went for it. They told him that there is a high likelihood that Michael Jackson would be staying there during this time. This is the time that he likes to visit the most. So they said that they won't know until we get there. And in the event that he

is there, we would stay in Michael Jackson's mother's suite, which is on the same floor. There were only two suites on that floor. You might get to meet Michael Jackson. You will definitely get to tour the suite.[22]

When they arrived, the family learned that Jackson was staying in the suite and that they would be housed in his mother's suite. Her siblings and cousins were wearing Michael Jackson t-shirts and buttons just in case they caught sight of the star. Later that day, in the hallway, they saw Jackson emerge from the elevator. She described the awe and excitement of her family who became even more thrilled when Jackson's assistant asked to photograph the children who were dressed in Jackson memorabilia. The family, content with their brush with the icon, retired to their suite and settled in for the evening. Later that night the same assistant who had photographed them knocked on their door.

> It was about 11:00 pm and we get a knock on our door. It's the same woman who took the photos, the personal assistant and she said, "Is your mom there?" . . . The woman said, "Michael Jackson wants to know if the kids can come down and join him in the hot tub." And my mom was like, *"No!"*[23]

Kym noted that her mother's reaction was out of character and emphatic. Kym stated that her mother was later surprised by her reaction. She said that it was visceral and protective. Afraid that the children would sneak out of the suite, Kym's mother slept in the room with them.

> We were very, very upset but eventually we fell asleep. We woke up the next day to go to Disney World and under the door in a manila folder were autographs to all the kids from Michael Jackson.[24]

The photographs and story continue to circulate among their family and friends over twenty years later. She states,

> We show them all the time. . . . My sister and cousin have theirs in the family album. . . . We have pictures because we went on a tour of his suite. We have pictures of us with the Grammy's. So it's a part a big story that we tell that culminates with we got his autograph and we were asked to be in the hot tub with him.[25]

The photograph of the icon has become part of their family archive. Kym states that the experience in many respects was most memorable for what

she learned about her mother through her reaction to Jackson's request. As the stories continue to circulate in their family, they always reflect back on the moment of recognition of their mother in another light. The photographic icon is an index of intimate family details and a larger visual narrative of black lived experience.

With his death no longer does the public have to live with the discomfort of Jackson's transmogrification as an active present. We can choose how we want to view him and how we want to register his mark on American cultural and racial and gender meaning. Tate states, "The unfortunate blessing of his departure is that we can now all go back to loving him as we first found him, without shame, despair, or complication."[26] How to remember Michael Jackson raises front and center the troubling presence of black visuality. It shows a reliance on iconicity that becomes more crucial when the icon literally and symbolically dies. It expresses a desire for a wholesome and complete representation of black subjects, one that does not show the visible seams of surgeries, scars, and burns. But there are so many images to choose from that signify beyond our limited framework and that become woven into our own individual psychic and personal relations.

NOTES

INTRODUCTION

1. Such films include Stan Lathan's *Beat Street* (1984), Joel Silberg's *Breakin'* (1984), and Michael Schultz's *Krush Groove* (1985).
2. W. J. T. Mitchell discusses a failed attempt to see a preview of the film on the campus of the University of Chicago in the spring before its national release. He writes, "Students from the university and the neighborhood had lined up for six hours to get the free tickets, and none of them seemed interested in scalping them at any price. Spike Lee made an appearance at the film's conclusion and stayed until well after midnight answering the questions of the overflow crowd. This event turned out to be a preview not simply of the film, but of the film's subsequent reception." W. J. T. Mitchell, "The Violence of Public Art: *Do the Right Thing*," in *Picture Theory: Essays on Verbal and Visual Representation* (Chicago: University of Chicago Press, 1994), 384–85.
3. See Michael T. Kaufman, "In a New Film, Spike Lee Tries to Do the Right Thing," *New York Times*, June 25, 1989, http://www.nytimes.com (accessed August 14, 2009).
4. Jay Carr, "Spike Lee Spotlights Race Relations," *Boston Globe*, June 25, 1989; reprinted in *Spike Lee's "Do the Right Thing,"* ed. Mark A. Reid (Cambridge: Cambridge University Press, 1997), 134.
5. Kara Keeling, *The Witch's Flight: The Cinematic, the Black Femme, and the Image of Common Sense* (Durham, NC: Duke University Press, 2007), 3.
6. Part of the rhetorical impact of *Do the Right Thing* is the soundtrack and its repetition of verses of the rap song "Fight the Power" from 1980s' mega hip-hop group Public Enemy. The film's use of music and sound incorporates both the long history of black expressive culture and, more specifically, the rise of a black culture industry in large part due to the hip-hop movement. Craig Watkins argues that the Spike Lee "joint" and the renewal of black filmmaking (more broadly) was made possible by the innovations and growing popularity of the hip-hop movement. See Watkins, *Representing: Hip Hop Culture and the Production of Black Cinema* (Chicago: University of Chicago Press, 1998), 165.
7. Discussing one scene where characters of various races and ethnicities face the filmic audience in portraiture style while spewing a litany of racist and xenophobic slurs, critic Jeffrey Bloomer comments: "Viewed today in this commemorative 20th-anniversary edition, the sequence has lost none of its raw power, even six months after the United States inaugurated its first black president. ('That's not to say all

racism is gone just because Barack is in the White House,' Lee intones in retrospective comments on the disc.)" Jeffrey Bloomer, *"Do the Right Thing*: Twentieth Anniversary Edition," DVD review, *Paste Magazine: Signs of Life in Music, Film and Culture,* July 1, 2009, http://www.pastemagazine.com/articles/2009/07/do-the-right-thing-20th-anniversary-edition.html (accessed July 29, 2009).

8. Quoted in Jason Matloff, "Too Hot to Handle: How Spike Lee Managed to 'Do the Right Thing,' Inciting Debate, Praise and Fury 20 Years Ago," *Los Angeles Times,* May 24, 2009, http://articles.latimes.com/2009/may/24/entertainment/ca-dotherightthing24 (accessed July 29, 2009).

9. See Herman Gray, *Watching Race: Television and the Struggle for "Blackness"* (Minneapolis: University of Minnesota Press, 1995).

10. See Craig Watkins, *Representing,* and *Hip Hop Matters: Politics, Pop Culture, and the Struggle for the Soul of a Movement* (Boston: Beacon Press, 2006).

11. Valerie Smith, "From 'Race' to Race Transcendence: *"Race," Writing, and Difference* Twenty Years Later," *PMLA* Special Topic: Comparative Racialization 123, no. 5 (October 2008): 1530.

12. Farah Jasmine Griffin, "'Race,' Writing, and Difference: A Meditation," *PMLA* Special Topic: Comparative Racialization 123, no. 5 (October 2008): 1517. Griffin mentions other important texts and scholars of the 1980s and early 1990s that were part of a paradigm shift in theorizing about race and difference. Scholars include Hazel Carby, Houston Baker Jr., Hortense Spillers, Cornel West, Sylvia Wynter, Gayatri Chakravorty Spivak, Anne McClintock, Edward Said, Mary Louise Pratt, Wahneema Lubiano, Toni Morrison, and Anthony Appiah among others. In a previously cited essay, Valerie Smith makes complementary points about the critical scholarship that formed a contemporary understanding doing race and gender work in the academy. She also comments on the contemporary growth in retrospective symposia and conference that mark this rich moment in cultural criticism, such as *"Reconstructing Womanhood*: A Future beyond Empire," organized by Tina Campt and Saidiya V. Hartman in 2007 in honor of the twentieth anniversary of Hazel Carby's study *Reconstructing Womanhood: The Emergence of the Afro-American Woman Novelist.*

13. Wahneema Lubiano, "'But Compared to What?': Reading Realism, Representation, and Essentialism in *School Daze, Do the Right Thing* and the Spike Lee Discourse," *Black American Literature Forum* 25, no. 2, Black Film Issue (Summer 1991): 256.

14. Ibid., 264.

15. Some key works that influence this study include Linda Williams, ed., *Viewing Positions* (New Brunswick, NJ: Rutgers University Press, 1997); bell hooks, *Reel to Real: Race, Sex, and Class at the Movies* (New York: Routledge, 1996); Kaja Silverman, *The Threshold of the Visible World* (New York: Routledge 1996); and Trinh Minh-ha, *Framer Framed* (New York: Routledge, 1992).

16. Judith Butler, "Endangered/Endangering: Schematic Racism and White Paranoia," in *Reading Rodney King, Reading Urban Uprising,* ed. Robert Gooding-Williams (New York: Routledge, 1993), 17. Critical race theorists and prison reform activists have been some of the most vocal at examining the field of vision as one constructed through racial discourse and scopic perception as reaffirmation of racialization. Jared Sexton's work, for example, points to the significance of the moment at which we "see" black in the public and how that informs our notions of threat and terror. See Sexton, *Amalgamation Schemes: Antiblackness and the Critique of Multiracialism* (Minneapolis: University of Minnesota Press, 2008).

17. Norman Bryson, "The Gaze in the Expanded Field," in *Vision and Visuality*, ed. Hal Foster (New York: New Press, 1988), 91–92. Bryson writes: "Between the subject and the world is inserted the entire sum of discourses which make up visuality, that cultural construct, and make visuality different from vision, the notion of unmediated visual experience. Between retina and world is inserted a screen of signs, a screen consisting of all the multiple discourses on vision built into the social arena."
18. W. E. B. DuBois, *The Souls of Black Folk*, introduction by Henry Louis Gates Jr. (New York: Bantam Books, 1989), xxxi; Judith Butler, *Gender Trouble: Feminism and the Subversion of Identity*, 2nd ed. (New York: Routledge, 1999); W. J. T. Mitchell, "Showing Seeing: A Critique of Visual Culture," *Journal of Visual Culture* 1, no. 2 (August 2002): 165–81.
19. DuBois, *The Souls of Black Folk*, 142.
20. Butler, *Gender Trouble*, ix, x. In a review of Butler's more recent study *Undoing Gender* (New York: Routledge, 2004), H. N. Lukes writes, "Troubling received categories remains Butler's work, but she has moved from explicating certain impasses in critical theory to deploying the form of the question as a way to address our troubles to futurity and social transformation" (633). See "Undoing the End of Theory," review of Judith Butler's *Undoing Gender*, *GLQ: A Journal of Lesbian and Gay Studies* 11, no. 4 (2005): 632–34.
21. Mitchell, "The Pictorial Turn," in *Picture Theory*, 13.
22. Mitchell, "Showing Seeing," 171.
23. David Marriott, *Haunted Life: Visual Culture and Black Modernity* (New Brunswick, NJ: Rutgers University Press, 2007), xx, xxi.
24. The continued obsession with getting the visual representation of blacks "right" in more recent debates about the Hollywood comedy *Barber Shop*, a film directed by Tim Story and starring rapper Ice Cube. Jesse Jackson's and Al Sharpton's anger with the black crew and cast for "negatively portraying" Martin Luther King Jr. and Rosa Parks were well documented and sparked a backlash by other black cultural critics who labeled the civil rights leaders out of step with contemporary racial politics and sensibilities. See Renee Graham, "Few Lost Hairs over 'Barbershop': Many Moviegoers See No Harm in Film's Dialogue," *Boston Globe*, September 28, 2002, E1. For an analysis of representation and racialized catastrophe, see Nicole Fleetwood, "Failing Narratives, Initiating Technologies: Hurricane Katrina and the Production of a Weather Media Event," *American Quarterly* 58, no. 3 (September 2006): 767–89.
25. Lubiano, "But Compared to What?" 274. Lubiano continues that Jade, Mookie's sister, is the only character who seems to question iconicity but is interrupted by Buggin' Out. Lubiano laments, "But the movie diminishes her intervention because, after all, within its terms, who is Jade but a sister who ought to but doesn't know when some White man is hitting on her and who has to be warned both by her brother and by the Tawana truth lurking behind and against her back?" (274).
26. Lauren Berlant, "Critical Inquiry, Affirmative Culture," *Critical Inquiry* 30 (Winter 2004): 447, 449, 450.
27. Sara Ahmed, "Affective Economies," *Social Text* 22, no. 2 (Summer 2004): 119.
28. Ibid., 120.
29. José Esteban Muñoz, "Feeling Brown: Ethnicity and Affect in Ricardo Bracho's *The Sweetest Hangover (and Other STDs)*," *Theatre Journal* 52 (2000): 70.
30. John L. Jackson Jr., *Real Black: Adventures in Racial Sincerity* (Chicago: University of Chicago Press, 2005), 15.

31. See Locke's "A Note on African Art," *Opportunity* (May 1924): 134–38; "The American Negro as Artist," *American Magazine of Art* (September 1931): 211–20.
32. For a few examples of such readings, see Jennifer DeVere Brody, "The Blackness of Blackness . . . Reading the Typography of *Invisible Man*," *Theatre Journal* 57 (2005): 679–98; Fred Moten, *In the Break: The Aesthetics of the Black Radical Tradition* (Minneapolis: University of Minnesota Press, 2003); *Black is . . . Black ain't: A Personal Journey through Black Identity*, videocassette, dir. Marlon Riggs, California Newsreel, 1995.
33. These texts have been crucial in shaping the understanding of how the currency of blackness functions in popular visual media. While much of the literature on black representation in the twentieth century addresses the lack of visual images or the limited portrayals of black in dominant visual culture, this study arises in a moment of saturation of black bodies, black cultural practices, and black public discourse. See Ed Guerrero, *Framing Blackness: The African American Image in Film* (Philadelphia: Temple University Press, 1993); Jacqueline Bobo, *Black Women as Cultural Readers* (New York: Columbia University Press, 1995); Manthia Diawara ed., *Black American Cinema* (New York: Routledge, 1993); Valerie Smith, ed., *Representing Blackness: Issues in Film and Video* (New Brunswick, NJ: Rutgers University Press, 1997); Gray, *Watching Race*; *BaadAsssss Cinema*, dir. Isaac Julien (Independent Film Channel, 2002); *Black is . . . Black ain't*; *Color Adjustment*, dir. Marlon Riggs (California Newsreel, 1991).
34. See Deborah Willis, *Reflections in Black: A History of Black Photographers from 1840 to Present* (New York: Norton, 2002); Deborah Willis and Carla Williams, *The Black Female Body: A Photographic History* (Philadelphia: Temple University Press, 2002); and Deborah Willis, ed., *Picturing Us: African American Identity in Photography* (New York: The New Press, 1996).
35. Michele Wallace, "'Why Are There No Great Black Artists?': The Problem of Visuality in African-American Culture" in *Black Popular Culture*, ed. Gina Dent (Seattle: Bay Press, 1992).
36. Wallace, like many other critics, explains how the dichotomy of negative/positive images does not allow for a reformulation of representational practice; instead it plays into racist ideology, given that the intention of cultural production through this logic is simply to reverse racist portrayals. She writes, "Not only does reversal, or the notion that blacks are more likeable, more compassionate, smarter, or even 'superior', not substantially alter racist preconceptions, it also ties Afro-American cultural production to racist ideology in a way that makes the failure to alter it inevitable." Wallace, "Introduction: Negative/Positive Images," in *Invisibility Blues: From Pop to Theory* (New York: Verso, 1990), 1.
37. Collins traces this paradox throughout debates and movements of the twentieth century and highlights the persistent concern among black intellectuals and cultural leaders about the representations of blacks in the visual sphere, especially as these images pertain to stereotypes. As an example, Collins discusses NAACP campaigns of the past that have mobilized against pejorative representations of blacks in dominant visual media (one of the most notable being the campaign against *Birth of a Nation*). Lisa Gail Collins, *The Art of History* (New Brunswick, NJ: Rutgers University Press, 2002), 1.
38. I borrow the concept of "negative differentiation" specifically in relation to an analysis of race and identification from Irit Rogoff's essay, "Other's Others," in *Vision in Context: Historical and Contemporary Perspectives on Sight*, ed. Teresa Brennan and

Martin Jay (New York: Routledge, 1996), 187–202. My use is also influenced by Elizabeth Cowie's well-known article, "Woman as Sign." *M/F* 1 (1978): 49–64.

39. See Mary Schmidt Campbell, "African American Art in a Post-Black Era," *Women and Performance: A Journal of Feminist Theory* 17, no. 3 (November 2007): 317–30.
40. Thelma Golden, *Freestyle* (New York: Studio Museum in Harlem, 2001), 14. Golden continues, "In the beginning, there were only a few marked instances of such an outlook, but at the end of the 1990s, it seemed that post-black had fully entered into the art world's consciousness. Post-black was the new black."
41. See chap. 1, "Beyond Black Representational Space," in Darby English's *How to See a Work of Art in Total Darkness* (Cambridge, Mass.: MIT Press, 2007).
42. Michele Wallace, "Modernism, Postmodernism, and the Problem of the Visual in Afro-American Culture," in *Aesthetics in Feminist Perspective*, ed. Hilde Hein and Carolyn Korsmeyer (Bloomington: Indiana University Press, 1993), 205–17.
43. Nicholas Mirzoeff, "On Visuality," *Journal of Visual Culture* 5, no. 1 (2006): 54.
44. Scholarship in art history, cultural theory, and film and media studies have illuminated the significance of imaging technologies to our understanding of the visual field and the viewing subject. Vision itself has been rendered much more than simply sensory perception. Jonathan Crary, in his classic study *Techniques of the Observer* (1992), demonstrates how the camera obscura not only created a new way of looking at the visible world but the technology was part of a larger movement to construct a new viewing (and therefore epistemological) subject. Martin Jay, "Cultural Relativism and the Visual Turn," *Journal of Visual Culture* 1, no. 3 (2002): 267–78.
45. See Fred Moten, "The Case of Blackness," *Criticism* 40, no. 2 (Spring 2008): 177–218.
46. Hal Foster, "Preface" to *Vision and Visuality*, ed. Foster, ix.
47. Mirzoeff, "On Visuality," 67.
48. Christian Metz, *The Imaginary Signifier: Psychoanalysis and the Cinema*, trans. Celia Britton et al. (Bloomington: Indiana University Press, 1982), 61.
49. Lindon Barrett, *Blackness and Value: Seeing Double* (Cambridge: Cambridge University Press, 1999), 215.
50. Ibid., 217.
51. Here, the reference to captivity and capitalism is influenced by Hortense J. Spillers, "Mama's Baby, Papa's Maybe: An American Grammar Book." *Diacritics* (Summer 1987): 65–81, and Roderick A. Ferguson's *Aberrations in Black: Toward a Queer of Color Critique* (Minneapolis: University of Minnesota Press, 2004).
52. Jon McKenzie's *Perform or Else: From Discipline to Performance* (New York: Routledge, 2001) provides an important analysis of the different paradigms of performance and their genealogies; Jill Dolan's "Geographies of Learning: Theater Studies, Performance, and the 'Performative,'" in *Geographies of Learning* (Middletown, Conn.: Wesleyan University Press, 2001), cautions against the abandonment of performance's theatrical roots by the various fields that borrow the language of performance and performative to discuss "the constructed nature of subjectivity (65).
53. Works that consider the origins, boundaries, and definitions of performance include McKenzie's *Perform or Else*; Richard Schechner's *Performance Theory*, 2nd ed. (New York: Routledge, 2003); Marvin Carlson's *Performance: A Critical Introduction*, 2nd ed. (New York: Routledge, 2003); and Peggy Phelan and Jill Lane's edited anthology, *The Ends of Performance* (New York: NYU Press, 1998).
54. Diana Taylor, *The Archive and the Repertoire: Performing Cultural Memory in the Americas* (Durham, NC: Duke University Press, 2003), 2, 3, 6.

55. Ibid., 15.
56. Peggy Phelan, *Mourning Sex: Performing Public Memories* (New York: Routledge, 1997), 3.
57. More recent scholarship on performance and digital culture, such as Brandi Catanese's analysis of the artist damali ayo, considers the impact and affect of performance as disembodiment in terms of the production of race and the politics of consumption of race, even when the racialized body is not present. Brandi Wilkins Catanese, "'How Do I Rent a Negro?': Racialized Subjectivity and Digital Performance Art." *Theatre Journal* 57 (2005): 699–714.
58. E. Patrick Johnson, *Appropriating Blackness: Performance and the Politics of Authenticity* (Durham, NC: Duke University Press, 2003), 8.
59. Thanks to Juana Maria Rodriguez for helping me distinguish these points in her commentary on an earlier version of the manuscript.
60. Peggy Phelan, *Unmarked: The Politics of Performance* (New York: Routledge, 1993), 18.
61. Jennifer DeVere Brody, "Black Cat Fever: Manifestations of Manet's *Olympia*," *Theatre Journal* 53 (2001): 99.
62. Catherine Soussloff and Mark Franko, "Visual and Performance Studies A New History of Interdisciplinarity," *Social Text* 20, no. 4 (Winter 2002): 37.
63. Henry Louis Gates Jr., "Critical Fanonism," *Critical Inquiry* 17, no. 3 (Spring 1991): 458. Of note, in the same issue of *Critical Inquiry* are responses to *Do the Right Thing* by W. J. T. Mitchell and Jerome Christensen. I mention this to signal the importance of this time period for critical theories on race and the institutionalization and visibility of black cultural production in public culture.
64. Homi Bhabha, "Interrogating Identity: Frantz Fanon and the Postcolonial Prerogative," in *The Location of Culture* (London: Routledge, 1994), 42, 50.
65. Frantz Fanon, *Black Skin, White Masks* (New York: Grove Press, 1967): 112.
66. Stuart Hall, "The After-Life of Frantz Fanon: Why Fanon? Why Now? Why *Black Skin, White Masks?*" in *The Fact of Blackness: Frantz Fanon and Visual Representation*, ed. Alan Read (Seattle: Bay Press, 1996), 16.
67. Yet, like Freud's account of the primal scene, Fanon aligns women with lack. About this Gwen Bergner writes: "In *Black Skin, White Masks*, women are considered as subjects almost exclusively in terms of their sexual relationships with men; feminine desire is thus defined as an overly literal and limited (hetero)-sexuality. But though feminine subjectivity clearly deserves broader description, the dimensions of its confinement within *Black Skin, White Masks* indicate the architecture of raced masculinity and femininity in the colonial contexts. So while it is not surprising that Fanon, writing in the early 1950s, takes masculine as the norm, it is necessary not only to posit alternative representations of femininity, but to consider how his account of normative raced masculinity depends on excluding femininities." Bergner's critique of Fanon is in line with arguments launched against Fanon's marginalization of women, especially women of color, but Berger also queries how Fanon's theory hinges on an exclusion of women. This exclusion produces a void in Fanon's theory and frames its limitation in articulating the gendered black subject position in the visual field. See Gwen S. Bergner, *Taboo Subjects: Race, Sex, and Psychoanalysis* (Minneapolis: University of Minnesota Press, 2005), 3.
68. David Marriott, *On Black Men* (New York: Columbia University Press, 2000), 68–69.
69. Marriott, *Haunted Life*, 2–3.

70. Daphne Brooks, *Bodies in Dissent: Spectacular Performances of Race and Freedom, 1850–1910* (Durham, NC: Duke University Press, 2006), 8.
71. Ahmed, "Affective Economies," 127.
72. See Stuart Hall, ed., *Representation: Cultural Representations and Signifying Practices* (London: Sage Publications, 1997), 18; Stuart Hall and Paul du Gay, eds. *Questions of Cultural Identity* (London: Sage Publications, 1996).
73. Fanon, *Black Skin, White Masks*, 112–13.
74. Daniel Y. Kim, *Writing Manhood in Black and Yellow: Ralph Ellison, Frank Chin, and the Literary Politics of Identity* (Stanford, Calif.: Stanford University Press, 2005), 5.
75. Lola Young, "Missing Persons: Fantasizing Black Women in *Black Skin, White Masks*," in *The Fact of Blackness*, ed. Read, 89.
76. Marriott, *Haunted Life*, 33.
77. Young, "Missing Persons," 94.
78. Ibid., 93.
79. Fanon, *Black Skin, White Masks*, 112.

CHAPTER ONE

1. I use "black freedom movements" and "black freedom struggles" to refer broadly to a range of strategies, protests, organized and spontaneous activities of black subjects to contest racial inequality and subjugation over a broad span of time. I use "civil rights era" to refer to the integrated and orchestrated movement between 1955 and 1968 led by members of black churches and civil organizations that has come to dominate the public understanding of the struggle for racial equality among blacks. Nikhil Singh has put forth a conceptualization of "the long civil rights era" that moves beyond a normative understanding of the period as discreetly marked and focused on a few exceptional individuals. See Nikhil Singh, *Black Is a Country: Race and the Unfinished Struggle for Democracy* (Cambridge: Harvard University Press, 2004).
2. Charles Sanders Peirce, "One, Two, Three: Fundamental Categories of Thought and of Nature," in *Peirce on Signs: Writings on Semiotic*, ed. James Hoopes (Chapel Hill: University of North Carolina Press, 1991), 181.
3. Marita Sturken and Lisa Cartwright, *Practices of Looking: An Introduction to Visual Culture* (New York: Oxford University Press, 2001), 357.
4. Robert Hariman and John Louis Lucaites, *No Caption Needed: Iconic Photographs, Public Culture, and Liberal Democracy* (Chicago: University of Chicago Press, 2007), 29.
5. Hariman and Lucaites are concerned with how iconic photographs circulate in public culture to manage contradictions and crises for liberal democracies. My concern is how iconic photography is used in public culture to reproduce dominant racial narratives that shore up the nation-state.
6. My use of affective response and sticking refers to Sara Ahmed's "Affective Economies" discussed in more detail in the introduction of this book. See Hariman and Lucaites, *No Caption Needed*, for "iconic affect" (36).
7. Evelyn Brooks Higginbotham, *Righteous Discontent: The Women's Movement in the Black Baptist Church, 1880–1920* (Cambridge: Harvard University Press, 1993).
8. Peter Applebome, "The Man Behind Rosa Parks," *New York Times*, December 7, 2005, A1.
9. Ibid.
10. Ibid.
11. Douglas Brinkley, *Rosa Parks* (New York: Lipper/Viking Book, 2005), 170, 171.

12. Jeremy W. Peters and Julie Bosman, "Rosa Parks Won a Fight, but Left a Licensing Rift," *New York Times*, October 8, 2006, http://www.nytimes.com/2006/10/08/business/yourmoney (accessed February 19, 2010).
13. Leigh Raiford, "Restaging Revolution: Black Power, *Vibe* magazine, and Photographic Memory," in *The Civil Rights Movement in American Memory*, ed. Renee C. Romano and Leigh Raiford (Athens: University of Georgia Press, 2006), 222.
14. About this, Martha Rosler writes that there is a "well-entrenched paradigm in which a documentary image has two moments: (1) the 'immediate,' instrumental one, in which an image is caught or created out of the stream of the present and held up as testimony, as evidence in the most legalistic of senses, arguing for or against a social practice and its ideological-theoretical supports, and (2) the conventional 'aesthetic-historical' moment, less definable in its boundaries, in which the viewer's argumentativeness cedes to the organismic pleasure afforded by the aesthetic 'rightness' or well-formedness (not necessarily formal) of the image. The second moment is ahistorical in its refusal of specific historical meaning yet 'history minded' in its very awareness of the pastness of the time in which the image was made." Martha Rosler, "In, Around, and Afterthoughts (On Documentary Photography)," in *The Photography Reader*, ed. Liz Wells (New York: Routledge, 2003), 268.
15. A few among them are John W. Mosley of Philadelphia, Richard Samuel Roberts in South Carolina, James Van Der Zee (well known) and Alix Dejean (lesser known) of Harlem, and Addison Scurlock of Washington, DC. See Willis, *Reflections in Black*; Niko Koppel, "In Thousands of Images, a Photographer Builds a History in Harlem," *New York Times*, July 21, 2008; Vernon Clark, "Philly's 'Picture-Taking Man' John W. Mosley Chronicled African-American Life," *Philadelphia Daily News*, February 8, 2010.
16. Quoted in Ellen S. Wilson's "Documenting Our Past: The Teenie Harris Archive Project," *Carnegie Online*, July/August 2003, http://www.carnegiemuseums.org/cmag/bk_issue/2003/julaug/cma.html (accessed September 26, 2006). Also see Laurence A. Glasco, "Documenting Our Past: The Teenie Harris Archive Project," July 5–November 16, 2003, Forum Gallery, Carnegie Museum of Art, http://www.cmoa.org/teenie/info.asp (accessed October 8, 2007).
17. Willis, *Reflections in Black*, 90.
18. See Glasco, "Documenting Our Past."
19. For much of his later life, Harris lived in poverty, receiving a modest Social Security income and no pension. In 1986 a local entrepreneur, Dennis Morgan, approached the seventy-eight-year old Harris and offered to manage his photographic collection and distribute his work. Harris signed a contract entrusting Morgan with his life's work for which Harris was paid $3,000. According to one of Harris's attorneys, "In return, this man promised to act as a distributor of Teenie's artwork, to pay Teenie royalties, and to protect the negatives." After turning over his collection to Morgan, Harris received very little financial compensation, although, according to Harris's heirs, Morgan claimed that in one year he made over $100,000 from selling prints of the work. Additionally, Morgan refused to return the collection to Harris. According to Harris's son Charles A. Harris, it is unclear whether Harris knew what he had signed given that he was semiliterate and had only an eighth-grade education; see documentary *One Shot: The Life and Work of Teenie Harris* (written by Joe Seamans, dir. Kenneth Love. San Francisco: California Newsreel, 2003). At the age of nearly ninety, Harris, working with pro bono attorneys, began legal proceedings to sue for the return of his work. He died in 1998 before the case was resolved. However, with

the cooperation of Harris's family, the attorneys continued to fight to regain Harris's life work. In 2000 courts ruled that Harris's estate should receive $4.3 million in financial compensation for the sale and distribution of his work. Harris's children waived their right to financial compensation in order to have their father's collection returned. Cynthia E. Kernick, "A Lucky Circumstance," in *Spirit of a Community: The Photographs of Charles "Teenie" Harris* (Greensburg, Pa.: Westmoreland Museum of Art, 2001), 16.

20. Interview with Charles A. Harris in *One Shot*; Louise Lippincott and Kerin Shellenbarger, interviewed by author, Carnegie Museum of Art, Pittsburgh, August 17, 2009 (herafter Lippincott interview and Shellenbarger interview).

21. Some of the images were labeled and titled before the museum gained possession. However, these titles and labels are attributed to the *Pittsburgh Courier* when images were captioned to run in the paper and by Harris's photo assistants. Louise Lippincott stated that Harris did not like to read and write and preferred the camera as his mode of communicating. Lippincott interview.

22. During my time with photo archivist Kerin Shellenbarger at the museum, she received information from historian Laurence Glasco, who has worked with the museum for years on cataloguing Harris's work, that in fact the water was not from a hydrant but from a hose.

23. When I interviewed Kerin Shellenbarger, she described an instance where she labeled an image of a young child giving a glass to an elderly woman in bed with a title similar to granddaughter giving a glass of water to an ailing grandmother, only later to learn through the *Courier* archives that the girl was a neighbor helping a woman who had been hurt when her roof collapsed. Shellenbarger interview.

24. Peirce, "One, Two, Three," 183.

25. Christian Metz, "Photography and the Fetish," in *The Photography Reader*, ed. Wells, 139.

26. Rosler, "In, Around, and Afterthoughts," 262.

27. The FSA Photographic Project, under the direction of Roy Stryker, created thousands of images, including Dust Bowl refugees, migrant laborers, rural poverty, and Japanese American internment, which were meant to serve the New Deal legislation and garner public support for Franklin Delano Roosevelt's policies to recover from the Great Depression. See William Stott, *Documentary Expression and Thirties America* (Chicago: University of Chicago Press, 1986); James Curtis, *Mind's Eye, Mind's Truth: FSA Photography Reconsidered* (Philadelphia: Temple University Press, 1992); Alan Trachtenberg, *Reading American Photographs: Images as History, Matthew Brady to Walker Evans* (New York: Hill and Wang, 1990); James Curtis, "Making Sense of Documentary Photography," from the Making Sense of Evidence series on *History Matters: The U.S. Survey on the Web*, located at http://historymatters.gmu.edu: 4 (accessed July 5, 2008).

28. See Martha Rosler's analysis of one of the most reproduced image in the world, Dorothea Lange's *Migrant Mother*, which was photographed in 1936 as part of the FSA project. Rosler asks what happens to the historic subjects of many of these iconic images. She looks at the news coverage of Florence Thompson, the mother photographed in *Migrant Mother*, who continued a lifetime of poverty. Rosler considers the incongruity between the life of the historic subject photographed and its reception and continued circulation. She quotes Thompson as saying that she has not benefited materially from the image and has tried unsuccessfully to stop its circulation. Rosler quotes Roy Stryker, the director of the FSA Photographic Project, as stating

about the photograph, "To me, it was the picture of Farm Security.... She has all of the suffering of mankind in her but all of the perseverance too.... You can see anything you want to in her. She is immortal" ("In, Around, and Afterthoughts," 267).

29. While the rationale behind the FSA Photographic Project was abundantly clear to photographers and for the most part to audiences, the depiction of race within the FSA School was filled with ambiguity. As has been well documented, FSA photographers were encouraged to focus more attention on the plights of rural whites given the administration's belief that these images would generate more sympathy from the national public than images of blacks. Whites were considered more deserving of government aid. See Nicholas Natanson, *The Black Image in the New Deal: The Politics of FSA Photographs* (Knoxville: University of Tennessee Press, 1992). In many instances where FSA photographers worked to document black subjects, dominant racial discourse dictated their crafting. James Curtis examines how Arthur Rothstein's images of blacks at Gee's Bend, Alabama, were orchestrated in such a way to support racial assumptions of the time, even if it meant denying or reimagining the personal narratives and biographical details of the photographic subjects. See Curtis, "Making Sense of Documentary Photography," 8–9.

30. Maren Stange, *Symbols of Ideal Life: Social Documentary Photography in America 1890–1950* (Cambridge: Cambridge University Press, 1989), xiii.

31. David A. Bailey and Stuart Hall, "The Vertigo of Displacement," in *The Photography Reader*, ed. Wells, 381.

32. While Parks and DeCarava's careers overlapped with Harris, they are about fifteen years younger than Harris.

33. See DeCarava's collaboration with Langston Hughes, *The Sweet Flypaper of Life* (New York: Simon and Schuster, 1955), which focuses on working-class families and urban life in Harlem.

34. Willis, *Reflections in Black*, 89.

35. In her study, *The Art of History: African American Women Artists Engage the Past*, Lisa Gail Collins describes how Parks spent a month with Watson documenting her everyday life. As part of this time with her, another iconic image emerged titled *Children with Doll* (1942). The image depicts Watson's young granddaughter and grandson crouched in a barren corner holding a white doll. Collins writes that Gordon "staged a picture of her grandchildren with their white doll in order to expose the critical lack of economic resources in the grandmother-led household, despite her hard work.... Through this work, Parks tried to increase viewers' awareness of poverty and racial discrimination and to foster their indignation that children were in physical danger due to these social conditions" (106).

36. Gordon Parks, "Half Past Autumn," interview by Phil Ponce, January 6, 1998, *NewsHour*, http://www.pbs.org/newshour/bb/entertainment/jan-june98/gordon_1-6.html (accessed July 5, 2008).

37. Roland Barthes, *Camera Lucida*, trans Richard Howard (New York: Hill and Wang, 1981), 88–89.

38. Martin Berger, "Civil Rights Photography and the Politics of Race in the 1960s America," unpublished draft of "The Formulas of Documentary Photography," in *In Black and White: Civil Rights Photography and 1960s America* (Berkeley: University of California Press, 2011).

39. Leigh Raiford, "'Come Let Us Build a New World Together': SNCC and Photography of the Civil Rights Movement," *American Quarterly* 59, no. 4 (December 2007): 1129–57.

40. Leigh Raiford and Renee C. Romano, "Introduction: The Struggle over Memory," in *The Civil Rights Movement in American Memory*, ed. Romano and Raiford, xiv.
41. Ibid., xvii.
42. I place "African American" in quotation marks because of the controversy that ensued during the election about whether Obama is African American, given that he is not a descendant of American slavery (although his white ancestors have a legacy in slave-owning). See Tavia Nyong'o's *The Amalgamation Waltz: Race, Performance, and the Ruses of Memory* (Minneapolis: University of Minnesota Press, 2009) for an astute analysis. Regarding the anticipation of declaring this historical marker, see *New York Times* headline, "Obama Elected President as Racial Barrier Falls," November 5, 2008. Also several sources announced that CNN topped all networks for viewership on November 4, 2008, the night of the 2008 presidential elections. Immediately afterward, CNN ran several commercials touting its rating. See "Election Night Ratings Blowout: 71.5 Million Watch Obama Win," *The Hollywood Reporter*, http://www.thrfeed.com/2008/11/election-rating.html (accessed November 8, 2008).
43. It is the movement toward "a more perfect union," as Obama phrased it in his 2008 Philadelphia address while campaigning to be the Democratic contender for United States president. Barack Obama, "A More Perfect Union" speech, Philadelphia, March 18, 2008, http://www.barackobama.com/2008/03/18/remarks_of_senator_barack_obam_53.php (accessed November 9, 2008).
44. A contemporary play *The Good Negro* engages with the use of visuality to forward notions of blacks as deserving of full citizenship status during the era.
45. *Moneta Sleet, Jr.: Pulitzer Prize Photojournalist*, Schomburg Center for Research in Black Culture's Traveling Exhibition Program, curated by Julia Van Haaften and Deborah Willis, New York City, November 8, 2007–December 31, 2007. Sleet worked for *The Amsterdam News* and *Our World* before joining the staff of *Ebony* magazine, for which he documented the civil rights struggles in the United States as well as the rise in independent African nations.
46. Doris E. Saunders, ed., *Special Moments in African-American History: 1955–1996. The Photographs of Moneta Sleet Jr.*, Ebony Magazine's Pulitzer Prize Winner (Chicago: Johnson Publishing, 1998), 140.
47. Deborah Willis, interview, in *One Shot* (transcribed by author) (hereafter Willis interview).
48. Charles A. Harris, telephone interview with author, November 12, 2009 (hereafter Harris interview).
49. Butler, *Undoing Gender*, 206, 225.
50. Nate Smith, interview, in *One Shot* (transcribed by author).
51. Bill Nichols, *Representing Reality: Issues and Concepts in Documentary* (Bloomington: Indiana University Press, 1991), 3.
52. Thanks to Shellenbarger and Lippincott for pointing out the recurrence of Harris's images inside of his work.
53. George Barbour, interview in *The Black Press: Soldiers without Swords*, prod. Stanley Nelson (San Francisco: California Newsreel, 1998).
54. Lionel Harris, interview in *One Shot*.
55. Charles Harris, "A Personal Tribute," in *Spirit of a Community*, 8.
56. Willis interview.
57. Ellen S. Wilson, "Filling in the Blanks: The Teenie Harris Archive Project Continues," *Carnegie Online*, January/February 2004, http://www.carnegiemuseums.org/cmag/bk_issue/2004/janfeb/feature2.html (accessed September 26, 2006).

58. Charles A. Harris, interview in *One Shot*.
59. Willis interview.
60. Harris interview.
61. Harris interview.
62. Shellenbarger interview.
63. bell hooks, "In Our Glory: Photography and Black Life," in *Picturing Us*, ed. Willis, 52.
64. Susan Sontag, *On Photography* (New York: Picador, 1977), 11; Barthes, *Camera Lucida*; and Peggy Phelan, "Francesca Woodman's Photography: Death and the Image One More Time," *Signs* 27, no. 4 (2004): 981.
65. For more on vernacular photography, see Stacey McCarroll Cutshaw and Ross Barrett, *In the Vernacular: Photography of the Everyday* (Seattle: University of Washington Press, 2008); Brian Wallis and Deborah Willis, *African American Vernacular Photography* (New York: Seidl/ICP, 2006).
66. See Brian Wallis, "Black Bodies, White Science: Louis Agassiz's Slave Daguerreotypes," in *Only Skin Deep: Changing Visions of the American Self*, ed. Coco Fusco and Brian Wallis (New York: Harry N. Abrams, 2003), 163–81.
67. Nicholas Mirzoeff. "The Shadow and the Substance: Race, Photography and the Index," in *Only Skin Deep*, ed. Fusco and Wallis, 112; Anna Pegler-Gordon, "Chinese Exclusion, Photography, and the Development of U.S. Immigration Policy," *American Quarterly* 58, no. 1 (March 2006): 51–77; David L. Eng, *Racial Castration: Managing Masculinity in Asian America* (Durham, NC: Duke University Press. 2001); Anthony W. Lee, *Picturing Chinatown: Art and Orientalism in San Francisco* (Berkeley: University of California Press, 2001).
68. Joseph Entin. "Modernist Documentary: Aaron Siskind's *Harlem Document*," *Yale Journal of Criticism* 12, no. 2 (1999): 369.
69. Ibid., 363.
70. Lippincott and Shellenbarger interviews.
71. Harris interview.
72. Glasco, "Double Burden: The Black Experience in Pittsburgh," in *African Americans in Pennsylvania: Shifting Historical Perspectives*, ed. Joe William Trotter and Eric Ledell Smith (University Park, Pa.: Pennsylvania State University Press, 1997), 425. The author borrows "bulldozer renewal" from urban historian Roy Lubove to describe policies that demolish pre-existing communities and institutions in the name of urban renewal.
73. There is very little documentation of the black civil rights movement locally in Pittsburgh, besides the riots that occurred in 1968. Even the *Pittsburgh Courier*, in part due to its national circulation, chose to prioritize coverage of activism in other parts of the country, specifically the South and East over the events in Pittsburgh. According to Glasco, Pittsburgh does not have a strong activist history among its black communities of fighting many of these structural changes that ultimately led to the Hill District's demise. Glasco argues that the lack of salient organizing among blacks in Pittsburgh is in large part due to its weak political presence throughout much of the twentieth century. Ibid., 426.
74. Harris, interview in *One Shot* (transcribed by author).
75. Of these images of Clay and family, one was published in the *Pittsburgh Courier— Muhammad Ali (Cassius Clay) lifting his mother Odessa Grady Clay, in room at Carlton House Hotel* (c. 1963). It consisted of the young boxer lifting his mother and both smiling and the image was captioned: "Mrs. Clay and her son Cassius . . . fighter's favorite fan." An article surrounds the photograph, headlined "Clay's Greatest Need

Is Trainer Who Can Teach Him Fundamentals." The piece is an analysis of the writer of Clay's weaknesses and a question of his discipline and ability to reach the heights of Joe Louis and other great black boxers whom Clay admires.

76. Since the first exhibit, the museum has held two more exhibits, *Documenting Our Past, Part Two* and *Part Three*. Harris's son, Charles A. Harris, curated the most recent.
77. Quoted in Wilson's "Documenting Our Past."
78. Wilson, "Filling in the Blanks."

CHAPTER TWO

1. Harry J. Elam Jr., "The Device of Race: An Introduction," in *African American Performance and Theater History: A Critical Reader*, ed. Harry J. Elam Jr. and David Krasner (New York: Oxford University Press, 2001), 4.
2. Thanks to Kyla Wazana Tompkins for clarifying many of these points.
3. Barrett, *Blackness and Value*, 21. To theorize blackness and value, Barrett uses Mary Douglas's study *Purity and Danger: An Analysis of the Concepts of Pollution and Taboo* (London: Routledge and Kegan Paul, 1966) and quotes: "Dirt is the by-product of a systematic ordering and classification of matter, in so far as ordering involves rejecting inappropriate elements" (35).
4. *Yellowman* program, Berkeley Repertory Theatre, January 23–March 7, 2004, 3.
5. Kathy Russell, Midge Wilson, and Ronald Hall, *The Color Complex: The Politics of Skin Color Among African Americans* (New York: Anchor Books, 1992), 2.
6. See Jared Sexton, *Amalgamation Schemes: Antiblackness and the Critique of Multiracialism* (Minneapolis: University of Minnesota Press, 2008); Nyong'O, *The Amalgamation Waltz*; Cherene Sherrard-Johnson, *Portraits of the New Negro Woman: Visual and Literary Culture in the Harlem Renaissance* (New Brunswick, NJ: Rutgers University Press, 2007).
7. H. Lin Classon, "Re-Evaluating *Color Struck*: Zora Neale Hurston and the Issue of Colorism," *Theatre Studies* 42 (1997): 11.
8. See P. Gabrielle Foreman, "Who's Your Mama?: 'White' Mulatta Genealogies, Early Photography, and Anti-Passing Narratives of Slavery and Freedom," *American Literary History* 14, no. 3 (Fall 2002): 505–39.
9. See Matthew Frye Jacobson's *Whiteness of a Different Color: European Immigrants and the Alchemy of Race* (Cambridge: Harvard University Press, 1999), and David Roediger's "Whiteness and Ethnicity in the History of 'White Ethnics' in the United States," in *Towards the Abolition of Whiteness: Essays on Race, Politics, and Working-Class History* (New York: Verso, 1994), 181–98.
10. A. Leon Higginbotham Jr. and Barbara K. Kopytoff, "Racial Purity and Interracial Sex in the Law of Colonial and Antebellum Virginia," in *Interracialism: Black-White Intermarriage in American History, Literature and the Law*, ed. Werner Sollors (New York: Oxford University Press, 2000), 131.
11. Cheryl I. Harris, "Whiteness as Property," *Harvard Law Review* 106, no. 8 (1993): 1707–91, 1777.
12. Ibid., 1778.
13. Taunya Banks, "Colorism: A Darker Shade of Pale," *UCLA Law Review* 47 (2000): 1711, 1743.
14. See Daphne Brooks's reading of minstrelsy's engagement with visuality, race, and bodily enactments in *Bodies in Dissent*. Brooks looks at how blackened-up white men's performances emphasized "a surplus corporeality and superabundant

representation as central thematic and visual attractions of the production" (26). In *Scenes of Subjection*, considering the visual and performative impact of "grotesque bodily acts" coded as black in minstrelsy, Hartman writes, "these performances of blackness regulated the excess they conjured up with the threat of punishment and humiliating discovery" (31). See Saidiya Hartman, *Scenes of Subjection: Terror, Slavery, and Self-Making in Nineteenth-Century America* (New York: Oxford University Press, 1997).

15. Brooks, *Bodies in Dissent*, 5, 65. Her use of Elin Diamond is *Unmaking Mimesis: Essays on Feminism and Theater* (New York: Routledge, 1997), 44.
16. Cherene Sherrard-Johnson, "'A Plea for Color': Nella Larsen's Iconography of the Mulatta," *American Literature* 76, no. 4 (December 2004): 833.
17. Quoted in Jennifer A. Cayer's "Roll yo' hips—don't roll yo' eyes: Angularity and Embodied Spectatorship in Zora Neale Hurston's Play *Cold Keener*," *Theatre Journal* 60 (2008): 48.
18. Hazel Carby, "The Politics of Fiction, Anthropology, and the Folk: Zora Neale Hurston," in *New Essays on "Their Eyes Were Watching God,"* ed. Michael Awkward (New York: Cambridge University Press, 1990), 74.
19. Harry J. Elam Jr. and Michele Elam, "Blood Debt: Reparations in Langston Hughes's *Mulatto*," *Theatre Journal* 61 (2009): 88, 98.
20. In recent articles, David Kadlec has written about her vexed relationship with ethnographic practices and Anthea Kraut has analyzed her exclusion from certain artistic traditions, specifically dance studies. See David Kadlec, "Zora Neale Hurston and the Federal Folk," *Modernism/modernity* 7, no. 3 (2000): 471–85; and Anthea Kraut, "Recovering Hurston, Reconsidering the Choreographer," *Women and Performance: A Journal of Feminist Theory* 16, no. 1 (March 2006): 71–90.
21. Kadlec, "Zora Neale Hurston and the Federal Folk," 479.
22. While with the WPA, she was an editor of the American Guide Series book *Florida* (1939). She also made sound recordings for the Folk Arts Committee of the WPA and the Library of Congress. Kadlec, "Zora Neale Hurston and the Federal Folk," 471–85.
23. Carby, "The Politics of Fiction, Anthropology, and the Folk," 77.
24. Cayer, "Roll yo' hips—don't roll yo' eyes," 39.
25. Ibid.
26. Kadlec, "Zora Neale Hurston and the Federal Folk," 482.
27. See David Krasner, "Migration, Fragmentation, and Identity: Zora Neale Hurston's *Color Struck* and the Geography of the Harlem Renaissance," *Theatre Journal* 53 (2001): 533–50; and Classon, "Re-Evaluating *Color Struck*," 4–18.
28. Regarding Hurston's engagement with aesthetics and representation of the era, Carby writes, "Hurston was a central figure in the cultural struggle among black intellectuals to define exactly who the people were that were going to become representatives of the folk. Langston Hughes shaped his discursive category of the folk in direct response to the social conditions of transformation, including the newly forming urban working class and 'socially dispossessed,' whereas Hurston constructed a discourse of nostalgia for a rural community." See Carby, "The Politics of Fiction, Anthropology, and the Folk," 77.
29. All page numbers cited in the text for *Color Struck* are from *Zora Neale Hurston: Collected Plays*, ed. Jean Lee Cole and Charles Mitchell (New Brunswick, NJ: Rutgers University Press, 2008).
30. Sandra L. Richards, "Writing the Absent Potential: Drama, Performance and the

Canon of African-American Literature," in *Performativity and Performance*, ed. Eve Kosofsky Sedgwick and Andrew Barker (New York: Routledge, 1995), 64–88.
31. Classon, "Re-Evaluating *Color Struck*," 16.
32. Hortense J. Spillers, "Changing the Letter: The Yokes, the Jokes of Discourse, or, Mrs. Stowe, Mr. Reed," in *Black, White, and in Color: Essays on American Literature and Culture* (Chicago: University of Chicago Press, 2003), 180.
33. Orlandersmith's previous works, *Beauty's Daughter* (1995), *Monster* (1996), and *The Gimmick* (1998), deal with a similar subject matter, that of a racialized young woman attempting to escape her deprived, subjugated conditions.
34. I am using Stuart Hall's definition of "conceptual maps" as shared systems of meaning within a given society. In terms of colorism, this means that audiences make the associations necessary to comprehend the logic and structure of the system where lightness is associated with potential, access, and beauty and blackness is weighted down, fixed, and denigrated.
35. All page numbers cited in text for *Yellowman* are from Dael Orlandersmith, *Yellowman and My Red Hand, My Black Hand* (New York: Vintage Books, 2002).
36. See Joe Adcock, "'Yellowman' Asks Much of its Actors and Audience," *Seattle Post-Intelligencer*, July 15, 2002, http://www.seattlepi.com/theater/78347_yellowmanq.shtml?dpfrom=thead (accessed November 5, 2009).

 Orlandersmith obtained significant support to develop the play through the Sundance Theatre Laboratory and the McCarter Theatre where *Yellowman* was commissioned and first produced in 2002. In the autumn of 2002, the Manhattan Theatre Club produced the play to large audiences. The playwright won the Susan Smith Blackburn Prize in 2003 for the play and the play is anthologized in editor Jeffrey Eric Jenkins's *The Best Plays of 2002–2003* (New York: Limelight Editions, 2003).
37. Alvin Klein, "A Love Story, with Cosmic Sweep," *New York Times*, January 20, 2002, sec. 14NJ, 12.
38. Interestingly enough, *Topdog/Underdog* is a play about black on black violence where two brothers struggles for power and recognition.
39. Alvin Klein, "A Study in Shades of Black," *New York Times*, April 21, 2002, sec. 14CN, 19.
40. Press release for *Yellowman* at the Manhattan Theatre Club, Boneau/Bryan-Brown (public relations firm), September 10, 2002.
41. I expressed this ambivalence in a review that I wrote in *Theatre Journal*. I would also like to correct an error that occurred through editorial process of my review in which Alma's father was described as her mother's husband. Orlandersmith gives no indication in the play that Alma's mother and father were married.
42. Fred Moten, "The Case of Blackness," *Criticism* 40, no. 2 (Spring 2008): 177–218.
43. In considering the place of black female playwrights in contemporary theater, Orlandersmith states: "Anna [Deavere Smith] is a sociologist, and what she does is documentary in theater. It is valid, and it is needed. But when you talk about Kia Corthron, Suzan-Lori Parks, and myself—we are writing characters. We are actually writing the characters. But, again, I am saying documentary theater is very valid." Dael Orlandersmith, interview, "Poof!: A New Perspective on Domestic Abuse from a Rising Voice in Contemporary Theater," KET, http://www.ket.org/content/american-shorts/poof/orlandersmith.htm (accessed September 13, 2008).
44. Ibid.
45. Krasner, "Migration, Fragmentation, and Identity," 538. Also see Richards's "Writing the Absent Potential" for its discussion of the importance of the visual in staging *Color Struck*.

46. Candice M. Jenkins, *Private Lives, Proper Relations: Regulating Black Intimacy* (Minneapolis: University of Minnesota Press, 2007), 147.
47. Ibid., 148, 149–50.
48. This is clearly noted in the litany of white and black men who for comic relief have dressed in drag as ordinary and well-known black women. For a few contemporary examples, see John Colapinto, "Armies of the Right: The Young Hipublicans," *New York Times Magazine*, May 25, 2003; Lynn Neary, "Rasputia: A Comic Type, or a Racial Stereotype?," National Public Radio, February 26, 2007, http://www.npr.org/templates/story/story.php?storyId=7608400 (accessed September 16, 2008).
49. Doris Witt, "Detecting Bodies: Barbara Neely's Domestic Sleuth and the Trope of the (In)visible Woman," in *Recovering the Black Female Body: Self-Representations by African American Women*, ed. Michael Bennett and Vanessa Dickerson (New Brunswick, NJ: Rutgers University Press, 2001), 170.
50. Karen Shimakawa, *National Abjection: The Asian American Body Onstage* (Durham, NC: Duke University Press, 2002), 2.
51. Julia Kristeva, *The Powers of Horror: An Essay on Abjection* (New York: Columbia University Press, 1982), 2.
52. Judith Butler, *Bodies That Matter: On the Discursive Limits of "Sex"* (New York: Routledge, 1993), 3.
53. Shimakawa, *National Abjection*, 18.
54. See Lisa Lowe, *Immigrant Acts* (Durham, NC: Duke University Press, 1996); Eng, *Racial Castration*.
55. Farah Jasmine Griffin, *"Who Set You Flowin'?": The African-American Migration Narrative* (New York: Oxford University Press, 1995), 4–5.
56. Ibid., 19.
57. Here, it is worth mentioning that Emma's cry, "Couldn't see," may also be read as a commentary on what John cannot see, what his vision fails to grasp, as it is suggested throughout the play that he has expressed desire for light-skinned black women, particularly Effie. However, given Hurston's fixation on what ails Emma and on her suffering, I read this line as Emma's reflection on her inability to see past her construction as despised black matter.
58. "Yellowman" is typically an insult to light-skinned black men used to associate his lightness with feminine features. However, it can also be a compliment if meant to convey sexual attractiveness because of skin color.
59. Here I use *denigrate/denigration* consciously to invoke its Latin roots "to blacken completely" as the lowest form of existence, and its reference of light-dark symbolism.
60. Ben Brantley, "Theater Review: Skin Tone as the Subtle Signal for Hatred in the Racial Family," *New York Times*, October 23, 2002; retrieved January 31, 2010, from http://theater.nytimes.com/mem/theater.
61. Barrett, *Blackness and Value*, 28.
62. See bell hooks' *Black Looks: Race and Representation* (Boston: South End Press, 1992).
63. The introduction of this book offers a more detailed account of Fanon's theory as it applies to race, subjectivity, and visual culture.
64. Marriott, *On Black Men*, 69.
65. By "recovery projects" I mean cultural works by black women that attempt to recover obscured historical narratives of black womanhood or that are meant to "correct" dominant notions and representations of black women as inferior beings. While I

sympathize generally speaking with the intentions behind much of this work, I am also critical of projects that attempt to portray an "accurate" representation of what it means to be black and woman.

66. Timothy Murray, "Facing the Camera's Eye: Black and White Terrain in Women's Drama," in *Reading Black, Reading Feminist: A Critical Anthology*, ed. Henry Louis Gates Jr. (New York: Meridian, 1990), 159–60.
67. Ibid.
68. Kristeva, *Powers of Horror*, 5.
69. In my analysis of black performance photographers and conceptual artists in chapter 3, I argue that black women enter the field of vision as excessive. In *Yellowman*, the marking of excess through representations of mournful, large dark bodies is quite different than the explicit and exposed pornographic bodies of contemporary black consumer culture.
70. In *Ethics After Idealism*, Chow analyzes how scholars have understood fascism as monstrosity and negation. Instead, Chow argues that fascist ideals, especially in visual representation, were promoted through the projection of larger-than-life, aestheticized surface ideals, or positivity. Her radical reading of fascism forces us to recognize the seduction of fascistic imagery and the comfort in aestheticized pleasure. Chow writes: "Instead of operating negatively as refusal, compensated lack, and defense mechanism, projection here is the positive instrument of transparency, of good intentions shining forth in dazzling light" (25). What is most significant about Chow's reinterpretation is that she moves away from a Freudian concept of negation because to negate is to deny or displace abjection and all that is unfamiliar on to the other. Rey Chow, *Ethics after Idealism: Theory-Culture-Ethnicity-Reading* (Bloomington: Indiana University Press, 1998).
71. Kristeva, *Powers of Horror*, 2, 10.
72. Francette Pacteau, "Dark Continent," in *With Other Eyes: Looking at Race and Gender in Visual Culture*, ed. Lisa Bloom (Minneapolis: University of Minnesota, 1999), 92.
73. Orlandersmith, "Light Skin, Dark Skin and the Wounds Below," *New York Times*, October 20, 2002, sec. 2, 5.
74. Kristeva, *Powers of Horror*, 5.

CHAPTER THREE

1. Pacteau, "Dark Continent," 97.
2. Brooks, *Bodies in Dissent*, 7.
3. For more on conflicts about art funding, standards of decency, and practice, see Lawrence Rothfield, ed., *Unsettling "Sensation": Arts-Policy Lessons from the Brooklyn Museum of Art Controversy* (New Brunswick, NJ: Rutgers University Press, 2001).
4. "The Mayor and the Arts, Round 2," *New York Times*, February 16, 2001, A18.
5. Some of the most well-documented examples are the NEA Four in which performance artists Karen Finley, Tim Miller, John Fleck, and Holly Hughes were vetoed from a grant review process because of subject matter and more relevant for my study the controversy surrounding and censorship of Marlon Riggs's *Tongues Untied* (Strand, 2008), also partly funded by NEA and sponsored through PBS's POV.
6. Monte Williams, "'Yo Mama' Artist Takes on Catholic Critic," *New York Times*, February 21, 2001, B3.
7. Jo Anna Isaak, "American Family," *Renee Cox: American Family* (New York: Robert Miller Gallery, 2001).

8. "The Mayor and the Arts, Round 2."
9. See David Elliott, "'Image', Black; A Survey of Black Photographers Has Some Striking Words," *San Diego Union-Tribune*, March 11, 2001, Books sec., 8; Williams, "'Yo Mama' Artist Takes on Catholic Critic."
10. Michael Eric Dyson, "One Man's Sacrilege, One Woman's Sanctity," *Chicago Sun-Times*, February 20, 2001, Editorial sec., 31.
11. Rebecca Schneider, *The Explicit Body in Performance* (New York: Routledge, 1997), 52.
12. Lorraine O'Grady, "Olympia's Maid: Reclaiming Black Female Subjectivity," *Afterimage* 20 (Summer 1992): 14.
13. José Esteban Muñoz, *Disidentifications: Queers of Color and the Performance of Politics* (Minneapolis: University of Minnesota Press, 1999), 5.
14. Ferguson, *Aberrations in Black*, 15.
15. Ibid., 15.
16. See Spillers, "Mama's Baby, Papa's Maybe," 65–81; Sharon Holland, *Raising the Dead: Readings of Death and (Black) Subjectivity* (Durham, NC: Duke University Press, 2000), 46.
17. See Wallace's *Invisibility Blues*.
18. Richard J. Powell, *Cutting a Figure: Fashioning Black Portraiture* (Chicago: University of Chicago Press, 2009), 10, 20.
19. Hershini Bhana Young, *Haunting Capital: Memory, Text, and the Black Diasporic Body* (Hanover, NH: Dartmouth College Press, 2006), 5.
20. Isaak, "American Family."
21. See Brody, "Black Cat Fever," 97.
22. Sir Mix-a-Lot, "Baby Got Back," *Mack Daddy* (Def American, 1992).
23. For more on the historic figure Saartjie Baartman and her influence on representation of black women, see Deborah Willis's edited collection *Black Venus 2010: They Called Her "Hottentot"* (Philadelphia: Temple University Press, 2010); Janell Hobson's *Venus in the Dark: Blackness and Beauty in Popular Culture* (New York: Routledge, 2005); Suzan-Lori Parks's *Venus* (New York: Theatre Communications Group, Inc, 1997).
24. Dorothy Roberts, *Killing the Black Body: Race, Reproduction, and the Meaning of Liberty* (New York: Random House, 1997).
25. Hazel Carby, "Policing the Black Female Body in an Urban Context," *Critical Inquiry* 18 (Summer 1992): 741. Carby also discusses how a similar discourse of moral panic and of black working-class and rural women's sexual deviance surfaced among the black middle class in urban environments and the public. An unattached black woman was considered "a threat to congenial black and white middle-class relations; and as a threat to the formation of black masculinity in an urban environment" (741).
26. Willis and Williams, *The Black Female Body*, xi.
27. Carla Williams, "The Erotic Image Is Naked and Dark," in *Picturing Us*, ed. Willis, 130, 131, 133.
28. Evelyn Hammonds, "Black (W)holes and the Geometry of Black Female Sexuality," *Differences: A Journal of Feminist Cultural Studies* 6, nos. 2–3 (1995): 132.
29. Phelan, *Unmarked*, 26.
30. Hammonds borrows the concept of "politics of silence" from Evelyn Brooks Higginbotham's important essay, "African American Women's History and the Metalanguage of Race," *Signs* 17, no. 2 (1992): 251–74, which examines the history of black women reformers in the nineteenth and early twentieth centuries who used

silence as a political strategy to resist dominant constructions of their sexualities and bodies.
31. Hammonds, "Black (W)holes and the Geometry of Black Female Sexuality," 141.
32. While Wallace specifically writes of the gendered position of black masculinity, I am specifying the corporeal figuration of the black female body that is gendered at times as feminine, other times as masculine, as hypersexual and as asexual. Maurice O. Wallace, *Constructing the Black Masculine: Identity and Ideality in African American Men's Literature and Culture, 1775–1995* (Durham, NC: Duke University Press, 2002), 30.
33. Silverman, *Threshold of the Visible World*, 10.
34. See my discussion of Fanon's "Look, a Negro!" anecdote in the introduction for a more detailed explication of this relationship.
35. Silverman, *The Threshold of the Visible World*, 19.
36. Jan Avgikos, "Tracey Rose: The Project," *Artforum* (October 2002): 152.
37. Lorraine Morales Cox, "A Performative Turn: Kara Walker's *Song of the South* (2005)," *Women and Performance: A Journal of Feminist Theory* 17, no. 1 (March 2007): 61, 78.
38. Stuart Hall, "What Is This 'Black' in Black Popular Culture?," in *Black Popular Culture*, ed. Gina Dent (Seattle: Bay Press, 1992), 25.
39. See Collins, *The Art of History*.
40. Spillers, "Mama's Baby, Papa's Maybe," 75.
41. See Christopher Holmes Smith, "'I Don't Like to Dream about Getting Paid': Representations of Social Mobility and the Emergence of the Hip-Hop Mogul," *Social Text* 21 (Winter 2003): 69–97, and Christopher Holmes Smith, "Hip-Hop Moguls," in *African Americans and Popular Culture*, vol. 3, *Music and Popular Art*, ed. Todd Boyd (Westport, Conn.: Praeger, 2008), 61–86.
42. Justin Timberlake, "Rock Your Body," *Justified* (Jive, 2002). Lyrics accessed on sing365.com on October 30, 2008.
43. "Spike Lee Calls Jackson's Flash a 'New Low': Janet Says Exposure Was Unintentional in Video Statement," Associated Press, February 4, 2004, http://www.msnbc.msn.com/id/4160392 (accessed October 20, 2009).
44. "Timberlake: Family Offended by Super Bowl," Associated Press, February 4, 2004, http://story.news.yahoo.com.
45. Donia Mounsef, "The Seen, the Scene, and the Obscene: Commodity Fetishism and Corporeal Ghosting," *Women and Performance: A Journal of Feminist Theory* 15, no. 2 (2005): 243–61.
46. Celine Parreñas Shimizu, *The Hypersexuality of Race: Performing Asian/American Women on Screen and Scene* (Durham, NC: Duke University Press, 2007), 34.
47. Ahmed, "Affective Economies," 118.
48. Carla Williams, "Body Baggage," *Newsday*, February 7, 2004, http://www.newsday.com/body-baggage-1.711053 (accessed February 10, 2004).
49. Frank Rich, "My Hero, Janet Jackson," *New York Times*, February 15, 2004.
50. Thanks to Ayanah Moor for clarifying this point and the phrase "global touring."
51. See Shanara Reid-Brinkley's "The Essence of Res(ex)pectability: Black Women's Negotiation of Black Femininity in Rap Music and Music Video," *Meridians: feminism, race, transnationalism* 8. no. 1 (2008): 236–60. Reid-Brinkley discusses the controversy at Spelman College about the airing of rapper Nelly's "Tip Drill" on BET's *Uncut*. In one scene of the video, the rapper slides a credit card between the buttocks of a black woman whose backside occupies the camera screen. Students and faculty

protested a bone-marrow drive that Nelly's foundation organized on campus in protest of representations of women in his video.

52. Mireille Miller-Young, "Hip-Hop Honeys and Da Hustlaz: Black Sexualities in the New Hip-Hop Pornography," *Meridians: feminism, race, transnationalism* 8, no. 1 (2008): 264.
53. In Reid-Brinkley's essay, "The Essence of Res(ex)pectability," she discusses "Take Back the Music," a year-long campaign that began in fall 2004, orchestrated by *Essence* magazine to call attention to misogyny in hip-hop music and videos.
54. Joan Morgan, *When Chickenheads Come Home to Roost: A Hip-Hop Feminist Breaks It Down* (New York: Simon and Schuster, 1999), 56–57.
55. Ayanah Moor, "Still," *Meridians: feminism, race, transnationalism* 8, no. 1 (2008): 205.
56. Written correspondence with Ayanah Moor, November 22, 2009.
57. Tricia Rose, *Black Noise: Rap Music and Black Culture in Contemporary America* (Hanover, NH: Wesleyan University Press, 1994), 169.
58. Ayanah Moor, "Statement of Practice," 2006, personal correspondence with author, December 5, 2009.
59. Andreana Clay, "'I Used to Be Scared of the Dick': Queer Women of Color and Hip-Hop Masculinity," in *Home Girls Make Some Noise: Hip Hop Feminism Anthology*, ed. Gwendolyn D. Pough (Mira Loma, Calif.: Parker Publishing, 2007), 159.
60. Lil' Kim, "Suck My Dick," *Notorious K.I.M.* (Atlantic Records, 2000). Lyrics transcribed by author. Also consulted Lyrics Domain, http://www.lyricsdomain.com/12/lil_kim/suck_my_dick.html (accessed February 21, 2010).
61. Lil' Kim, "How Many Licks." Lyrics transcribed by author. Also consulted Lyrics Domain, http://www.lyricsdomain.com/12/lil_kim/how_many_licks.html (accessed April 22, 2008).
62. Imani Perry, *Prophets of the Hood: Politics and Poetics in Hip Hop* (Durham, NC: Duke University Press, 2004), 182.
63. Susan Bordo, "'Material Girl': The Effacements of Postmodern Culture," in *The Madonna Connection: Representational Politics, Subcultural Identities, and Cultural Theory*, ed. Cathy Schwichtenberg (Boulder, Colo.: Westview, 1993), 270.
64. "In the Press," MAC AIDS Fund official website. February 7, 2000, http://www.macaidsfund.org/news/pr_rl_maryj_lil_kim.html (accessed December 5, 2009).
65. "Lil' Kim's 'Bionic Booty' Booted from 'Dancing with the Stars,'" *Seattle Times*, May 5, 2009, http://seattletimes.nwsource.com/html/television/2009180591_ztv06dancing.html (accessed December 5, 2009).

CHAPTER FOUR

1. Monica L. Miller, *Slaves to Fashion: Black Dandyism and the Styling of Black Diasporic Identity* (Durham, NC: Duke University Press, 2009), 4–6.
2. Shane White and Graham White, *Stylin': African American Expressive Culture from its Beginnings to the Zoot Suit* (Ithaca, NY: Cornell University Press, 1998), 2, 153.
3. Robin D. G. Kelley, *Race Rebels: Culture, Politics, and the Black Working Class* (New York: Free Press, 1994), 163.
4. Powell, *Cutting a Figure*, 128, 130.
5. Kelefa Sanneh, "Fine and Dandy," *Transition* 12, no. 4 (2003): 123.
6. Regina Austin, "'A Nation of Thieves': Consumption, Commerce, and the Black Public Sphere," in *The Black Public Sphere: A Public Culture Book*, ed. The Black Public Sphere Collective (Chicago: University of Chicago Press, 1995), 239.

7. For more on subculture studies, see Dick Hebdige, *Subculture: The Meaning of Style* (London: Routledge, 1979), Stuart Hall and Tony Jefferson, *Resistance through Rituals: Youth Subcultures in Post-War Britain* (London: Hutchinson, 1976), and Ken Gelder and Sarah Thornton, eds., *The Subcultures Reader* (London: Routledge, 1997).
8. Austin, "A Nation of Thieves," 243.
9. Roland Barthes, *The Fashion System*, trans. Matthew Ward and Richard Howard (Berkeley: University of California Press, 1983).
10. Dorinne Kondo, "Fabricating Masculinity: Gender, Race, and Nation in the Transnational Circuit," in *About Face: Performing Race in Fashion and Theater* (New York: Routledge, 1997), 16.
11. Jackson, *Real Black*, 15.
12. See Rose, *Black Noise*.
13. Nelson George, *Hip Hop America* (New York: Penguin Books, 1998), 158.
14. Kobena Mercer, "Black Hair/Style Politics," in *The Subcultures Reader*, ed. Gelder and Thornton, 430.
15. Noel McLaughlin, "Rock, Fashion and Performativity," in *Fashion Cultures: Theories, Explorations and Analysis*, ed. Stella Bruzzi and Pamela Church Gibson (London: Routledge, 2000), 269.
16. Holmes Smith, "Hip-Hop Moguls," 61.
17. George, *Hip Hop America*, 158–59.
18. See William Eric Perkins, "Rap Attack: An Introduction," in *Droppin' Science: Critical Essays on Rap Music and Hip-Hop Culture* (Philadelphia: Temple University Press, 1996).
19. Mark Spiegler, "Marketing Street Culture: Bringing Hip-Hop Style to the Mainstream," *American Demographics* (November 1996): 29.
20. See Laura J. Kuo, "The Commoditization of Hybridity in the 1990s U.S. Fashion Advertising: Who is cK one?," in *Beyond the Frame: Women of Color and Visual Representation*, ed. Neferti X. M. Tadiar and Angela Y. Davis (New York: Palgrave Macmillan, 2005), 31–47.
21. See Paul Smith, "Tommy Hilfiger in the Age of Mass Customization," in *Popular Culture: A Reader*, ed. Raiford Guins and Omayra Zaragoza Cruz (Thousand Oaks, Calif.: Sage Publications, 2005), 151–58.
22. The magazine has featured Karl Kani in at least four articles in four years, and in 1996 the magazine labeled his company "BE Company of the Year."
23. See Tariq K. Muhammad, "From Here to Infinity: A Hip-Hop Clothier with Mainstream Appeal, Karl Kani Is Poised to Become the Fashion World's New Wunderkind," *Black Enterprise* 26, no. 11 (June 1996): 140–47; and Leslie E. Royal, "Hip-Hop on Top: We Look at the Elements and Top Designers that Have Helped Urban Fashion Skyrocket, and Predict Where the Industry Is Headed," *Black Enterprise* 30, no. 12 (July 2000): 91–94.
24. Nina S. Hyde, "Springing Softly Burrows: Stephen Burrows' Flair for the Sensual," *Washington Post*, November 11, 1977, D11.
25. Ginia Bellafante, "A Fallen Star of the '70s Is Back in the Business," *New York Times*, January 1, 2002, B1.
26. As a part of a larger trend toward the increasing visibility of black male figures in American popular culture, this transition of rappers to designers runs parallel with a number of rap stars becoming film actors and directors.
27. Nancy Jo Sales, "Hip-Hop Goes Universal," *New York* 32, no. 18 (May 10, 1999): 25.

28. Davis enumerates the fashion process as 1) Invention; 2) Introduction; 3) Fashion Leadership; 4) Increasing Social Visibility; and 5) Waning. See Fred Davis, *Fashion, Culture, and Identity* (Chicago: University of Chicago Press, 1992), 137.
29. Diana Crane, *Fashion and Its Social Agendas: Class, Gender, and Identity in Clothing* (Chicago: University of Chicago Press, 2000).
30. The exception to this would be Jennifer Lopez's lines in the early part of the 2000s, which received a great deal of attention and branched out into perfumes and other accessories. However, by 2009, she was reportedly halting production of at least one of her clothing lines due to lackluster sales and interest. See Julee Kaplan's "Jennifer Lopez Exits Apparel in the U.S.," *Women's Wear Daily*, June 24, 2009, http://www.wwd.com/markets-news/jennifer-lopez-exits-apparel-in-the-us-2187085 (accessed October 29, 2009).
31. See "Eve Re-Launching Fetish Clothing Line," *World Entertainment News Network*, May 17, 2004; Julee Greenberg, "Eve Gives Fetish Another Try," *Women's Wear Daily* 126 (June 14, 2007): 9.
32. See Apple Bottom official website, http://lifestyle.applebottoms.com/company.asp (accessed October 29, 2009).
33. Perry, *Prophets of the Hood*, 157.
34. Notorious B.I.G., "Big Poppa," *Ready to Die* (Bad Boy Records, 1994). Lyrics transcribed by author.
35. See Thomas Frank, *The Conquest of Cool: Business Culture, Counterculture, and the Rise of Hip Consumerism* (Chicago: University of Chicago Press, 1997), and Thomas Frank and Matt Weiland's *Commodify Your Dissent: Salvos from the Baffler* (New York: W. W. Norton, 1997).
36. Barthes, *The Fashion System*, 14.
37. Kondo, *About Face*, 158.
38. For more on the ghetto action film and its relationship to hip-hop, see Watkins, *Representing*.
39. Barthes, *The Fashion System*, 13.
40. Davis, *Fashion, Culture, and Identity*, 26.
41. Kuo, "The Commoditization of Hybridity," 36.
42. Royal, "Hip-Hop on Top," 94.
43. Guy Trebay, "A Fashion Statement: Hip-Hop on the Runway," *New York Times*, February 9, 2002, B4.
44. For a more detailed profile on Combs's impact on mainstream fashion and his ambivalent embrace by the fashion industry, see Michael Specter's profile, "I Am Fashion: Guess Who Puff Daddy Wants to Be?" *New Yorker*, September 9, 2002, 117–27.
45. Sales, "Hip-Hop Goes Universal," 28.
46. Sally Beatty, "Kellwood to Buy Urban-Style Label Phat Fashions," *Wall Street Journal*, January 9, 2004, A9.
47. Sales, "Hip-Hop Goes Universal," 24.
48. Hazel V. Carby, *Race Men* (Cambridge: Harvard University Press, 1998).
49. Royal, "Hip-Hop on Top," 94.
50. Herman Gray, "Black Masculinity and Visual Culture," *Callaloo* 18, no. 2 (1995): 401.
51. George Epaminondas, "Pharrell Williams: Interview," *InStyle* 15, no. 3 (March 2008): 291.
52. Eric Wilson, "Who Put the Black in Black Style?" *New York Times*, August 31, 2006, G1.
53. Ibid.
54. Ibid.

CHAPTER FIVE

1. The exhibit *Fatimah Tuggar: Fusion Cuisine* ran from September 28, 2000, through October 21, 2000, at The Kitchen in New York City.
2. Unpublished artist statement, *Fusion Cuisine*, 2000.
3. My use of the term "the West" is with some skepticism throughout this chapter. It takes into account Nikhil Singh's critique: "The political community of the modern civic nation has been imagined first as something that can contain inequalities generated by the protections of private accumulation and market activity. At the same time, the civic nations of Europe and America have also formed against one another as a dominant 'core' in a world system in which territorial conquest, forced labor, and colonization have been central to a history of nationalizing otherwise heterogeneous social territories and articulating them in a common entity, often called 'the West.' In other words, these nations have formed the kind of collective identity for which the historical frameworks of race and legacies of racism have been employed to produce both a concept of the people and the legitimacy of the state" (36). See Singh, *Black Is a Country*.
4. I borrow the term "digital assemblage" from Jennifer González. See "The Appended Subject: Race and Identity as Digital Assemblage," in *Race in Cyberspace*, ed. Beth E. Kolko, Lisa Nakamura, and Gilbert Rodman (New York: Routledge, 2000), 27–50.
5. See Donna Haraway, *Modest_Witness@Second_Millennium.FemaleMan©_Meets_OncoMouse™: Feminism and Technoscience* (New York: Routledge, 1997). Haraway appropriates the term from Steven Shapin and Simon Schaffer's *Leviathan and the Air-Pump: Hobbes, Boyle, and the Experimental Life* (Princeton, NJ: Princeton University Press, 1985). She queers and makes corporeal the "objective" civil male "modest witness" of their text.
6. Kaja Silverman, *The Subject of Semiotics* (New York: Oxford University Press), 214.
7. Ibid., 222.
8. Some of these important developments in 1990s took place in the works of feminist of color. bell hooks's concept of "black looks" is one such interventionist theory. See hooks, *Black Looks*. Also see Minh-ha, *Framer Framed*.
9. Keeling, *The Witch's Flight*.
10. Sylvie Fortin, "Digital Trafficking: Fatimah Tuggar's Imag(in)ing of Contemporary Africa," *Art Papers*, March/April 2005, http://www.artpapers.org/feature_articles/feature1_2005_0304.htm (accessed April 23, 2009).
11. Manuel Castells, "Materials for an Exploratory Theory of the Network Society," *British Journal of Sociology* 51, no. 1 (2000): 5–24.
12. Sidney Littlefield Kasfir, *Contemporary African Art* (London: Thames and Hudson, 1999).
13. See ibid., and Olu Oguibe and Okwui Enwezor, *Reading the Contemporary: African Art Theory to Marketplace* (Cambridge, Mass.: MIT Press, 1999).
14. I refer to Dorinne Kondo's critique of "cosmopolitanism" as promoted by key male intellectuals. In chapter 5, "Fabricating Masculinity: Gender, Race, and Nation in the Transnational Circuit," of *About Face*, Kondo examines the masculinist elitism and class hierarchy that undergird the contemporary deployment of "cosmopolitanism" in cultural theory.
15. By digital divide, I use a generic phrase that refers to the unequal distribution of technology and the imbalance of technological literacies based on race, class, gender, and geographic factors. For critical scholarship on the relationship of race, gender, and technology, see Alondra Nelson, "Introduction: Future Texts," in "Afrofuturism,"

ed. Alondra Nelson, special issue of *Social Text* 20, no. 2 (2002): 1–15, and Alondra Nelson and Thuy Linh N. Tu, with Alicia Headlam Hines, eds., *Technicolor: Race, Technology, and Everyday Life* (New York: New York University Press, 2001).

16. Nelson, "Introduction," 4.
17. Recent anthologies like Beth Kolko, Lisa Nakamura, and Gilbert Rodman, eds., *Race in Cyberspace* (London: Routledge, 2000) and Nelson and Tu's *Technicolor* have attempted to address these inadequacies in race/technology discourses. See also Erika Muhammad, "Black High-Tech Documents," in *Struggles for Representation: African American Documentary Film and Video*, ed. Phyllis Rauch Klotman and Janet K. Cutler (Bloomington: Indiana University Press, 1999), on the work of contemporary black artists who use new technologies to enter discourses on race, access, and nation.
18. See Haraway, *Modest_Witness*; Rosi Braidotti, *Metamorphoses: Towards a Materialist Theory of Becoming* (Malden, Mass.: Blackwell, 2002); and Anna Everett, "The Revolution Will Be Digitized: Afrocentricity and the Digital Public Sphere," in "Afrofuturism," ed. Alondra Nelson, special issue of *Social Text* 20, no. 2 (2002): 125–46. Everett debunks myths of what she calls "black technophobia" by looking at the innovative uses and appropriations of new technology by black communities (132). Jennifer González, looking at configurations of gendered and racialized identity in digital space, examines how these are based often on physiological tropes of racial and sexual differences and normative representational codes ("The Appended Subject").
19. Muhammad, "Black High-Tech Documents," 299.
20. Everett, "The Revolution Will Be Digitized," 137.
21. Carol Kino, "Fatimah Tuggar at Greene Naftali," *Art in America* 89, no. 9 (2001): 155–56.
22. The installation is also reminiscent of cinematic trends in the 1950s to create a multisensory filmic experience, such as Cinerama, 3-D films, and Smell-O-Vision.
23. The passage in Jamaica Kincaid's text reads: "That the native does not like the tourist is not hard to explain. For every native of every place is a potential tourist, and every tourist is a native of somewhere. Every native everywhere lives a life of overwhelming and crushing banality and boredom and desperation and depression, and every deed, good and bad, is an attempt to forget this. Every native would like to find a way out, every native would like a rest, every native would like a tour. But some natives—most natives in the world—cannot go anywhere. They are too poor. They are too poor to go anywhere. They are too poor to escape the reality of their lives; and they are too poor to live properly in the place where they live, which is the very place you, the tourist, want to go—so when the natives see you, the tourist, they envy you, they envy your ability to leave your own banality and boredom, they envy your ability to turn their own banality and boredom into a source of pleasure for yourself." See Jamaica Kincaid, *A Small Place* (New York: Farrar, Straus and Giroux, 1988), 18–19.

Tuggar's *Meditation on Vacation* (2002) is directly in conversation with Stephanie Black's critically acclaimed documentary *Life and Debt* (2001), which examines the exploitative policies of the World Bank and the International Monetary Fund in Jamaica. The film is driven by didactic narration adapted from Jamaica Kincaid's nonfiction text, *A Small Place* and addresses its audience as "you," the tourist who comes to Jamaica unaware of its geopolitical conditions. Tuggar uses the same narration to put her video in dialogue with Black's film. Whereas Black's film is geared to representing "the victims" and "the perpetrators" of contemporary transnational capital flows, Tuggar's work considers the nuances, contradictions, and ephemera

that results from these systems. See *Life and Debt*, dir. Stephanie Black, Tuff Gong International, 2001.
24. Catanese, "How Do I Rent a Negro?," 711.
25. Fortin, "Digital Trafficking."
26. See Kaja Silverman's *Flesh of My Flesh* (Stanford: Stanford University Press, 2009) for an analysis of how the privilege of difference has paralyzed thought on interrelatedness.
27. Ann Weinstone, *Avatar Bodies: A Tantra for Posthumanism* (Minneapolis: University of Minnesota Press, 2004), 4.
28. Ibid., 4–5.
29. Martha Gever, "The Feminism Factor: Video and its Relation to Feminism," in *Illuminating Video: An Essential Guide to Video*, ed. Doug Hall and Sally Jo Fifer (San Francisco: Aperture, 1990), 226–41.
30. Amy Kaplan, "Manifest Domesticity," *American Literature* 70, no. 3 (1998): 581–606.
31. Karal Ann Marling, *As Seen on TV: The Visual Culture of Everyday Life in the 1950s* (Cambridge: Harvard University Press, 2000), 243.
32. For discussion of the female viewing audience and the television in domestic space, see Lynn Spigel, *Make Room for TV: Television and the Family Ideal in Postwar America* (Chicago: University of Chicago Press, 1992).
33. Marling, *As Seen on TV*, 266.
34. Fortin, "Digital Trafficking."
35. Silverman, *Threshold of the Visible World*, 205.
36. Toni Morrison, *Playing in the Dark: Whiteness and the Literary Imagination* (New York: Vintage, 1993), 33.
37. Artist statement quoted in *New York Arts Magazine*, http://nyartsmagazine.com/59/towards.htm.
38. Vivian Sobchack, "'At the Still Point of the Turning World': Meta-morphing and Meta-stasis," in *Meta-morphing: Visual Transformation and the Culture of Quick-Change*, ed. Vivian Sobchack (Minneapolis: University of Minnesota Press, 2000), 149.
39. Vivian Sobchack, "The Scene of the Screen: Envisioning Cinematic and Electronic 'Presence,'" in *Electronic Media and Technoculture*, ed. John Thornton Caldwell (New Brunswick, NJ: Rutgers University Press, 2000), 137–55.
40. Lennie Bennett, "The Ironic Eye," *St. Petersburg Times*, November 10, 2002, 10F; Joanne Milani, "Continental Divide," *Tampa Tribune*, December 1, 2002, 1; Dan Tranberg, "Works on Feminist Theme Reflect Individual Visions," *Cleveland Plain Dealer*, October 5, 2001, E1.
41. Elizabeth Janus, "Fatimah Tuggar: Art and Public," *Artforum* 39, no. 5 (2001): 147.
42. The Internet-based project is located at http://www.artproductionfund.org/inspace/tuggar/cs.html.
43. Holland Cotter, "Finding Art in the Asphalt," *New York Times*, September 12, 2008, http://www.nytimes.com/2008/09/12/arts/design/12stre.html?pagewanted=all (accessed April 7, 2009).
44. See Tom Finkelpearl, *Dialogues in Public Art* (Cambridge, Mass.: MIT Press, 2000).
45. Olu Oguibe, "Forsaken Geographies: Cyberspace and the New World 'Other,'" paper presented at the Fifth International Cyberspace Conference, Madrid, June 1996. Full text available at http://internet.eserver.org/oguibe/ (accessed November 26, 2009).
46. Silverman, *Threshold of the Visible World*, 201–2.
47. Guillermo Gómez-Peña, "The Virtual Barrio @ the Other Frontier (or the Chicano Interneta)," in *Clicking In: Hot Links to a Digital Culture*, ed. Lynn Hershman Leeson (Seattle: Bay Press, 1996), 176.

48. Olu Oguibe, "Art, Identity, Boundaries: Postmodernism and Contemporary African Art," in *Reading the Contemporary: African Art from Theory to Marketplace*, ed. Olu Oguibe and Okwui Enwezor (Cambridge: MIT Press, 1999), 16.
49. In "Art, Identity, Boundaries: Postmodernism and Contemporary African Art," Oguibe discusses an encounter between postmodern critic Thomas McEvilley and African artist Ouattara who now lives in New York. According to Oguibe, when McEvilley interviewed Ouattara, he asked questions that fit into a predetermined narrative about what an African artist is; questions about his "native" land and his family. Oguibe argues that Ouattara could only resist these questions through silence, aware of the power imbalance in the exchange.

CODA

1. David Gates, "Finding Neverland," *Newsweek*, July 13, 2009, 35.
2. "Pop Icon Michael Jackson Is Dead." *Los Angeles Times*, June 25, 2009.
3. Greg Tate, "Michael Jackson: The Man in Our Mirror: Black America's Eulogies for the King of Pop Also Let Us Resurrect His Best Self," *Village Voice*, June 30, 2009, http://www.villagevoice.com/2009-07-01/news/michael-jackson-the-man-in-our-mirror/ (accessed November 21, 2009).
4. Brooks Barnes, "A Star Idolized and Haunted, Michael Jackson Dies at 50," *New York Times*, June 26, 2009, http://www.nytimes.com/2009/06/26/arts/music/26jackson.html (accessed November 20, 2009).
5. Gates, "Finding Neverland," 35.
6. Geoff Boucher and Elaine Woo, "Michael Jackson's Life Was Infused with Fantasy and Tragedy," *Los Angeles Times*, June 26, 2009, http://www.latimes.com/news/obituaries/la-me-jackson-obit26-2009jun26,0,1970798.story (accessed November 20, 2009).
7. Barnes, "A Star Idolized and Haunted."
8. Boucher and Woo, "Michael Jackson's Life."
9. Tate, "Michael Jackson."
10. Without fail, Jackson's death provided the opportunity to make relevant again many of his cultural products and to generate new cultural production as a reflection on his death. Todd Gray, a black photographer who shot Jackson and his brothers for about a decade between the mid-1970s and 1980s released a book of his images of Jackson entitled *Before He Was King*. Gray, in an interview, discusses the peculiarity of Jackson's relationship to reality and fantasy: "Traveling with MJ and the J5 was akin to being in a bubble. Security blanketed us while on the road. Michael was so engrossed in the development of his career that he had a disproportionate world view. I (and others) had to watch our language: no swear words, sexual references, dirty jokes. He maintained an ultra moral, verbal-antiseptic space around himself, and perhaps saw the world through the atmosphere of this space. He chose to focus on pleasant things. As a result he may not have been able to make clear distinctions between the space that constituted his reality and the one we refer to as the "world." "A Q&A with Todd Gray, Author of *Michael Jackson: Before He Was King*," http://www.amazon.com (accessed November 20, 2009).
11. Michael Awkward, *Negotiating Difference: Race, Gender, and the Politics of Positionality* (Chicago: University of Chicago Press, 1995), 180.
12. Gates, "Finding Neverland," 38.

13. "Michael Jackson: Black or White," *The Brian Lehrer Show*, WNYC, June 26, 2009, audio recording, http://www.wnyc.org/shows/bl/episodes/2009/06/26 (transcribed by author).
14. Awkward. *Negotiating Difference*, 180.
15. Margo Jefferson, *On Michael Jackson* (New York: Vintage Books, 2006), 98.
16. Quincy Jones, "Remembering Michael," *Newsweek*, July 23, 2009, 40. The last line of Jones's statement references Michael Jackson's hit song "Ben" (1972), written by Don Black and Walter Scharf. The song was the theme to a film of the same name and included the following lyrics: "Ben, the two of us need look no more / We both found what we were looking for / With a friend to call my own / I'll never be alone / And you, my friend, will see / You've got a friend in me." Jones suggests that Jackson had much more ease singing about his love of rodents than possible or imagined romantic love with a woman. Lyrics copied from http://www.lyrics007.com/Michael Jackson Lyrics/Ben Lyrics.html
17. Boucher and Woo, "Michael Jackson's Life."
18. The photograph is part of shoot by Henry Diltz that features Michael Jackson without the rest of the Jackson 5.
19. "Michael on Ebony," *Ebony*, November 18, 2009, http://ebony-special-tribute-book.amazonwebstore.com (accessed November 20, 2009).
20. "A Classy Tribute," *Ebony*, November 4, 2009, http://ebony-special-tribute-book.amazonwebstore.com (accessed November 20, 2009).
21. This is a return to a bell hooks' phrase used in chapter 1.
22. Kym Platt, phone interview with author, New York City, November 21, 2009 (transcribed by author)
23. Ibid.
24. Ibid.
25. Ibid.
26. Tate, "Michael Jackson."

BIBLIOGRAPHY

Abel, Elizabeth, Barbara Christian, and Helene Moglen, eds. *Female Subjects in Black and White: Race, Psychoanalysis, Feminism.* Berkeley: University of California Press, 1997.
Adcock, Joe. "'Yellowman' Asks Much of Its Actors and Audience." *Seattle Post-Intelligencer*, July 15, 2002, http://www.seattlepi.com/theater/78347_yellowmanq.shtml?dpfrom=thead (accessed November 5, 2009).
Agrem, Darren E. "'The South Got Something to Say': Atlanta's Dirty South and the Southernization of Hip-Hop America." *Southern Culture* (Winter 2006): 55–73.
Ahmed, Sara. "Affective Economies." *Social Text* 22, no. 2 (Summer 2004): 117–39.
Alexander, Elizabeth. *The Black Interior.* St. Paul, Minn.: Graywolf Press, 2004.
Allers, Kimberly L. "The Diversity List." *Fortune*, August 22, 2005.
Anderson, Lisa M. *Black Feminism in Contemporary Drama.* Urbana: University of Illinois Press, 2008.
Applebome, Peter. "The Man behind Rosa Parks." *New York Times*, December 7, 2005, A1.
Aumont, Jacques. *The Image.* Translated by Claire Pajackowska. London: British Film Institute, 1997.
Austin, Regina. "'A Nation of Thieves': Consumption, Commerce, and the Black Public Sphere." In *The Black Public Sphere: A Public Culture Book*, ed. The Black Public Sphere Collective, 229–52. Chicago: University of Chicago Press, 1995.
Avgikos, Jan. "Tracey Rose: The Project." *Artforum*, October 2002.
Awkward, Michael. *Negotiating Difference: Race, Gender, and the Politics of Positionality.* Chicago: University of Chicago Press, 1995.
BaadAsssss Cinema. Dir. Isaac Julien. Independent Film Channel, 2002.
Bailey, David A., and Stuart Hall. "The Vertigo of Displacement." In *The Photography Reader*, ed. Liz Wells, 380–86. New York: Routledge, 2002.
Bailey, Lee. "Phat Farms the Desert—An American Hip Hop Label Sets Out to Conquer the United Arab Emirates." *DNR*, June 26, 2006.
Banks, Taunya. "Colorism: A Darker Shade of Pale." *UCLA Law Review* (2000): 1705–46.
Barnes, Brooks. "A Star Idolized and Haunted, Michael Jackson Dies at 50." *New York Times*, June 26, 2009, http://www.nytimes.com/2009/06/26/arts/music/26jackson.html (accessed November 20, 2009).
Barrett, Lindon. *Blackness and Value: Seeing Double.* Cambridge: Cambridge University Press, 1999.

Barthes, Roland. *Camera Lucida*. Translated by Richard Howard. New York: Hill and Wang, 1981.

———. *The Fashion System*. Translated by Matthew Ward and Richard Howard. Berkeley: University of California Press, 1983.

———. *Image, Music, Text*. Translated by Stephen Heath. New York: Hill and Wang, 1977.

Beatty, Sally. "Kellwood to Buy Urban-Style Label Phat Fashions." *Wall Street Journal*, January 9, 2004.

Bellafante, Ginia. "A Fallen Star of the '70s Is Back in the Business." *New York Times*, January 1, 2002, B1.

Bennett, Lennie. "The Ironic Eye." *St. Petersburg Times*, November 10, 2002.

Bennett, Lerone, Jr., et al. *Tradition and Conflict: Images of a Turbulent Decade, 1963–1973*. New York: Studio Museum in Harlem, 1985.

Bennett, Michael, and Vanessa Dickerson, eds. *Recovering the Black Female Body: Self-Representations by African American Women*. New Brunswick, N.J.: Rutgers University Press, 2001.

Benston, Kimberly. *Performing Blackness: Enactments of African-American Modernism*. New York: Routledge, 2000.

Berger, Martin. "Civil Rights Photography and the Politics of Race in the 1960s America." In *Black and White: Civil Rights Photography and 1960s America*. Berkeley: University of California Press, 2011.

Bergner, Gwen S. *Taboo Subjects: Race, Sex, and Psychoanalysis*. Minneapolis: University of Minnesota Press, 2005.

Berlant, Lauren. "Critical Inquiry, Affirmative Culture." *Critical Inquiry* 30 (Winter 2004): 445–51.

Berson, Misha. "Confronting Racism within the Black Community." *Seattle Times*, July 25, 2002.

———. "Highly Praised 'Yellowman' Gets Under the Skin." *Seattle Times*, July 7, 2002.

Bhabha, Homi K. *The Location of Culture*. London: Routledge, 1994.

———. "Remembering Fanon." *New Formations*, no. 1 (Spring 1987): 118–24.

Black is . . . Black ain't: A Personal Journey through Black Identity. Dir. Marlon Riggs. Videocassette. California Newsreel, 1995.

The Black Press: Soldiers without Swords. Prod. Stanley Nelson. San Francisco: California Newsreel, 1998.

Blessing, Jennifer. *Rrose is a Rrose is a Rrose: Gender Performance in Photography*. New York: Guggenheim Museum and Harry N. Abrams, 1997.

Bloom, Lisa, ed. *With Other Eyes: Looking at Race and Gender in Visual Culture*. Minneapolis: University of Minnesota Press, 1999.

Bloomer, Jeffrey. "*Do the Right Thing*: Twentieth Anniversary Edition." DVD review, *Paste Magazine: Signs of Life in Music, Film and Culture*, July 1, 2009, http://www.pastemagazine.com/articles/2009/07/do-the-right-thing-20th-anniversary-edition.html (accessed July 29, 2009).

Blumenberg, Hans. "Light as a Metaphor for Truth: At the Preliminary Stage of Philosophical Concept Formation" In *Modernity and the Hegemony of Vision*, ed. David Michael Levin, 30–62. Berkeley: University of California Press, 1993.

Bobo, Jacqueline. *Black Women as Cultural Readers*. New York: Columbia University Press, 1995.

Bordo, Susan. "'Material Girl': The Effacements of Postmodern Culture." In *The Madonna Connection: Representational Politics, Subcultural Identities, and Cultural Theory*, ed. Cathy Schwichtenberg, 265–90. Boulder, Colo.: Westview, 1993.

Boucher, Geoff, and Elaine Woo. "Michael Jackson's Life Was Infused with Fantasy and Tragedy." *Los Angeles Times*, June 26, 2009, http://www.latimes.com/news/obituaries/la-me-jackson-obit26-2009jun26,0,1970798.story (accessed November 20, 2009).

Braidotti, Rosi. *Metamorphoses: Towards a Materialist Theory of Becoming*. New York: Polity Press, 2002.

Brantley, Ben. "Skin Tone as the Subtle Signal for Hatred in the Racial Family." *New York Times*, October 23, 2002.

Braziel, Jana Evans, and Kathleen LeBesco. "Introduction: Performing Excess." *Women and Performance: A Journal of Feminist Theory* 15, no. 2 (2005): 9–13.

Brennan, Teresa, and Martin Jay, eds. *Vision in Context: Contemporary Perspectives on Sight*. New York: Routledge, 1996.

Brinkley, Douglas. *Rosa Parks*. New York: Lipper/Viking Book, 2005.

Brody, Jennifer DeVere. "Black Cat Fever: Manifestations of Manet's *Olympia*." *Theatre Journal* 53 (2001): 95–118.

———. "The Blackness of Blackness . . . Reading the Typography of *Invisible Man*." *Theatre Journal* 57 (2005): 679–98.

———. *Impossible Purities: Blackness, Femininity, and Victorian Culture*. Durham, N.C.: Duke University Press, 1998.

Brooks, Daphne A. "'All That You Can't Leave Behind': Black Female Soul Singing and the Politics of Surrogation in the Age of Catastrophe." *Meridians: feminism, race, transnationalism* 8, no. 1 (2008): 180–204.

———. *Bodies in Dissent: Spectacular Performances of Race and Freedom, 1850–1910*. Durham, N.C.: Duke University Press, 2006.

Brown, Ann. "Simmons Gets $140 Million for Clothing Labels." *Black Enterprise* 34, no. 8 (March 2004): 25.

Brown, Jayna. *Babylon Girls: Black Women Performers and the Shaping of the Modern*. Durham, N.C.: Duke University Press, 2008.

Brown, Suzanne S. "Hip-Hop Artists Are Building Design Empires More Phat than Fad Style with a Vibe." *Denver Post*, September 16, 2004.

Burgin, Victor. *In/different Spaces: Place and Memory in Visual Culture*. Berkeley: University of California Press, 1996.

Butler, Judith. *Bodies that Matter: On the Discursive Limits of "Sex."* New York: Routledge, 1993.

———. "Endangered/Endangering: Schematic Racism and White Paranoia." In *Reading Rodney King, Reading Urban Uprising*, ed. Robert Gooding-Williams. New York: Routledge, 1993.

———. *Gender Trouble: Feminism and the Subversion of Identity*. 2nd ed. New York: Routledge, 1999.

———. *The Psychic Life of Power: Theories in Subjection*. Stanford, Calif.: Stanford University Press, 1997.

———. *Undoing Gender*. New York: Routledge, 2004.

Campbell, Mary Schmidt. "African American Art in a Post-Black Era." *Women and Performance: A Journal of Feminist Theory* 17, no. 3 (November 2007): 317–30.

Canby, Vincent. "Critic's Notebook: Spike Lee Stirs Things Up at Cannes." *New York Times*, May 20, 1989, http://movies.nytimes.com (accessed August 14, 2009).

———. "Review/Film: Spike Lee Tackles Racism in 'Do the Right Thing.'" *New York Times*, June 30, 1989, http://www.nytimes.com (accessed August 14, 2009).

Caramanica, Jon. "It's Not Easy Being Pink." *New York Times*, October 17, 2004, 9.

Carby, Hazel. "Policing the Black Female Body in an Urban Context." *Critical Inquiry* 18 (Summer 1992): 738–55.

———. "The Politics of Fiction, Anthropology, and the Folk: Zora Neale Hurston." In *New Essays on "Their Eyes Were Watching God*," ed. Michael Awkward, 71–93. New York: Cambridge University Press, 1990.

———. *Race Men*. Cambridge: Harvard University Press, 1998.

Carlson, Marvin. *Performance: A Critical Introduction*. 2nd ed. New York: Routledge, 2003.

Carpenter, Faedra Chatard. "Addressing "The Complex"-ities of Skin Color: Intra-Racism and the Plays of Hurston, Kennedy, and Orlandersmith." *Theatre Topics* 19, no. 1 (March 2009): 15–27.

Carr, Jay. "Spike Lee Spotlights Race Relations." *Boston Globe*, June 25, 1989. Reprinted in *Spike Lee's "Do the Right Thing*," ed. Mark A. Reid (Cambridge: Cambridge University Press, 1997).

Castells, Manuel. "Materials for an Exploratory Theory of the Network Society." *British Journal of Sociology* 51 (2000): 5–24.

Catanese, Brandi Wilkins. "'How Do I Rent a Negro?': Racialized Subjectivity and Digital Performance Art." *Theatre Journal* 57 (2005): 699–714.

Cayer, Jennifer A. "Roll yo' hips—don't roll yo' eyes: Angularity and Embodied Spectatorship in Zora Neale Hurston's Play *Cold Keener*." *Theatre Journal* 60 (2008): 37–69.

Chow, Rey. *Ethics after Idealism: Theory-Culture-Ethnicity-Reading*. Bloomington: Indiana University Press, 1998.

Clark, Vernon. "Philly's 'Picture-Taking Man' John W. Mosley Chronicled African-American Life." *Philadelphia Daily News*, February 8, 2010.

Classon, H. Lin. "Re-Evaluating *Color Struck*: Zora Neale Hurston and the Issue of Colorism." *Theatre Studies* 42 (1997): 4–18.

Clay, Andreana. "'I Used to Be Scared of the Dick': Queer Women of Color and Hip-Hop Masculinity." In *Home Girls Make Some Noise: Hip Hop Feminism Anthology*, ed. Gwendolyn D. Pough, 149–65. Mira Loma, Calif.: Parker Publishing, 2007.

Colapinto, John. "Armies of the Right: The Young Hipublicans." *New York Times Magazine*, May 25, 2003.

Cole, Jean Lee, and Charles Mitchell, eds. *Zora Neale Hurston: Collected Plays*. New Brunswick, N.J.: Rutgers University Press, 2008.

Collins, Lisa Gail. *The Art of History: African American Women Artists Engage the Past*. New Brunswick, N.J.: Rutgers University Press, 2002.

Color Adjustment. Dir. Marlon Riggs. California Newsreel, 1991.

Cotter, Holland. "Finding Art in the Asphalt." *New York Times*, September 12, 2008, http://www.nytimes.com/2008/09/12/arts/design/12stre.html?pagewanted=all (accessed April 7, 2009).

Cox, Lorraine Morales. "A Performative Turn: Kara Walker's *Song of the South* (2005)." *Women and Performance: A Journal of Feminist Theory* 17, no. 1 (March 2007): 59–87.

Cowie, Elizabeth. "Woman as Sign." *M/F* 1 (1978): 49–64.

Crane, Diana. *Fashion and Its Social Agendas: Class, Gender, and Identity in Clothing*. Chicago: University of Chicago Press, 2000.

Crary, Jonathan. *Suspensions of Perception: Attention, Spectacle, and Modern Culture*. Cambridge: MIT Press, 1999.

———. *Techniques of the Observer*. Cambridge, Mass.: MIT Press, 1992.

Crouch, Stanley. *One Shot Harris: The Photographs of Charles "Teenie" Harris*. New York: Harry N. Abrams, 2002.

Curtis, James. "Making Sense of Documentary Photography." *History Matters: The U.S. Survey on the Web*, http://historymatters.gmu.edu/mse/photos/ (accessed July 5, 2008).

———. *Mind's Eye, Mind's Truth: FSA Photography Reconsidered*. Philadelphia: Temple University Press, 1992.
Cutshaw, Stacey McCarroll, and Ross Barrett. *In the Vernacular: Photography of the Everyday*. Seattle: University of Washington Press, 2008.
Cvetkovich, Ann. *An Archive of Feelings: Trauma, Sexuality, and Lesbian Public Cultures*. Durham, N.C.: Duke University Press, 2003.
———. "Public Feelings." *South Atlantic Quarterly* 106, no. 3 (Summer 2007): 459–68.
Danton, Eric. "For Rap Stars, Business Is Overtaking Music." *Seattle Times*, August 20, 2007.
Darley, Andrew. *Visual Digital Culture: Surface Play and Spectacle in New Media Genres*. London: Routledge, 2000.
Davis, Fred. *Fashion, Culture and Identity*. Chicago: University of Chicago Press, 1992.
De Bolla, Peter. "The Visibility of Visuality." In *Vision in Context: Historical and Contemporary Perspectives on Sight*, ed. Teresa Brennan and Martin Jay, 63–81. New York: Routledge, 1996.
DeCarava, Roy, and Langston Hughes. *The Sweet Flypaper of Life*. New York: Simon and Schuster, 1955.
Dezeuze, Anna. "Assemblage, Bricolage, and the Practice of Everyday Life." *Art Journal* (Spring 2008): 31–37.
Diamond, Elin. *Unmaking Mimesis: Essays on Feminism and Theater*. New York: Routledge, 1997.
Diawara, Manthia, ed. *Black American Cinema*. New York: Routledge, 1993.
"Do the Right Thing @ 20: Spike Lee Looks Back." Spike Lee interview by Henry Louis Gates Jr., 2009, http://www.theroot.com/multimedia/do-right-thing-20-spike-lee-looks-back (accessed August 16, 2009).
Dolan, Jill. "Geographies of Learning: Theater Studies, Performance, and the 'Performative.'" In *Geographies of Learning: Theories and Practice, Activism and Performance*. Middletown, Conn.: Wesleyan University Press, 2001.
Doss, Erika. "Affect." *American Art* 23, no. 1 (2009): 9–11.
Douglas, Mary. *Purity and Danger: An Analysis of the Concepts of Pollution and Taboo*. London: Routledge and Kegan Paul, 1966.
Doy, Gen. *Black Visual Culture: Modernity and Postmodernity*. London: I. B. Tauris, 2000.
Drucker, Susan J., and Gary Gumpert, eds. *Voices in the Street: Explorations in Gender, Media, and Public Space*. Cresskill, N.J.: Hampton Press, 1997.
Druckrey, Timothy, ed. *Electronic Culture: Technology and Visual Representation*. New York: Aperture, 1996.
DuBois, W.E.B. *The Souls of Black Folk*. Introduction by Henry Louis Gates Jr. New York: Bantam Books, 1989.
DuCille, Anne. *Skin Trade*. Cambridge: Harvard University Press, 1996.
Dyson, Michael Eric. *Between God and Gangsta Rap: Bearing Witness to Black Culture*. New York: Oxford University Press, 1996.
———. "One Man's Sacrilege, One Woman's Sanctity." *Chicago Sun-Times*, February 20, 2001, editorial sec., 31.
Ebron, Paulla. *Performing Africa*. Princeton, N.J.: Princeton University Press, 2002.
Edelman, Shimon. *Representation and Recognition in Vision*. Cambridge, Mass.: MIT Press, 1999.
Edwards, Nick. "Hang with Rappers in the Boardroom." *Financial Times*, September 26, 2006, 13.

Elam, Harry J., Jr. *Taking It to the Streets: The Social Protest Theater of Luis Valdez and Amiri Baraka*. Ann Arbor: University of Michigan Press, 1997.

Elam, Harry J., Jr., and Michele Elam. "Blood Debt: Reparations in Langston Hughes's *Mulatto*." *Theatre Journal* 61 (2009): 85–103.

Elam, Harry J., Jr., and David Krasner, eds. *African American Performance and Theatre History: A Critical Reader*. New York: Oxford University Press, 2000.

"Election Night Ratings Blowout: 71.5 Million Watch Obama Win." *The Hollywood Reporter*, http://www.thrfeed.com/2008/11/election-rating.html (accessed November 8, 2008).

Elliott, David. "'Image', Black; A Survey of Black Photographers Has Some Striking Words." *San Diego Union-Tribune*, March 11, 2001, Books sec., 8.

Ellison, Ralph. *Invisible Man*. New York: Random House, 1952.

Eng, David. *Racial Castration: Managing Masculinity in Asian America*. Durham, N.C.: Duke University Press, 2001.

English, Darby. *How to See a Work of Art in Total Darkness*. Cambridge, Mass.: MIT Press, 2007.

Entin, Joseph. "Modernist Documentary: Aaron Siskind's *Harlem Document*." *Yale Journal of Criticism* 12, no. 2 (1999): 357–82.

Epaminondas, George. "Pharrell Williams." *Instyle* 15, no. 3 (March 2008): 291.

Espinosa, Renata. "Simmons Sells Sexy at Baby Phat." *Fashion Wire Daily*, September 8, 2007.

"Eve Re-Launching Fetish Clothing Line." *World Entertainment News Network*, May 17, 2004.

Everett, Anna. "The Revolution Will Be Digitized: Afrocentricity and the Digital Public Sphere." *Social Text* 20, no. 2 (2002): 125–46.

Fanon, Frantz. *Black Skin, White Masks*. Translated by Charles Lam Markmann. New York: Grove Press, 1967.

Favor, Martin. *Authenticating Blackness: The Folk in the New Negro Renaissance*. Durham, N.C.: Duke University Press, 1999.

Ferguson, Roderick A. *Aberrations in Black: Toward a Queer of Color Critique*. Minneapolis: University of Minnesota Press, 2004.

Ferguson, Russell, Martha Gever, Trinh T. Minh-ha, and Cornel West, eds. *Out There: Marginalization and Contemporary Cultures*. New York: New Museum of Contemporary Art and MIT Press, 1990.

Finkelpearl, Tom. *Dialogues in Public Art*. Cambridge, Mass.: MIT Press, 2000.

Fiske, John. *Media Matters: Race and Gender in U. S. Politics*. Minneapolis: University of Minnesota Press, 1996.

Fleetwood, Nicole. "Failing Narratives, Initiating Technologies: Hurricane Katrina and the Production of a Weather Media Event." *American Quarterly* 58, no. 3 (September 2006): 767–89.

———. "Rev. of Dael Orlandersmith's 'Yellowman,'" *Theatre Journal* 55, no. 2 (May 2003): 331–32.

Foreman, P. Gabrielle. "Who's Your Mama?: 'White' Mulatta Genealogies, Early Photography, and Anti-Passing Narratives of Slavery and Freedom." *American Literary History* 14, no. 3 (Fall 2002): 505–39.

Fortin, Sylvie. "Digital Trafficking: Fatimah Tuggar's Imag(in)ing of Contemporary Africa." *Art Papers*, March/April 2005, http://www.artpapers.org/feature_articles/feature1_2005_0304.htm (accessed April 23, 2009).

Foster, Hal. *The Return of the Real*. Cambridge, Mass.: MIT Press, 1996.

———, ed. *Vision and Visuality*. New York: New Press, 1988.
Frank, Thomas. *The Conquest of Cool: Business Culture, Counterculture, and the Rise of Hip Consumerism*. Chicago: University of Chicago Press, 1997.
Frank, Thomas, and Matt Weiland. *Commodify Your Dissent: Salvos from the Baffler*. New York: W. W. Norton, 1997.
Freydkin, Donna. "Rappers Wrap Up in Clothing Lines." *USA Today*, August 13, 2003, D2.
Fuchs, Elinor. "Staging the Obscene Body." *Drama Review* 33, no. 1 (1989): 33–58.
Gage, Jack. "The Top Ten in the U.S. Our list of the 200 Best Small U.S. Companies." *Forbes-Asia*, October 30, 2006.
Gaines, Jane. "White Privilege and Looking Relations: Race and Gender in Feminist Film Theory." *Screen* 29, no. 4 (1988): 12–27.
Gates, David. "Finding Neverland." *Newsweek*, July 13, 2009, 35.
Gates, Henry Louis, Jr. "Critical Fanonism." *Critical Inquiry* 17, no. 3 (Spring 1991): 457–70.
Gauntlett, David, ed. *Web Studies: Rewiring Media Studies for the Digital Age*. London: Arnold, 2000.
Gelder, Ken, and Sarah Thornton. *The Subcultures Reader*. London: Routledge, 1997.
George, Nelson. *Hip Hop America*. New York: Penguin Books, 1998.
Gever, Martha. "The Feminism Factor: Video and Its Relation to Feminism." *Illuminating Video: An Essential Guide to Video Art*, ed. Doug Hall and Sally Jo Fifer, 226–41. San Francisco: Aperture, 1990.
Gilroy, Paul. *Against Race: Imagining Political Culture beyond the Color Line*. Cambridge: Belknap Press of Harvard University Press, 2000.
Gladwell, Malcolm. "Annals of Style: The Coolhunt." *New Yorker*, March 17, 1997, 78–88.
Glasco, Laurence. "Documenting Our Past: The Teenie Harris Archive Project," July 5–November 16, 2003, Forum Gallery, Carnegie Museum of Art, http://www.cmoa.org/teenie/info.asp (accessed October 8, 2007).
———. "Double Burden: The Black Experience in Pittsburgh," In *African Americans in Pennsylvania: Shifting Historical Perspectives*, ed. Joe William Trotter and Eric Ledell Smith. University Park: Pennsylvania State University Press, 1997.
Goldberg, David Theo. *Racist Culture: Philosophy and the Politics of Meaning*. Cambridge, Mass.: Blackwell, 1993.
Golden, Thelma, with Hamza Walker, et al. *Freestyle*. New York: The Studio Museum in Harlem, 2001.
Gómez-Peña, Guillermo. "The Virtual Barrio @ the Other Frontier (or the Chicano Interneta)." In *Clicking In: Hot Links to a Digital Culture*, ed. Lynn Hershman Leeson, 173–79. Seattle: Bay Press, 1996.
González, Jennifer. "The Appended Subject: Race and Identity as Digital Assemblage." In *Race in Cyberspace*, ed. Beth E. Kolko, Lisa Nakamura, and Gilbert Rodman, 27–50. New York: Routledge, 2000.
González-Crussi, F. *On Seeing: Things Seen, Unseen, and Obscene*. New York: Overlook Duckworth, 2006.
Gooding-Williams, Robert. *Look, a Negro!: Philosophical Essays on Race, Culture and Politics*. New York: Routledge, 2006.
Graham, Renee. "Few Lost Hairs over 'Barbershop': Many Moviegoers See No Harm in Film's Dialogue." *Boston Globe*, September 28, 2002, E1.
Gray, Herman. "Black Masculinity and Visual Culture." *Callaloo* 18, no. 2 (1995): 401.

---. *Watching Race: Television and the Struggle for "Blackness."* Minneapolis: University of Minnesota Press, 1995.
Greenberg, Julee. "Eve Gives Fetish Another Try." *Women's Wear Daily* 126 (June 14, 2007): 9.
Griffin, Farah Jasmine. "'Race,' Writing, and Difference: A Meditation." *PMLA* Special Topic: Comparative Racialization. 123, no. 5 (October 2008): 1516–21.
---. "Textual Healing: Claiming Black Women's Bodies, the Erotic and Resistance in Contemporary Novels of Slavery." *Callaloo* 19, no. 2 (1996): 519–36.
---. *"Who Set You Flowin'?": The African-American Migration Narrative.* New York: Oxford University Press, 1995.
Guerrero, Ed. *Framing Blackness: The African American Image in Film.* Philadelphia: Temple University Press, 1993.
"Half Past Autumn." Gordon Parks, interviewed by Phil Ponce, January 6, 1998, *NewsHour,* http://www.pbs.org/newshour/bb/entertainment/jan-june98/gordon_1-6.html (accessed July 5, 2008).
Hall, Rashaun. "Hip-Hop, INC." *Essence* 36, no. 2 (June 2005): 102.
Hall, Stuart. "The After-Life of Frantz Fanon: Why Fanon? Why Now? Why Black Skin, White Masks?" In *The Fact of Blackness: Frantz Fanon and Visual Representation,* ed. Alan Read, 12–37. Seattle: Bay Press, 1996.
---. "New Ethnicities." In *Stuart Hall: Critical Dialogue in Cultural Studies,* ed. David Morley and Kuan-Hsing Chen, 441–49. London: Routledge, 1996.
---. "What Is This 'Black' in Black Popular Culture?" In *Black Popular Culture,* ed. Gina Dent, 21–33. Seattle: Bay Press, 1992.
Hall, Stuart, ed. *Representation: Cultural Representations and Signifying Practices.* London: Sage Publications, 1997.
Hall, Stuart, and Paul du Gay, eds. *Questions of Cultural Identity.* London: Sage Publications, 1996.
Hall, Stuart, and Tony Jefferson. *Resistance through Rituals: Youth Subcultures in Postwar Britain.* London: Hutchinson, 1976.
Hammonds, Evelyn. "Black (W)holes and the Geometry of Black Female Sexuality." *Differences: A Journal of Feminist Cultural Studies* 6:2–3 (1995): 126–45.
Hansberry, Lorraine. *The Movement: Documentary of a Struggle for Equality.* New York: Simon and Schuster, 1964.
Haraway, Donna. *Modest_Witness@Second_Millennium.FemaleMan©_Meets_OncoMouse™: Feminism and Technoscience.* New York: Routledge, 1997.
Hariman, Robert, and John Louis Lucaites. *No Caption Needed: Iconic Photographs, Public Culture, and Liberal Democracy.* Chicago: University of Chicago Press, 2007.
Harper, Philip Brian. *Are We Not Men? Masculine Anxiety and the Problem of African-American Identity.* New York: Oxford University Press, 1996.
Harris, Cheryl I. "Whiteness as Property." *Harvard Law Review* 106, no. 8 (1993): 1707–91.
Hartman, Saidiya. *Scenes of Subjection: Terror, Slavery, and Self-Making in Nineteenth-Century America.* New York: Oxford University Press, 1997.
Hay, Carla. "Hot Fashion . . . Pharrell Williams." *Billboard,* October 9, 2004.
Hayward, Philip, ed. *Picture This: Media Representations of Visual Art and Artists.* 2nd rev. ed. Luton, England: University of Luton Press and Arts Council of England, 1998.
Hebdige, Dick. *Subculture: The Meaning of Style.* London: Routledge, 1979.
Higginbotham, A. Leon, Jr., and Barbara K. Kopytoff. "Racial Purity and Interracial Sex in the Law of Colonial and Antebellum Virginia." In *Interracialism: Black-White Intermar-*

riage in American History, Literature and the Law, ed. Werner Sollors, 81–139. New York: Oxford University Press, 2000.

Higginbotham, Evelyn Brooks. "African American Women's History and the Metalanguage of Race." *Signs* 17, no. 2 (1992): 251–74.

———. *Righteous Discontent: The Women's Movement in the Black Baptist Church, 1880–1920*. Cambridge: Harvard University Press, 1993.

Hobson, Janell. *Venus in the Dark: Blackness and Beauty in Popular Culture*. New York: Routledge, 2005.

Holland, Sharon. *Raising the Dead: Readings of Death and (Black) Subjectivity*. Durham, N.C.: Duke University Press, 2000.

Holmes Smith, Christopher. "Hip-Hop Moguls." In *African Americans and Popular Culture*, vol. 3, *Music and Popular Art*, ed Todd Boyd, 61–86. Westport, Conn.: Praeger, 2008.

———. "'I Don't Like to Dream about Getting Paid': Representations of Social Mobility and the Emergence of the Hip-Hop Mogul." *Social Text* 2, no. 4 (Winter 2003): 69–97.

hooks, bell. *Black Looks: Race and Representation*. Boston: South End Press, 1992.

———. "In Our Glory: Photography and Black Life." In *Picturing Us: African American Identity in Photography*, ed. Deborah Willis, 43–53. New York: New Press, 1996.

———. *Reel to Real: Race, Sex and Class at the Movies*. New York: Routledge, 1996.

———. "Selling Hot Pussy: Representations of Black Female Sexuality in the Cultural Marketplace." In *Writing on the Body*, ed. Katie Conboy, Nadia Medina, and Sarah Stanbury, 113–28. New York: Columbia University Press, 1997.

"House of Dereon." *Ebony* 61, no. 4 (February 2006): 88.

Hurston, Zora Neale. *Color Struck: A Play in Four Scenes*. In *Black Female Playwrights: An Anthology of Plays before 1950*, ed. Kathy A. Perkins. Bloomington: Indiana University Press, 1989.

Hyde, Nina S. "Springing Softly Burrows: Stephen Burrows' Flair for the Sensual." *Washington Post*, November 11, 1977, D11.

"In Defense of P. Diddy." *Wall Street Journal*, November 4, 2003, A18.

Isaak, Jo Anna. "American Family." In *Renee Cox: American Family*. New York: Robert Miller Gallery, 2001.

Jackson, John L., Jr. *Harlemworld: Doing Race and Class in Contemporary Black America*. Chicago: University of Chicago Press, 2001.

———. *Racial Paranoia: The Unintended Consequences of Political Correctness*. New York: Basic Civitas Books, 2008.

———. *Real Black: Adventures in Racial Sincerity*. Chicago: University of Chicago Press, 2005.

Jackson, Shannon. "Performing Show and Tell." *Journal of Visual Culture* 4, no. 2 (2005): 163–77.

Jacobson, Matthew Frye. *Whiteness of a Different Color: European Immigrants and the Alchemy of Race*. Cambridge: Harvard University Press, 1999.

Janus, Elizabeth. "Fatimah Tuggar: Art and Public." *Artforum* 39, no. 5 (2001): 147.

Jay, Martin. "Cultural Relativism and the Visual Turn." *Journal of Visual Culture* 1, no. 3 (2002): 267–78.

Jefferson, Margo. *On Michael Jackson*. New York: Vintage Books, 2006.

Jenkins, Candice M. *Private Lives, Proper Relations: Regulating Black Intimacy*. Minneapolis: University of Minnesota Press, 2007.

Jenkins, Jeffrey Eric. *The Best Plays of 2002–2003*. New York: Limelight Editions, 2003.

Johnson, E. Patrick. *Appropriating Blackness: Performance and the Politics of Authenticity*. Durham, N.C.: Duke University Press, 2003.

Johnson, Thomas L., and Phillip C. Dunn, eds. *A True Likeness: The Black South of Richard Samuel Roberts, 1920–1936*. Columbia, S.C.: Bruccoli Clark, 1986.

Jones, Kellie. "(Un)Seen and Overheard: Pictures by Lorna Simpson." In *Lorna Simpson*, ed. Kellie Jones, Thelma Golden, and Chrissie Iles. London: Phaidon, 2002.

Jones, Quincy. "Remembering Michael." *Newsweek*, July 23, 2009, 40.

Juhasz, Alexandra. *AIDSTV: Identity, Community, and Alternative Video*. Durham, N.C.: Duke University Press, 1995.

———, ed. *Women of Vision: Histories in Feminist Film and Video*. Minneapolis: University of Minnesota Press, 2001.

Kadlec, David. "Zora Neale Hurston and the Federal Folk," *Modernism/modernity* 7, no. 3 (2000): 471–85.

"Kanye Launches Fashion Label." *World Entertainment News Network*, June 7, 2004.

Kaplan, Amy. "Manifest Domesticity." *American Literature* 70, no. 3 (1998): 581–606.

Kaplan, Julee. "Jennifer Lopez Exits Apparel in the U.S." *Women's Wear Daily*, June 24, 2009, http://www.wwd.com/markets-news/jennifer-lopez-exits-apparel-in-the-us-2187085 (accessed October 29, 2009).

Kasfir, Sidney Littlefield. *Contemporary African Art*. London: Thames and Hudson, 1999.

Kaufman, Michael T. "In a New Film, Spike Lee Tries to Do the Right Thing," *New York Times*, June 25, 1989, http://www.nytimes.com/1989/06/25/movies/in-a-new-film-spike-lee-tries-to-do-the-thing.html?scp=5&sq=do%20the%20right%20thing%20review%201989&st=cse (accessed August 14, 2009).

Keeling, Kara. *The Witch's Flight: The Cinematic, the Black Femme, and the Image of Common Sense*. Durham, N.C.: Duke University Press, 2007.

Kelley, Robin D. G. *Race Rebels: Culture, Politics, and the Black Working Class*. New York: Free Press, 1994.

———. *Yo' Mama's Disfunktional!: Fighting the Culture Wars in Urban America*. Boston: Beacon Press, 1997.

Kernick, Cynthia E. "A Lucky Circumstance." In *Spirit of a Community: The Photographs of Charles "Teenie" Harris*. Greensburg, Pa.: Westmoreland Museum of Art, 2001.

Kim, Daniel Y. *Writing Manhood in Black and Yellow: Ralph Ellison, Frank Chin, and the Literary Politics of Identity*. Stanford, Calif.: Stanford University Press, 2005.

Kincaid, Jamaica. *A Small Place*. New York: Farrar, Straus, Giroux, 1988.

Kino, Carol. "Fatimah Tuggar at Greene Naftali." *Art in America* 89, no. 9 (2001): 155–56.

Kinon, Critina. "Combs Is the 'King' of Design." *New York Daily News*, April 9, 2008.

Klein, Alvin. "A Love Story, with Cosmic Sweep." *New York Times*, January 20, 2002.

———. "A Study in Shades of Black." *New York Times*, April 21, 2002.

Kolko, Beth E., Lisa Nakamura, and Gilbert Rodman, eds. *Race in Cyberspace*. New York: Routledge, 2000.

Kondo, Dorinne. *About Face: Performing Race in Fashion and Theater*. New York: Routledge, 1997.

Koppel, Niko. "In Thousands of Images, a Photographer Builds a History in Harlem." *New York Times*, July 21, 2008, http://www.nytimes.com/2008/07/21/nyregion/21photographer.html?_r=1&ref=todayspaper&oref=slogin (accessed July 28, 2008; and August 16, 2009).

Krasner, David. "Migration, Fragmentation, and Identity: Zora Neale Hurston's *Color Struck* and the Geography of the Harlem Renaissance." *Theatre Journal* 53 (2001): 533–50.

Kraut, Anthea. "Recovering Hurston, Reconsidering the Choreographer." *Women and Performance: A Journal of Feminist Theory* 16, no. 1 (March 2006): 71–90.

Kristeva, Julia. *The Powers of Horror: An Essay on Abjection.* New York: Columbia University Press, 1982.

Kuo, Laura J. "The Commoditization of Hybridity in the 1990s U.S. Fashion Advertising: Who Is cK one?" In *Beyond the Frame: Women of Color and Visual Representation,* ed. Neferti X. M. Tadiar and Angela Y. Davis, 31–47. New York: Palgrave Macmillan, 2005.

Lawson, Steven F. Civil Rights Crossroads: Nation, Community, and the Black Freedom Struggle. Lexington: University Press of Kentucky, 2003.

Lee, Anthony W. *Picturing Chinatown: Art and Orientalism in San Francisco.* Berkeley: University of California Press, 2001.

Leeds, Jeff. "Don't Believe the Hype. A Hip-Hop Mogul Says It's Propaganda." *New York Times,* May 16, 2005, C1.

The Library of Congress. *A Small Nation of People: W.E.B. DuBois and African American Portraits of Progress.* With essays by David Levering Lewis, and Deborah Willis. New York: Amistad, 2003.

Life and Debt. Dir. Stephanie Black. Tuff Gong International, 2001.

"Lil' Kim's 'Bionic Booty' Booted from 'Dancing with the Stars.'" *Seattle Times.* May 5, 2009, http://seattletimes.nwsource.com/html/television/2009180591_ztv06dancing.html (accessed December 5, 2009).

Lipke, David. "Power Brands—An Exclusive Survey of the 50 Best-Known Men's Labels in America." *DNR,* November 21, 2005.

———. "Urban Planning: Bold Moves Revitalize Sean John." *DNR* 37, no. 20 (May 14, 2007).

Lister, Martin, ed. *The Photographic Image in Digital Culture.* London: Routledge, 1995.

Locke, Alain. "The American Negro as Artist." *American Magazine of Art* (September 1931): 211–20.

———. "A Note on African Art." *Opportunity* (May 1924): 134–38.

Louis, Yvette. "Body Language: The Black Female Body and the Word in Suzan-Lori Parks's *The Death of the Last Black Man in the Whole Entire World.*" In *Recovering the Black Female Body: Self-Representations by African American Women,* ed. Michael Bennett and Vanessa Dickerson, 141–64. New Brunswick, N.J.: Rutgers University Press, 2001.

Lowe, Lisa. *Immigrant Acts.* Durham, N.C.: Duke University Press, 1996.

Lubiano, Wahneema. "'But Compared to What?': Reading Realism, Representation, and Essentialism in *School Daze, Do the Right Thing* and the Spike Lee Discourse." *Black American Literature Forum* 25, no. 2, Black Film Issue (Summer 1991): 253–82.

Lukes, H. N. "Undoing the End of Theory." *GLQ: A Journal of Lesbian and Gay Studies* 11, no. 4 (2005): 632–34.

Lunenfeld, Peter, ed. *The Digital Dialectic: New Essays on New Media.* Cambridge, Mass.: MIT Press, 1999.

Marable, Manning, and Leith Mullings. *Freedom: A Photographic History of the African American Struggle.* New York: Phaidon, 2002.

Marling, Karal Ann. *As Seen on TV: The Visual Culture of Everyday Life in the 1950s.* Cambridge: Harvard University Press, 2000.

Marriott, David. *Haunted Life: Visual Culture and Black Modernity.* New Brunswick, N.J.: Rutgers University Press, 2007.

———. *On Black Men.* New York: Columbia University Press, 2000.

Massood, Paula J. *Black City Cinema: African American Urban Experience in Film.* Philadelphia: Temple University Press, 2003.

Matloff, Jason. "Too Hot to Handle: How Spike Lee Managed to 'Do the Right Thing,' Inciting Debate, Praise and Fury 20 Years Ago." *Los Angeles Times*, May 24, 2009, http://articles.latimes.com/2009/may/24/entertainment/ca-dotherightthing24 (accessed July 29, 2009).

"The Mayor and the Arts, Round 2," *New York Times*, February 16, 2001, A18.

McCarthy, Anna. *Ambient Television: Visual Culture and Public Space*. Durham, N.C.: Duke University Press, 2001.

McKenzie, Jon. *Perform or Else: From Discipline to Performance*. New York: Routledge, 2001.

McLaughlin, Noel. "Rock, Fashion and Performativity." In *Fashion Cultures: Theories, Explorations and Analysis*, ed. Stella Bruzzi and Pamela Church Gibson, 264–85. London: Routledge, 2000.

Mercer, Kobena. "Black Hair/Style Politics." In *The Subcultures Reader*, ed. Ken Gelder and Sarah Thornton, 420–35. London: Routledge, 1997.

Meszors, Jackie. "Trend Spotter." *Apparel Magazine* 45, no. 12 (August 2004): 4.

Metz, Christian. *The Imaginary Signifier: Psychoanalysis and the Cinema*. Translated by Celia Britton et al. Bloomington: Indiana University Press, 1982.

———. "Photography and the Fetish" In *The Photography Reader*, ed. Liz Wells, 138–45. New York: Routledge, 2002.

"Michael Jackson: Black or White." *The Brian Lehrer Show*, WNYC, June 26, 2009, audio recording, http://www.wnyc.org/shows/bl/episodes/2009/06/26 (transcribed by author).

Middleton, Dianna. "Urban Retailers Struggle to Keep Up with Trends." *McClatchy—Tribune Business News*, January 28, 2008.

Milani, Joanne. "Continental Divide." *Tampa Tribune*, December 1, 2002, 12.

Miller, Monica L. *Slaves to Fashion: Black Dandyism and the Styling of Black Diasporic Identity*. Durham, N.C.: Duke University Press, 2009.

Miller, Stuart. "The Education of Dael Orlandersmith." *American Theatre* (July/August 2002): 26–29, 70–71.

Miller-Young, Mireille. "Hip-Hop Honeys and Da Hustlaz: Black Sexualities in the New Hip-Hop Pornography." *Meridians: feminism, race, transnationalism* 8, no. 1 (2008): 261–92.

Minh-ha, Trinh. *Framer Framed*. New York: Routledge, 1992.

Mirzoeff, Nicholas. "On Visuality." *Journal of Visual Culture* 5, no. 1(2006): 53–79.

———. "The Shadow and the Substance: Race, Photography and the Index." In *Only Skin Deep: Changing Visions of The American Self*, ed. Coco Fusco and Brian Wallis, 111–27. New York: Harry N. Abrams, 2003.

———, ed. *Diaspora and Visual Culture*. New York: Routledge, 1999.

———, ed. *The Visual Culture Reader*. New York: Routledge, 1998.

Mitchell, W.J.T. "Benjamin and the Political Economy of the Photograph." In *The Photography Reader*, ed. Liz Wells, 53–58. New York, Routledge, 2002.

———. *Picture Theory: Essays on Verbal and Visual Representation*. Chicago: University of Chicago Press, 1994.

———. *The Reconfigured Eye: Visual Truth in the Post-Photographic Era*. Cambridge, Mass.: MIT Press, 2001.

———. "Showing Seeing: A Critique of Visual Culture." *Journal of Visual Culture* 1, no. 2 (August 2002): 165–82.

Moneta Sleet, Jr.: Pulitzer Prize Photojournalist. Schomburg Center for Research in Black Culture's Traveling Exhibition Program. Curated by Julia Van Haaften and Deborah Willis. New York, New York. November 8, 2007–December 31, 2007.

Moor, Ayanah. "Still," *Meridians: feminism, race, transnationalism* 8, no. 1 (2008): 205–6.
Moore, Booth. "Beyonce a Fashion Designer?" *Los Angeles Times*, September 9, 2005, E22.
———. "Name Brand; Queen Latifah, 50 Cent and Eve Joining swelling ranks of celebrity designers." *Los Angeles Times*, August 9, 2003, E1.
———. "Urban Warriors." *Los Angeles Times*, February 11, 2003, E8.
Morgan, Joan. *When Chickenheads Come Home to Roost: A Hip-Hop Feminist Breaks It Down*. New York: Simon and Schuster, 1999.
Morrison, Toni. *Playing in the Dark: Whiteness and the Literary Imagination*. New York: Vintage Books, 1993.
———. "Unspeakable Things Unspoken: The Afro-American Presence in Afro-American Literature." *Michigan Quarterly Review* (1988): 1–34.
Moten, Fred. "The Case of Blackness," *Criticism* 40, no. 2 (Spring 2008): 177–218.
———. *In the Break: The Aesthetics of the Black Radical Tradition*. Minneapolis: University of Minnesota Press, 2003.
Mounsef, Donia. "The Seen, the Scene and the Obscene: Commodity Fetishism and Corporeal Ghosting." *Women and Performance: A Journal of Feminist Theory* 30, no. 15 (2005): 243–61.
Muhammad, Erika. "Black High-Tech Documents." In *Struggles for Representation: African American Documentary Film and Video*, ed. Phyllis R. Klotman and Janet K. Cutler, 298–314. Bloomington: Indiana University Press, 1999.
Muhammad, Tariq K. "From Here to Infinity: A Hip-Hop Clothier with Mainstream Appeal, Karl Kani Is Poised to Become the Fashion World's New Wunderkind." *Black Enterprise* 26, no. 11 (June 1996): 140–47.
Muñoz, José Esteban. *Disidentifications: Queers of Color and the Performance of Politics*. Minneapolis: University of Minnesota Press, 1999.
———. "Feeling Brown: Ethnicity and Affect in Ricardo Bracho's *The Sweetest Hangover (and Other STDs)*." *Theatre Journal* 52 (2000): 70.
Murray, Timothy. "Facing the Camera's Eye: Black and White Terrain in Women's Drama." In *Reading Black, Reading Feminist: A Critical Anthology*, ed. Henry Louis Gates Jr., 155–75. New York: Meridian, 1990.
Natanson, Nicholas. *The Black Image in the New Deal: The Politics of FSA Photography*. Knoxville: University of Tennessee Press, 1992.
Naughton, Julie. "The Three Faces of Eve." *Women's Wear Daily* 92, no. 52 (September 9, 2006): 12.
Neal, Mark Anthony. *Soul Babies: Black Popular Culture and the Post-Soul Aesthetic*. New York: Routledge, 2002.
Neary, Lynn. "Rasputia: A Comic Type, or a Racial Stereotype?," National Public Radio, February 26, 2007, http://www.npr.org/templates/story/story.php?storyId=7608400 (accessed September 16, 2008).
Nelson, Alondra. "Introduction: Future Texts." *Social Text*, Afrofuturism Special Issue 20, no. 2 (2002): 1–15.
Nelson, Alondra, Thuy Linh N. Tu, with Alicia Headlam Hines, eds. *Technicolor: Race, Technology, and Everyday Life*. New York: New York University Press, 2001.
Nichols, Bill. *Representing Reality: Issues and Concepts in Documentary*. Bloomington: Indiana University Press, 1991.
Norment, Lynn. "A Family Affair." *Ebony* 61, no. 2 (December 2005): 148.
Nussbaum, Martha. "Invisibility and Recognition: Sophocles' *Philoctetes* and Ellison's *Invisible Man*." *Philosophy and Literature* 23, no. 2 (1999): 257–83.

Nyong'o, Tavia. *The Amalgamation Waltz: Race, Performance, and the Ruses of Memory.* Minneapolis: University of Minnesota Press, 2009.

O'Grady, Lorraine. "Olympia's Maid: Reclaiming Black Female Subjectivity." *Afterimage* (1992): 14–23.

Oguibe, Olu. "Art, Identity, Boundaries: Postmodernism and Contemporary African Art." In *Reading the Contemporary: African Art from Theory to Marketplace*, ed. Olu Oguibe and Okwui Enwezor, 16–29. Cambridge: MIT Press. 1999.

———. "Forsaken Geographies: Cyberspace and the New World 'Other.'" Paper presented at the 5th International Cyberspace Conference, June 1996, Madrid, Spain. Full text available at http://eserver.org/internet/oguibe/.

Oguibe, Olu, and Okwui Enwezor. *Reading the Contemporary: African Art Theory to Marketplace*. Cambridge, Mass.: MIT Press, 1999.

Ogunnaike, Lola. "For a Fresh Mix, the Retro Kids Hit Rewind." *New York Times*, November 19, 2006, 9.

Omi, Michael, and Howard Winant. *Racial Formation in the United States: From the 1960s to the 1990s.* New York: Routledge, 1994.

One Shot: The Life and Work of Teenie Harris. Dir. Kenneth Love. Written by Joe Seamans. San Francisco: California Newsreel, 2003.

Orlandersmith, Dael. *Beauty's Daughter, Monster, The Gimmick: Three Plays.* New York: Vintage Books, 2002.

———. "Light Skin, Dark Skin and the Wounds Below." *New York Times*, October 20, 2002, 2:5.

———. *Yellowman and My Red Hand, My Black Hand.* New York: Vintage Books, 2002.

Pacteau, Francette. "Dark Continent." In *With Other Eyes: Looking at Race and Gender in Visual Culture*, ed. Lisa Bloom, 88–104. Minneapolis: University of Minnesota Press, 1999.

Pallay, Jessica. "Pharrell, Clothed and Ready to Sell." *DNR*, September 6, 2004.

———. "Simmons' Departure Sparks Uncertainty." *Fashion Wire Daily*, September 3, 2007.

Parks, Suzan-Lori. *Venus.* New York: Theatre Communications Group, 1997.

Pegler-Gordon, Anna. "Chinese Exclusion, Photography, and the Development of U.S. Immigration Policy." *American Quarterly* 58, no. 1 (March 2006): 51–77.

Peirce, Charles Sanders. "One, Two, Three: Fundamental Categories of Thought and of Nature." In *Peirce on Signs: Writings on Semiotic*, ed. James Hoopes. Chapel Hill: University of North Carolina Press, 1991.

Perkins, William Eric. "Rap Attack: An Introduction." In *Droppin' Science: Critical Essays on Rap Music and Hip-Hop Culture*, ed. Perkins, 1–46. Philadelphia: Temple University Press, 1996.

Perry, Imani. *Prophets of the Hood: Politics and Poetics in Hip Hop.* Durham, N.C.: Duke University Press, 2004.

Peters, Jeremy W., and Julie Bosman. "Rosa Parks Won a Fight, but Left a Licensing Rift." *New York Times*, October 8, 2006, http://www.nytimes.com/2006/10/08/business/yourmoney (accessed February 19, 2010).

Phelan, Peggy. "Francesca Woodman's Photography: Death and the Image One More Time." *Signs* 27, no. 4 (2004): 979–1004.

———. *Mourning Sex: Performing Public Memories.* New York: Routledge, 1997.

———. *Unmarked: The Politics of Representation.* New York: Routledge, 1993.

Phelan, Peggy, and Jill Lane, eds. *The Ends of Performance.* New York: NYU Press, 1998.

"The Photographers: Richard Saunders." Carnegie Library of Pittsburgh, http://www.clpgh.org/exhibit/photog9.html (accessed January 11, 2008).

"Pop Icon Michael Jackson Is Dead." *Los Angeles Times*, June 25, 2009.
Powell, Richard J. *Cutting a Figure: Fashioning Black Portraiture*. Chicago: University of Chicago Press, 2009.
Quinn, Eithne. *Nuthin' but a "g" Thang: The Culture and Commerce of Gangsta Rap*. New York: Columbia University Press, 2005.
Rabinowitz, Paula. *They Must Be Represented: The Politics of Documentary*. New York: Verso, 1994.
Raiford, Leigh. "'Come Let Us Build a New World Together': SNCC and Photography of the Civil Rights Movement." *American Quarterly* 59, no. 4 (December 2007): 1129-57.
Raiford, Leigh, and Renee C. Romano, eds. *The Civil Rights Movement in American Memory*. Athens: University of Georgia Press, 2006.
Read, Alan, ed. *The Fact of Blackness: Frantz Fanon and Visual Representation*. Seattle: Bay Press, 1996.
Reid-Brinkley, Shanara R. "The Essence of Res(ex)pectability: Black Women's Negotiation of Black Femininity in Rap Music and Music Video." *Meridians: feminism, race, transnationalism* 8, no. 1 (2008): 236-60.
Rich, Frank. "My Hero, Janet Jackson." *New York Times*, February 15, 2004.
Richards, Sandra L. "Writing the Absent Potential: Drama, Performance and the Canon of African-American Literature." In *Performativity and Performance*, ed. Eve Kosofsky Sedgwick and Andrew Barker, 64-88. New York: Routledge, 1995.
Roberts, Dorothy E. *Killing the Black Body: Race, Reproduction, and the Meaning of Liberty*. New York: Random House, 1997.
Robins, Kevin. *Into the Image: Culture and Politics in the Field of Vision*. New York: Routledge, 1996.
Roediger, David R. *The Wages of Whiteness: Race and the Making of the American Working Class*. London: Verso, 1999.
———. "Whiteness and Ethnicity in the History of 'White Ethnics' in the United States." In *Towards the Abolition of Whiteness: Essays on Race, Politics, and Working-Class History*, 181-98. New York: Verso, 1994.
Rogoff, Irit. "'Other's Others': Spectatorship and Difference." In *Vision in Context: Historical and Contemporary Perspectives on Sight*, ed. Teresa Brennan and Martin Jay, 187-202. New York: Routledge, 1996.
———. *Terra Infirma*. New York: Routledge, 2000.
Rose, Tricia. *Black Noise: Rap Music and Black Culture in Contemporary America*. Hanover, N.H.: Wesleyan University Press, 1994.
Rosler, Martha. "In, Around, and Afterthoughts (On Documentary Photography)." In *The Photography Reader*, ed. Liz Wells, 261-74. New York: Routledge, 2003.
Rothfield, Lawrence, ed. *Unsettling "Sensation": Arts-Policy Lessons from the Brooklyn Museum of Art Controversy*. New Brunswick, N.J.: Rutgers University Press, 2001.
Royal, Leslie E. "Hip-Hop on Top: We Look at the Elements and Top Designers that Have Helped Urban Fashion Skyrocket, and Predict Where the Industry Is Headed." *Black Enterprise* 30, no. 12 (July 2000): 91-94.
Rozhon, Tracie. "Phat Fashions Is Being Sold to Kellwood for $140 Million." *New York Times*, January 9, 2004, C4.
———. "The Rap on Puffy's Empire." *New York Times*, July 24, 2005, 3.
———. "Russell Simmons Brings His Style to a New Clothing Line." *New York Times*, August 5, 2003, C5.
Rush, Michael. *New Media in Late 20th-Century Art*. New York: Thames and Hudson, 1999.

Russell, Kathy, Midge Wilson, and Ronald Hall. *The Color Complex: The Politics of Skin Color Among African Americans*. New York: Anchor Books, 1992.

"Russell Simmons: Impresario, Executive, Yoga Enthusiast." *Vanity Fair*, November 1, 2005.

Sales, Nancy Jo. "Hip-Hop Goes Universal," *New York* 32, no. 18 (May 10, 1999): 23–29.

Sanneh, Kelefa. "Fine and Dandy." *Transition* 12, no. 4 (2003): 120–31.

Saunders, Doris E., ed. *Special Moments in African-American History: 1955–1996: The Photographs of Moneta Sleet, Jr. Ebony Magazine's Pulitzer Prize Winner*. Chicago: Johnson Publishing, 1998.

Schechner, Richard. *Performance Theory*. 2nd ed. New York: Routledge, 2003.

Schneider, Rebecca. *The Explicit Body in Performance*. New York: Routledge, 1997.

Schulke, Flip. *He Had a Dream: Martin Luther King, Jr., and the Civil Rights Movement*. New York: W. W. Norton, 1995.

Sefton-Green, Julian, ed. *Digital Diversions: Youth Culture in the Age of Multimedia*. London: UCL Press, 1998.

Sexton, Jared. *Amalgamation Schemes: Antiblackness and the Critique of Multiracialism*. Minneapolis: University of Minnesota Press, 2008.

Shapin, Steven, and Simon Schaffer. *Leviathan and the Air-Pump: Hobbes, Boyle, and the Experimental Life*. Princeton, N.J.: Princeton University Press, 1985.

Sherrard-Johnson, Cherene. "'A Plea for Color': Nella Larsen's Iconography of the Mulatta," *American Literature* 76, no. 4 (December 2004): 833–69.

———. *Portraits of the New Negro Woman: Visual and Literary Culture in the Harlem Renaissance*. New Brunswick, N.J.: Rutgers University Press, 2007.

Shimakawa, Karen. *National Abjection: The Asian American Body Onstage*. Durham, N.C.: Duke University Press, 2002.

Shimizu, Celine Parreñas. *The Hypersexuality of Race: Performing Asian/American Women on Screen and Scene*. Durham, N.C.: Duke University Press, 2007.

Silverman, Kaja. *Flesh of My Flesh*. Stanford: Stanford University Press, 2009.

———. *The Subject of Semiotics*. New York: Oxford University Press, 1983.

———. *The Threshold of the Visible World*. New York: Routledge, 1996.

Singh, Nikhil. *Black Is a Country: Race and the Unfinished Struggle for Democracy*. Cambridge: Harvard University Press, 2004.

Sloan, Lester. "Roy DeCarava Retrospective." Nieman Foundation for Journalism, http://www.nieman.harvard.edu/reports/99-4_00-1NR/Sloan_DeCarava.html (accessed September 19, 2006).

Smith, Paul. "Tommy Hilfiger in the Age of Mass Customization." In *Popular Culture: A Reader*, ed. Raiford Guins and Omayra Zaragoza Cruz, 151–58. Newbury Park, Calif.: Sage, 2005.

Smith, Valerie. "From 'Race' to Race Transcendence: *"Race," Writing, and Difference* Twenty Years Later." *PMLA* Special Topic: Comparative Racialization. 123, no. 5 (October 2008): 1528–33.

———, ed. *Representing Blackness: Issues in Film and Video*. New Brunswick, N.J.: Rutgers University Press, 1997.

Sobchack, Vivian. "'At the Still Point of the Turning World': Meta-Morphing and Meta-Stasis." In *Meta-Morphing: Visual Transformation and the Culture of Quick-Change*, ed. Vivian Sobchack, 131–58. Minneapolis: University of Minnesota Press, 2000.

———. "The Scene of the Screen: Envisioning Cinematic and Electronic 'Presence.'" In *Electronic Media and Technoculture*, ed. John Thornton Caldwell, 137–55. New Brunswick, N.J.: Rutgers University Press, 2000.

Sollors, Werner. *Neither Black nor White Yet Both: Thematic Explorations of Interracial Literature.* New York: Oxford University Press, 1997.

Sontag, Susan. *On Photography.* New York: Picador, 1977.

Soussloff, Catherine, and Mark Franko. "Visual and Performance Studies A New History of Interdisciplinarity." *Social Text* 20, no. 4 (Winter 2002): 29–45.

Specter, Michael. "I Am Fashion: Guess Who Puff Daddy Wants to Be?" *New Yorker*, September 9, 2002, 117–27.

Spiegler, Mark. "Marketing Street Culture: Bringing Hip-Hop Style to the Mainstream." *American Demographics* (November 1996): 29.

Spigel, Lynn. *Make Room for TV: Television and the Family Ideal in Postwar America.* Chicago: University of Chicago Press, 1992.

"Spike Lee Calls Jackson's Flash a 'New Low': Janet Says Exposure Was Unintentional in Video Statement." Associated Press, February 4, 2004, http://www.msnbc.msn.com/id/4160392 (accessed October 20, 2009).

Spillers, Hortense J. "Changing the Letter: The Yokes, the Jokes of Discourse, or, Mrs. Stowe, Mr. Reed." In Spillers, *Black, White, and in Color: Essays on American Literature and Culture.* Chicago: University of Chicago Press, 2003.

———. "Mama's Baby, Papa's Maybe: An American Grammar Book." *Diacritics* (Summer 1987): 65–81.

Spirit of a Community: The Photographs of Charles "Teenie" Harris. Greensburg, Pa.: Westmoreland Museum of Art, 2001.

Stange, Maren. "'Illusion Complete within Itself': Roy Decarava's Photography." *Yale Journal of Criticism* 9, no. 1 (1996): 63–92.

———. *Symbols of Ideal Life: Social Documentary Photography in America 1890–1950.* New York: Cambridge University Press, 1992.

Stott, William. *Documentary Expression and Thirties America.* Chicago: University of Chicago Press, 1986.

Sturken, Marita, and Lisa Cartwright, eds. *Practices of Looking: An Introduction to Visual Culture.* New York: Oxford University Press, 2001.

Tate, Greg. "Michael Jackson: The Man in Our Mirror: Black America's Eulogies for the King of Pop Also Let Us Resurrect His Best Self." *Village Voice*, June 30, 2009, http://www.villagevoice.com/2009-07-01/news/michael-jackson-the-man-in-our-mirror/ (accessed November 21, 2009).

Taylor, Diana. *The Archive and the Repertoire: Performing Cultural Memory in the Americas.* Durham, N.C.: Duke University Press, 2003.

Thomas, Kendall. "'Ain't Nothin' Like the Real Thing': Black Masculinity, Gay Sexuality, and the Jargon of Authenticity." In *The House That Race Built: Black Americans, U.S. Terrain*, ed. Wahneema Lubiano, 116–35. New York: Pantheon, 1997.

Thompson, Stephanie. "Hip-Hop Lines Go from Bling to Black Tie; Phat Farm, Others Follow Puffy in Luxury, Couture Arenas." *Advertising Age*, November 21, 2005.

"Timberlake: Family Offended by Super Bowl," Associated Press, February 4, 2004, http://story.news.yahoo.com.*Tongues Untied.* Dir. Marlon Riggs. Strand, 2008.

Trachtenberg, Alan. *Reading American Photographs: Images as History, Matthew Brady to Walker Evans.* New York: Hill and Wang, 1990.

Tranberg, Dan. "Works on Feminist Theme Reflect Individual Visions." *The Plain Dealer*, October 5, 2001.

Trebay, Guy. "A Fashion Statement: Hip-Hop on the Runway." *New York Times*, February 9, 2002, B4.

———. "Maturing Rappers Try a New Uniform: Yo, a Suit!" *New York Times*, February 6, 2004, A1.

Van Meter, William. "You Got a Problem with My Hoodie." *New York Times*, April 27, 2006.

Venable, Malcolm. "Pharrell Williams Steps into a New Arena." *Virginian-Pilot and Ledger-Star*, September 3, 2004.

Wald, Gayle. *Crossing the Line: Racial Passing in Twentieth-Century U.S. Literature and Culture*. Durham, N.C.: Duke University Press, 2000.

Waldron, Clarence. "Russell Simmons Talks about Kimora Hip-Hop, and New Ways to Make Money." *Jet*, September 25, 2006.

Wallace, Maurice O. *Constructing the Black Masculine: Identity and Ideality in African American Men's Literature and Culture, 1775–1995*. Durham, N.C.: Duke University Press, 2002.

Wallace, Michele. *Invisibility Blues: From Pop to Theory*. New York: Verso, 1990.

———. "Modernism, Postmodernism and the Problem of the Visual in Afro-American Culture." In *Aesthetics in Feminist Perspective*, ed. Hilde Hein and Carolyn Korsmeyer, 205–17. Bloomington: Indiana University Press, 1993.

———. "'Why Are There No Great Black Artists?': The Problem of Visuality in African-American Culture." In *Black Popular Culture*, ed. Gina Dent. Seattle: Bay Press, 1992.

Wallace, Thurman. *The Blacker the Berry* . . . New York: Simon and Schuster, 1996.

Wallis, Brian. "Black Bodies, White Science: Louis Agassiz's Slave Daguerreotypes." In *Only Skin Deep: Changing Visions of The American Self*, ed. Coco Fusco and Brian Wallis, 163–81. New York: Harry N. Abrams, 2003.

Wallis, Brian, and Deborah Willis. *African American Vernacular Photography*. New York: Steidl/ICP, 2006.

Watkins, S. Craig. *Hip Hop Matters: Politics, Pop Culture, and the Struggle for the Soul of a Movement*. Boston: Beacon Press, 2006.

———. *Representing: Hip-Hop Culture and the Production of Black Cinema*. Chicago: University of Chicago Press, 1998.

Weinstone, Ann. *Avatar Bodies: A Tantra for Posthumanism*. Minneapolis: University of Minnesota Press, 2004.

White, Shane, and Graham White. *Stylin': African American Expressive Culture from its Beginnings to the Zoot Suit*. Ithaca, N.Y.: Cornell University Press, 1998.

"Who Wants to Be a Billionaire? Pharrell Gives Blueprint as New Apparel Collection Debuts." *PR Newswire*, August 9, 2004, 1.

Williams, Carla. "Body Baggage." *New York Newsday*, February 8, 2004.

———. "The Erotic Image Is Naked and Dark." In *Picturing Us: African American Identity in Photography*, ed. Deborah Willis. New York: The New Press, 1994.

Williams, Linda, ed., *Viewing Positions* (New Brunswick, N.J.: Rutgers University Press, 1997).

Williams, Monte. "'Yo Mama' Artist Takes on Catholic Critic," *New York Times*, February 21, 2001, B3.

Willis, Deborah, ed. *Picturing Us: African American Identity in Photography*. New York: The New Press, 1994.

———. *Reflections in Black: A History of Black Photographers from 1840 to Present*. New York: Norton, 2002.

———, ed. *Black Venus 2010: They Called Her "Hottentot."* Philadelphia: Temple University Press, 2010.

Willis, Deborah, and Carla Williams. *The Black Female Body: A Photographic History*. Philadelphia: Temple University Press, 2002.

Wilson, Ellen S. "Documenting Our Past: The Teenie Harris Archive Project," *Carnegie Online*, July/August 2003, http://www.carnegiemuseums.org/cmag/bk_issue/2003/julaug/cma.html (accessed September 26, 2006).

———. "Filling in the Blanks: The Teenie Harris Archive Project Continues," *Carnegie Online*, January/February 2004, http://www.carnegiemuseums.org/cmag/bk_issue/2004/janfeb/feature2.html (accessed September 26, 2006).

Wilson, Eric. "Who Put the Black in Black Style?" *New York Times*, August 31, 2006, G5:1.

Witt, Doris. "Detecting Bodies: Barbara Neely's Domestic Sleuth and the Trope of the (In)visible Woman." In *Recovering the Black Female Body: Self-Representations by African American Women*, ed. Michael Bennett and Vanessa Dickerson, 165–94. New Brunswick, N.J.: Rutgers University Press, 2001.

Young, Hershini Bhana. *Haunting Capital: Memory, Text, and the Black Diasporic Body*. Hanover, N.H.: Dartmouth College Press, 2006.

Young, Lola. "Missing Persons: Fantasizing Black Women in *Black Skin, White Masks*." In *The Fact of Blackness: Frantz Fanon and Visual Representation*, ed. Alan Read, 86–101. Seattle: Bay Press, 1996.

INDEX

Abernathy, Ralph, 36
abjection/abjectness, 72, 90–91, 95, 100–101, 103–4; national abjection, 90–91
Academiks, 173
Acconci, Vito, 197
Adams, Michael Henry, 174
Adidas, 147, 150, 155, 158
affect, 6, 9–12, 18, 69, 74, 77, 81; iconic affect, 34
affective economies, 10–11, 131
affective power, 2, 6, 7, 8, 22, 24, 34, 85
Africa(n), 177–78, 182–84, 187–88, 191, 193–95, 197–98, 204; West Africa, 188, 195
Africaine (Studio Museum Harlem), 201
Africanist, 194
Agassiz, Louis, 57
Ahmed, Sara, 10–11, 24–25, 131
Ali, Muhammad, 65. *See also* Clay, Cassius
American(a), 152, 159–60, 162–75, 178, 190; "American Dream," 194
American exceptionalism, 10, 33, 47
American Family (Cox), 107, 114
American Gothic (photograph by Gordon Parks, painting by Grant Wood), 44
American Place Theatre, 84
Anderson, Pamela, 143
Apollo, the, 208, 212
Applebome, Peter, 35
Apple Bottom, 161
"Art-as-Urban-Development," 199
Artforum, 124
Art Production Fund, 198
Asian Americans, 90–91; Chinatown, 57; Chinese immigrants, 57; theater, 90

Astaire, Fred, 193
Austin, Regina, 150
Awkward, Michael, 211–12
ayo, damali, 186; www.rent-a-negro.com, 186

Baartman, Saartje, 118–19, 133. *See also* Hottentot Venus
Babour, George, 50
Baby Back (Cox), 115
Baby Got Back (Moor), 136–37
"Baby Got Back" (Sir Mix-a-Lot), 115, 136–37
Baby Phat, 160
Bailey, David A., 43
Baker, Josephine, 109
Banks, Taunya, 76–77
Barber Shop (film), 221n24
Barrett, Lindon, 17–18, 73, 94, 214
Barrie, Scott, 157
Barthes, Roland, 45, 54, 152, 162, 164
b-boy, 150, 158, 166
Beauty's Daughter (Orlandersmith), 84
Berger, Martin, 45
Bergner, Gwen S., 224n67
Berkeley Repertory Theatre, 74, 84
Berlant, Lauren, 10, 11
BET, 133; *Uncut*, 133
Better Homes and Gardens, 192
Beyonce, 127, 160; Dereon, 160
Bhabha, Homi, 22
"Big Poppa" (Notorious B.I.G.), 161
Black, Stephanie, 184; *Life and Debt*, 184
Black Arts Movement, 148
black body, 29–32, 75, 111–12, 128, 147
black celebrity, 3, 46, 64–65, 68, 112, 117, 138

black cultural criticism, 4, 7, 12–15, 20, 109, 118, 147
black cultural production, 4, 79–80, 86, 92
black cultural studies, 4, 12, 16
black culture industry 4, 209, 219n6
Black Enterprise, 156
Blacker the Berry . . ., The (Thurman), 78
black female body, 29–32, 75, 95, 101, 104, 105–33
Black Female Body, The (Willis and Williams), 120
black freedom movements/struggles, 33–37, 45, 53
black hair style/politics, 31, 153
Black Is . . . Black Ain't (Riggs), 222n32
Black Leather Lace-Up (Cox), 116
black male body, 29–30, 111, 147–75
black masculinity, 29–30, 137, 147–75, 213; black male icon of hip-hop, 133–34, 151
blackness, 29–32, 37, 47, 70, 73–74, 77, 78, 80, 85–86, 89, 92, 95–96, 110, 111, 113, 118, 119, 145, 152, 211, 214; as decay, 85; as figuration, 5, 6, 18, 28, 30, 31, 94, 110, 111, 112, 118, 136, 140, 143, 144, 212; post-blackness, 13–14; staging blackness, 82; as visual truth, 5, 29, 36, 43, 85, 86, 95
Black No More (Schuyler), 78
Black Panther Party, 148
black pathology, 74, 85, 212
black popular culture, 125–27, 132, 137
"Black Popular Culture" (conference), 12–13
black power movement, 87
black representation/representational space, 4, 5, 9, 10, 14, 47
black self-fashioning, 147, 173
Black Style Now (Museum of the City of New York), 173
black subcultural authenticity, 150, 152
black vernacular culture, 5, 149–50
Bloomer, Jeffrey, 219n7
Boas, Franz, 81
Bolden, Frank, 64
Bordo, Susan, 143
Boucher, Geoff, 210
Boxer Cassius Clay (Muhammad Ali) kissing his mother Odessa Grady Clay, with his brother Rudy and father Davis, looking on, at Carlton House Hotel (Harris), 65
Boy George, 143
Bracho, Ricardo A., 11
Braidotti, Rosi, 183

Brantley, Ben, 93
Brewer, John, 51–52, 68
Brinkley, Douglas, 36
Brody, Jennifer DeVere, 21, 114
Brooklyn Museum, 106–8
Brooks, Daphne, 24, 77, 105
Bronx Museum of Art, 198–200
Brown, Henry Box, 77
Buggin' Out, 10
Burrows, Stephen, 157, 174
Bush, George H. W., 4
Butler, Judith, 7, 8, 48–49, 90; on normativity/normalization, 48–49

Campt, Tina, 220n12
Carby, Hazel, 78, 80, 120, 172; *Reconstructing Womanhood*, 220n12
Carlton House Hotel, 65–67
Carnegie Museum of Art, 38, 40–41, 47, 55, 68
Carter, Michael, 58
Cary, Jonathan, 223n44
Catanese, Brandi, 186–87
Catholic League for Religious and Civil Rights, 107
Cayer, Jennifer, 80
CBS, 129–31
Changing Space (Tuggar), 198–99
Chapbell, Edna
Chicano, 11
Childress, Alice, 72; *Wedding Band*, 72
Chow, Rey, 235n70
Chriss, Nicholas C., 34–35
Ciao Bella (Rose), 124
cinematic identification, 180
civil rights, 33–39, 45–46, 53, 57, 64; post–civil rights, 39, 60, 86, 212
Clap, Face, Lean and Glow (Moor), 134
"Classic American Flava" (Phat Farm), 163–65
Classon, H. Lin, 75, 81
Clay, Andreana, 137
Clay, Cassius, 65–66, 68
Clay, Rudy, 65–66
Clemente, Roberto, 64
Clinton presidency, 128
Cold War, 177–78, 187, 190
Collins, Lisa Gail, 13, 127
Collins, Tracy, 169–70; "I am King" advertisement (photograph), 169; Roca Wear advertisement featuring Jay-Z (photograph), 170

colorism, 29, 72–105; color coding, 29; color hierarchies, 29, 72, 75, 94; colorist system and ideology, 29, 76, 78, 83, 86, 88, 93, 102; interracial, 72, 75, 76, 81; intraracial, 72–74, 77, 81, 85; as paranoiac self-surveillance, 105; as taboo, 74
Color Struck (Hurston), 28, 72, 75, 79–83, 86, 91–93, 95
Combs, Sean, 128, 145, 158, 166–68, 174; "I am King" slogan, 147, 168; King cologne, 168; Sean John, 167, 173; as Sean "P. Diddy" Combs, 145. *See also* Sean John (company)
Committed to the Image (Brooklyn Museum), 106, 108
"commoditized hybridity" (Kuo), 156, 165, 166, 173
composite/compositing, 181, 198
consumption, 36, 125, 152, 177, 184
Conveyance (Tuggar), 201
corpse, 90
Cosby Show, The, 3–4
Cotter, Holland, 199
Coty Award, 157
Couple in the Cage, The (Fusco and Gómez-Peña), 31
Cousins at Pussy Pond (Cox), 114
Cox, Renee, 29, 106–9, 113–18, 125, 131–32; *American Family*, 107, 114; *Baby Back*, 115; *Black Leather Lace-Up*, 116; *Cousins at Pussy Pond*, 114; *Hot En Tott*, 113; *Yo Mama's Last Supper*, 106–8, 113–14, 131
Crane, Diane, 152, 159
Crips, 163
Critical Inquiry (journal), 4
critical race theory, 6, 74

Dancing with the Stars (television show), 144
Dapper Dan, 153; Dapper Dan's Boutique, 155
Davis, Betty, 127
Davis, Fred, 152, 159, 165
DeCarava, Roy, 43–44; and Langston Hughes, 228n33; *Man coming up the subway stairs*, 44
Def Jam Records, 158
Dejeuner sur L'Herbe, Le (Manet), 114
Deleuze, Gilles, 2
democracy, 33, 44, 46, 47, 205; American democracy as progress, 33, 46, 47, 192
Dia Art Foundation, 15
Dickerson, Ernest, 1

digital archive, 38, 68–69
digital art, 6, 7, 30, 133–34, 177–201; assemblage, 179, 181; bricolage, 197; cut/cutting, 181, 190, 193; photomontage, 177, 187, 189, 195, 204. *See also* suture
"digital divide," 182; race/technology divide, 183
digital media, 30, 133, 178, 180, 182, 183, 189, 196, 203–4
disco, 157
disfiguration, 94
Documenting Our Past (Carnegie Museum of Art), 38, 68
Do the Right Thing (Lee), 1–5, 10, 24; twentieth-anniversary edition DVD, 219–20n7
drama, 12, 71, 81, 83, 84, 105; closet drama, 78; dramatic texts/works, 71, 72, 73, 77, 78, 84. *See also* theater
dramaturgy, 74
Driving Miss Daisy (film), 3
DuBois, W. E. B., 7–8, 12, 78
DuCille, Anne, 86
Dyson, Michael Eric, 108

Ebony, 215
Eckstine, Billy, 54
Elam, Harry J., Jr., 71, 79
Elam, Michelle, 78–79
Ellington, Duke, 64
Ellison, Ralph, 11, 12, 15; *Invisible Man*, 12
embodiment/disembodiment, 18, 24, 29, 34, 73, 95, 103, 104, 109, 110, 117, 154, 168
Eng, David, 57, 123
English, Darby, 14, 15
Entin, Joseph, 58
epidermal schema/ epidermalization, 22, 23, 32, 73, 75, 77, 95
Evans, Walker, 42
Eve, 160; Fetish clothing line, 160
Everett, Anna, 183
excess, 9, 105, 119, 121, 125, 132, 141
excess flesh, 9, 28, 104, 109–12, 121–32, 137, 142–44

Facebook, 209
Fanon, Frantz, 21–28, 95–96, 123; Fanonian moment, 21–28
Farm Security Administration (FSA) Photographic Project (1935–42), 42; FSA School, 42, 44

fashion system, 152, 162
Fauset, Jessie Redmon, 78; *Plum Bun*, 78
Federal Writers' Project, 79
femininity, 88, 89, 92, 93, 102, 110–11, 113, 143, 152, 161, 224n63; idealized, 29, 88, 110–11; racialized, 89, 92, 113, 161
feminist art, 84, 110, 124, 190–91
feminist theory, 6, 8, 18, 29, 84, 95–96, 110, 120, 122, 134, 179, 181, 183, 190–91, 194; black feminist scholarship, 4–6, 12–13, 96, 120, 122, 134–35; feminist film theory, 6, 179, 182–83
Ferguson, Roderick, on Marx, 111
Fifth Element, The (film), 201
50 Cent, 158
"Fight the Power" (Public Enemy), 1, 3
film theory, 2, 6, 16–17, 42, 180–82, 203; "the cinematic," 2. *See also* suture
Finkelpearl, Tom, 199
Fire!! (literary magazine), 81
First Amendment, 107
Flight to Canada (Reed), 82
Fonda, Jane, as Barbarella, 141
Foreman, P. Gabrielle, 75
"forsaken geographies" (Oguibe), 200–201
Fortin, Sylvie, 181, 187
Foster, Hal, 15
Franko, Mark, 21
Freestyle (Studio Museum Harlem), 14
FUBU (For Us, By Us), 156–57
Fuchs, Elinor, 110
Funnyhouse of a Negro (Kennedy), 72
Fusco, Coco, 31
Fusion Cuisine (Tuggar), 177, 192–95, 197

GAP, the, 158
Gates, David, 209, 211–12
Gates, Henry Louis, Jr., 4, 22
gaze, 61, 66, 93, 111–12, 121, 124
George, Nelson, 153, 155
Gimmick, The (Orlandersmith), 84
Giuliani, Rudolph, 106–8
Glasco, Larry, 39, 60
globalization, 177, 183, 186
global touring, 133
Golden, Thelma, 13–14, 15
Gómez-Peña, Guillermo, 31, 203
Graham, Renee, 221n24
Grande Odalisque, Le (Ingres), 115
Gray, Fred, 35–36
Gray, Herman, 4, 172

Gray, Todd, 244n10
Grier, Pam, 109
Griffin, Farah Jasmine, 4, 91–92
Group portrait of children, some in bathing suits, standing on Webster Avenue under spray from fire hose, near Webster Avenue firehouse at Wandless Street, Hill District (Harris), 40; alternative titles, 40
Gucci, 153, 162

Halberstam, Jack, 137
Halberstam, Judith, 137
Hall, Ronald, 74
Hall, Stuart, 22, 43, 125
Hammonds, Evelyn, 121–22
Haraway, Donna, 179
Hariman, Robert, 33
Harlem, 39, 58, 153, 155, 207
Harlem Document (publication), 58
Harlem Renaissance, 77, 78
Harrell, Andre, 171–72
Harris, Charles A., 47, 51–53, 59
Harris, Charles "Teenie," 28, 37–41, 47–70, 113, 135; *Boxer Cassius Clay (Muhammad Ali) kissing his mother . . .*, 65; *Group portrait of children, some in bathing suits . . .*, 40; *Man, possibly Al West . . .*, 49; *Photographer taking a picture of boxer Muhammad Ali . . .*, 68; *Portrait of Charles "Teenie" Harris . . .*, 52; *Portrait of man wearing light colored shirt . . .*, 60; *Portrait of man wearing plaid double pocket shirt and moustache . . .*, 60; *Rudy Clay, brother of boxer Cassius Clay . . .*, 66; *Self portrait of Charles "Teenie" Harris*, 48; *Two men standing on brick road . . .*, 62; *Woman holding cigarette . . .*, 55
Harris, Cheryl, 76, 77
Harris, Woogie, 38
Hartman, Saidiya, 220n12
Henderson, Horace, 54
Hendricks, Barkley L., 148
Henry, Deidre N., 85
Henry, Sarah, 175
heteronormativity, 137
Higginbotham, A. Leon, 76, 77
Higginbotham, Evelyn, 34
Hilfiger, Tommy, 147, 155–56, 159
Hill District, 28, 38–39, 49–51, 53–54, 60, 64, 69
Hine, Lewis, 42

hip-hop, 29–30, 148; as Americana, 29–30, 159, 163–75; music, 137, 147, 154; music video, 132–42; pornography, 133
hip-hop fashion, 147–75; fashion companies, 145; as fashion system, 29–30, 152
hip-hop feminist, 134
hip-hop industry, 145, 155, 158–59, 171
hip-hop mogul, 128, 144, 145, 154, 158–59, 166, 174
Holland, Sharon, 112
Holy Virgin Mary, The (Ofili), 107
hoodie, 158, 159, 163
hooks, bell, 54, 234n62, 241n8, 245n21
Horne, Lena, 54, 68
Hot En Tott (Cox), 113
Hottentot Venus, 109, 113, 118–19. See also Baartman, Saartje
"How Many Licks" (Lil' Kim), 139–42
Hughes, Langston, 78–79, 81, 103; *Mulatto*, 78, 103; and Roy DeCarava, 228n33
Hunter, Paul, 133
Hurricane Katrina, 10
Hurston, Zora Neale, 72–73, 77–84, 86–87, 89–92; *Color Struck*, 28, 72, 75, 79–83, 86, 91–93, 95; *Jonah's Gourd Vine*, 79; *Their Eyes Were Watching God*, 79
Hyde, Nina, 157
hypericonization, 37
hypermasculinity, 137
hypersexuality, 131
hypervisibility, 16, 47, 96, 111–12; definition of, 16, 111

icon, 10, 30, 33–34, 36–37, 41–42, 46, 64, 68, 154, 158, 161, 173, 207–18
iconicity, 2, 10, 28, 30, 33, 37, 42, 66, 113–18, 208, 214, 215, 218
iconography, 10, 77
image, 10; negative/positive images, 13, 15, 48, 112
imago, 23–24, 26, 96, 100, 102, 109, 111, 120, 123, 124; black female imago, 100, 124
index, 41–43, 51, 57; indexicality, 28, 41–42, 51, 52, 57–58, 60, 64
Industrial Revolution, 201
Ingres, Jean-Auguste-Dominique, *Le Grande Odalisque*, 115
invisibility, 9, 15, 27, 47, 53, 89–90, 94, 111, 113, 121–22, 191, 201
Invisible Man (Ellison), 12

Isaak, Jo Anna, 108, 114
Izod, 150

Jackson, Clark, 85
Jackson, Janet, 29, 109, 127–32; Super Bowl performance, 127–31
Jackson, John, 11, 152
Jackson, Michael, 3, 30, 207–18; as alien/nonhuman, 209; "Ben," 245n16; as black/not black, 211; in death, 30, 207–18; of Gary, Indiana, 214; as icon, 30, 207–8, 214–15, 217; memorabilia, 217; moonwalk, 214; perverse sexuality/asexuality, 213; as "Peter Pan," 209; and plastic surgery, 214; suite at Disney World, 216
Jackson, Millie, 109
Janus, Elizabeth, 198
Jay, Martin, 15
Jay-Z, 128, 158, 168. See also Roca Wear
Jefferson, Margo, 213
Jenkins, Candice, 88
Jim Crow, 35, 79, 81, 86, 94, 149
Johannesberg Bienniale, 31
Johnson, E. Patrick, 20
Jonah's Gourd Vine (Hurston), 79
Jones, Louis, 54
Jones, Quincy, 162, 213; on Michael Jackson, 213; and *Vibe* (magazine), 162

Kaldec, David, 79–80
Kangol, 156
Kani, Karl, 156, 157
Kaplan, Amy, 191
Kasfir, Sidney Littlefield, 182
Keeling, Kara, 2, 181; on "the black femme," 181
Kelley, Robin, 148
Kellwood, 171
Kennedy, Adrienne, 72, 97; *Funnyhouse of a Negro*, 72
Khoisan (South African), 118
Kim, Christine Y., 14
Kim, Daniel, 25–26
Kincaid, Jamaica, 184, 242n23; *A Small Place*, 184
King, Bernice, 47
King, Martin Luther, Jr., 10, 36, 37, 47
Kitchen, the, 177–78, 191
"Kitchen Debate," 192
Klein, Alvin, 84

Klein, Calvin, 155
Kondo, Dorinne, 152, 162
Kopytoff, Barbara, 76, 77
Krasner, David, 87
Kraut, Anthea, 232n20
Kristeva, Julia, 90, 97, 100, 103
Kuo, Laura, 156, 165

Lacan, Jacques, 123
Lady and the Maid, The (Tuggar), 187, 190, 197
Lange, Dorothea, 42
Lang, Helmut, 162
Larsen, Nella, *Passing* and *Quicksand*, 78
Last Supper, The (da Vinci), 106
Latinos, 148, 163–64, 203
Lauren, Ralph, 155, 159, 162
Lawrence, David, 50
Lawrence, Francis, 139
Lee, Anthony, 57
Lee, Joie, 1
Lee, Russell, 42
Lee, Spike, 1–5, 10; on Barack Obama, 3; *Do The Right Thing* (Lee), 1–5, 10, 24; on Janet Jackson, 129–30; as Mookie, 1–2
Leonardo da Vinci, 106
Life, 43, 45
Life and Debt (Black), 184
Ligon, Glenn, 13–14, 15
Lil' Kim, 29, 109, 127, 138–44; as "bionic booty," 144; as Candy Kim, 140; as Edible Doll, 139; "How Many Licks," 139–42; as Nightrider Kim, 142; as Pin-Up Kim, 141; as Queen Bee, 140; "Suck My Dick," 138–39
Lippincott, Louise, 52, 59, 68
Little X, 133
LL Cool J, 156
Locke, Alain, 12
Look (magazine), 34
Lopez, Jennifer, 160, 166
Los Angeles Times, 210, 214
Lubiano, Wahneema, 4–6, 10, 220n12
Lucaites, John Louis, 33

Madonna, 143
Malcolm X, 10
Man, possibly Al West, standing outside West Auto Body Shop with tire display, 2407 Centre Avenue, Hill District (Harris), 49
Man coming up the subway stairs (DeCarava), 44

Manet, Edouard, 21, 114, 116; *Le Dejeuner sur L'Herbe*, 114; *Olympia*, 21, 114
Manhattan Theatre Club, 84–85
March on Washington, 47
March to Selma, 47
Marling, Karal Ann, 192
Marriott, David, 9, 23–27, 95–96
masculinity, 9, 29, 88, 102, 137; racialized, 102
Masio Hotel, 38
mass culture, 125–26
mass customization, 156
mass markets, 159
Matloff, Jason, 3
Mays, Benjamin, 147
Mecca USA, 162
Meditation on Vacation (Tuggar), 184–85, 187
memory, 19, 45–46, 48, 68–70, 84, 94, 102, 103–4, 124, 128; collective memory, 68–70; consensus, 45–46, 69; and trauma, 82, 97
Mercer, Kobena, 153
Metz, Christian, 16–17, 42
Miller, Monica, 147
Miller-Young, Mireille, 133
Millner, Sharon, 190; *Scenes from the Micro-War*, 190
Mirzoeff, Nicholas, 15, 16, 57
miscegenation, 88
Mitchell, W. J. T., 8, 10
mixing, 153; remixing, 116, 118, 137
McCarter Theatre, 84
McCollom, Michael, 174
McLaughlin, Noel, 153
"modest witness" (Haraway), 179, 205
Monster (Orlandersmith), 84
Moor, Ayanah, 29, 109, 135–36; *Baby Got Back*, 136–37; *Clap, Face, Lean and Glow*, 134; on "global touring," 237n50; *Still*, 134–36
Morales Cox, Lorraine, 124
Morgan, Joan, 134
Morrison, Toni, 88, 194; *Paradise*, 88
Moshood, 156
Moten, Fred, 85
Motley, Archibald, 78; *The Octoroon Girl*, 78
Mounsef, Donia, 130
Mrs. Coretta Scott King and her daughter Bernice at the funeral of Dr. King (Sleet), 47
MTV, 130–31, 133, 143, 168; MTV Music Video Awards, 138
Muhammad, Erika, 183

Muhammad, Tariq K., 156
mulatta, 74, 75, 78, 89
Mulatto (Hughes), 78, 103
Munoz, Jose Esteban, 11, 111
Murray, Timothy, 96–97
Museum of Modern Art (MOMA), 179, 181
Museum of the City of New York, 173–75
Mutu, Wangechi, 182
"My Adidas" (Run D.M.C.), 155

NAACP (National Association for the Advancement of Colored People), 78, 222n37
nationalism, 29, 152–53, 166, 192, 194
Neely, Barbara, 89
negation, 16, 24, 82, 100, 102, 104, 110, 111, 211, 235n70
"Negro Problem," 8
Nelly, 158, 161
Nelson, Alondra, 182
New Economy, 158
New Museum of Contemporary Art, 179
New Negro, The (Locke), 12
Newsweek, 211, 214–15
New York City, 39, 84, 104, 106–8, 168; Times Square, 168
New York Photo League, 58
New York Times, 35, 84, 132, 167, 209
Nichols, Bill, 49
Nigeria, 177, 178, 189, 191
"nipplegate," 130
Nixon, Richard, 192
non-iconicity, 9, 28, 64
North Carolina, 89, 104
Notorious B.I.G., 138, 161; "Big Poppa," 161
Number 2 Train (Shabazz), 149
Nuyorican Poet's Café, 84
Nyong'o', Tavia, 229n42

Obama, Barack, 212; as "African American," 46; as president, 46; as senator, 3
Octoroon Girl, The (Motley), 78
Ofili, Chris, 107; *The Holy Virgin Mary*, 107
O'Grady, Lorraine, 111
Oguibe, Olu, 200, 204
Olympia (Manet), 21, 114
One Shot, 28, 49–52
One Shot (film), 52
Opportunity Magazine, 81
optical paradigm, 95
Orlandersmith, Dael, 28, 73, 82–95; *Beauty's Daughter*, 84; on documentary theater, 86, 233n43; *The Gimmick*, 84; *Monster*, 84; *Yellowman*, 72, 82–87, 93–104
Overshown, Howard, 84
Owens, Jesse, 37, 68

Pacteau, Francette, 100, 105
Paradise (Morrison), 88
Parks, Gordon, 42–44; *American Gothic*, 44
Parks, Rosa, 34–38, 64
Parks, Suzan-Lori, 84, 236n33; *Topdog/Underdog*, 84
Parrenas Shimizu, Celine, 131
Passing (Larsen), 78
Paste Magazine, 219–220n7
Pegler-Gordon, Anna, 57
Peirce, Charles Sanders, 33, 42–43
perception, 8, 72, 73, 89, 92, 95, 123, 164, 196
Perez, Rosie, 1
performance, 2, 6, 7, 12, 18–21, 24, 28, 29, 31, 33, 49–52, 71–73, 77, 79, 82, 84, 90, 110, 112, 115, 118, 123–24, 132, 134, 136, 138, 142, 144, 161, 197, 208, 209, 210, 211, 214; "looking good" as performance, 149–52; performance theory, 6, 18–21, 110, 122
performativity, 8, 18, 19, 20, 29, 71; the performative, 6, 7, 20, 21, 29, 77, 78, 79, 96, 104, 110, 112, 118–19, 122, 124–25, 130, 137, 142, 147, 150, 154, 166, 186
Perry, Imani, 142–43, 161
Phat Farm, 158–60, 163–66
Phelan, Peggy, 19–21, 24, 54, 89, 122
Photographer taking a picture of boxer Muhammad Ali (Cassius Clay) possibly in Carlton House Hotel (Harris), 68
photography, 12, 28, 33–70, 106–20, 148–50; daguerreotype, 57, 120; documentary, 33, 42–45, 58–60
photomontage, 187, 189
pictorial/visual turn, 8
Piper, Adrian, 197
Pittsburgh, 28, 37–38, 49–50, 54, 60, 64, 135
Pittsburgh Courier, 38–40, 49–50, 53–54, 56, 64
Pittsburgh Post-Gazette, 52, 53
Platt, Kym, 216
Plum Bun (Fauset), 78
Portrait of Charles "Teenie" Harris, holding camera and standing on sidewalk (unknown), 52

Portrait of man wearing light colored shirt with pack of cigarettes in front pocket, standing in front of chain link fence (Harris), 60
Portrait of man wearing plaid double pocket shirt and moustache, standing in front of chain link fence (Harris), 60
portraiture, 44, 54, 135, 148
Powell, Richard, 113, 124, 135, 143 148
projection, 2, 23, 96, 100, 101, 113
Public Art Fund, 199
Public Enemy, 1
Puerto Rico, 64; Puerto Ricans, 166
"pushbutton malaise," 192

queer theory, 12
Quicksand (Larsen), 78

racialization, 22, 71, 77, 127, 152; as amputation/castration, 26; "race men," 172; racializing norms, 86
Radio Raheem, 2, 3, 24
Raiford, Leigh, 37, 45
Reagan administration, 4
Reconstructing Womanhood (Carby), 220n12
Reed, Ishmael, *Flight to Canada*, 82
refashioning, 164, 175
rendering, 7, 17, 23, 24, 25, 27, 34, 47, 49, 90, 92, 110, 111, 117, 118, 124, 137, 187, 200–201, 208, 210, 213; definition of, 7
Rich, Frank, 132
Riggs, Marlon, 222nn32–33, 235n5; *Black Is . . . Black Ain't*, 222n32; *Tongues Untied*, 235n5
Riis, Jacob, 42
Robert Miller Gallery, 108
Roberts, Dorothy, 120
Robo Makes Dinner, 187–88, 190
Roca Wear, 168, 173. See also Jay-Z
rock music, 153–54
"Rock Your Body" (Timberlake), 128
Rodriguez, Juana Maria, 224n59
Rogers, Ginger, 193
Rogoff, Irit, 222–23n38
Romano, Renee C., 45
Rose, Tracey, 31–32, 109, 118–25, 182; *Ciao Bella*, 124; *Span I*, 31; *Span II*, 31; *TKO*, 123–24; *Venus Baartman*, 118
Rose, Tricia, 152
Rosler, Martha, 42, 190; *Semiotics of the Kitchen*, 190

Ross, Diana, 133
Royal, Leslie E., 172
Rudy Clay, brother of boxer Cassius Clay (Muhammad Ali) reading newspaper in kitchen, possibly Carlton House Hotel (Harris), 66
Run-D.M.C., 155, 158
RuPaul, 143
Rush Management, 155
Russell, Kathy, 74

Sales, Nancy Jo, 171
Sanneh, Kalefa, 149
Saunders, Richard, 43
Scenes from the Micro-War (Millner), 190
Schechner, Richard, 19
Schneeman, Carolee, 124
Schneider, Rebecca, 110
Schuyler, George, 78; *Black No More*, 78
scopic regime, 16–18, 26, 73, 119
Scott King, Coretta, 47
Sean John (company), 167, 168, 173. See also Combs, Sean
segregation, 53, 79, 85, 86, 148
self-fashioning, 148
self-presentation, 148
Self portrait of Charles "Teenie" Harris (Harris), 48
Semiotics of the Kitchen (Rosler), 190
Sensation (Brooklyn Museum), 107
Sexton, Jared, 220n16
Shabazz, Jamel, 148; *Number 2 Train*, 149
Shange, Ntozake, 97
Sharpton, Al, 212
Shellenbarger, Kerin, 40, 54, 59
Sherman, Cindy, 124, 197
Sherrard-Johnson, Cherene, 78
Shimakawa, Karen, 90–91
Shonibare, Yinka, 182
Silverman, Kaja, 30, 123, 180, 194, 202
Simmons, Kimora Lee, 160
Simmons, Russell, 155, 158–66, 168, 171
Singh, Nikil, 225n1; on "the West," 241n3
Sir Mix-a-Lot, 115; "Baby Got Back," 115, 136–37
Siskind, Aaron, 58
Sisquo, 140–41
slaves/slavery, 57, 75, 85, 127, 140, 147; Atlantic slave trade, 127
Sleet, Moneta, Jr., 43, 46–47, 55; *Mrs. Coretta Scott King and her daughter Bernice at the funeral of Dr. King*, 47

Small Place, A (Kincaid), 184
Smith, Christopher Holmes, 128, 144
Smith, Nate, 49
Smith, Paul, 156
Smith, Valerie, 4, 220n12, 222n33
Smith, Willi, 157
Sobchack, Vivian, 196
Sontag, Susan, 54
Soussloff, Catherine, 21
South, the, 39, 79, 81, 91, 94–95, 104
South Carolina, 57, 104
Span I (Rose), 31
Span II (Rose), 31
spectatorship, 37, 68, 78, 179, 196, 205
Spiegler, Marc, 155
Spillers, Hortense, 82, 112, 127
Sprinkle, Annie, 124
Stange, Maren, 43
Steel Town, 60
Still (Moor), 134–36
Story, Tim, *Barber Shop*, 221n24
Stowe, Harriet Beecher, *Uncle Tom's Cabin*, 82
Street Art, Street Life (Bronx Museum), 198
Student Nonviolent Coordinating Committee (SNCC), 45
Studio Museum (Harlem), 201
subjugation, 13, 17, 33, 57, 89, 92–93, 97, 100, 102, 107, 123, 142, 147
Suburbia (Tuggar), 195
"Suck My Dick" (Lil' Kim), 138–39
Sundance Theatre Laboratory, 233n36
suture, 9, 30, 180–82, 194, 197, 202–3, 204; digital suture, 181, 204
synesthesia, 3, 211

"Take Back the Music," 238n53
Tate, Greg, 208
Taylor, Diana, 19
technology, 30, 179, 182, 183, 187, 189, 193, 194, 196, 198, 200, 202, 203, 204; consumer/domestic, 177, 190, 192; and fantasy, 192–93, 194, 203
technology studies, 30, 179, 183, 189
technotopia, 193
Tempo (MOMA), 184
terror, 22, 75, 83, 88, 93, 94, 96, 99, 101, 104, 124, 220n16, 231–32n14
theater, 18, 20, 21, 71, 73, 77–78, 79, 81; Asian American theatre, 90; black theatre, 71, 77–78; and vision, 79. *See also* drama

Their Eyes Were Watching God (Hurston), 79
"Think Different" (Apple advertising campaign), 36
Thurman, Wallace, 78, 81; *The Blacker the Berry . . .*, 78
Timberlake, Justin, 128–30, 132; "Rock Your Body," 128
TKO (Rose), 123–24
Tompkins, Kyla, 231n2
Tongues Untied (Riggs), 235n5
Topdog/Underdog (Parks), 84
Transient Transfer (Tuggar), 198–200
trauma, 22, 23, 73, 82, 86–87, 91, 93, 97, 131; via colorist logic, 28, 72–73; psychic, 29, 72, 73; traumatic visions, 95–103; traumatic wound, 99
Trebay, Guy, 167
Tuggar, Fatimah, 30, 177–205; *Changing Space*, 198–99; *Conveyance*, 201; *Fusion Cuisine*, 177, 192–95, 197; *The Lady and the Maid*, 187, 190, 197; *Meditation on Vacation*, 184–85, 187; *Robo Makes Dinner*, 187–88, 190; *Suburbia*, 195; *Transient Transfer*, 198–200; *Working Woman*, 195
Twitter, 207
Two men standing on brick road, holding torn plaid shirt, man on right holding cigarette, with chain link fence in background (Harris), 62

Uncle Tom's Cabin (Stowe), 82
underdevelopment, 179
United Press International (UPI), 34; photo of Rosa Parks on bus, 35
unknowability, 27
urban real, the, 152

value, 73, 94
Venus Baartman (Rose), 118
VH1, 168
Vibe (magazine), 29, 162
video vixens/hoes, 133, 138
visibility, 7, 9, 12–13, 15, 16, 29, 89, 107, 111–12, 121, 122, 127, 132, 156, 157, 159; black visibility, 7, 12–13, 15, 29, 121, 122, 127; definition of, 16
visible seams, 9, 157, 180, 197–98, 204
vision, 5, 6, 7, 8, 13, 16, 17–18, 21, 24, 26, 27, 28, 29, 31, 72, 73, 77, 79, 82, 85, 89, 93, 94, 95, 99, 102, 104, 113, 121, 123, 127, 163, 177, 209; definition of, 16;

vision (cont.)
　failure of, 28, 29, 72, 73, 75–76, 82, 93, 94, 100, 102; field of, 5, 6, 7, 8, 15, 16, 18, 23, 27, 28, 29, 72, 73, 89, 99, 109, 113, 127; metaphor of, 22, 72, 78; and performance, 21, 28, 72; technologies of, 17, 21; traumatic, 95; troubling, 6, 28, 29, 31, 93
visuality, 5–6, 8, 9, 13, 14, 15, 16, 20, 21, 23, 27, 29, 30, 31, 38, 71, 73, 95–96, 109–10, 112, 114, 121, 122, 124, 149, 181, 210; definition of, 16; discourse of, 7, 15, 24; and performance, 29, 31, 73, 109–10, 149; terror of, 96
visualization, 3, 8, 16, 72, 87, 96; definition of, 16; and performance, 7
Vuitton, Louis, 147

Walker, George, 77
Walker, Kara, 124
Wallace, Maurice, 95, 123
Wallace, Michele, 12–13, 15, 112
Watkins, Craig, 4, 219n4
Watson, Ella, 44
Wedding Band (Childress), 72
Weems, Carrie Mae, 118
Weinstone, Ann, 189
White, Blanche, 89
White, Graham, 147
White, Shane, 147
white privilege, 76, 85
white/whiteness, 75–76, 85, 95, 113
Williams, Bert, 77

Williams, Carla, 118, 120–21, 131; *The Black Female Body*, 120
Williams, Hype, 133
Williams, Pharrell, 172–73; Billionaire Boys Club and Ice Cream, 172; as Pharrell, 158
Williams, Serena, 109
Willis, Deborah, 12, 39, 43, 47; *The Black Female Body*, 120
Wilson, Eric, 174–75
Wilson, Midge, 74
Winfrey, Oprah, 3, 211, 212
Witt, Doris, 89
Woman holding cigarette, and Robin Bullard on her lap, seated behind sheet cake inscribed "Happy Birthday Peg" in kitchen, for birthday party for Margaret Bullard, 2801 Bedford Avenue (Harris), 55
Woo, Elaine, 210
Wood, Grant, *American Gothic*, 44
Working Woman (Tuggar), 195
wound, 9, 26, 89, 99, 100, 181; psychic, 11, 95

Yellowman (Orlandersmith), 72, 82–87, 93–104
Yo Mama's Last Supper (Cox), 106–8, 113–14, 131
Young, Hershini, 113–14
Young, Lola, 26–27

Zealy, Joseph T., 57
zoot suit, 148, 150